Praise for LAW AND POPULAR CULTURE

"While teaching an honors class on law and society, I found the Asimow–Mader book to be a constant source of quotable and relevant source material for classroom use. The chapters were especially nuanced in combining social science findings with insights from cinema studies. After retirement, I continue to find the chapters relevant in film lectures on legal themes to audiences of retirees. A second edition will make an original work only more relevant and up to date."

—*Edward Gross, University of Washington, Dept. of Sociology (Emeritus)*

"Asimow and Mader convincingly argue that popular representations of law are crucial to how people understand and perceive the legal system. This is an important, social constructionist insight that is not stressed often enough in law schools. The book is very well organized and shines in its emphasis on cinematic techniques, using films as illuminating case studies through which to more fully understand the American criminal and civil justice systems. The authors' cultural legal approach is exciting because it treats popular culture as just as worthy of study as the cases and statutes normally studied in law schools. This is the leading text for law and popular culture courses—enjoy!"

—*Jennifer L. Schulz, Associate Dean and Associate Professor,*
Faculty of Law, University of Manitoba, Canada

"*Law and Popular Culture* is a welcome addition to the teaching literature in this important and burgeoning field. It may be used as a primary or secondary text, with a concise introductory overview followed by analytical chapters on important individual films or television shows in the context of this dynamic field of study. This structure, together with thoughtful organization (initially by broad topic such as "the adversary system," and later by subject matter, either civil or criminal) facilitates teacher flexibility as to which chapters to include and which films or television shows (or substitutes) to assign for student viewing before each class. I highly recommend this book."

—*Donald Papy, Adjunct Faculty, University of Miami School of Law*

"Using both familiar (*Anatomy of a Murder, 12 Angry Men*) and less-known texts (*Counsellor at Law, Philadelphia*) from a variety of eras, *Law and Popular Culture* offers an excellent framework for introducing college students to the study of film and its pervasive influence on our understanding of the law and lawyers. Scholarly yet accessible, it works not only as an authoritative text on popular culture but also as a clear and concise guide to understanding how our legal system functions, making it easily adaptable to diverse audiences, including freshman students. The questions at the end of each chapter work exceptionally well in generating spirited yet thoughtful class discussion and debate."

—*Gary Peter, College of Education and Human Development, University of Minnesota*

"*Law and Popular Culture* is an excellent introduction to the legal system. The text is a comprehensive approach to law and popular culture tha⸱ ⸱⸱⸱ ⸱⸱udents as they seek to understand the laws and dynamic nature of society. I appr⸱ ⸱⸱⸱ legal information followed by film concepts. This structure ⸱⸱⸱ not just those interested in law. With this book, I have be⸱ ⸱⸱⸱ deeper understanding of the legal system and our ever-chan⸱ ⸱⸱⸱

—*Deb⸱ ⸱⸱⸱*
Coordinator of General Studies Courses, and Adjun⸱ ⸱⸱⸱

Praise for the First Edition of **LAW AND POPULAR CULTURE**

"*Law and Popular Culture* combines film history, social history and legal issues in a readable and engaging way. Better still, the course Asimow and Mader propose will help any would-be lawyer to see his or her role in society in a more humane and responsible way. But best of all, this book and this course offer entertainment as well as enlightenment. I never wanted to be a lawyer, but if this course had been around when I was in college, I would happily have embraced it."

—Richard Schickel, Film critic, Time Magazine, *documentarian,*
and author of numerous books on film history and criticism

"*Law and Popular Culture: A Course Book* will become an instant classic. Focusing on exemplary films and television shows about law and lawyers, Asimow and Mader present insightful readings and interpretations of both their narrative and visual elements. This book provides a stellar example of the kind of intellectual excitement that can be generated in the classroom and a truly invaluable resource for teachers and students eager to explore the increasing important connections of law and popular culture."

—Austin Sarat, William Nelson Cromwell Professor of Jurisprudence and Political Science,
Amherst College, and author of numerous works on law and society
and law and popular culture

"In all cases [the authors] intersperse examination of the film with searching and far-reaching questions to guide the reader's thinking. These questions both guide and stimulate students in their study, always adding new material to the classroom and frequently directing the instructor into new fields of inquiry. What we have here is a first-class textbook that should serve as a model for more texts in fields of inquiry that feed on and in turn sustain popular culture."

—Ray B. Browne, in Journal of Popular Culture

"This course book is a terrific read and will be for readers a terrific resource. Even instructors who do not require it of their students should require it of themselves."

—William Haltom, Law & Politics Book Review

"Looking toward the law, Asimow and Mader use popular culture to illuminate such legal topics as constitutional rights, alternative legal systems, rules of ethics, and the actual daily life of lawyers. Looking toward movies, they use popular culture's handling of legal themes to elucidate such topics as genre, editing, and stylistic realism. This beating to and fro encourages an understanding of how the law affects popular culture (e.g., the Hays Code) as well as how popular culture affects the law (e.g., who is attracted into the profession by popular culture's portrayal of lawyers). Most important, though, the book unlocks the semiotic possibilities of the intersection of law and popular culture for the students to explore."

—Douglas Goodman, in Law & Social Inquiry

"The book is not a typical law school case book. It is short, well written and of interest to the entire profession and to producers of popular culture about law because of the important issues the authors raise about the relationship between the two."

—Andrew Schepard, New York Law Journal

LAW AND POPULAR CULTURE

This book is part of the Peter Lang Media and Communication list.
Every volume is peer reviewed and meets
the highest quality standards for content and production.

PETER LANG
New York • Washington, D.C./Baltimore • Bern
Frankfurt • Berlin • Brussels • Vienna • Oxford

MICHAEL ASIMOW AND SHANNON MADER

LAW AND POPULAR CULTURE

A COURSE BOOK

SECOND EDITION

PETER LANG
New York • Washington, D.C./Baltimore • Bern
Frankfurt • Berlin • Brussels • Vienna • Oxford

Library of Congress Cataloging-in-Publication Data

Asimow, Michael.
Law and popular culture: a course book /
Michael Asimow, Shannon Mader. — Second edition.
pages cm.
Includes bibliographical references and index.
1. Law in motion pictures. 2. Law on television.
3. Justice, Administration of, in motion pictures.
4. Justice, Administration of, on television.
5. Popular culture—United States.
6. Law—Social aspects—United States.
I. Mader, Shannon. II. Title.
PN1995.9.J8A85 791.43'65540973—dc23 2013003335
ISBN 978-1-4331-1324-6 (paperback)
ISBN 978-1-4539-1080-1 (e-book)

Bibliographic information published by **Die Deutsche Nationalbibliothek**.
Die Deutsche Nationalbibliothek lists this publication in the "Deutsche
Nationalbibliografie"; detailed bibliographic data is available
on the Internet at http://dnb.d-nb.de/.

The paper in this book meets the guidelines for permanence and durability
of the Committee on Production Guidelines for Book Longevity
of the Council of Library Resources.

© 2013 Peter Lang Publishing, Inc., New York
29 Broadway, 18th floor, New York, NY 10006
www.peterlang.com

Printed in the United States of America

Michael Asimow dedicates this book to Merrie.

Shannon Mader dedicates this book to Albert William Mader.

Contents

Acknowledgments

The authors gratefully acknowledge the contribution to this book by Norman Rosenberg, DeWitt Wallace Professor of History at Macalester College, St. Paul, Minnesota. Professor Rosenberg was originally one of the collaborators on the first edition of this book and wrote significant parts of the text. We appreciate Professor Rosenberg's contributions and his generous decision to allow us to use them in both editions of the book.

Paul R. Joseph was Professor of Law at Shepard Broad Law Center, Nova Southeastern University, in Fort Lauderdale, Florida. Professor Joseph tragically died in 2003. Professor Joseph was one of the original collaborators on this book, but he had to withdraw because of other commitments. Professor Joseph wrote part of the chapter on the criminal justice system, and we are most grateful that he allowed us to use it in this book. We also acknowledge the contribution to Chapter 1 of Professor Joyce Penn Moser of Stanford University. Professor Moser planned to collaborate on the second edition of this book but was unable to do so.

We have discussed the material in this book with far too many people to name here, but we always benefited greatly from their insights. We would especially like to thank the users of the first edition of the book for their wonderful suggestions, including David Fisher, Kirk Junker, Scott Mulligan, Gary Peter, and Debbie Shapiro. If only we could have embraced all of their suggestions! We also gratefully

acknowledge the assistance of Richard Abel, Dyanne Asimow, Stuart Banner, Paul Bergman, Samantha Black, Ray Browne, Drew Casper, Kimberle Crenshaw, John Denver, Steve Derian, Sharon Dolovich, Jennifer Factor, Sam Feldman, Steve Greenfield, Gillian Lester, Stefan Machura, Carrie Menkel-Meadow, Francis Nevins, Guy Osborn, Peter Robson, Charles Rosenberg, William Rubenstein, Gary Schwartz, Andrew Schepard, David Schultz, Brad Sears, Louis Schiff, Rafael Simon, Rob Waring, Dan Watanabe, and Steven Yeazell.

Lastly, we would like to thank the students in Asimow's seminars on Law and Popular Culture at UCLA Law School and at Stanford Law School. They inspired us to believe that it made sense to write a course book for a course that didn't yet exist. Many of their ideas and comments found their way into the first and second editions of this book.

Of course, we bear the responsibility for any errors or omissions.

Preface

We're in a segregated Alabama courtroom in the mid-1930s. The packed room is hushed as Atticus Finch rises to begin his closing argument to the jury in the case of Tom Robinson. Robinson, a young black man, is falsely accused of raping a white woman. The film is *To Kill a Mockingbird* (1962).

Two white eyewitnesses (the alleged victim and her father) have testified against Tom Robinson. The jury is all male and all white. Finch's closing is brave and eloquent. He says: "In our courts all men are created equal. I'm no idealist to believe firmly in the integrity of our courts and our jury system. That's no ideal to me. That is a living, working reality." But the case is hopeless. The jury quickly convicts Tom Robinson. Soon he is dead, supposedly shot while trying to escape.

With his stirring but futile defense of Tom Robinson, Atticus Finch became the patron saint of lawyers. The heroic character of Atticus Finch inspired countless young people to become lawyers. It has the same power to inspire them today.

Now we're in a different courtroom. It's in Boston and the time is the 1980s. The film is *The Verdict* (1982). Frank Galvin staggers to his feet to deliver his closing argument. Galvin's client, Deborah Ann Kaye, went into the hospital to give birth. Something terrible happened during anesthesia and she is in a permanent vegetative state. Galvin is a hopeless alcoholic, a loser who ignored the case almost until the trial began. His opponent, Ed Concannon, is a big firm partner who rep-

resents the Archdiocese of Boston, which operated the hospital. Concannon has played every dirty trick in the book to defeat Galvin. The judge seems to be in Concannon's pocket. Galvin's closing argument ignores the facts of the case and urges the jury to do justice. The jury returns with a stunning verdict for the plaintiff. We leave the theater with the satisfied feeling that justice was done, but the film paints a dark picture of the character and ethics of the two lawyers. Few would be inspired to take up the legal profession after seeing this film.

This book is designed to be used as the reader for a course in law and popular culture. The course studies movies like *To Kill a Mockingbird* (Chapter 3), *The Verdict* (Chapter 4), and many other films and television shows. The course on law and popular culture originated as a law school offering, but the model works well in a wide range of undergraduate or graduate programs. The first edition of this book was used in programs as diverse as American studies, criminal justice, mass media, and film and television studies, and within such traditional departments as history, political science, or sociology.

The course on law and pop culture explores the interface between two subjects of enormous importance to the lives of everyone—law and popular culture. Why should we care about the interaction of these subjects?

Law pervades modern society. Increasingly, courts decide some of the most fundamental social and economic problems of society, including such hot-button issues as abortion, the death penalty, the right of privacy, gun control, homosexual marriage, affirmative action, or federal health care legislation. Indeed, the U.S. Supreme Court decided that George W. Bush rather than Al Gore won the 2000 election (*Bush v. Gore*, 2000).

So many aspects of our lives are profoundly affected by laws, police, judges, and lawyers. We want the police and the courts to catch and convict criminals to keep us safe, but we want our privacy to be protected and the rights of the accused to be safeguarded. We want our legal system to deliver justice, but sometimes it fails to do so. What do we mean by "justice" and why can't the legal system deliver it? Lawyers are among the most despised of all professions. Why is this? Is it justified? What do lawyers actually do, anyway? Everyone needs to know much more about law, lawyers, and the legal system than they do now.

Popular culture is even more pervasive than law. All of us swim in a sea of films, television shows, books, songs, advertisements, and numerous other imaginative texts. The average family watches about five hours of television each day, not counting time spent watching TV content on mobile devices. During thirty minutes of watching television, we consume more images than a member of pre-industrial society would have consumed in a lifetime. Everyone needs to know

much more than they do about popular culture in order to understand, interpret, and fight back against the onslaught of images that assault us every day.

The course in law and popular culture is intended to deepen students' understanding of both law and popular culture and the many ways in which they influence each other. The wall between law and popular culture allows a lot of traffic to pass in both directions. In particular, we believe that popular culture both *reflects* and *constructs* our perceptions of the law. It can also *change* the way that the players in the legal system behave.

In addition to considering questions about law and lawyers, this course focuses on filmmaking, film history, and film theory. As we watch these legally themed movies or TV shows, what can we learn about writing, directing, editing, or scoring? How are these narratives constructed? What's the filmmaker's hidden agenda? What makes a pop culture product seem "realistic"? What genre do these films fall into, and do they respect the rules of that genre? How did the business practices of the industry or the cultural trends of the time influence the production and reception of the film or TV show?

We do not assume that instructors in law and pop culture have any training (formal or otherwise) in law, filmmaking, film theory, history, or in any other discipline. The book is written in plain English, without theoretical jargon, and it can be taught by anyone who enjoys popular culture and is interested in law. The materials treat each movie or TV show as both a cultural and as a legal text as well as a work of art and a product manufactured to entertain a mass audience and make a profit. Our job is to supply the materials to make the course work, no matter what the background of the person who is teaching it.

Each chapter in this book (except the introduction) is based on a particular film or television show involving law and lawyers. The book deals with many issues of criminal and civil justice and with problems of law practice and legal ethics. It discusses how the lawyers in the film or TV show are represented. It tackles such institutions as law school, the jury, big law firms, and the economics of law practice. And it addresses all of these issues and institutions in a critical and challenging way.

When students are brought face-to-face with popular culture, the result is different from the typical college-level course. Normally, the teacher is the expert, and the students passively soak up as much of the teacher's knowledge as they can absorb. But in a course based in the media of popular culture, the students share expertise with the instructor. Every student in the room is *already* an expert in interpreting popular culture. They know the language of film and television. They have been practicing that language since before they learned to talk, much less read. Every student has seen hundreds of movies, thousands of hours of television shows (not

to mention their exposure to music or the Internet). In many cases, the students have consumed far more popular culture than the instructor has (Denvir 1996).

The result is electrifying. The students bring with them deeply felt opinions about pop culture. They are moved and inspired, or infuriated, by films like *To Kill a Mockingbird, Anatomy of a Murder, The Verdict,* or *Philadelphia.* They are full of ideas, arguments, and interpretations. They speak up in class. They argue with each other and with the instructor. They are not overawed by the instructor's interpretation of a film because their interpretation may be just as valid. The level of interactivity in the classroom equals that in the most engaging and best-taught classes.

Appropriately to the world of film and television, this preface is an ill-disguised pitch. It's pitched to the people who decide what courses they want to teach and what books to assign for those courses. We hope that a course based on these materials will be fun to take and to teach. But it's not all fun and games and it certainly isn't fluff. As we said, the twin subjects of law and popular culture are two of the most meaningful in the lives of our students. Students deserve and will benefit from a critical and serious examination of these subjects and the many ways they interface with each other.

We wish to all students and teachers of law and popular culture an enjoyable and stimulating tour through these two vitally important and constantly intersecting worlds.

Michael Asimow &
Shannon Mader

PART I

Law, Lawyers, and the Legal System

1

Introduction to *Law and Popular Culture*

1.01 What this book is about

This book is meant as the reader for a course with the general theme of "Law and Popular Culture."[1] It is suitable for undergraduate and graduate classes or seminars in American studies, criminal justice, political science, film studies or other academic programs, as well as in law schools. Therefore, it provides material on the study of popular culture that may be unfamiliar to most law students, as well as material on law, lawyers, and the legal system that may be unfamiliar to most non-law students. Each chapter, with the exception of this introduction, consists of readings based on a particular film or television show that students should view before class discussion begins. (In some classes, the films are viewed outside of class; in others, they are viewed at the beginning of the class.) Individual instructors, of course, can substitute different films or readings for those suggested.

1.02 Definitions of "popular culture" and "popular legal culture"

This book frequently uses the words "popular culture" and "popular legal culture." What do we mean by these vague terms?

1.02.1 The double meaning of "popular culture" and "popular legal culture"

We use the terms *popular culture* (often shortened to "pop culture") and *popular legal culture* in this book in *two distinct ways* (see Friedman 1989). These might be called the "broad" and "narrow" meanings of these words.

According to the "broad" approach, the term "popular culture" means all of the knowledge, behaviors, beliefs, and attitudes possessed by people in a particular society or subgroup of that society. Using a similar broad meaning, *popular legal culture* refers to everything people know or think they know about law, lawyers, and the legal system. We frequently have the broad meaning in mind when we use the term "popular culture." For example, we sometimes hear that America has a "culture of violence," meaning that there are many people who behave violently in America. As another example, the U.S. Supreme Court said that *Miranda* warnings have become "part of our national culture" (see ¶1.05.1). The Court might have used the words "popular legal culture" instead of "national culture," because it was referring to what everybody knows (or thinks they know) about the warnings that police must give suspects after they are arrested.

The "narrow" approach is quite different. Under the "narrow" approach, "popular culture" means media *products* (whether in the form of films, television, print publications, music downloads, stage plays, and so on) that are manufactured and marketed for popular consumption. We use this narrow definition when we say that people consume a lot of pop culture, meaning that they watch a lot of television or movies. Again using the narrow approach, "popular legal culture" means media products about law, lawyers, or the legal system.

1.02.2 Popular culture and high culture

There is a well-understood distinction between "popular culture" and "high culture." Popular culture (using the narrow approach set out in ¶1.02.1) covers commercially produced works intended for the entertainment of mass audiences. Pop culture producers assume that consumers will enjoy and quickly forget these works. In contrast, "high culture" refers to works that are produced and marketed for consumption by elite rather than popular audiences. For example, high culture incorporates classical music and opera, paintings and other works of visual art, poetry, or serious fiction—usually older fiction that has succeeded in being recognized as literature. Works of high culture are intended to have lasting rather than merely transitory value. Generally, the production of works of high culture is less collab-

orative and commercial than the production of works of popular culture. However, many works that were originally produced as mass entertainment are later promoted to high culture status such as the novels of Charles Dickens or Mark Twain, the stories of Edgar Allan Poe, or the plays of Shakespeare. Perhaps detective stories by Arthur Conan Doyle and Raymond Chandler have also made the leap into the sort of high culture studied in serious literature classes.

Countless academics have researched and taught about high culture, as if it were the only kind of cultural product that counts. Other academics have scorned popular culture as escapist trash that imparts false consciousness to the masses while capturing profits for its producers. Today, however, a large number of scholars take popular culture seriously and subject it to the same sort of critical analysis that is traditionally accorded to high culture. For example, TV shows like *I Love Lucy, The Wire,* or *The Sopranos,* or movies like *The Matrix,* which were originally intended as mass entertainment, are now the subject of serious scholarly inquiry. Numerous academic journals and associations focus on pop culture products, and many undergraduate and graduate courses and seminars concentrate on various aspects of pop culture. This book applauds that movement and seeks to join it by focusing on popular *legal* culture, which is a small slice of the academic pop culture universe.

1.03 Why a course in law and popular culture?

In the preface to this book, we argued that both law and popular culture pervade nearly everyone's life. Therefore a course or seminar devoted to the interface of law and pop culture in our society is relevant and useful to students. As the preface also argued, students bring with them literacy in popular culture and familiarity with visual culture. As a result, students feel comfortable engaging in lively class discussions of particular films or television shows.

First, as to law: American courts rule on nearly every major question of social policy, and, with the rise of constitutional courts worldwide, this is true of many other countries as well. The United States has more lawyers per capita (over a million at last count) and more litigation than almost any other country. It also has the unenviable distinction of confining more people in penal institutions than any other country. The United States has 5% of the world's population but 25% of the world's population of incarcerated persons.[2] Indeed, law pervades and structures all social relations. As Paul Kahn wrote: "We experience the rule of law not just when the policeman stops us on the street or when we consult a lawyer on how to create a corporation. The rule of law shapes our experience of meaning everywhere and at all times. It is not alone in shaping meaning, but it is rarely absent" (Kahn

1999, 124). For example, many highly personal decisions relating to sexuality and marriage are reduced to legal questions: Can same-sex couples marry? If they do, can they file joint income tax returns? Are gay people protected from job discrimination? Can a lesbian retain custody of her child? Can someone who has cohabited without getting married assert legal rights when the relationship breaks up? Thus everyone needs to know about the legal system, what lawyers do, and how courts and other legal institutions work.

Second, as to popular culture: Popular culture is even more pervasive than law. Virtually everywhere in the world, people are subjected to a torrent of sounds and images designed to entertain them, mold their opinions, and persuade them to buy things. Vital political, social, and economic issues seem to be reduced to the flood of images on their television or mobile-device screens. Almost everyone is accustomed to spending large amounts of their precious leisure time seeking information and pleasure from consuming media. The average household consumes about 34 hours of television per week or about five hours per day and many people spend much more time than that.[3] We hope that film or a TV show will help us experience particular emotions and sensations (such as laughing or crying or being scared, angry, or aroused) without the risk of really feeling these emotions.

The pervasiveness of popular culture seems to be accelerating with the vast multiplication of channels available on television, new methods of consumption (such as mobile devices, laptops, or DVRs), and the infinite quantities of information available in cyberspace. A large amount of this material is popular *legal* culture in the form of countless movies and television shows about law and lawyers. Most people who read this book have already spent thousands of hours in movie theaters and in front of their computers or television sets, reading popular novels, surfing the net, or hearing popular music. All of this incessant media consumption produces important effects in those who consume it and in society generally. Everyone needs to know more about popular culture in order to be able to better understand its implications and effects and to criticize and deconstruct it where necessary.

As James Snead wrote, "we have to be ready, as film-goers, not only to see films, but also to see through them; we have to be willing to figure out what the film is claiming to portray, and also to scrutinize what the film is actually showing. Finally, we need to ask from whose social vantage point any film becomes credible or comforting, and ask why" (1994, 142).

While all forms of popular culture are important and instructive, this book focuses on feature films and television about law and lawyers, as opposed to other media like music, stage plays, novels, video games, or comic books. This approach is largely employed for reasons of pedagogical convenience—DVDs of films and

TV shows are easily available for rental or purchase (and increasingly available on demand) and thus are convenient objects of classroom study. Besides, we had to impose an arbitrary boundary to keep the subject under reasonable control.

This book does not attempt definitive discussion of literary or cultural or film theory[4] or definitive discussion of topics in law and legal theory. We draw on theoretical material when we believe it will be helpful to teachers and students in discussing and understanding the interface between law and popular culture. The book is intended for a diverse group of academic programs, both graduate and undergraduate, taught by instructors of diverse background and interests. Extensive treatment of any particular set of theoretical materials would make the book much longer and probably less useful for most of its readers. We anticipate that particular teachers will enrich class discussion by drawing on their own preferred theoretical orientation (and they may wish to add supplementary written materials to enhance such discussions).

1.04 The relationship between popular culture and the law

Popular legal culture has a complex relationship to law, lawyers, and the legal system. The relationship might be expressed as a feedback loop—that is, law affects pop culture and pop culture affects law (see ¶1.05.1 for further discussion).

1.04.1 Popular culture as reflection

Popular culture in the narrow sense (see ¶1.02.1) *reflects* popular culture in the broad sense.[5] In other words, works of popular culture often illuminate what real people actually do and believe. For example, TV commercials attempt to tap into our consumerist attitudes and sexual fantasies as well as our social, physical, and economic anxieties—while also trying to change our buying habits (Mittell 2010, ch. 2). Thus pop culture is likely to reflect the dominant ideologies of society, such as consumer capitalism, gender roles, or commonly shared stereotypes.[6] Similarly, the works of popular *legal* culture reflect what people generally believe about law, lawyers, and legal institutions.

Of course, popular culture in the narrow sense is never a perfect reflection of popular culture in the broad sense. Works of popular culture are informed by a variety of factors—everything from the commercial constraints under which they are produced, the economic interests of those who pay for them, and the ideological bias of their creators—that complicate their relationship to popular culture in the

broad sense. Pop culture producers always distort reality, including the operation of the legal system, for dramatic, commercial, or ideological purposes. Nevertheless, popular culture, in the narrow sense, can still tell us a lot about popular culture, in the broad sense. For example, if movies usually show lawyers who are greedy and dishonest, this is evidence that many people share this view—or, at least, that film-makers believe that they do. Similarly, old movies can tell us a lot about gender and family relationships of earlier times.

1.04.2. Media effects

Popular culture in the narrow sense powerfully *changes* popular culture in the broad sense. The consumers of works of popular culture are affected in ways that go far beyond entertainment or pleasure. To take the most obvious example, commercials change the buying habits of consumers as they "learn" information about new products or retailers. More relevant to this course, most people "learn" most of what they know (or think they know) about law and lawyers from consuming popular legal culture. Indeed, pop culture often invites viewers to work as surrogate police, jurors, judges, and lawyers, allowing them to vicariously experience and learn about the legal system from the inside. People learn details of law practice (such as that people address the judge as "your honor") and broader and contestable notions about law and justice (such as that the jury system delivers justice or that cross-examination is a useful way to ferret out the truth). But it's important to realize that people are learning from a highly unreliable source, because the media of pop culture consist of fictitious stories made up to entertain them. Pop culture products are often wildly out of sync with reality. Just to identify a few of the most frequent whoppers in the area of law, the police don't pursue, much less catch, most criminals; most criminal cases are plea bargained rather than go to trial; trials occur months or years after the crime, not the next week; lawyers are far more concerned with earning fees than pursuing justice; and lawyers can't give speeches while cross-examining witnesses.

Viewers may passively accept the messages that are spoon-fed to them by pop culture or they may resist those messages and form their own interpretations of the material (see ¶1.05.5.). Either way, whether the viewers are passive or active in their consumption of pop culture, they are using pop culture materials to *construct* their personal views of reality (including the reality about law and lawyers). The ways that popular culture in the narrow sense helps to construct popular culture in the broad sense is an important and controversial subject that is discussed in greater detail at ¶4.04.

1.04.3 The cultural study of law

A study of popular culture can help us understand law and law practice differently from the way we would understand it by going to law school or by reading books or articles about law. For example, the highly successful series *24* presented the view that the use of torture in interrogating suspects in emergency situations is both legal and effective, regardless of the actual law on the subject (which forbids torture). The show may well have made torture more acceptable to the public than it otherwise would have been. The film *Zero Dark Thirty* (2012) reinforced this message. In this respect, *24* and *Zero Dark Thirty* form part of a long tradition of the glorification of vigilante justice, cowboys, rogue police, and superheroes in pop culture.[7]

This book views law from a *legal realist* perspective, meaning that law is what judges, jurors, lawyers, legislators, police, and others involved in making or applying the formal law *actually do* as distinguished from what the law books say they *should do.* This is often called "law in action" as opposed to "law in the books." What these lawmakers and law appliers *do* depends on what they *believe;* and what they believe is heavily influenced by their own experiences and perceptions of the world outside the law, including the popular legal culture they have consumed. Thus, legal realists seek to understand how the formal law is actually applied on the ground and why and how it changes. They want to understand the informal ways that people resolve legal disputes. To understand these matters, legal realists consider many factors outside the formal written law, including popular legal culture (Friedman 1989). For these reasons, the works of popular culture can and should be studied as legal texts—as authoritative in their own way as the more familiar written texts like case law and statutes. We call this the *cultural study of law,* and we believe it can be valuable to students and lawyers alike.[8]

In many situations, seeing movies or TV shows about law and lawyers can place legal issues or issues of professional practice in a different perspective. Pop culture gives us indelible role models of good and bad lawyers (see Hermann 2012; ¶4.03). Pop culture can alert us to real problems in the legal system, such as unethical behavior by lawyers or judges, or the many ways that law fails to deliver justice.[9] Do we feel differently about the insanity defense after seeing *Anatomy of a Murder* (discussed in Chapter 2)? About the death penalty after seeing *Dead Man Walking* (Chapter 11)? About the tort system after seeing *A Civil Action* (Chapter 12)?

1.05 The (many) meanings of cultural texts

This subsection introduces some basic principles of cultural theory that are drawn on throughout the book.

1.05.1 The feedback loop between law and popular culture— Miranda and Dragnet

As previously mentioned (¶1.04), there is an important feedback loop (sometimes called "interpenetration") between law and popular culture. Law influences pop culture and pop culture influences law. An example of this is the relationship between the *Miranda* decision and *Dragnet*.

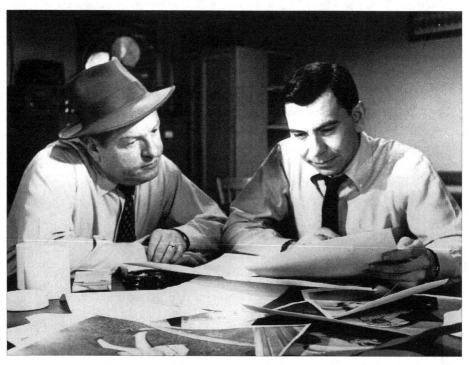

Figure 1.1. *DRAGNET*—Sgt. Joe Friday (Jack Webb) and Officer Frank Smith (Ben Alexander) analyze the evidence. NBC/Photofest. ©NBC.

The U.S. Supreme Court's decision in *Miranda v. Arizona* (1966) established that persons in police custody can remain silent and consult an attorney before being questioned. They must be warned that anything they say can be used against them and that if they can't afford an attorney, one will be appointed for them. Many people thought that the present conservative U.S. Supreme Court would overrule *Miranda*, but they were wrong. In *Dickerson v. United States* (2000), the Supreme Court reaffirmed *Miranda*. Chief Justice William Rehnquist insisted that the

Miranda rights not only rested on firm constitutional foundations but were "part of our national culture." The *Dickerson* opinion is an example of the feedback loop or interpenetration of law and culture in America—a legal decision (*Miranda*) found its way into film and television which in turn created a popular culture usage (using culture in the broad sense referred to in ¶1.02.1); that cultural usage then has an impact on the law (*Dickerson*).

Dragnet was initially a hit TV show during the 1950s, and it returned to the network schedule in 1967, a year after *Miranda*.[10] Many believe it introduced *Miranda* rights into "our national culture." *Dragnet's* creator and star, Jack Webb, insisted his program mirror the actual procedures of the Los Angeles Police Department, whose case files provided the material for the weekly episodes. Consequently, on *Dragnet*, Webb's character, Sergeant Joe Friday, and his partner informed everyone they arrested of their *Miranda* rights. Other TV programs and films followed suit, thus entrenching in popular culture the notion that suspects must be told their *Miranda* rights.[11]

1.05.2 The process of meaning-making—signifier and signified

The interpenetration of legal practice and visual media is not a new phenomenon. Artistic depictions of the Roman goddess Justitia, for example, have long provided a popular visual image of the relationship between law and justice.[12] Justitia is usually portrayed as a blindfolded woman with an unsheathed sword (to symbolize the state's power) in one hand and a scale (to represent the goal of fairly measured justice) in the other.

The field of semiotics concerns the process of "signification," which is often referred to as "meaning-making." In semiotics, images like Justitia are referred to as "signs." A sign is treated as the basic building block of human communication. Each sign contains two parts. The first is the *signifier*, the image, word, or sound (or, as in the case of films and TV shows, the combination of these) that people encounter. The *signified*, the other half of the sign, refers to the various possible meanings that a signifier generates as it circulates among readers and viewers.

In most cases, people expect that others will comprehend the meaning of commonly used signs. The producers of TV commercials, for example, assume that every viewer will understand that the visual image of a car signifies a real-life "car," a four-wheel machine in which people move around. This type of association, which is called *denotative*, produces straightforward, literal meanings that are widely shared. Viewers make sense of signs through the use of codes which are systems of meaning that help the viewer to organize and understand the world. Thus, to make

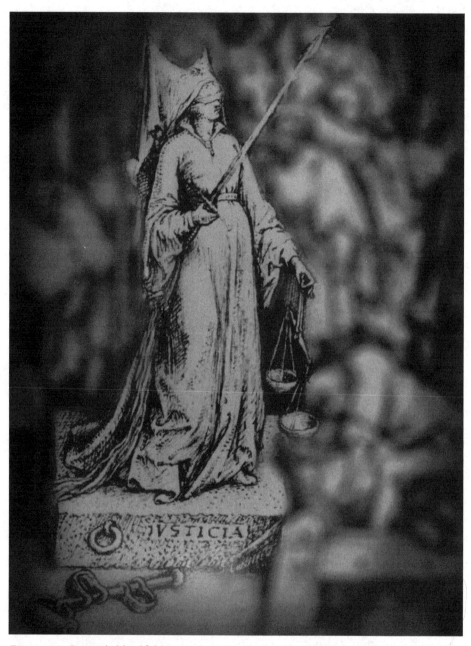

Figure 1.2. Justitia's blindfold, sword, and scales symbolize our expectations of justice. Gravensteen Castle, Ghent, Belgium. ©Merrie Asimow, 2012.

sense out of the car commercial, the viewer makes use of a code of commercials (that explains that somebody is trying to sell you something) and a code of transportation equipment (that distinguishes cars from skateboards).

The denotative meaning of a statue or picture of Justitia is simply that of a blindfolded woman holding a scale and brandishing a sword. But the image of Justitia produces another kind of association that is called a "connotative" meaning. For example, the image might mean that our justice system is powerful but also fair and impartial. Connotative meanings involve a far wider range than denotative ones. More importantly, these connotative meanings proliferate and overlap as signs come together to make up a written or visual text. The connotative meanings of a visual text often stimulate controversy—or, as students of visual culture like to say, the construction of meanings takes place on contested terrain.

1.05.3 Justitia's blindfold

The story of how visual renditions of Justitia changed over time provides a good example of the way in which the connotative dimension of meaning-making is a contested, social/cultural/historical process. In the Middle Ages, Justitia usually lacked a blindfold. Addition of a blindfold during the fifteenth and sixteenth centuries signified important changes in—and conflicts over—the legal systems of Western Europe. Initially, the blindfold over Justitia's eyes may have connoted a *critical* message—the legal system was using force without considering all sides of a dispute. The law unleashed the sword, this new image of *blinded justice* suggested, to serve the interests of the powerful against the powerless.

This same image, however, could also carry a positive meaning—that law was impartial, blind to differences in rank and status. Even though the critical meanings never disappeared, images of blind justice became a familiar sight in town squares and public buildings during the sixteenth and seventeenth centuries and increasingly signified that a modern legal system would treat everyone equally.

1.05.4 How do films and TV shows produce contested meanings?

When *Dragnet* showed the LAPD advising suspects of their *Miranda* rights, it joined an ongoing process of signification that extends into our own times—and beyond. To some TV viewers of the late 1960s, the set of signs that appear in a scene involving a *Miranda* warning might mean that the police were following the law. In addition, because the program claimed to realistically depict police work in the

City of Angels—"only the names have been changed to protect the innocent" the show's famous voice-over claimed—the image of the Miranda warnings could plausibly be seen as another sign of *Dragnet's* "authenticity."

However, this same text, and the series of signs that it contains, could have produced quite different meanings. Even during the 1950s, *Dragnet* attracted comedic interpretations. A hit record by the satirist Stan Freeberg lampooned the program's minimalist, staccato-like dialogue such as "book him on a 385." Some viewers could interpret *Dragnet* ironically, as more of a satire than an accurate reflection of law enforcement practices. The show would be enjoyable and funny precisely because it seemed so silly.

The comic connotations became more prominent when *Dragnet* returned to network television in 1967. Joe Friday, whose whole life apparently involved bureaucratic police routines, often seemed, especially to younger viewers, out of touch with the freewheeling cultural values and practices of the late 1960s. A biography of Jack Webb, entitled *Just the Facts, Ma'am* (invoking a line of dialogue used constantly by Sergeant Friday), suggests that *Miranda* warnings appeared so often that some viewers likely interpreted them as ridiculing, rather than reflecting, the LAPD's practices (Moyer & Alvarez 2001).

Subsequently, it became even more difficult to see *Dragnet* as a serious police drama. A 1987 motion picture version that starred Dan Aykroyd as Joe Friday was a flat-out comedy. (Tom Hanks plays a bumbling cop in this film, which includes a rap version of *Miranda* rights.) Later, as the actual LAPD appeared permanently mired in controversy and corruption, *Dragnet* attracted a new set of comical connotations when it circulated in re-runs. In fact, TVLAND, the "retro" cable channel, which regularly featured the 1967–71 episodes, surrounded them with tongue-in-cheek promotional spots that cued viewers to watch *Dragnet* as a parody of the law in action. Although *Dragnet* had become a source of parody, some people think the basic concept retained its dramatic power. In 2003, Dick Wolf (the successful producer of *Law & Order* and its numerous spinoffs—see Chapter 8) brought a serious and updated version of *Dragnet* back to television. Once more Sgt. Jack Webb tells suspects and witnesses "just the facts, ma'am." The show lasted for two seasons.

As the example of *Dragnet* suggests, media texts, and the signs within them, are often transformed by changing circumstances. Viewers watching a 1970 episode today will instantly identify it, as a result of clothing and automobile styles, as "history," a set of signs from the past. However, at the same time, *Dragnet* remains, in all of its many connotations, part of our present (and perhaps our future) culture as well. Most importantly, *Dragnet* and all of the other legal films and TV shows

about law in circulation today rely on a historically rooted set of media forms and practices that go back to the earliest days of the movies. These forms and practices (discussed in ¶1.06) continue to shape what viewers expect to encounter in a legally themed film or TV show.

1.05.5 Viewer-response theory

In reader-response theory, the consumers of a text construct their own interpretation of that text. This approach (labeled "viewer-response" in the case of visual media like film or television) rejects the claim that anyone, including the authors or creators of an item of popular culture, know some "correct" way of interpreting it, or deciding "what it is about," or "what it means." (Fish 1980; Staiger 2002; Morley 1992). Any text both invites and yields more than a single, authoritative meaning. As a result, the meaning encoded by the creator of a text may be entirely different from the meaning decoded by spectators. Reader- or viewer-response analysis is common in cultural studies; numerous writers have sought to determine empirically the responses of particular spectators to particular texts. (We discuss viewer-response theory further in ¶4.04.6.)

How a person is likely to interpret a text, and make a rational or emotional connection of that text to his or her own life depends critically on such factors as the person's class, race, gender, or political views, the other texts that the person has previously consumed, the viewer's expectations and mood, and the time and place that the interpretation occurs (Staiger 1992, 2002). Feminist writers, for example, often argue that men and women are likely to interpret texts such as films differently and complain that critics often privilege a phallocentric or male-centered reading (for additional discussion, see ¶10.06.7). Some viewers will interpret a film in accordance with the purportedly "dominant" view, one based on a conservative ideology that the way things are is the right way. Others will interpret it in accordance with a "resistant" view, one based on an ideology that would change the existing power relations of class, race, sexuality, or the like. Some may interpret it seriously, others ironically, so that the meaning is the opposite of what the filmmaker may have intended.

Thus, according to David Papke (1996a), Francis Ford Coppola intended in *The Godfather* (1972) to challenge the myth that the United States lived by the rule of law and enjoyed an economic system that provided opportunity to all. Instead, Coppola intended *The Godfather* to present the lawless and criminal Corleone family as a symbol for the American legal system and its ruthless and predatory business practices as a metaphor for capitalist America. However, view-

ers interpreted the films in a manner that resisted Coppola's intention. They believed that it celebrated the mythic family and old-fashioned notions of community. Vito Corleone's story, they thought, illustrated that a poor man, through drive and diligence, could become successful. They approved of the apparent endorsement of power over law. Since police are on the take, judges in the Mafia's pocket, and lawyers make offers that cannot be refused, the Corleone family's violent version of justice seemed appealing. In his public statements, Coppola expressed disappointment that viewers took from his film a meaning that sharply contradicted the intended meaning.

Viewer-response theory argues against trying to find any universal standard for evaluating arguments about the possible meanings of a text. Stanley Fish (1980) argues that "interpretive communities," whose members share similar educational and experiential backgrounds, tend to ascribe similar meanings to a given text. Nevertheless, such communities may be unable to persuade others of the "truth" of their view. People, in short, can make valid and interesting judgments about the nature of the cultural and legal texts concerning law or any other institution or social practice, without believing that everyone else must assent to their views. We have tried to take that fundamental insight seriously in this book, leaving to our readers—and our students—the responsibility of interpreting the many cultural texts we will be discussing.

1.06 Filmmaking and reality

1.06.1 Micro and macro reality

Most audience members at mainstream movies and most consumers of TV shows expect to experience a sense of realism or verisimilitude, meaning that the story should ring true. This means that the story should feel as if it could actually happen in the world. The characters should behave and react emotionally like people the viewer recognizes. For that reason, most movies and TV shows adopt a naturalistic method of story-telling. Of course, horror or fantasy stories or cartoons are not designed or expected to feel realistic, and some viewers don't care about verisimilitude. They seek an emotional response or have something different in mind altogether.

All of us recognize that what we see in the theater or on TV is not "reality." We know that filmed images are not the same as people and events in the real world. The events of real life (like courtroom trials) are simplified, streamlined, and

amped up for the purposes of entertainment and to fit the required time slots. We see only what the filmmaker chose to put in front of the camera, edited to create artificial views of reality (like cutting back and forth between people having a conversation) and condensing many hours of film down to two hours or so, and a much shorter period for TV episodes. We know that the film or TV show was probably filmed on a set, not in the place where it pretends to be located.

Still, if the film or TV show is successful in imparting a sense that it is realistic, something magical occurs: We "suspend disbelief" and pretend that the story involves real people with real emotions experiencing real events. Indeed, because of the large size of a movie screen and the skillful direction, music, and acting, a film may seem more real than just real. We experience an emotional, an "affective," response. We identify intensely with the characters; we weep when terrible things happen to the good guys and rejoice when bad things happen to bad guys. Because we make believe that these stories are true, skillful filmmakers can feed us their version of history, or their political or ideological point of view, and we may accept it because it all seems so realistic.

Increasingly, creators of film and television series deliberately introduce anti-realistic material and viewers have been willing to accept it. For example, the innovative TV show *Ally McBeal* (see ¶7.02.4) featured a young lawyer with an unhappy personal life. Episodes of *Ally McBeal* repeatedly made use of animated sequences that were designed to inform viewers about what Ally was feeling. A recurrent motif on the show was a cartoon of a dancing baby, intended to illustrate Ally's concern that her biological clock was ticking.

Pop culture stories are never "realistic" in the sense that they exactly or even approximately reproduce reality. We should not criticize them for failing to do so (see Elkins 2004, 845–49; Elkins 2007). However, the authors believe that pop culture stories should tell larger truths, even if they manipulate reality to entertain us or to satisfy the constraints of the medium. The film should be authentic in the macro sense—that is, the big picture—even if it can never be realistic in the micro sense. If we're lucky, the film might even illuminate mythic or psychological truths of much larger scope. (Denvir 2011)

We also think there is pedagogical value in pointing out how pop culture products depict law and lawyers in ways that depart from objective reality. It is interesting to observe these differences and ask why they have occurred. Is it ignorance by the filmmaker or is it a need to entertain by exaggerating or falsifying the reality? Often, we can understand the world of law practice better (for example, the world of law firms discussed in ¶¶4.08.1, and 13.05) when we see how that world is depicted in pop culture—even though such portrayals are wildly exaggerated or

flat out wrong. Finally, millions of viewers are learning about law and lawyers from what they see in fictitious movies and TV shows (see ¶¶1.04.2, 4.04). We need to know what kinds of misinformation the public is absorbing.

As we discuss in ¶8.08, the subject of "realism" in film is quite complicated. Ideas of what is realistic in movies have changed greatly over time. Realism often turns out to be more a matter of style and filmmaking technique than actual fidelity to events and characters in the real world.

1.06.2 Making legal films and TV shows seem "real"

Films and TV shows tell stories by making constant use of narrational and visual *conventions* that are specific to the particular genre in which the pop culture product is situated. For instance, the *establishing shot* for a trial film or TV show usually comes from a considerable distance away from the action (i.e., a *long shot*) and often looks upward at a courthouse or a courtroom. The judge usually is introduced in a similar, upwardly tilted long shot. This form of representation helps to certify the authority of courts and judges.

Once a long shot has established the *represented space* in which the trial narrative will unfold, a film or TV show uses the standard shot-scale and changes in *camera angles* to tell a story. Moments of high drama and acute tension are signaled through *closeups,* which are supposed to reveal a character's private, emotional state. The sudden swelling of a musical soundtrack adds a cue about the intended meaning of a certain shot. By changing the angle from which the camera shoots characters and situations, the filmmaker provides additional cues about what is going on. Film and TV viewers enjoy an *omniscient, god-like view* from which to observe the represented space and dramatic situations. The camera is often positioned so that viewers seem to be watching from the jury box and hearing and seeing everything that the jury in the film hears and sees.

The actors engage in familiar behaviors. Lawyers interview clients in jail, cross-examine hostile witnesses in court, make impassioned closing arguments. All this contributes to a sense of verisimilitude. Indeed, everything that a viewer sees in the finished film, including characters, props, costumes, and sets, embellishes the sense of the reality of the story. Students of cinema refer to the framing of the picture, and of everything in it, as *mise-en-scène* (pronounced "mize on seen"). The mise-en-scène of a trial film, for example, generally imitates the arrangement of a typical courtroom: raised judge's bench, a reporter, a gavel, and a jury box with a rail. All these items are necessary to make us believe we're looking at a real courtroom rather than a set.

1.06.3. The editing process

In addition to the shot scale and the use of familiar sets and behaviors, film and TV reality depends on the conventions that regulate the editing process. *Editing* refers to the ways in which individual camera shots are spliced together or *cut* during post-production in order to make the final version of a movie or TV show (see Mittell 2010, 195–202; Bordwell & Thompson 2010, ch. 6). (In the old days, two strips of film were physically cut and pasted together; today editing is done via digital technology, but the term "cut" is still used.)

Film and TV producers favor *continuity* cutting. Continuity cutting tries to paper over the gaps in space or time between shots to achieve a sense of continuity, so that the finished film will appear seamless, natural, and realistic. They generally avoid "jump-cuts," which involve abrupt shifts from one shot to another unless the director wishes to disorient viewers. For instance, in cutting between two scenes in two different places at two different times, editors will sometimes use a similar gesture or action (such as a character lighting a match) to paper over the gaps or carry over the sound from one scene into the next (see ¶6.05.2).

Another editing technique known as *montage* splices together a series of brief, separate shots (see ¶13.09.3). For example, montage could be used to show the testimony of a lengthy list of witnesses in a matter of seconds. Though obviously artificial (the witnesses may have testified over the course of several days), audiences accept this convention because it makes narrative sense (there's no point in showing the testimony of each witness) and because the characters are performing a similar action (that is, testifying) and this provides a sense of visual continuity. Further, by rapidly cutting from one witness to another, the montage may suggest that the prosecution has built an imposing case against a defendant.

Editing allows the compression of "real-life" time into "reel-life" time. A neatly dressed attorney begins to address an attentive jury. Abruptly, the film cuts to a shot of the same attorney, now disheveled, rambling on to a group of nodding jurors. Contemporary viewers do not need a printed insert telling them that "many hours pass" in order to understand what has been happening. The passage of time can also be shown through a *dissolve,* where a second shot is superimposed on the first one, or through a *fade out/fade in,* where the picture gradually darkens until it fades to black and then gradually brightens to a new shot. Fades are also used in cutting to commercials and from commercials back to the action in a TV show.

The editing process also heightens the sense of reality of conversations among characters through a convention known as the *shot-reverse shot system.* Rather than

capturing two people talking to one another in the same shot, individual shots are edited so that the finished film alternates between characters. Two cameras film the action, each focused on one of the two people talking. There will be a shot of one character talking and a reverse shot of the other replying. The shot-reverse shot convention provides viewers with a variety of different looks at the unfolding story while still enabling them to imagine that they are watching a real conversation.

1.06.4 Filmmaking today

The conventions outlined above still prevail. Virtually every film and TV production uses them. However, they have been supplemented by new ways of creating film and TV narratives. Digital equipment speeds the editing process, thus allowing for the densely edited films that audiences became accustomed to in the 1990s. Computer-generated graphics promote a more elaborate, more cluttered mise-en-scène because anything can be inserted into the final print.

The way in which viewers see film is also changing technologically, so that people often watch movies according to the rhythms of their own daily lives rather than in the darkened quiet of a theater. As viewers become more accustomed to a media-saturated environment, most films and TV programs have adopted a more frenzied, edgy pace than older Hollywood films. Images flow by with increased speed and viewers are expected to make meanings in much less time than did their parents and grandparents. See ¶¶2.07.2 and 2.07.3 for discussion of long takes, which are typical of older films and TV shows, and of quick cutting, which is more typical of newer films and TV shows.

1.06.5 Intertextuality

People who consume a new legal pop culture product inevitably compare it to generically similar products they've consumed earlier. Similarly, they compare an actor's performance and persona with the actor's earlier roles. This phenomenon is called *intertextuality.* Intertextuality occurs often in the world of popular legal culture. Because of the sheer volume of pop culture texts about law (film, TV, novels, etc.), people understand a new legally oriented film or TV show text in light of earlier ones. See ¶¶9.01 and .02, which refer to intertextuality in *12 Angry Men.* The star of that film, Henry Fonda, acquires great credibility in his role because of his earlier roles and the movie is often referred to in later films or TV shows about the jury. The same is true for Paul Newman's role in *The Verdict* (see ¶4.01.2). Sometimes producers make use of intertextuality by explicitly referring

to another text, as frequently occurs on shows like *The Simpsons* or *South Park*. The process of intertextuality allows people to judge the authenticity and meanings of pop cultural texts such as *The Good Wife* by comparing it to other law-related TV programs and movies they've seen. More importantly, intertexuality has begun to span the divide between "real" and "reel" legal institutions. People increasingly ask questions such as "why can't judges run trials like Judge Judy?" or "why don't lawyers give concise closing arguments like they do on *Law & Order*?" Media representations, in other words, sometimes provide the basis on which people evaluate the work of the law. Intertextuality is explored further in ¶¶3.03.2 and 4.01.2.

Notes

1. The authors have prepared a teacher's manual, which is available from the publisher for use by instructors. To request the manual, please email customerservice@plang.com or Michael Asimow at asimow@law.stanford.edu or Michael@asimow.com.
2. Wikipedia, "United States Incarceration Rate."
3. Tim Surette, "How Much Television Do You Watch Per Week? Jan. 3, 2011. http://www.tv.com/news/how-much-television-do-you-watch-per-week-24833/
4. For accessible and enlightening treatments of film and cultural theory, see Gitlin 2002; Grossberg et al. 2006, chapters 5–6; Staiger 1992.
5. See Mittell 2010, ch. 8.
6. "Film is a powerful repository of maps of social life, of common-sense knowledge, and can give us insight into persistent contemporary struggles about the organization of gender in family and social life" (Johnson 2005, 187, internal quotation marks deleted).
7. See Manderson 2011. Manderson points out that long before the advent of modern communication technologies like film or television, popular culture in the form of songs, oral stories, and pagan rites formed a site of resistance to formal law. He also observes that Justice Antonin Scalia of the U.S. Supreme Court gave a speech in which he specifically drew on the use of torture by Jack Bauer on *24* to argue that torture was legal in certain circumstances (2011, 39). In commenting on Manderson's paper, Carodine offers additional examples of prominent figures in government and academic life who refer to Jack Bauer to justify torture (2011, 54–56)
8. For treatment of the cultural study of law, see Kahn 1999; Berman 2001; Sarat & Simon 2001; Binder & Weisberg 1997; Reichman 2008.
9. Austin Sarat and his co-authors argue that pop culture casts a "side shadow" on the law by showing it from a new perspective. "The moving image attunes us to the 'might-have-beens' that have shaped our worlds and the 'might-bes' against which those worlds can be judged and toward which they might be pointed....It opens up largely unexplored areas of inquiry as we chart the movement from law on the books to law in action to law in the image" (Sarat, Douglas & Umphrey 2005, 1–2).
10. For discussion of *Dragnet*, see Lenz 2003, 86–91. Watch a *Dragnet* episode at http://www.hulu.com/watch/501. It's about the LSD menace. Do you find it realistic? Or just campy?

11. See Steiner, Bauer & Talwar (2011), which chronicles the appearance of *Miranda* warnings in various police and legal shows. *Miranda* warnings appear less frequently in contemporary police and forensic shows than in years past.
12. See Resnik & Curtis 2007, 160–64; Resnik & Curtis 1987, 1754–64.

The Adversary System and the Trial Genre

Assigned Film: *Anatomy of a Murder* (1959)

2.01 *Anatomy of a Murder*—The film and the book

We might have chosen many films to launch the course—and many instructors will make other choices.[1] We chose *Anatomy of a Murder* because we think it is the best courtroom movie ever made. *Anatomy* is one of a group of outstanding films made between the late 1950s and early 1960s that are sometimes called the golden age of legal films.

Everything about *Anatomy of a Murder* is memorable: the tense courtroom drama, the stunning jazz score by Duke Ellington (who also played Pie-Eye), the direction of Otto Preminger, the crackling screenplay by Wendell Mayes, and even the clever "anatomy" titles at the beginning by Saul Bass. The performances of James Stewart (Paul Biegler), Arthur O'Connell (Parnell McCarthy), Ben Gazzara (Lt. Manion), George C. Scott (Claude Dancer), and Lee Remick (Laura Manion) are all outstanding. Indeed, Stewart, O'Connell, and Scott were nominated for Academy Awards, and the film was nominated for seven Oscars altogether, although it didn't win any. Most of all, we see a striking picture of the adversary system at work (see ¶2.04.2).

The film was adapted from a bestselling 1958 book by John D. Voelker (under the pseudonym of Robert Traver). Voelker was appointed to serve on the

Michigan Supreme Court three days after the book was accepted for publication. In the introduction to the 25th anniversary edition of the book, Voelker explains that he had worked many years as a prosecutor, defense lawyer, and judge and wanted to write a book that showed criminal trials as they really were, rather than in the over-dramatized way they often appeared in the movies (Traver 1983). Voelker (an avid fisherman) based the book on a real Michigan murder case in which he had served as defense council. As in the movie, the defendant, an army officer, was found not guilty by reason of insanity (Shaul 2001, 85; S. Bergman 2001, 90). The movie follows the book closely but one plot detail is different. Mary Pilant was Quill's employee in the book, not his daughter. The screenwriters improved on Voelker's story, to excellent dramatic effect.

Joseph N. Welch. Welch, who played Judge Weaver, was a Boston lawyer who had never acted professionally. Welch became a media celebrity during the televised Army-McCarthy hearings of 1954. These hearings put on display the demagogic conduct of Senator Joseph N. McCarthy of Wisconsin. The hearings looked into McCarthy's improbable charge of Communist infiltration of the U.S. Army. Welch's actions as the lead attorney for the Army, especially his emotional response to McCarthy's attempt to slander a young associate in Welch's Boston law firm—"Have you no sense of decency, sir? At long last, have you left no sense of decency?"—were widely credited with hastening McCarthy's downfall.

Director Otto Preminger (1905–86) studied law at the University of Vienna, although it is not known whether he graduated. His father was a lawyer. He made several legally themed movies besides *Anatomy of a Murder* including *Advise and Consent* (1962), *The Court Martial of Billy Mitchell* (1955), and *Daisy Kenyon* (1947). For an in-depth look at Preminger's work on *Anatomy of a Murder,* including casting decisions and directorial technique, see Hirsch 2007, chap. 11.

2.02 The trial genre

The term *genre* refers to a body of films or other texts that share important themes, subjects, or stylistic motifs. (See Mittell 2010, 234–58) Filmmakers, publicists, critics, and spectators all rely on genres (such as the western, the musical, or the his-

torical epic) to predict what ideas might prove marketable and to select which films to watch. Pop culture creators expect audience members to feel comfortable with the recurring narrative structures and conventions, the familiar character types, and the expected endings.

However, genres are unstable. Moviemakers constantly play with even the most familiar genres. By varying generic codes and upsetting audience expectations, filmmakers introduce novelty and update genres that have become stale. Film scholars often draw boundaries between genres, chart their changing forms and box office fortunes, and use genre theory to compare and contrast films. Academic and media critics sometimes identify new genres by discovering common links between films.

The trial film is such a creation. Classical Hollywood filmmakers never set out to make a "trial movie." They called a product such as *Marked Woman* (1937) a "melodrama" or, less charitably, a "woman's weepie." Today, however, many students of law and popular culture see trial films as a coherent genre, with a recognizable history.[2] To qualify for membership in the trial genre, a trial should consume significant time within the film or TV show. Silbey (2001) discusses the genre and its typical conventions and signifying practices. Trial films are normally set in a specific physical space: the massive courthouse (usually shown in long-distance establishing shots), its hallways, and courtrooms. Trial films usually position viewers as if they were the actual decision makers—in the jury box, for example, during closing arguments. This positioning suggests that the viewer should participate along with the judge, lawyers, and jurors in finding out the truth. The protagonist is usually one of the lawyers who triumphs over various obstacles and somehow achieves justice. The lawyers square off against each other, each spinning a particular story or version of the facts; a neutral judge presides and enforces procedural and evidence rules. The trial process brings out various secrets and hidden relationships between the characters. The film ends with a decision, usually a jury verdict, that resolves the conflicts of the trial.

Anatomy of a Murder is an honored member of the trial genre, especially because a remarkably high percentage of the film's running time is set in the courtroom. Does *Anatomy of a Murder* depart in any respect from the conventions of the trial genre?

This book will consider several movies and TV shows that fit the trial genre, but it will also discuss films about lawyers that contain no trial scenes (or only very brief ones). Popular legal culture (in the narrow sense) includes far more than films or television shows about trials.

2.03 *Anatomy* and the Production Code

2.03.1 Hays, Breen, and the Production Code

Between 1934 and 1968, Hollywood maintained a rigid system of self-regulation called the Production Code.[3] The Code was first adopted in 1930 by the industry's trade association. Former postmaster general Will Hays then headed the association, so that the Code is often referred to as the Hays Code. Hollywood producers agreed to be bound by the Code because they were being subjected to tremendous pressure to clean up the movies. Much of this pressure came from state and local government censorship boards, which often cut newly released movies to ribbons. At that time, the movies were not protected from government censorship by the First Amendment (*Mutual Film Corp. v. Ohio Industrial Commission* 1915). Additional pressure came from various private groups, particularly the Catholic Church. The producers felt that they were better off with a system of industry self-censorship than letting hostile outsiders do it for them. Thus, the Code was an important victory for conservatives who wanted to clean up the movies. It can be viewed as an early skirmish in the "culture wars" that have been fought out between contending forces on the field of popular culture right down to the present day.

From 1930–34, the Code had no effective enforcement mechanism. As a result, it was mostly ignored. Economic pressures resulting from the Depression caused filmmakers to include as much lurid material as possible to lure audiences into the theaters. *Counsellor at Law* (1933), the great lawyer film discussed in Chapter 5, was made during the 1930–34 window and featured themes involving corruption, bigotry, and class struggle that would never have made it past the censors after 1934 (see ¶5.05).

In 1934, the industry set up an administrative body called the Production Code Administration (PCA) that enforced the Code with great effectiveness. The PCA started work on July 1, 1934. For many years, it was run by a shrewd and knowledgeable man named Joseph Breen. Under Breen's guidance, the PCA reviewed every line of dialogue, as well as every costume and song lyric, to make certain that the Code was observed. Especially during the first twenty years or so that the PCA existed, no film could be displayed in any American theater without first receiving a seal from the PCA. As we watch films made during the Hays Code era, we should always keep in mind what effect the Code had on the final product. Because of revisions insisted on by Breen and his staff, the final version of the film was often radically different from the original script.

Rules of the Hays Code. Among the most important provisions of the Hays Code was the rule that crime could never pay. Thus, criminals had to be punished or killed by the end of the film. Sex outside of marriage had to be punished, generally by death or disgrace of the transgressor who was usually the woman. In addition, sex had to be handled with extreme discretion; on-screen, brief, closed-mouth kisses were permitted, but all other sexual behavior had to occur off-screen (and in the viewer's imagination). Moreover, serious treatment of certain subjects was ruled out of movie plots entirely, including homosexuality, abortion, divorce, and miscegenation (sex between people of different races). These subjects could sometimes be subtly suggested if filmic codes prescribed by the PCA were observed but could never be treated directly. We consider this aspect of the Code further in chapters 13 and 14.

2.03.2 The decline and fall of the Production Code

The PCA exercised unchallenged power during the 1930s, 1940s, and early 1950s, but the enforcement process became less rigid by the late 1950s and early 1960s. This change occurred for several reasons. First, Breen's successors as PCA directors were somewhat more tolerant. Second, the U.S. Supreme Court held that movies were protected by the First Amendment (*Joseph Burstyn, Inc. v. Wilson* 1952). This decision greatly reduced the powers of state and local government censorship boards, which in turn lessened the need for Hollywood self-censorship. Third, European art movies (which were much more explicit and were never subject to the Code) began to attract large audiences. Fourth, television became a feared competitor, and filmmakers felt they had to put something on the screen that would pull audiences out of their living rooms and into the theaters. Television stations and networks were regulated by the Federal Communications Commission and were subject to strict statutory prohibitions on "indecency." Each station had a three-year license that could be revoked for misconduct such as showing "indecent" material. (This, of course, was long before the rise of unregulated cable television.) As a result, each of the TV networks censored all programming even more strictly than the Code censored the movies.

Preminger's rebellion. Some American producers and directors rebelled against the Code. The most prominent rebel was Otto Preminger, producer and director of *Anatomy of a Murder*. Preminger (an independent producer who had broken away from the studios) despised the Code or any other form of censorship. Before *Anatomy*, he had produced, directed, and successfully released two movies without PCA approval. The films were *The Moon Is Blue* (1953), a racy comedy that created a sensation by using the word "virgin," and *The Man with the Golden Arm* (1955), a brutal drama about heroin addiction. Preminger showed other filmmakers that it was possible to flout the PCA and get away with it and make some serious money in the process. Numerous other independents followed Preminger's lead in the late 1950s and the result was a breakdown in the Code's authority.

By the mid-1950s, the Code seemed a relic of the past. Filmmakers were fed up with negotiating artistic nuances with the PCA. Facing stiff competition from television, Hollywood's moguls fought back by making movies that featured "mature" depictions of hot-button issues. Hollywood released a number of "adult-themed" movies, including *A Streetcar Named Desire* (1951), *A Place in the Sun* (1951), *Baby Doll* (1956), *Tea and Sympathy* (1956), and *Cat on a Hot Tin Roof* (1958). The PCA cleared these films. They dealt candidly with issues such as homosexuality, abortion, impotence, and adultery (see Klinger 1994, 37–51) in ways that the TV networks could not duplicate. The industry accompanied these films with lavish and suggestive advertising campaigns that cued ticket-buyers what to expect. The lobby card for *Tea and Sympathy*, a film that dealt with homosexuality, proclaimed that "Even the Most Daring Story Can Be Brought to the Screen with Courage, Honesty, and Good Taste."

In the late 1950s and 1960s, the Code became an embarrassment and more and more films were released without PCA approval. Yet the Code continued to function. In the film *Hitchcock* (2012), several amusing scenes show Alfred Hitchcock groveling before the Board in 1960, trying to get its seal of approval for *Psycho* (which involved a vicious knife-murder of a woman who was taking a shower) without mutilating the film too much (see Rebello 1990). Ultimately, in 1968, Jack Valenti, the newly appointed head of the industry's trade association, ditched the Code and substituted the ratings system, a descendant of which remains in use today.

2.03.3 Anatomy of a Murder *and the Production Code*

In a perverse way, the Production Code actually helped Hollywood portray the kinds of controversial issues presented in *Anatomy of a Murder*. By complying with the PCA's rules, directors could deal with matters such as legal corruption and sexuality without incurring a massive counterattack from puritanical local censorship boards or from the Catholic Church.

For example, *Marked Woman* (1937) was a courtroom drama starring Humphrey Bogart and Bette Davis. It fictionalized the prosecution of a group of New York mobsters who ran a fabled prostitution ring. It changed the occupation of its female characters from hookers to "party girls." The film avoided any direct portrayal of sexual activity. At the same time, by using familiar movie conventions, such as a fadeout just at the point where a specific, sexualized image might violate the Code, the film could connote the kind of "parties" that the women such as Bette Davis's character were really attending.

Figure 2.1. *ANATOMY OF A MURDER*: Paul Biegler (James Stewart) questions Mary Pilant (Kathryn Grant) about the panties she found in the laundry. © Columbia Pictures Credit: Columbia Pictures/Photofest.

By working with the PCA on dialogue and visual imagery, Hollywood could satisfy the informed moviegoer. Such spectators could easily decode the sexuality that was connoted, but never explicitly denoted (see ¶1.05.2 for explanation of these terms), by the filmic conventions employed in movies such as *Marked Woman*. By the late 1940s, particularly after the PCA approved a film version of James J. Cain's steamy novel, *The Postman Always Rings Twice* (1946), filmmakers recognized that most material could be crafted to satisfy the PCA and local censorship boards.

Nevertheless, Breen would have required drastic changes to a film like *Anatomy of a Murder* if it had appeared before the mid-1950s. Its dialogue about the details of the alleged rape (such as spermatogenesis, vaginal medical examinations, contraception, and ejaculation), as well as the concentration on Laura's panties, would never have gotten by the censors. Indeed, all this was quite startling even to late 1950s viewers. By that time, however, the PCA had relaxed its standards. It insisted on little more than substitution of the word "violation" for "penetration" (Preminger put up a fight on this point, but finally gave in). In addition, the movie hints that a killer avoided legal punishment and that an adulterous spouse got away with her transgression; each of these narrative themes would have violated the Code as Breen had administered it. Thus the PCA's laxity in approving *Anatomy* was partly the result of changing standards. However, the PCA also knew that Preminger would fight back and release the film without its approval if necessary.

Anatomy in Chicago. Preminger's autobiography claims that the police chief of Chicago attempted to censor the film, not for any of these reasons, but because it mentions contraception! The chief stated that he would not want his 18-year-old daughter to hear the word. Preminger rejoined that if he had an 18-year-old daughter, he would make sure that she understood as much as possible about contraception. The next day he went to court; a federal judge viewed the film and ordered the City to release it without any cuts (Preminger 1977).

2.04 Justice, the adversary system, and *Anatomy of a Murder*

If popular legal culture teaches viewers about law and lawyers, as we assert in ¶1.04.2 and ¶4.04, what does *Anatomy of a Murder* actually teach? About the rela-

tionship of law and justice? (see ¶2.04.1 for discussion of issues relating to "justice")? About prosecutors and defense lawyers? About the insanity defense? About whether an adversarial trial is a good way to ascertain the truth about events that occurred in the past, such as the question of what led up to the shooting of Barney Quill? (See ¶2.04.2 for discussion of the adversary system.)

2.04.1 Law and justice

First some definitions of "law" and "justice":

We define "law" to include not only the binding rules and procedures set forth in statutes and court decisions, but also in the legal realist sense of what judges, lawyers, and other actors in the legal process *actually do* (see ¶1.04.3). Many forests have been sacrificed in pursuit of the meaning of "law," but we won't enter any further into that debate here.

There is also a vast literature on the subject of "justice."[4] One major distinction is between "substantive" and "procedural" justice. *Substantive justice* means that persons receive what they are "due," meaning that the "truth" has been discovered and the "correct" result has occurred. The guilty are convicted and appropriately punished, the innocent set free. Substantive justice also means that persons are treated in a consistent manner; those whose circumstances are alike are treated alike. *Procedural justice* is quite different from substantive justice. Procedural justice means that the proper procedures are followed, whether or not the trial reaches the "correct" result or reveals the "truth" about what happened.

Many lawyers are uncomfortable with notions of substantive justice because they understand how difficult it is ever to find out the truth, especially about events that occurred in the past. Who is telling the truth, who is lying? What did happen, for example, between Barney Quill and Laura Manion or between Laura and Lt. Manion? What was Lt. Manion's state of mind when he gunned down Quill? We, the audience, never find out, because the movie lacks the customary flashbacks to the bloody events. Neither do Biegler, Dancer, Judge Weaver, or the jurors. Lawyers are also uneasy discussing substantive justice because, in the real world, human behavior defies easy representation; there are at least two sides to every question worth talking about. Even when we claim to be certain about what happened, it can still be hard to know for sure what would be a "correct," "just," or a "moral" response.

Therefore, lawyers prefer to talk about procedural rather than substantive justice. Lt. Manion receives procedural justice because he gets a fair trial by jury, with a good lawyer doing everything ethically possible in his defense. The prosecution does everything ethically possible to win a conviction. A competent and fair-minded

judge presides. All constitutional rights are respected. This is our familiar "adversary system," which has been glorified in countless movies and television shows.

2.04.2 The adversary system

The adversary system is used in English-speaking countries—the United States, Britain and Commonwealth countries such as Australia, Canada, South Africa, and India. The adversary system visualizes the dispute as a contest between two sides (prosecution and defense in a criminal case, plaintiff and defendant in a civil case). The adversary system depends on the lawyers to investigate the case before trial and to present the strongest possible argument for their side at the trial. If either side gives up (for example, if the defendant pleads guilty) or if the dispute is settled (for example, through a plea bargain), the case is over. If neither side gives up and the case is not settled, a passive decision maker (judge or jury) decides which side wins. A judge ordinarily states the reasons for the decision, but the jury states no reasons for its decision.

The underlying assumption of the adversary system is that the best way to find out the truth is to have two skilled, committed lawyers battle it out.[5] The lawyers choose the jurors because each one can exercise a substantial number of peremptory challenges (see ¶9.09.2 for criticism of peremptory challenges). The lawyers control which issues will be contested, who the witnesses will be, in what order they will be called, and what questions will be asked of them. The trial proceeds according to a strictly prescribed order the judge cannot alter: opening statements, prosecution's case, defense's case, closing arguments. (For more detail, see ¶8.01.5 on criminal trials and ¶12.01 on civil trials.) The trial judge acts as an umpire, keeps order, and rules on evidentiary objections but otherwise is neutral and, in a jury trial, mostly passive. In England, judges are more active. They can sum up the evidence for the jury, which may influence the verdict. In the United States, most judges are not permitted to express any opinion on the evidence or, if they do have that power, are reluctant to exercise it.

Each lawyer spins the evidence into a story that he or she hopes will engage with the jury's own experience. (For further discussion of the story approach, see ¶8.06.) In *Anatomy*, Dancer's story is that Lt. Manion exacted cold-blooded vengeance for his wife's affair with Quill. Biegler's story is that Manion was overcome with an irresistible impulse to kill Quill after discovering that Quill had raped his wife. A jury makes the final call. If the proper procedures are followed, say most lawyers, that's as close to justice as any legal system can get.

Stephen Landsman, a proponent of the adversary system writes:

> The central precept of the adversary process is that out of the sharp clash of proofs presented by adversaries in a highly structured forensic setting is most likely to come the information upon which a neutral and passive decisionmaker can base the resolution of a litigated dispute acceptable to both the parties and society. (1984, 2)

Do you agree that a trial conducted under the adversary system is the best way to find out the truth and reach a just result? How about the assumption that the battle is between two equally competent and equally well-funded lawyers? What happens when the lawyers are not equally competent or one is backed up by much greater resources than the other? In the criminal justice system, for example, almost all defendants are represented by public defenders. Public defenders have massive caseloads and can give little attention to each case. Prosecutors have unlimited resources to investigate the case; defense lawyers often conduct no investigation at all (see Findley 2011). In civil cases, as illustrated in *The Verdict* (Chapter 4) or *A Civil Action* (Chapter 12), there is often a huge disparity between the resources and skills of the plaintiff and defense lawyers.

What accounts for the popularity of the adversary system in the United States beyond the fact that it is traditional and most people don't understand the alternatives? Certainly the system is good for lawyers, but is it good for society? Does our reverence for the adversary system reflect our commitment to individualism and free enterprise capitalism? Does it reflect our distrust of government officials in general and judges in particular? Could pop culture have anything to do with our attitudes on this subject? Do films like *Anatomy*, or countless television shows about lawyers (beginning with *Perry Mason* and extending through *Law & Order* to the many criminal-defense oriented shows in the present), serve the function of legitimating the adversary system in the minds of viewers?[6] (Lawyer television shows are discussed in Chapter 7.)

2.04.3 The inquisitorial system

European, Asian, and Latin American countries follow the Napoleonic Code (adopted by France in 1804) and are heavily influenced by French and German law. These countries employ a different approach to deciding civil and criminal cases called the *inquisitorial system*.[7] Despite its unfortunate name, this system is nothing like the "Spanish Inquisition" and might better be described as the "inquiry system." Under the inquisitorial system, the goal is to find the truth, not to settle a dispute between the two sides.

Although the details of the inquisitorial systems differ in the countries that use it, the pattern is consistent. In the case of a serious crime, magistrate judges (rather

than police or prosecutors) supervise the investigation and assemble a written dossier. The magistrate judge interrogates the accused and directs the police and prosecutors how to investigate the case. Prosecutors regard themselves as impartial officials whose job is to assist the magistrate judge to determine the truth; they do not see themselves as an adversary of the defense.

In these countries, judges are on a separate career track from lawyers. Judges receive specialized judicial training from the time they graduate from law school. They are promoted to higher courts based on their performance. Thus inquisitorial system judges are likely to be professionalized and nonpolitical. If at any point during the investigation, the investigating judge decides that a defendant is innocent or has a legal defense, the judge terminates the case. If the judge does not dismiss the case, it goes to trial. In most countries that follow the inquisitorial system, there are no plea bargains or guilty pleas; all criminal defendants are tried unless the judge has dismissed the case.

Much of the evidence at the trial is presented in written form. The judge is in charge of the proceedings and calls and questions the witnesses in whatever order the judge deems best, although the prosecutor and defense lawyers are also allowed to question witnesses. There are no strict rules of evidence. The defense lawyer generally is not permitted to engage in pretrial investigation; instead, the defense lawyer's main responsibility is to argue for a dismissal on some legal point or to try to secure a more lenient penalty. In most inquisitorial systems, there is no jury; many countries employ a combination of judges and lay assessors to find the facts. The lay assessor system is further discussed in ¶9.06.3.

Our adversarial system assumes, and the players in it are socialized to believe, that the truth can best be discovered and justice achieved through the clash of skillful lawyers, one or both of whom have an incentive to obscure the truth. The parties (prosecution and defense lawyers or the contending lawyers in a civil case) would find it highly inappropriate for the judge to take over the process. This dynamic is illustrated by a scene in *The Verdict* (Chapter 4); the plaintiff's lawyer, Frank Galvin, is outraged when the judge takes over the questioning of his expert and discredits the witness. In contrast, the basis of the inquisitorial system is a belief that a proceeding controlled by the judge, rather than the lawyers, has a better chance to discover the truth and do justice.

2.05 Legal ethics in *Anatomy of a Murder*

The film bristles with issues relating to criminal law, trial practice, and the rules of evidence, as well as about prosecutors and defense lawyers, but we will reserve

further discussion of most of them to later chapters. However, *Anatomy of a Murder* contains a famous scene that raises profoundly important ethical issues. This is the scene in which Paul Biegler meets Lt. Manion in jail and gives him what sidekick Parnell McCarthy describes as "the lecture." Biegler coaxes Manion into coming up with the insanity defense. As Biegler leaves, he tells Manion to think about how crazy he really was.

The ABA and the Model Rules. The American Bar Association is a voluntary nationwide organization consisting of more than 400,000 lawyers. It offers its members a wide range of educational programs and publications and engages in efforts to improve and reform the law through resolutions adopted by its House of Delegates. One of the ABA's most important functions is to write and interpret a set of ethical rules for lawyers.

The current version of these rules is called the ABA Model Rules of Professional Conduct. The Model Rules were adopted in 1983 and have been amended on several occasions since that time.[8] Although the Model Rules are not binding, most states have adopted them as ethical rules that are binding on the lawyers admitted to practice in those states. Each state has a mechanism to investigate violations of ethical rules and to discipline violators. Generally, the state bar associations handle this chore. In theory, lawyers who violate binding ethical rules are subject to various forms of discipline up to and including disbarment (which means cancellation of the lawyer's license to practice law). Historically, however, these state enforcement mechanisms have not been very effective. Generally, only the worst sort of ethical violations (such as stealing a client's money) have resulted in serious disciplinary sanctions. Nevertheless, most lawyers take the ethical rules seriously and try to understand and comply with them.

There is a fine line between advising a client about what the applicable law provides (which is proper) and suborning perjury by helping the client concoct a false version of the facts (which is improper). Rule 3.4(b) of the ABA's Model Rules (see box) states: "A lawyer shall not...counsel or assist a witness to testify falsely. . . ." Obviously, this rule is difficult to enforce because conversations between lawyers and clients or witnesses that might violate the rule occur in the privacy of the

lawyer's office. Besides, the rule is vague and many possible violations, like Biegler's lecture, fall into a gray area between proper and improper conduct. (We consider another potential violation of Rule 3.4(b) in ¶4.05.1, which concerns a conversation in which a lawyer prepares a witness to give testimony at the trial.)

Did Biegler violate Rule 3.4(b)?[9] Should Biegler have been required to ask Manion what happened before discussing the law of homicide with him?

2.06 Defenses to homicide in *Anatomy of a Murder*

As Biegler made clear in "the lecture," Manion had few options in defending against a charge of first degree murder (meaning a premeditated killing—see ¶8.04.1 for discussion of the different types of homicide).

2.06.1 The unwritten law

Manion thought he had a defense based on the "unwritten law." The so-called "unwritten law" gave a man the right to kill when he discovered his wife having sex with another man (often described by the legal term *flagrante delicto*). The unwritten law was also sometimes applied when a father or brother killed the seducer of an unmarried daughter or sister. The defense reflects old assumptions that husbands owned wives and were entitled to protect their property or that family honor could be protected with lethal force. As a result, the unwritten law defense was available only to men, not to women, and probably not to an unmarried man.

The "unwritten law" defense was once recognized by statute in Texas, Utah, and New Mexico and by court decision in Georgia, but all four states have now rejected the defense (LaFave 2010, §15.2(b)(5)). Nevertheless, in other states, the unwritten law was often applied as an informal practice.[10] Lawyers successfully argued the unwritten law to juries in murder cases and prosecutors sometimes declined to bring charges in cases covered by it. However, since Lt. Manion did not catch Laura having sex with Quill, the "unwritten law" argument would not have worked. Did the jury verdict in *Anatomy of a Murder* suggest that the jurors were applying their own version of the unwritten law?

One juror, interviewed many years after the real trial on which the book and movie were based, see ¶2.01, declared that the defendant was justified in what he did and was not temporarily insane. "I was a soldier and a soldier is trained to defend and that's what the lieutenant did—defend his wife. I felt he had a right to do what he did. Why should he suffer the rest of his life to let a man do that to his wife?" (S. Bergman 2001).

2.06.2 Insanity

Persons are not criminally responsible for acts they commit while insane. The idea is that a person should be treated, rather than blamed and punished, for acts committed by reason of mental illness. The problem, of course, is how to distinguish between defendants who should be treated for insanity and those who should be blamed and punished for their crimes, given that many criminals suffer from some sort of mental illness.

Under the traditional rule set forth in the English *M'Naghten* case, a person is insane if, because of some mental disease, he did not understand the physical consequence of what he was doing, or, if he did understand it, was unable to distinguish right from wrong (LaFave 2010, ¶7.2). Although the *M'Naghten* test is vague and difficult to apply and does not match up to the criteria of mental illness used by psychiatrists, it remains by far the most commonly used legal standard.

Nobody believed that Manion could satisfy the *M'Naghten* test—he knew what he was doing and he knew it was wrong. However, Michigan and some other states also recognize a form of temporary insanity called irresistible impulse, meaning that under the circumstances the defendant could not control his own conduct (LaFave 2010 ¶7.3). As Biegler told Manion, this defense could give the jurors a hook if they wanted to acquit Manion for other reasons. (This is, in fact, probably what happened in the real trial on which the book and movie is based—see ¶2.06.1, last paragraph.) On the facts, the irresistible impulse defense seems weak because an hour lapsed between the time Manion found out about the rape and the time he gunned down Quill; it is difficult to say that his actions were impulsive.

Trials involving the insanity defense are normally a battle of prosecution and defense experts, as occurred in *Anatomy of a Murder.* In the film, the prosecution's expert was unconvincing because he had not actually examined the defendant. How convincing did you find the defense expert?[11] Defendants who are acquitted because of insanity are not set free but instead are confined in a psychiatric hospital until they are considered to be cured and safe to release into the general population. In many situations, particularly dangerous insane persons are never released. Apparently, because Manion's insanity was only temporary and he seemed to be fully recovered, he was not hospitalized after being acquitted.

2.06.3 Manslaughter

The crime of voluntary manslaughter covers an intentional killing caused by a provocation that would cause a reasonable person to lose normal self-control. (The degrees of homicide are further discussed in ¶8.04.1.) Manslaughter is a much

less serious crime than murder. Thus if Manion believed either that Laura had been having an affair with Quill or that Quill had raped her, and he then killed Quill in the heat of passion, he would be guilty only of manslaughter rather than murder. Thus manslaughter would cover the situation described by both versions of the facts in *Anatomy*—the rape story and the consensual affair story. However, the fact that an hour elapsed between Manion's discovery—whether of rape or consensual sex—and the time he killed Quill undermines the manslaughter claim (just as it did the irresistible impulse claim) because Manion had plenty of time to cool off.

Should Biegler have requested that the judge instruct the jury to consider voluntary manslaughter? That would have allowed the jury to find Manion guilty of manslaughter rather than murder, in case the jury rejected the irresistible impulse defense. In other words, a manslaughter instruction would give the jury an opportunity to strike a compromise between conviction of first degree murder and acquittal. However, Biegler apparently decided to roll the dice rather than allow the jury to compromise. It was all or nothing—first degree murder or not guilty.

2.07 Film theory and cinematic technique in *Anatomy of a Murder*

2.07.1 Editing

TV and movies of today rely heavily on editing to build scenes. Consider, for instance, any cross-examination scene from *Law & Order* (discussed in Chapter 8). Instead of being filmed in one *long take* (meaning a continuous, uninterrupted shot of substantial length), the scene will be broken into a series of brief closeups or medium closeups (shots of persons from their chest up). For instance, the scene may begin with a closeup of prosecutor McCoy asking the defendant a pointed question. As he is posing the question, the camera may cut to a medium closeup of the defendant squirming. The camera may then cut to a closeup of the defendant's attorney looking on with concern. As the defendant begins to respond, the camera may cut back to a closeup of the defendant. As the defendant continues speaking, the camera may cut to a closeup of a juror listening intently or to a closeup of a relative of the victim listening with obvious disdain and skepticism.

Although cumbersome to describe, such a sequence of shots flows naturally on screen and allows viewers to appreciate the psychological dynamics in the scene. Furthermore, by cutting back and forth between prosecutor and defendant in a *shot-reverse shot* pattern (an editing technique in which a shot of two people talking is

broken down into alternating closeups of each person—see ¶1.06.3), the editing conveys the give-and-take, back-and-forth nature of a cross-examination.

2.07.2 Editing—Preminger's long takes and deep focus

With the exception of portions of Dancer's cross-examination of Lt. Manion and Laura Manion, the trial sequences in *Anatomy* are *not* shot or edited in the way described in ¶2.07.1. Instead of using quick cutting, Preminger shoots most of the trial scenes in long takes in which the camera follows the lawyers as they walk to and from the bench, the jury box, and the witness stand. Furthermore, instead of employing numerous closeups, Preminger uses mostly *long shots* (shots of persons from their feet up) and *medium long shots* (shots of persons from the waist or knees up), in which the various characters are simultaneously present within the frame. The result is that the frame is often filled with multiple figures—some in the foreground, some in the middle ground, and some in the background. When Preminger shoots a conversation, both speakers are usually in the frame (he doesn't cut back and forth between them).

The long takes in *Anatomy* reflect Preminger's directing philosophy. In an interview with Peter Bogdanovich, Preminger said: "I have a great belief in the intelligence of the audience. I try to do things as subtly and with as little punctuation as possible....Every cut interrupts the flow of storytelling. When I want a closeup, I either have the people come closer to the camera or move the camera closer to them" (Bogdanovich 1997, 626, 634).

The preference for heavy editing in modern film and television reflects the tastes of modern viewers who often find older movies (such as *Anatomy of a Murder*) "slow." Did you find it slow? Today, an individual shot almost never lasts longer than three seconds (and most are shorter than that). Try it. Count three seconds (a thousand and one...) and you will undoubtedly see a cut before you get to a thousand and three.

Anatomy also features *deep-focus photography.* Deep-focus photography is a way of shooting a scene so that both the background and the foreground of the shot remain in sharp focus. The opposite of deep-focus is shallow-focus. Most scenes in a movie are shot in shallow-focus, meaning that only the foreground or the background is in sharp focus. The rest of the scene is out of focus. When a scene is shot in deep-focus, however, the figures in the background are as clear as those in the foreground. Theorists of the 1940s and 1950s saw deep-focus photography, made famous by Orson Welles in *Citizen Kane* (1941), as a way to make a movie seem more "realistic." The technique gradually lost its cultural cachet, but Steven

Spielberg helped restore some of its appeal by using it in his early movies such as *Jaws* (1975).

Preminger photographs the trial. The effect of *Anatomy's* use of deep-focus and long takes is illustrated in the scenes in which the camera faces the attorneys' tables as one of the attorneys questions a witness. Consider, for instance, Biegler's cross-examination of Dr. Raschid. Although Biegler is in the foreground, dominating the frame, Lodwick, Dancer, Lt. Manion, Laura Manion, Maida, Parnell McCarthy, and the crowd of spectators are visible in the background at various points in the scene. Instead of being riveted on Biegler, our eyes are thus free to roam. Notice, however, that when Preminger wants us to concentrate on Biegler, he stops using deep-focus, thus rendering the background figures indistinct.

2.07.3 Distance and objectivity

Preminger tried to represent two effects by shooting the trial scenes in the way he did: distance and objectivity. Because we seldom see witnesses in closeup, we cannot read their facial expressions and reactions as clearly as TV shows such as *Law & Order* encourage us to do. Thus, the subtle twitches or lip biting that typically signal to viewers that a witness is lying are barely perceptible. As a result, *Anatomy* doesn't tell us how we're supposed to assess a witness. This gives us greater latitude to decide for ourselves who is telling the truth and who isn't.

Because there are so few closeups, we are also likely to feel more detached from the characters than in many other trial films where we are invited to become emotionally invested in the defendant or the victim. In *Anatomy of a Murder,* however, we develop little emotional investment in Lt. Manion or Laura Manion. We seldom see either of them in closeup. Instead, we observe their reactions from a distance, which denies us the intimacy we expect in trial films.

Consider, for instance, the scene in which Dancer cross-examines Laura Manion about whether she always wears panties. Instead of cutting to a closeup of Laura as she is asked such an intrusive question, the camera follows Dancer as he steps away from the witness stand and goes back to his table to take a drink of water. When the verdict is announced, we see the characters only in a long shot without the customary congratulations between the defendant and his legal team and Laura is not even in the courtroom. The result of such techniques is to shift our

attention away from the truth or falsity of the witness's statement to the trial strategy and tactics of the contending attorneys.

Indeed, *Anatomy* is a good example of *objectivity* (see ¶4.09.3). An objective film reveals little about the inner life of the characters—their thoughts, emotions, feelings, fantasies, and the like. Not much is disclosed about Biegler's feelings, aside from the fact that he wants to win the Manion case, and even less about the feelings of Lt. Manion and Laura Manion. We see only what they do (Biegler's trial tactics, Laura's flirtacious behavior) and we must guess at how they feel.

Perhaps these techniques help explain why *Anatomy* is the favorite trial film of many lawyers. Unlike most trial films, *Anatomy* is primarily about the trial process itself, rather than romance scenes or the emotions of the participants, much less issues like the quest for revenge in westerns or a detective-style whodunit. As film critic V. F. Perkins has observed, *Anatomy* "is designed to examine the mechanism by which a verdict is reached, not to establish the accuracy or the fallibility of the verdict itself" (Perkins 1972, 148).

2.07.4 Music

Music is an important element of filmmaking. It can control the audience's perception of the entire work. Image and music together can multiply the psychological and emotional impact of a scene. Also, music can be a guide through the movie, shaping the perception and interpretation of particular images. Discordant music in a horror movie can enhance the scary encounter, while familiar romantic music can add to the anticipation of a growing relationship. Many films use hit songs to create a period flavor, establish a mood, make people laugh or cry, elicit emotions, and create additional interest in the movie through successful soundtrack albums or hit singles. In short, music can sweep the viewer into the world of the movie by making it seem more dramatic and exciting (Brabec & Brabec 2011).

Anatomy of a Murder has an unusual and famous jazz score, composed and performed by Duke Ellington. Ellington wrote most of the music on location because Preminger wanted him to absorb the local atmosphere. Why do you think Preminger chose a jazz score for *Anatomy of a Murder?*

2.08 Review questions

1. What elements should a film have to be placed in the "trial genre?" (¶2.02). Does *Anatomy of a Murder* depart from the conventions of other courtroom movies or television shows you've seen?

2. Why do you think trial films have such enduring popularity?

3. Some people urge that the Hollywood censorship code (¶2.03) should be brought back in modernized form in order to reduce the amount of vulgarity, sexuality, and violence in the movies. They argue that the ratings system now in effect (G, PG, PG-13, R, etc.) is ineffective. They point out that many great films (such as the golden age trial films including *Anatomy of a Murder*) were made while the Code was in effect. Do you agree with this proposal?

4. Legally themed films often focus on the relationship between law and justice (¶2.04). In *Anatomy*, does "procedural justice" equal "substantive justice?"

5. If you could design our legal system from scratch, would you adopt the "adversary system" or the "inquisitorial system" (see ¶¶2.04.2 and 2.04.3)? Why?

6. Did Biegler violate Model Rule 3.4(b) in his meeting with Lt. Manion (see ¶2.05)?

7. Do you think the jury was correct in acquitting Manion based on the irresistible impulse variation of the insanity defense (see ¶2.06)?

8. Why did Preminger decide to use a jazz score in *Anatomy* (see ¶2.07.4)?

9. The material on cinematic technique in this chapter (¶2.07) discusses Otto Preminger's long takes, use of deep-focus photography, objectivity and lack of closeups, and use of music. Please select a scene from the film that illustrates one or more of these (or other) directing decisions and explain what Preminger is trying to achieve in the scene.

10. Treating Laura Manion's panties as a signifier (see ¶1.05.2), what did the panties signify to viewers of the film in 1959? What do they signify now?

Notes

1. Any classic legal film can be substituted for *Anatomy of a Murder*. As *Anatomy* runs for 2 hours and 40 minutes, instructors may want to use a film with a shorter running time. We suggest other films from the "golden age" of courtroom movies such as *Witness for the Prosecution* (1957), *Inherit the Wind* (1960), *A Man for All Seasons* (1966), or *To Kill a Mockingbird* (1962), if the latter film is not going to be used elsewhere in the course. For discussion of *Anatomy of a Murder,* see Denvir 2012; Bergman & Asimow 2006, 64–68; Harris 1987, ch. 5; Perkins 1972.

2. For treatment of the courtroom movie genre, see Bergman & Asimow 2006; Chase 2002; Greenfield, Osborn & Robson 2001; D. Black 1999; Krutch 1955; Papke 2001; Silbey 2001.

3. See G. Black 1997 and 1994; Doherty 1999; Leff & Simmons 1990; Walsh 1996; Vieira 1999.

4. Some important jurisprudential works on justice include Rawls 1971; Dworkin 2011.

5. See Frank 1963;9; Kagan 2001; Landsman 1984; Strier 1996.

6. See Asimow 2007a ; Asimow 2005.

7. See Damaska 1986; Langbein 1985; Langer 2004.

8. American Bar Association 2003. The rules can be found by Googling American Bar Association and ethics rules. A current PDF copy of the rules is located at http://www.americanbar.org/content/dam/aba/migrated/cpr/mrpc/mcpr.authcheckdam.pdf

9. See Wydick 1995.

10. The unwritten law is often practiced in tribal areas of Middle Eastern countries, such as Iran and Pakistan, under the name "honor killings." Honor killings are not legal under the law of those countries but the practice is nevertheless tolerated. A graphic example of honor killing appears in the Iranian film *The Stoning of Soraya M.* (2008), in which a woman falsely accused of committing adultery is stoned to death.

11. For discussion of expert witnesses in the movies, see Caudill 2008. We discuss expert witnesses further in ¶8.05.

Lawyers as Heroes

Assigned Film: *To Kill a Mockingbird* (1962)[1]

3.01 *To Kill a Mockingbird*—The book and the film

Harper Lee's only book, *To Kill a Mockingbird*, appeared in 1960 and has sold more than thirty million copies. Countless students in high school or college American literature classes have read it. The character of Atticus Finch was based on Lee's father, A. C. Lee, a lawyer in Monroeville, Alabama. Harper Lee grew up in Monroeville, and the set used in the film as the Maycomb County courtroom duplicates the courthouse in Monroeville (which is now preserved as a museum). The character of Scout resembles the young Harper Lee herself; that of Dill is based on the writer Truman Capote whom Lee knew as a child. The story of Atticus and Tom Robinson is fictitious, although Mr. Lee once represented two blacks who killed a merchant and were hanged in the Monroeville jail. Harper Lee attended the University of Alabama Law School but dropped out before graduation.

The film received eight Academy Award nominations, including best picture, best director (Robert Mulligan), best musical score, and best supporting actress (Mary Badham who played Scout). It won three: best screenplay, best art direction, and best actor (Gregory Peck). By any account a classic film, it is the only legally themed movie to make the American Film Institute's top 100 list (at 34th). Many lawyers claim that the book or the film influenced their decision to attend law

school. Atticus Finch has become an iconic, heroic attorney, and several newspaper articles that questioned his ethics or strategy in *Mockingbird* triggered a deluge of criticism from his many fans.

3.02 Harper Lee and the Scottsboro boys

3.02.1 Messages from the author and filmmaker

The late 1950s and early 1960s were an important time for the civil rights movement and an era of fierce racial conflict in the South. Many white southerners bitterly resisted the decision of the U.S. Supreme Court in *Brown v. Board of Education* (1954). *Brown* established that legally segregated schools violated the Constitution. The struggle to secure black voting rights and to end segregation of schools and other public facilities became intense and bloody. Demagogic racists such as Governors George Wallace of Alabama and Orval Faubus of Arkansas made opposition to integration the centerpiece of their political appeal.

Harper Lee's book addressed racism in Alabama and the limitations of the southern legal system in cases of alleged black-on-white crime. Writing in the late 1950s and publishing in 1960, Lee set her tale many years in the past. This was a strategy to defuse the criticism that would have erupted in Alabama had she located the story in the present. What *was* Harper Lee trying to say to her readers (and filmmaker Robert Mulligan and screenwriter Horton Foote to film viewers)? How did these visions compare to those of the civil rights activists who were marching during the late 1950s and early 1960s?

3.02.2 The Scottsboro boys[2]

To Kill a Mockingbird recalled the tragic story of the "Scottsboro Boys," which unfolded in Harper Lee's home state of Alabama in 1931 and for years thereafter. The Scottsboro Boys were a group of young black men (aged 13 to 19) who had been "riding the rails" in a railroad boxcar in hopes of finding a job somewhere "down the line," a common practice during the Depression years of the 1930s. A fight with some white men, who were either thrown off or jumped from the train, left these black men alone with two young white women, Victoria Price and Ruby Bates. Price and Bates later accused the black men of committing gang rape. The men were pulled off the train and jailed in Scottsboro, Alabama. The governor of Alabama called in the National Guard to protect the men from being lynched, an all too common occurrence in those days.

There is strong reason to believe that the two women lied about having been raped. They might have concocted the rape story to gain publicity or to justify their presence in the train with black men. Medical examinations showed evidence of sexual intercourse involving Price but no scratches or bruises on either of the women's bodies. As discussed below, Bates (but not Price) later recanted her charges of rape. The men faced the southern legal system with woefully inept legal representation (the entire county bar was appointed to represent them which amounted to no defense at all). After hasty trials, conducted amidst threats of mob violence, eight of the defendants were sentenced to death.

The convictions produced a firestorm of protest in the North. The International Labor Defense Committee (ILDC), which had close ties to the U.S. Communist Party, and the staunchly anticommunist National Association for the Advancement of Colored People (NAACP), vied with one another to control the appeals. The NAACP accused communists in the ILDC of being more interested in using the Scottsboro case for their own propaganda aims by winning black support than in winning the legal battle.

In *Powell v. Alabama* (1932), the U.S. Supreme Court set aside the convictions. It held that Alabama's failure to provide adequate legal counsel in death penalty cases violated the due process clause of the Fourteenth Amendment (which provides that no state "shall deprive any person of life, liberty, or property without due process of law"). This decision was the first to impose due process restrictions on state criminal trials, a trend that continued throughout the rest of the twentieth century.

In March 1933, Alabama retried the Scottsboro boys. The ILDC hired Samuel Leibowitz to represent the defendants. Leibowitz was a noncommunist New York lawyer specializing in criminal law. At the trial of Hayward Patterson, Leibowitz produced powerful evidence of innocence. Ruby Bates denied that any sexual assaults had occurred. Leibowitz also conducted a slashing cross-examination of Victoria Price, suggesting that her sexual history (which included prostitution) made the rape charges unlikely. (Present law contains "rape shield" provisions that prohibit introduction into evidence of an alleged rape victim's prior sexual history, but such evidence was customary before the 1980s.) Probably offended by Leibowitz's attack on southern white womanhood, an all-white jury quickly found the Scottsboro defendants guilty.

Alabama's legal system tested this claim in the courtroom of Judge James E. Horton. After Patterson's conviction in April 1933, Judge Horton postponed any further trials because of the inflamed local atmosphere. Then, in June, in the wake of nationwide demonstrations on behalf of the Scottsboro boys, Judge Horton set aside the jury verdict against Patterson.

Judge Horton's decision was based in part on an evaluation of the evidence. Once Ruby Bates had recanted her earlier statements, the judge set aside Victoria Price's uncorroborated testimony because he found it evasive and contradictory. He also claimed that women like Price are prone to make false accusations of rape for ulterior purposes. In time, other Alabama officials began to doubt Price's story, but she never recanted it. Alabama officials immediately took the other Scottsboro cases away from Judge Horton and assigned them to another judge. The remaining defendants were again convicted of rape.

Meanwhile, the political-legal maneuvering continued. Leibowitz broke with the ILDC and formed, with the support of non communist groups, the American Scottsboro Committee (ASC) in 1934. Subsequently, the ILDC, ASC, NAACP, and American Civil Liberties Union (ACLU) joined forces as the Scottsboro Defense Committee and increasingly focused on narrower legal strategies in preference to the political agitation that the Communist Party had earlier mounted.

The Scottsboro convictions were again reversed by the U.S. Supreme Court in 1935, this time because blacks had been excluded from the jury pool (*Norris v. Alabama* 1935). Eventually, in 1937, Leibowitz and his allies agreed to a compromise: Four of the defendants secured their release, but the other five remained in prison. Four were ultimately paroled, one escaped. Astoundingly, the last defendant was not paroled until 1950, only ten years before the publication of *To Kill a Mockingbird*. He was ultimately pardoned by Governor George Wallace in 1976. The tragic story of the Scottsboro Boys has been the subject of a television docudrama,[3] a PBS documentary,[4] and a musical by the acclaimed team of Kander and Ebb.[5] There are also numerous websites devoted to the Scottsboro episode.

Many of the issues involving legal strategy that swirled around the Scottsboro cases seem applicable to the trial of Tom Robinson in *To Kill a Mockingbird*. Atticus Finch tried a lower-key approach than Leibowitz. He did not attack Mayella's chastity, but his charge that she tried to seduce a black man was just as much a challenge to the social and sexual mores of the White South and just as likely to fail as Leibowitz's all-out attack on Victoria Price's sexual history.

3.03 Lawyers as heroes[6]

The American Film Institute named Atticus Finch the greatest hero in the history of the movies in 2003.[7] What do we mean when we call a real or fictitious character a "hero"? What elements of Finch's character might cause a film viewer to see him as a hero?

3.03.1 The revisionist view of Atticus Finch

Not everyone sees Finch as a heroic character. Osborn (1996, 1141–42) argues:

> Atticus cannot see beyond his law books. Indeed, he seems scared to do so, as if it would unleash the real demons in the town. He plays along with the system. Atticus is a willing participant in a ritual that he knows to be absurd....Atticus Finch is as childlike as his daughter Scout. His vision of law is as unrealistic and yet as touching as her vision of childhood. Both hold views that are more eccentric than the town's identifiable eccentric, Boo Radley....
>
> In a town like this, willful, if nonviolent, disobedience to the "law" is the only possible alternative....In fact, [*Mockingbird*] is the first great film of the Sixties that makes a convincing case that a new kind of lawyer is needed, one who will fight to eliminate the "system" rather than participate in it. The film shuts the door on the Fifties, while illuminating the hypocrisy of the decade's child-like vision.

Does Osborn's argument reprise the debate between the ILDC and the NAACP over how to conduct the Scottsboro case during the 1930s?[8] Where are you in this debate—does Atticus Finch qualify as a real hero?

3.03.2 Heroic intertextuality—Young Mr. Lincoln *and* Mockingbird

Mockingbird is often compared to director John Ford's masterpiece *Young Mr. Lincoln* (1939), which centers on Abraham Lincoln as a young lawyer. Lincoln (played by Henry Fonda) steps forward to defend two young white men accused of murder, first from a lynch mob, and later from what seems to be an overwhelming legal case against them. Like Fonda's Lincoln, Gregory Peck's Atticus moves his long, lanky body slowly and deliberately; he weighs issues carefully; and his character commands filmic space by its sheer presence.

Atticus' struggle to achieve justice in a racially charged atmosphere invokes the spirit of Lincoln, especially as Lincoln's image has been constructed through pop-cultural representations of U.S. history, including *Lincoln* (2012). Through its powerful visual imagery, the film seems to offer a larger political context that critics such as Osborn find to be absent in *Mockingbird*.

The intertextuality between *To Kill a Mockingbird* and *Young Mr. Lincoln* goes beyond the Lincolnesque iconography. During the 1930s and 1940s, the PCA forbade moviemakers to portray the lynching of blacks. Consequently, movies such as *Fury* (1937), *The Ox-bow Incident* (1943), *They Won't Forget* (1937), and *Young Mr. Lincoln* used various devices to suggest, but not squarely address, the lynch-

law problem. Each film involves lynching themes but the victims of mob violence are white. *Young Mr. Lincoln* suggests racial themes by portraying its young white defendants, like the Scottsboro boys, as "outsiders" who are just passing through. The movie ends with metaphorical images of the coming of the Civil War, the bloody conflict that liberated the slaves.

As another example of intertextuality, we discuss in ¶9.02 whether a viewer who saw Fonda's earlier role as Lincoln might ascribe similar characteristics to his later role as "Juror No. 8" in *12 Angry Men*.

3.04 Tom Robinson was clearly innocent, right?

Why are you so sure? Are those who feel Robinson was innocent unfairly denigrating the testimony of a woman who claims she was sexually assaulted? Would you feel any differently about Atticus Finch if he suspected that Robinson might not be innocent?

3.05 The trial strategy of Atticus Finch

Regardless of whether he qualifies as a hero, Atticus Finch lost the Tom Robinson case. Shortly after the jury delivered its verdict, Robinson was dead, supposedly shot while trying to escape. If you had represented Tom Robinson, would you have done anything differently from Finch? Here are some possible strategies that you might consider:

- Move for a change of venue. Why didn't Finch try to move the case out of Maycomb County into some other Alabama county where the jury wouldn't have known the Ewells and where public opinion might not have been inflamed against Robinson? Indeed, some members of the jury were part of the lynch mob.
- Dismiss the jury. Robinson might have received a fairer trial if the judge had been the finder of facts rather than a jury. Alternatively, after the jury verdict, move that the judge set it aside as unsupported by the evidence (hoping for a Judge Horton-like decision—see ¶3.02.2).
- Attempt to negotiate a plea bargain before trial. The vast majority of criminal cases are plea bargained, not actually tried (see ¶8.01.4). In a plea bargain, the defendant agrees to plead guilty in return for a reduction of the charges or a promise of a reduced sentence. Perhaps Finch could have cut a deal in which Robinson pleaded guilty to

assault or some such lesser crime. Of course, Robinson might have refused to go along with this strategy, but surely he appreciated the odds against him if the case went to a jury. Harper Lee's book says that the county attorney was "prosecuting almost reluctantly" (Lee 1999, 201). Given community sentiment, however, the prosecutor might not have felt able to agree to a plea bargain.

- Don't allow Mayella to cut short her cross-examination by refusing to say anything more. Ask the judge to hold her in contempt if she refuses to testify. Further draw out the Ewells' family history to make clear the physical abuse and possible incest between father and daughter.

- Perhaps Robinson should not have taken the stand. His testimony only served to inflame the jury against him. In most criminal trials, the defendant does not testify, and the defense strategy is to argue that the prosecution has failed to prove its case beyond a reasonable doubt. At least, Finch could have done a better job of preparing Robinson so he would not have said that he "felt sorry" for Mayella. (For discussion of "witness coaching," see ¶4.05.1.)

- Argue to the jury for a lesser-included offense. Finch should have given the jury a chance to convict Robinson of a lesser charge such as assault. As the case was presented, the jury had only two choices— guilty of rape or acquittal.

- Challenge the exclusion of blacks from the jury pool in order to lay the foundation for an appeal on this issue, as Leibowitz did in the Scottsboro trial.

- Make a less confrontational closing argument. As a white southerner, Atticus should have realized that the argument that Mayella tried to seduce Tom was guaranteed to alienate the jury. Similarly, the suggestion that our courts should be the "great leveler" was also likely to be a loser. Lower-class white jurors don't want to hear about "leveling" when they at least enjoyed a higher status than blacks. Instead, Finch might have stayed with the argument that Robinson was a humble, hardworking, and respectful Negro who has lived in this town all his life and never caused any trouble.

- Take the language down a few notches. The members of this jury don't use phrases such as "unmitigated temerity" very often.

- Ask the jury for mercy as well as justice. If Robinson had made a terrible mistake and actually touched Mayella Ewell against her will, it was a mistake that surely does not justify the death penalty.

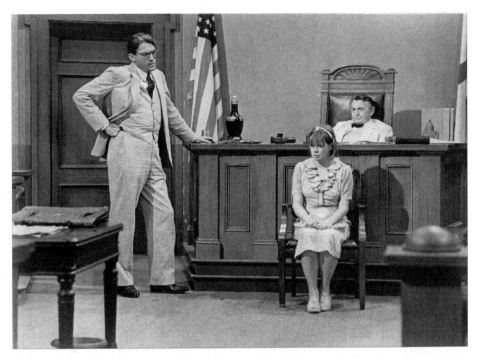

Figure 3.1. *TO KILL A MOCKINGBIRD*. Atticus Finch (Gregory Peck) cross-examines Mayella Ewell (Collin Wilcox Paxton). Universal Pictures/Photofest © Universal Pictures).

3.06 Atticus Finch and Boo Radley

At the end of the film, Finch and the sheriff cover up the fact that Boo Radley killed Bob Ewell, and they lie about what really happened. Even though Boo might have been acquitted of murder, because he acted in the defense of another, the exposure and a public trial would have destroyed this fragile man. Did Finch act unethically or immorally? Some critical commentators have noted that Atticus and the sheriff act differently toward Boo Radley, a white man, than toward Tom Robinson, a black. Do you see a significant difference?

ABA Model Rule 4.1 deals with the obligation of lawyers to be truthful (see boxed material in ¶2.05 for an explanation of the Model Rules). Rule 4.1 says: "In the course of representing a client a lawyer shall not knowingly: (a) make a false statement of material fact or law to a third person...." Did Finch violate Rule 4.1 when he covered up Boo Radley's killing of Bob Ewell?

3.07 Filmic analysis of *Mockingbird*

3.07.1 Robert Mulligan

To Kill a Mockingbird was directed by Robert Mulligan, a former divinity student from the Bronx. A veteran of live TV productions, Mulligan made his Hollywood debut with *Fear Strikes Out* (1956), a biographical picture about the nervous breakdown of baseball star Jimmy Piersall. This movie focused on Piersall's troubled relationship with his demanding father, and critics praised Mulligan for his sensitive handling of the father-son theme.

3.07.2 Memories of childhood

In addition to being about a trial, *To Kill a Mockingbird* is about a father-child relationship. In fact, trial sequences take up less than half of the film. The rest focuses on the childhood experiences of Jem and Scout, Atticus Finch's children.

The opening credits immediately establish the film's focus on childhood. The film opens with an overhead shot of a cigar box. A pair of hands (perhaps those of the adult Scout) enters the frame and opens the box. Inside the box are Jem and Scout's childhood bric-a-brac—marbles, jacks, crayons, old coins, a harmonica, a whistle, a clothespin, and Atticus' watch. The camera lingers on each object in extreme closeup as Elmer Bernstein's beautiful score plays in the background and a child's voice is heard offscreen.

The enlarged objects and the offscreen voice suggest a child's perspective on the world. At the same time, the score, the slow dissolves, the lingering camera movements, and the presence of Atticus' watch (note the sound of its ticking) all suggest *memories* of childhood—a childhood colored by the passage of time and filtered through the nostalgic reminiscences of an adult. *To Kill a Mockingbird*'s point of view is thus a complex one: On the one hand, the point of view is that of a child; on the other, it is that of an adult looking back at her childhood.

The movie reminds us that we are seeing the events as they are filtered through memory by having Scout, as an adult, narrate the film but from a child's perspective. Theorists would describe the story as "focalized" through the consciousness of both the child Scout and the adult Scout.

> **Framing scenes through windows.** Visually, the film highlights the fact that events are being filtered through Scout's childhood memories by framing scenes through windows. Take, for instance,

the scene early in the film in which Scout reads in bed while Atticus looks on. Instead of shooting the scene entirely from inside Scout's room, Mulligan begins the scene with the camera looking in through Scout's window. The scene is thus framed by Scout's window. Filmmakers often use windows and doors as frames to give scenes the look of a framed photograph. Furthermore, although the camera eventually penetrates the window and enters Scout's room, its placement at the beginning of the scene has a distancing effect—we are distanced from the characters, just as Scout is distanced from her own childhood.

The final shot of the film repeats this device—with one important difference. As in the earlier scene, the camera begins the scene by looking in through a window. This time we see Atticus cradling Scout as they sit up, watching Jem. Instead of entering the room, however, the camera pulls back, retreating from the Finch house altogether. The poignancy of this final shot derives in large measure from the receding camera movement, suggesting as it does that the film is leaving the world of Scout's childhood and consigning it to the past once and for all.

3.07.3 Between two worlds—Childhood and law

To Kill a Mockingbird is, of course, about more than just childhood and growing up. It is also about the law. There is, however, a tension between the film's focus on childhood and its focus on law. The legal system—with the exceptions of family court and juvenile court—is almost exclusively an adult world. Children have almost no role or voice in it. Children have little understanding of the law. The world of cops and robbers, not lawyers and judges, is featured in children's books, games, and movies. For a film or a novel to tackle these two themes at once is unusual.

The film straddles these two worlds by shifting perspectives and styles when it shifts between them. When it focuses on the world of Jem and Scout, the film adopts a rather florid visual style. (For another discussion of florid lighting in the film *Philadelphia*, see ¶13.09.2.) Oblique angles, closeups, and low-key lighting (that is, a lighting scheme that leaves large parts of the image in darkness and shadow) are used to suggest a child's exaggerated perspective on the world. The children's nocturnal visit to the Radley house illustrates the use of these techniques. In fact, the use of shadow is so extensive in the scene that "Boo" Radley is literally reduced to a shadow.

Similarly, when Bob Ewell attacks Jem and Scout in the forest, the scene plays out in a series of close-ups of struggling hands and Scout's eyes—neither Bob Ewell's nor Boo Radley's face is seen. In this way, the scene restricts our point of view to Scout's.

Another scene in which our perspective is limited is Tom Robinson's arraignment. The arraignment is viewed from the children's perspective—which is to say it's not viewed at all. The arraignment occurs offscreen because neither Scout nor Jem can see it; only Dill, whom they have hoisted above them, can see it. Mulligan refrains from showing us what Dill sees, however, because he wants to anchor us in Scout and Jem's perspective.

The trial, however, is filmed "objectively"—meaning that it is not filtered through anyone's consciousness. Thus there are no shadows, no slow dissolves, no oblique angles, no lingering camera movements, and very few extreme closeups. This makes the trial sequence seem rather flat, visually speaking, as compared to the rest of the film, but it also serves to differentiate the legal world from the children's world.

In addition, the movie suggests how adults view the world differently from children. Scout and Jem see Bob Ewell as a kind of boogeyman—a sinister, almost spectral figure who comes out at night. (Note the scene in which Ewell peers into Atticus' car while Jem is inside—the car window distorts Ewell's features, making him look like a leering ogre.) At the trial, however, Ewell comes across as something more prosaic—a poor, uneducated bully.

The trial sequences thus function as stylistic counterpoints to the rest of the film, and viewers can see them as offering a more mature, more distanced perspective on the world than the earlier scenes. By dropping the children's point of view, Mulligan suggests that Scout is dropping that point of view as well. She now sees the world as an adult sees it. In this regard, what Scout sees—the conviction of an innocent man—is ultimately less important than *how* she sees: objectively and from a distance.

3.08 Melodrama and *Mockingbird*

3.08.1 The melodramatic mode in American movies

According to film scholar Linda Williams, melodrama is not merely one genre among others in American cinema but "the fundamental mode of popular American movies" (1998, 42). She means that a great many American movies are melodramas, at least to some degree. The word *melodrama* generally suggests heightened emotionality, which is characteristic of many American movies. Such American films as *Avatar* (2009), *The Blind Side* (2009), or *Titanic* (1997) are good examples. However, there is more to movie melodrama than emotionality.

Melodrama is a narrative form that seeks to establish moral clarity (Brooks 1976). It does this by situating the struggle between villain and hero within a social context in which the villain's viciousness and the hero's virtue go unrecognized at first because of their social standing. The villain is typically a respected member of the dominant social group, whereas the hero is usually a member of a subordinate social group. The eventual triumph of the hero thus brings about a victory for virtue and a process of moral clarification for society as a whole. The heightened emotionality in such films plays as a signifier of moral virtue. We (and the movie's other characters) come to recognize the hero's virtue by witnessing the hero's suffering. The villain, on the other hand, rarely experiences any suffering, and the only emotion the villain typically expresses is relish at the hero's suffering.

Williams gives a concise description of how this process operates in the typical Hollywood film:

> [T]he basic vernacular of American moving pictures consists of a story that generates sympathy for a hero who is also a victim and that leads to a climax that permits the audience, and usually the other characters, to recognize that character's moral value. This climax revealing the moral good of the victim can tend in one of two directions: either it can consist of a paroxysm of pathos (as in the woman's film or family melodrama variants) or it can take that paroxysm and channel it into the more virile and action-centered variants of rescue, chase, and fight (as in the western and all the action genres). (Williams 1998, 58)

This analysis accurately describes many legally themed films. Typically, the role of the hero is split into a passive victim (typically the plaintiff in a civil trial or the defendant in a criminal trial) and an active lawyer who represents the victim. The client's status as a victim makes the lawyer's cause morally praiseworthy. Make the client a victimizer, as happens, for instance, in *Primal Fear* (1996), and the virtue of the lawyer is called into question. Moreover, the client in legal films is typically someone with less money and power than the party on the other side. This scenario, too, is a fundamentally melodramatic convention. In addition to *Mockingbird* (discussed below), numerous other films discussed in this book fit the melodramatic model, including *The Verdict* (Chapter 4), *A Few Good Men* (Chapter 10), *Philadelphia* (Chapter 13), and *A Civil Action* (Chapter 12).

3.08.2 Melodrama in films with racial themes[9]

In another book, Williams (2001) examines narratives about race, such as *Uncle Tom's Cabin* (1903), *The Birth of a Nation* (1915), *Gone with the Wind* (1939), and the TV series *Roots* (1977). She concludes that racial stories are structured in

melodramatic terms and that narratives about race can be broken down into two basic traditions: the Tom and anti-Tom traditions.

The Tom tradition originated with Harriet Beecher Stowe's *Uncle Tom's Cabin* (1995), one of the most popular and widely adapted American novels of the nineteenth century. The significance of the novel, according to Williams, consisted in its "interweaving of a conventional sentimental story of youthful female suffering on the model of Dickens (Little Eva's death by consumption) with a more distinctively American story of a racialized Christ-like passion (Tom's death by beatings from his white master)" (Williams 2001, 47). Moreover, a black man (Tom) witnesses and empathizes with Eva's suffering, while a white man (George Shelby) witnesses and empathizes with Tom's suffering. The depiction of cross-racial sympathy was a signal event in the history of the American novel. Even more resonant than the depiction of cross-racial sympathy was the depiction of a black man suffering in distinctly Christ-like terms.

The anti-Tom tradition was developed by white Southerners, who created their own novels and plays in response to the success of *Uncle Tom's Cabin*. Instead of depicting blacks as victims, these novels and plays portrayed blacks as victimizers. Frequently, the victim was a white woman.

Clarification—"Uncle Tom": In current usage, the term "Uncle Tom" has taken on negative connotations of passivity and obsequiousness. However, the character of Tom in *Uncle Tom's Cabin* is anything but obsequious; his master beats him to death because Tom refuses to obey. He is, however, a passive figure; for Stowe, Tom's passivity was a sign of his Christ-like virtue. The term "Uncle Tom" acquired negative connotations because passivity in the face of white domination became despised during the civil rights movement. In addition, some of the anti-Tom books and plays purported to be adaptations of *Uncle Tom's Cabin*; these works appropriated the figure of Tom and portrayed him as a grotesquely obsequious and submissive slave.

The Clansman **and** *The Birth of a Nation.* Perhaps the most famous anti-Tom novel was Thomas Dixon's *The Clansman: A Historical Romance of the Ku Klux Klan* (1905), A virulently racist novel that portrayed blacks as subhuman brutes who lusted after

white women, *The Clansman* was turned into a film by the pre-
miere director of his era, D. W. Griffith. The resulting film, *The
Birth of a Nation* (1915), broke box office records and revolution-
ized the art of film, while at the same time portraying blacks in
the most viciously racist terms ever seen in American film.

In the 1930s, the anti-Tom tradition was updated and softened by Margaret
Mitchell's *Gone with the Wind* (1936) and David O. Selznick's film version (1939).
The novel was the runaway bestseller of the 1930s, and the film was for many years
the biggest moneymaker in history. In the 1970s, the Tom tradition was modern-
ized by Alex Haley's novel *Roots* (1976) and the TV miniseries based on it (1977).
Haley's novel was a bestseller, and the miniseries was *the* television event of the
1970s.

In the 1990s, the Tom and anti-Tom traditions were played out in real life. The
racial divisiveness of the O. J. Simpson trial, lay in its ability to mobilize both nar-
ratives. The prosecution's story was about a white woman's victimization at the
hands of a black man; the defense's story was about an innocent black man unjustly
prosecuted by white police officers and a white criminal justice system. The power
of the videotaped beating of Rodney King, on the other hand, lay in its visualiza-
tion of one of the most potent images in the Tom tradition: the beating of a black
man by white men.

To Kill a Mockingbird is the quintessential trial film in the Tom tradition
(Harper Lee's choice of Tom Robinson's first name may be no coincidence). Indeed,
Williams claims that the novel and the film version "constitute what we might now
call the contemporary national consensus version of the Tom story." (Williams
2001, 258) According to Williams, contemporary versions of the Tom story (such
as *The Help, A Time to Kill, Amistad, The Green Mile,* or *The Hurricane*) are typi-
cally told from either a safe historical or geographical distance, permitting the racial
victims and villains to be clearly marked as figures out of a racially prejudiced time
(the past) or place (the deep South). We know that even if justice is not done, that
we, as audience-jury, will feel righteously condemnatory about the racial injustice—
it is southern, it is archaic. If put in the position of the jury we can be certain that
we would judge more fairly. (Williams 2001, 258) *Mockingbird,* of course, was set
in both a remote time (the mid-1930s) and place (a deep-South small town).

The *Mockingbird* version of the Tom story splits the victim role between a pas-
sive victim (Robinson) and an active hero (Atticus Finch). Robinson's moral virtue
derives from his victimization at the hands of whites (the Ewells and the prosecu-
tor). The moral virtue of Atticus Finch, on the other hand, derives from his sym-

pathy for and willingness to fight on Robinson's behalf.

Some commentators have criticized these types of films for portraying their black victims in largely passive terms. *Mockingbird* is emblematic in this regard. Although on trial for his life, Tom Robinson does not play an active role in his defense. The more active hero of these films is the white lawyer, or, in the case of *The Green Mile* (1999), the white prison guard, who fights on behalf of the black defendants.

Seen in this context, *Philadelphia* (Chapter 13) is an interesting variation of the Tom tradition. In that film, a white man is the passive victim and a black man is the active hero. The white victim in *Philadelphia,* however, is a more active character than the black victim in *Mockingbird.* Andrew Beckett is portrayed in more multidimensional terms (we learn very little about Tom Robinson's private life). In addition, Beckett is much more active in litigating his case than Robinson. He is constantly whispering to Joe Miller or jotting down notes on his tablet. Do you think *Philadelphia* would have been made differently if Andrew Beckett had been black and Joe Miller white? As discussed in ¶13.04.4, very few films (other than *Philadelphia*) have significant black lawyer roles. Also discussed in ¶13.04 are the stereotypical roles available to blacks during most of the history of the movies.

3.09 Review questions

1. What messages are book author Harper Lee, screenwriter Horton Foote, and director Robert Mulligan sending to the audience of this film?
2. What parallels do you see between the saga of the Scottsboro boys and the trial of Tom Robinson (see ¶3.03.2)?
3. Aside from Atticus Finch, please identify your favorite "heroic" lawyer in popular legal culture. What makes that person "heroic" in your eyes?
4. Recall the distinction between substantive and procedural justice (¶2.04.1). Did Tom Robinson receive "justice" in either sense?
5. Do you have any doubts about Tom Robinson's innocence (¶3.04)?
6. Assume that Tom Robinson wasn't killed and that Finch appealed. The Alabama Supreme Court reversed and called for a new trial. Finch is unavailable this time, and you have agreed to represent Robinson at the new trial. Will you do anything differently than Finch (¶3.05)?
7. Do you agree with Osborn's analysis of the character of Atticus Finch (¶3.03.1)? Why or why not?
8. Choose a different film from *Mockingbird.* Is it a "melodrama" as

defined by Williams and Brooks (¶3.08.1)? Explain why the film fits or does not fit their definition of melodrama.

Notes

1. Numerous films depict lawyers in heroic roles. Consider *American Violet* (2008), *Philadelphia* (1993; the subject of Chapter 13), *In the Name of the Father* (1993), or *Ghosts of Mississippi* (1996). You might also consider *Erin Brockovich* (2000), although the protagonist is a paralegal rather than a lawyer. Among older films, consider *Inherit the Wind* (1960; based on Clarence Darrow and the Scopes monkey trial), *A Man for All Seasons* (1966; about the trial of Sir Thomas More for treason against King Henry VIII), or *Young Mr. Lincoln* (1939). The last is a classic film directed by John Ford that shares many elements with *Mockingbird*.

 As to films involving lawyers and black-white racial issues, we suggest *Intruder in the Dust* (1949), *Pinky* (1949), *A Time to Kill* (1996), *Amistad* (1997), or *Ghosts of Mississippi* (1996). *Scottsboro: An American Tragedy* (2000) is a powerful televised documentary on the Scottsboro case that provoked controversy for the way that it represented the left-wing politics surrounding the defense of the Scottsboro case.

2. See Klarman (2009); Goodman 1994; Sundquist 1995. *The Alabama Law Review* published a symposium on *To Kill a Mockingbird* in 1994. (Hoff, 1994) The symposium includes numerous interesting articles, many of which draw parallels to the Scottsboro case. See especially Johnson 1994; Fair 1994.

3. *Judge Horton and the Scottsboro Boys* (1976).

4. *Scottsboro: An American Tragedy* (2000).

5. *The Scottsboro Boys* (2010). The musical was nominated for 12 Tony awards but didn't win any.

6. For discussion of lawyers as heroes, see Clark 1993; Rosenberg 1991; Greenfield 2001.

7. http://www.afi.com/100years/handv.aspx. For discussions of Atticus Finch as a hero, see Asimow 1996; Atkinson 1999; Lubet 1999; Althouse 1999; Osborn 1996; Phelps 2002; Shaffer 1981 (Shaffer has written repeatedly about the character of Atticus Finch).

8. For similar criticism of Atticus Finch, see Freedman 1994; Gladwell 2009, 26; Banks 2006.

9. See Brooks 1976; Fiske 1996; Singer 2001; Williams 1998.

Lawyers as Villains

Assigned Film: *The Verdict* (1982)[1]

4.01 *The Verdict*—Book and film

Barry Reed's novel *The Verdict* was published in 1980.[2] Reed (1927–2002), a successful Boston lawyer and author of four legally themed novels, stated that the book was not based on a real case. In the book, Galvin and Concannon appear much as they do in the film, but the other characters and many plot details differ. For example, in the book, Galvin took some depositions (he didn't ignore the case until ten days before trial). In addition, in the critical scene near the end of the film, the judge allows the copy of the admitting report to be admitted as evidence.

4.01.1 David Mamet and Sidney Lumet

David Mamet, the outstanding dramatist and director, adapted Reed's book into a screenplay. Mamet's father, stepfather, and two siblings were lawyers. Mamet himself worked on other movies with legal themes, including *The Winslow Boy* (1999) and *Oleanna* (1994). *The Verdict*'s director, Sidney Lumet, made numerous legally themed movies in his distinguished career, including *Find Me Guilty* (2006), *Night Falls on Manhattan* (1997), *Guilty as Sin* (1993), *Q&A* (1990), *Prince of the*

City (1981), *Serpico* (1973), *Daniel* (1983) and *12 Angry Men* (1957). He also co-wrote, co-produced, and directed the cable television series *100 Centre St.*

The Internet Movie Database. The authors generated this list of Lumet's movies in an instant by a search on the Internet Movie Database (http://www.imdb.com). This essential tool has information on every person ever involved with the movies or television. It also contains easily searchable information on every movie or TV show ever made, including a plot summary, the cast, and others involved such as writers or directors. For newer films, it contains newspaper reviews, reader ratings and comments, and business information. Try it! It's free of charge. Another valuable resource is Wikipedia, which contains detailed information about films, TV shows, and people involved in the culture industry.

The Verdict received five Academy Award nominations: best picture, best director (Lumet), best screenplay (Mamet), and acting nominations for Paul Newman and James Mason. However, it garnered no Oscars.

4.01.2 Paul Newman

During a career spanning more than half a century, Paul Newman created an identifiable character type who moves from movie to movie: a flawed, often amoral and self-absorbed hero who sometimes rebels against the establishment and often is at war with himself. In *The Young Philadelphians* (1959), Newman played an ambitious tax lawyer who shrugs off the displeasure of his elite law firm and successfully defends an old college friend accused of murder. In *Hud* (1963) and *Cool Hand Luke* (1967), he portrayed charming but irresponsible loners who confront uncomprehending father figures and uncaring bureaucracies. His role as a middle-aged con-man in *The Sting* (1973) anticipated his portrayal of the middle-aged ambulance chaser in *The Verdict*. In both movies, his character sobers up enough to pull off one great performance—an intricate "sting" in the former film and an improbable legal victory in the latter. In both cases, he triumphs over opponents even more ethically soiled than himself. In *Absence of Malice* (1981), a legally themed movie replete with bad prosecutors and irresponsible journalists, Newman memorably plays an innocent everyman smeared by a newspaper story who fights back against these evil forces to clear his name.

4.02 Public opinion of lawyers

Public opinion polling suggests that lawyers have plummeted in public esteem during the last several decades. A survey in 1973 indicated that only 13% of respondents strongly agreed that "most lawyers would engage in unethical or illegal activities to help a client." An additional 23% agreed slightly and 57% disagreed slightly or strongly (Asimow 2000a, 537–38). That was then.

The 2012 Gallup Poll on Honesty/Ethics in Professions asked respondents, "Please tell me how you would rate the honesty and ethical standards of people in these different fields—very high, high, average, low, or very low."

Only 19% of respondents rated lawyers very high or high and 37% rated them low or very low. Actually, this dismal result was an improvement over the 2009 figures. In 2009, only 13% gave lawyers a high or very high rating. In the 2012 survey, lawyers narrowly topped business executives and labor union leaders (each had 18%). Lawyers had a fairly comfortable lead over stockbrokers (12%), advertising practitioners (11%), telemarketers (8%), and lobbyists, members of Congress, and car salespeople (all 7%). Nurses topped the list with 84% ranking them very high or high.[3]

Granted, lawyers have never ranked as the most trusted professionals. Dislike of lawyers is deeply rooted in history and literature. Dickens, for example, loathed lawyers and his 1853 serialized book *Bleak House* is probably the most anti-lawyer novel of all time (Tartakovsky 2012). One reason the general public dislikes lawyers is that the most prominent public role of lawyers involves criminal defense, even though only a tiny fraction of all lawyers do that type of work. The public will always blame defense lawyers for helping criminals whom the public fears and detests. A second reason is that people most often deal with lawyers during stressful times such as when they are going through bankruptcy, a divorce, or a lawsuit. People naturally tend to blame the lawyers for the miserable and expensive experience (particularly the lawyer on the other side but often their own lawyer as well). However, these reasons for disliking lawyers have *always* been there; they did not suddenly pop up during the last twenty or thirty years.

Can you think of other reasons why public opinion of lawyers might have declined so sharply during the last two or three decades? Try asking your friends and family members this question.

4.03 Bad lawyers in the movies

Movie portrayals of lawyers were usually favorable from 1930 (when sound was introduced) until the mid-1970s. However, starting in the mid-1970s, this trend

reversed sharply, so that most lawyers shown in films during the last forty years have been negatively portrayed (Asimow 2000a, which surveyed over 300 films).

According to the analysis in Asimow (2000a), the determination of whether a lawyer is "good" or "bad" depends on answering two questions. The first test is personal. It is based on the lawyer's character, what kind of a human being the lawyer seems to be. One way to phrase the personal test is that a good lawyer is someone that you would like to have as your friend, meaning you see the lawyer as a decent and pleasant human being who has somehow balanced the personal and professional sides of life. The second test is based on professionalism. A good lawyer is one that the public would regard as a good professional, meaning the lawyer appears to be competent, ethical, and dedicated to clients. Thus a "good lawyer" is one that passes *both* the personal and professional tests. A "bad" lawyer is one that flunks *either* the personal or professional test or both of them.

For example, the study classifies *Anatomy of a Murder* as a "good lawyer" movie because Biegler, Dancer, and Lodwick all seem like decent people and competent, ethical lawyers. However, it classifies *The Verdict* as a "bad lawyer" movie since Galvin, Concannon, and Fischer can all be classified as "bad," though for different reasons. Many movies have several lawyers, some good and some bad. These films are classified as "mixed."

From 1930 to 1970, around two-thirds of movies represented the lawyers as "good." However, since 1970, only about one-third of the lawyers seem "good." There are obvious problems with the methodology used in drawing this conclusion. One problem is that the good/bad judgment of particular characters is subjective; other viewers might well disagree with a particular judgment. In addition, most interesting filmic characters are nuanced, with both good and bad elements. This makes them difficult to classify on a binary good/bad scale (Greenfield et al. 2001, ch. 4). Still, whether one disagrees with a particular classification or even the classification scheme in general, the trend from favorable to unfavorable lawyer portrayals during the last thirty to forty years is unmistakable.

What is the significance of this result? As discussed below, if most movies feature bad lawyers, that would confirm the negative survey evidence discussed in ¶4.02, because pop culture tends to reflect prevailing public attitudes. The trend toward negativity in film might also be reinforcing that negative public attitude. We explore this double relationship between pop culture and public attitudes further in the next section.

4.04 The relationship between works of pop culture and public attitudes—The cultivation effect

4.04.1 Popular culture as follower of public opinion

Popular culture in the narrow sense tends to reflect popular culture in the broad sense. See ¶1.02.1 for discussion of the broad and narrow meanings of popular culture and ¶1.04.1 for discussion of pop culture as reflection of what people believe about the world. If filmmakers believe that most people dislike and distrust lawyers, they will make movies about unlikable and dishonest lawyers. Films that track popular viewpoints are more likely to resonate with viewers than those that challenge them. In other words, ticket buyers are more likely to accept as realistic and true a "bad" lawyer movie than one about bad grandmothers, algebra teachers, or rabbis. It seems fairly clear that the stunning fall in the public opinion of lawyers over the last thirty to forty years (¶4.02) is accurately reflected by the increasingly negative movie representations of lawyers during the same time period (see ¶4.03).

4.04.2 Popular culture as leader of public opinion

The assertion that movies tend to reflect public opinion is less controversial than the reverse assertion. Are bad lawyer movies *one of the factors* that have negatively affected the public opinion of lawyers? Do bad lawyer movies cause people to acquire negative feelings about lawyers? Do the movies reinforce the negative feelings they already have?

We believe that the answer to these questions is yes. Try this thought experiment: Do you know what it was like to fight in Vietnam or World War II? If your answer to that question is yes, what are your sources of information? Could one of the most important sources be the various war movies you've seen? Do you know anything about the life of cowboys or detectives? Or what goes on in a hospital emergency room or the police forensics lab? Probably you think you know quite a lot, but where did you get this information? Not, we'll wager, from any real cowboys or detectives or personal experience in the ER or the forensics lab. Instead, it probably came from movies or television (or possibly novels). How is it that in France, when people are arrested, they demand their *Miranda* warnings—even though *Miranda* warnings are not required by French law (Villez 2009, 275). They could only have picked up this information from American television shows.

Alternatively, consider TV commercials. Commercials offer slick and appealing little stories and memorable images to make you want to buy something.

Similarly, thirty-second political sound bites offer up neatly packaged little dramas about candidates or issues. At one level, most people understand that these commercial and political stories are likely to be superficial at best and bogus at worst. We know that we should never depend on them as a reliable source of information about the product or the candidate. On another level, though, these cleverly produced messages exert a powerful impact on how we see the world. Otherwise, business and political candidates are wasting billions of dollars on commercial messages. We do not think their money is wasted.

In short, we see popular culture (in the narrow sense) as a powerful "teacher," and we believe that everyone has acquired information or misinformation (popular culture in the broad sense) from this source. In other words, we "construct" our view of reality by working with information that is derived in part from works of popular culture. Pop culture teaches us small bits of information (for example, that you should address a judge as "your honor" and a particular advertised drug is good for what ails you). It also teaches us ways of viewing and understanding the world (for example, that lawyers are dishonest and greedy).

4.04.3 The cultivation effect[4]

The "cultivation effect" is a theory pioneered by cognitive psychologists that tries to explain how pop-cultural images affect the way people view reality. The cultivation effect comes into play when we are called on to perform "heuristic reasoning." Heuristic reasoning means decision making where there is no reward for a right answer or penalty for a wrong answer—such as answering a question on a poll. When we engage in heuristic reasoning, we don't spend time or money researching the answer (as we might if we were choosing a college or a new car). Instead, we use mental shortcuts, called "heuristic devices" (or just "heuristics") to come up with a quick answer.

One such shortcut is called the "availability heuristic," meaning that we rely (perhaps too much) on whatever information is readily available. The most easily available source is large files or "bins" of more or less relevant information and images already stored in our brains (sometimes these mental files are referred to as "schema"). We tend to pull the information from the top of the bin. Whether we will access a particular piece of data or image from the bin depends on how recently it has been placed in the bin and how frequently similar material has been deposited there. It also depends on the vividness of the event that placed it there.

Popular culture deposits information on a vast number of subjects into millions of "bins" in our brains. In addition, and this is the key point, we don't always

"source discount" this information. In other words, we may forget that the information came from fictitious stories in film or television, and we tend to treat such information as if it were true. And we are more likely to do so when the information concerns something (like criminal justice, forensics, emergency medicine, or herding cattle) about which we lack firsthand information.

Sometimes, it is difficult to prove that the cultivation effect is working, but we often suspect that it is. Many prosecutors and judges believe that the "CSI effect" induces juries to acquit criminal defendants if the prosecution has failed to introduce forensic evidence of guilt.[5] It appears that the successful TV show *24* caused many people to accept that torture was necessary and effective in dealing with terrorist threats (see ¶1.04.3). Some believe that pop culture representations of various forms of madness influenced the development of the law of insanity (Covey 2009) or that pop culture has influenced the development of the law concerning sexual predators (Sherwin 2011).

4.04.4 Studies of the cultivation effect

Many studies have documented the existence of the cultivation effect. For example, suppose the question is whether you are likely to get mugged if you visit New York City. People who watch a lot of television are much more likely to answer yes to this question than people who watch less frequently. In general, heavy TV watchers think this is a "meaner" world than people who do not watch much. The heavy watchers think there is a higher crime rate, and there are more police officers, lawyers, or prostitutes, and more alcoholism or drug abuse, than light watchers (Shanahan & Morgan 1999, ch. 3). Heavy viewers of soap operas have much different beliefs about the prevalence of marital discord than non-viewers (Shrum 1996).

> **Cultivation effects—*L.A. Law* and *Judge Judy*.** One interesting cultivation effect study (Pfau 1995) compared people who were heavy watchers of *L.A. Law* and people who never or almost never watched the show. Heavy watchers thought that lawyers had more power and better character, were more physically attractive and more sociable than people who didn't watch the show. Watching *L.A. Law* seemed to make viewers admire lawyers more than the general public does. This effect even applied to lawyers themselves; attorneys who watched the show had more favorable views about their profession than lawyers who didn't watch the show.

Another study (Podlas 2001) focused on jurors who were waiting to be called for jury panels. One group of jurors frequently watched the TV show *Judge Judy*. A second group seldom or never watched it. There were dramatic differences in the way the two groups viewed the role of the judge. For example, 83% of frequent viewers thought the judge should ask questions during the trial and should be aggressive with litigants. Only 38% of non-viewers thought that the judge should ask questions and be aggressive with litigants. Another question was whether the judge's silence means that the judge believed a witness's answer. Of the frequent viewers, 74% thought that silence meant belief; of non-viewers, only 13% thought that.

The numerous "bad" lawyer movies may have contributed—along with many other factors—to the declining public image of lawyers. (See Hyland 2008). The strength of the cultivation effect, remember, depends on the frequency, recency, and vividness of exposure to particular representations. Bad lawyer movies have been both recent and frequent during the last three or four decades. Moreover, the vividness of movie portrayals is undeniable—the characters are played by skilled, charismatic actors, and the films are directed and scored by consummate professionals.

According to a study of first-year law students in six countries including the United States (taken on the first day of law school), the students distrusted lawyers just as much as the general population. (Why would the students want to spend time and money to enter such a disreputable profession?) More importantly, about 60% of them admitted that popular culture was helpful or very helpful to them in forming their opinions (Asimow et al. 2005).[6] This is solid evidence that the cultivation effect is working.

4.04.5 Lawyers on television versus lawyers in the movies

Televised portrayals of lawyers are more favorable—and far more prevalent—than movie portrayals. Older lawyer shows like *L.A. Law* and *Perry Mason*, as well as contemporary shows like *The Good Wife* and *Law & Order*, seem to offer, on balance, relatively favorable pictures of lawyers. (See Chapter 7 for discussion of legal television.) The cultivation effect from these TV shows may improve the public's opinion of lawyers. Obviously, people consume far more TV than movies and the cultivation effect of a long-lasting TV series must be quite substantial. Perhaps the

cultivation effect caused by the positive TV lawyer portrayals swamps the cultivation effect of negative lawyer movies.

Nevertheless, we should not dismiss the negative cultivation effect of bad lawyer movies despite the apparently positive effect of good lawyer TV shows. A particular movie can offer a more vivid exposure—a greater emotional impact—than a TV show (or even a TV series). Consider the many differences between watching a movie at the theater and watching a TV show. (See ¶¶7.03.2 and 7.03.3, which describe the differences in the conditions of consumption of film and TV.) Do these differences suggest that a movie might have a greater emotional impact than a TV episode or even a TV series? Obviously, the impact on viewers of consuming a movie will be much reduced if they see the movie at home on cable or DVD, or through streaming video or other modern technologies as is increasingly the case.

4.04.6 Viewer response theory [7]

Cognitivist approaches such as cultivation theory (¶4.04.3) treat media consumers as passive sponges who indiscriminately file away bits of dubious information. In many instances, this approach does not adequately describe the experience of consuming popular culture media. Many communications theorists utilize a "viewer response" model of media consumption (see also ¶1.05.5, which introduces viewer response theory). Sometimes these models are referred to as "active audience" or "uses and gratifications" theories.

The idea of viewer response theory is that media consumers are not passive recipients of whatever is served up to them ("cultural dopes") but instead are actively interpreting and remaking the material. The emphasis is on what the viewer does to the text, not the other way around. In consuming films or television, viewers seek pleasures and entertainment of various kinds, such as experiencing a desired emotion (laughing, crying, being scared, aroused, or puzzled), altering a mood, or escaping from normal routines. They may be trying to acquire information of various sorts or to enjoy a social experience with friends or family.

According to viewer response theory, consumers do not simply soak up all of the information served up to them by fictitious stories. These theorists believe that viewers are deliberately and actively making their own meanings from culture products. These meanings may be quite different from those intended by the producer of the product. Viewers can, if they choose to, meaningfully distinguish truth from fiction and the substantial from the ephemeral. Indeed, these theorists believe that viewers are capable of rejecting the messages embedded in the narratives (particularly those

reflecting dominant white/male/heterosexist/middle class discourses) and of substituting their own meanings and interpretations that are opposed to such discourses.

The cultivation effect discussed in ¶4.04.3 to 4.03.5 and the viewer-response model discussed in ¶4.04.6 are not necessarily inconsistent with each other because of the enormous differences in the conditions of consumption of any particular pop culture product. Many viewers and watchers may be passively soaking up information dispensed by fictional stories in the manner suggested by cultivation theorists. For example, they may be watching a television show while doing something else at the same time (such as homework or cooking dinner) or while dozing on the couch. Other viewers may be actively resisting or modifying the messages served up by the media producers as suggested by viewer response theorists. Some viewers may be doing both at the same time—unthinkingly accepting some messages, resisting others. Some cultural products invite viewer reinterpretation, others discourage it. Both of the approaches to the study of media effects are valid, depending on the particular viewer's social situation and media competency, the circumstances of the particular act of media consumption, and the determinacy or indeterminacy of the particular media product being consumed.

4.05 Ethical problems in *The Verdict*

Galvin and Concannon do some very bad things. How many can you list (see Bergman & Asimow 2006, 198)? This section asks whether some of the lawyers' bad conduct violated the rules of legal ethics.

4.05.1 Witness coaching

Consider the scene in *The Verdict* in which Concannon prepares Dr. Towler for trial and compare it to the "lecture" scene in *Anatomy of a Murder* discussed in ¶2.05. Witness preparation can present difficult ethical problems. ABA Model Rule 3.4(b) states: "A lawyer shall not...counsel or assist a witness to testify falsely."

On the one hand, it is appropriate (indeed mandatory) in American practice to prepare a witness for a deposition or a trial by going over the witness's direct testimony and preparing the witness for cross-examination. (In many countries, however, this is considered unethical and inappropriate.) Witness preparation enables witnesses to present testimony clearly and forcefully, in a way that a judge or jury can understand and believe. It also enables witnesses to avoid mistakes while being cross-examined, such as by volunteering information or losing their cool. However, it is improper to cause the witness to testify to something substantively different

from what the witness would otherwise have said. Sometimes even a subtle suggestion by the lawyer can influence the witness to testify in a way he or she might not have done. This probably occurred in *Anatomy of a Murder*. Did Concannon cross this line in *The Verdict* with Dr. Towler?

4.05.2 Ambulance chasing

Galvin tries to hustle business by handing out his business cards at the funerals of strangers. When doing so, he falsely states that he knew the deceased. This form of business-getting is improper.

The legal and ethical rules relating to attorney advertising have changed radically over the last forty years. Historically, any form of advertising was forbidden. However, in *Bates v. State Bar of Arizona* (1977), a 5 to 4 majority of the U.S. Supreme Court held that a blanket prohibition on truthful advertising violated the free-speech rights of lawyers. (This is one of many post-1970 decisions protecting "commercial speech" under the First Amendment.) The *Bates* decision set loose the flood of attorney advertising we see today on television, radio, Yellow Pages, bus benches, and so forth. Television advertising by attorneys alone totals over half a billion dollars each year[8] (an average of around $500 for each of the one million American lawyers), and that doesn't count advertising in the Yellow Pages, billboards, paying for favorable Google display of the lawyer's websites, or the other forms of Internet advertising. Yellow Pages advertising by lawyers might total close to $1 billion per year. (Do you think advertising in the Yellow Pages is a waste of money?)

Under ABA Model Rule 7.1, advertising messages or any other communication designed to get business must be truthful. Such messages cannot contain any misrepresentations or create an unjustified expectation about results the lawyer can achieve. Galvin's false statements to grieving relatives that he was acquainted with the deceased violated Rule 7.1.

The First Amendment's protection for truthful attorney advertising does not extend to "ambulance chasing." This term refers to signing up clients (usually victims of an accident) by directly soliciting the victims or their surviving relatives. In *Ohralik v. State Bar of Ohio* (1978), the Supreme Court held that a lawyer could be disciplined for directly approaching accident victims in the hospital.

A direct pitch to victims, as in *Ohralik,* is completely different from anonymous newspaper or television ads. The direct pitch involves the application of pressure by sophisticated attorneys or their employees—"sign here now!"—on unsophisticated victims and demands an immediate response. Movies such as *The Rainmaker*

and *The Sweet Hereafter* (both 1997) contain vivid images of direct pitches to injured or grieving victims. Thus, business solicitation through truthful newspaper or TV ads is permitted, but face-to-face pitches to strangers are not.

ABA Model Rules and ambulance chasing. Model Rule 7.3(a) generalizes the *Ohralik* ruling: "A lawyer shall not by in-person or live telephone contact solicit professional employment from a prospective client with whom the lawyer has no family or prior professional relationship when a significant motive for the lawyer's doing so is the lawyer's pecuniary gain" (ABA 2003). This rule certainly covers Galvin's activity in handing out business cards at the funerals of strangers.

Rule 7.2(c) also prohibits the payment of compensation to anyone for recommending the lawyer's services; this rule prohibits payments to nurses, ambulance drivers, bail bondsmen and the like for referring clients to the attorney. This traditional form of obtaining business remains common practice despite the rule against it.

Today, virtually all attorneys engage in some form of solicitation of business. The competition for desirable clients is fierce. How do you think Concannon's firm solicits business? Could Galvin refine his solicitation methods by sending letters to the surviving relatives of deceased strangers, truthfully advertising his availability to perform whatever legal work the survivors needed?

4.05.3 The settlement offer

Television and the movies give the false impression that most civil and criminal cases are resolved through jury trials. In fact, only a tiny percentage of all legal cases (civil or criminal) ever go to trial. The lawyers always try to settle cases before, or even during, trial and are often forcefully urged to do so by judges (as occurs in a famous scene in *The Verdict*).

Galvin committed a breach of legal ethics by failing to stay in touch with Doneghy and by failing to communicate the settlement offer to them. Model Rule 1.4(a) provides: "A lawyer shall keep a client reasonably informed about the status of a matter and promptly comply with reasonable requests for information." The comment to Rule 1.4 states: "A lawyer who receives from opposing counsel an offer

of settlement…should promptly inform the client of its substance unless prior discussions with the client have left it clear that the proposal will be unacceptable." In addition, Rule 1.2(a) states: "A lawyer shall abide by a client's decision whether to accept an offer of settlement of a matter."

Galvin's ethical problems run deeper than his failure to communicate the settlement offer. He has breached the lawyer's obligation of loyalty to the client. Because he seems so focused on pursuing his own moral redemption by winning rather than settling the Kaye case (see ¶4.07 for discussion of attorney redemptions), he forgot that his ultimate duty is to his clients, not to himself.

4.06 Legal errors in *The Verdict*

In addition to ethical miscues, *The Verdict* is replete with legal errors. We offer this information not to criticize the film for being inaccurate (it's designed to entertain, not to instruct viewers in the law of evidence), but to show that Judge Hoyle was heavily biased in favor of the defense and to answer questions by non-lawyer readers about whether Hoyle's rulings were correct.

One glaring example of Hoyle's bias is his ruling that Galvin cannot introduce the copy Kaitlin Costello made of the original admitting form before Dr. Towler altered it. Under the "best evidence" rule, the original of a document should be admitted rather than a copy, since the original is more likely to be correct. But that rule is obviously inapplicable in *The Verdict* because the issue was whether the original or the copy was correct. Even if the document was not admitted, there was no basis for striking Nurse Costello's testimony since she was a firsthand witness to the critical events concerning Kaye's admission to the hospital, and her testimony was highly relevant to the issue of whether Towler had testified truthfully.

Galvin's closing argument to the jury, while stirring, was completely inappropriate. It is simply a call for the jury to ignore the evidence and do justice. He does not refer to the evidence in his favor (there isn't any). He says: "But today you are the law.…If we are to have faith in justice, we need only believe in ourselves and act with justice. I believe there is justice in our hearts." He was not permitted to mention his trump card—the altered admission report—because the judge excluded all testimony about it and instructed the jury to ignore it. But, of course, he doesn't have to mention it. The jury isn't about to forget what it heard. (We discuss jury nullification further in Chapter 9.)

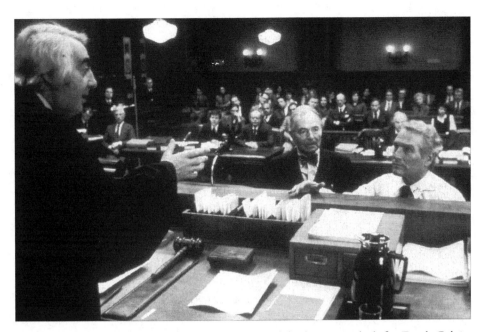

Figure 4.1. *THE VERDICT.* Judge Hoyle (Milo O'Shea) cuts no slack for Frank Galvin (Paul Newman) as Ed Concannon (James Mason) looks on approvingly. Twentieth Century Fox Film Corp./Photofest. © Twentieth Century Fox Film Corp.

4.07 Redemption of lawyers

Normally, we think of an attorney as a professional who represents people in exchange for money. It's a living for the attorney, but little more. However, sometimes the job of representing a particular client can be a transformative experience, making the attorney a different and better human being and professional. Such lawyerly redemptions often occur in the movies and, sometimes (although more rarely), in real life as well. (P. Bergman 2001).

In *The Verdict,* Galvin is a hopeless alcoholic and completely incompetent (see Parker 2006). He scratches out a living from settling meager personal injury cases. He loathes himself. Yet the Kaye case transforms his life. He neglected the case almost to the eve of trial, but when he staggers into the hospital to photograph his comatose client, something changes in him. Suddenly, he finds himself on a mission to win justice for her. By virtue mostly of good luck and breaking into a mailbox, he pulls off a stunning victory. He tells the jury to ignore the law and do justice. It works. The jury disregards the judge's instruction to ignore the evidence of the

altered admission report. At the end of the film, we see Galvin in the office, sipping coffee rather than a celebratory cocktail. Is the Kaye case the springboard from which Galvin can redeem his life and career?

Attorney redemption occurs in several other movies featured in this book. In *A Few Good Men* (Chapter 10), JAG lawyer Daniel Kaffee is a playboy who settles every case and concentrates mostly on coaching the base's softball team. Then he's assigned the defense of two Marines who killed a fellow Marine while performing a disciplinary Code Red at Guantanamo Bay. The brass expects Kaffee to quietly plea bargain this embarrassing case, but he's pushed into a vigorous defense by the clients' unwillingness to accept a plea bargain as well as by the disdain of Col. Jessep and the efforts of his tenacious co-counsel JoAnne Galloway. He's also motivated by the memory of his father who was a famous military lawyer. Somehow, it all comes together and the lightweight lawyer becomes a heavyweight. We believe that he's destined for a great legal career.

In *A Civil Action* (Chapter 12), attorney Jan Schlichtmann, a materialistic personal injury lawyer, rises above himself to fight to the bitter end in the case of a group of parents in Woburn who had lost their children to leukemia. Suddenly, he sees himself as a seeker of justice rather than just a hack lawyer who earns big fees by settling injury cases. In this case, however, the redemption is costly. He loses his law firm, his home, and virtually everything else he owns and must file for bankruptcy.

Finally, in *Philadelphia* (Chapter 13), attorney Joe Miller is a moderately successful African American personal injury lawyer. He refuses to represent Andrew Beckett who claims that he was fired by a big law firm because he had AIDS. Why would Miller want to take the risk of challenging the biggest firm in Philadelphia in what will obviously be a difficult case? Besides he is repelled by gay people and by AIDS. In a critical scene in the law library, however, it dawns on Miller that discrimination against disabled people is the same as racial discrimination. It is just as humiliating and just as wrong. And with that, he takes Beckett's case and fights it to victory. In the process of representing Beckett, we realize that Miller has shed his homophobia and is a better man for it.

4.08 The two hemispheres of law practice[9]

4.08.1 Distinguishing the hemispheres

Sociologists of the legal profession have observed that law practice is divided into two completely different worlds ("hemispheres"). One hemisphere is represented

by Galvin, as well as by Paul Biegler, Atticus Finch, George Simon, Joe Miller, and Jan Schlichtmann (Chapters 2, 3, 5, 12, 13). Practitioners in this hemisphere represent individuals or small businesses without much wealth. Lawyers who practice employment law (on the employee's side), family law, personal injury law (on the side of the victims), immigration, criminal defense, landlord-tenant, or probate, or who represent small business, fall into this category. The other hemisphere is represented by firms like Ed Concannon's. The same is true of Jerome Facher in *A Civil Action* (Chapter 12) and Charles Wheeler in *Philadelphia* (Chapter 13). Generally lawyers in the second hemisphere practice in large to very large firms, although a few small firms or even solo practitioners can be found in the second hemisphere. The factor that defines lawyers in the second hemisphere is that they represent wealthy individuals or institutions, including medium to big business as well as governments and large nonprofits such as the Catholic Church in *The Verdict*.

Heinz and Laumann's study of Chicago lawyers (1982) demonstrated that the two hemispheres of law practice are almost completely separated from each other. The members of each hemisphere belong to their own professional associations, and they seldom mingle socially with lawyers from the other hemisphere. The lawyers who practice in the first group went to non-prestigious law schools, whereas the lawyers who practice in the second group mostly attended the top-twenty law schools. Lawyers in the second group on average make much more money than lawyers in the first group. The comparison between Concannon's magnificent office and Galvin's small and trashy office says it all.

4.08.2 Ethical issues in the two hemispheres

The ethical and moral issues suggested by *The Verdict* can be related to the two hemispheres of law practice. Lawyers in group one tend to get into different kinds of trouble from lawyers in group two. Galvin engages in unethical ambulance chasing; Concannon would not be caught dead chasing ambulances, but he'll hustle clients in more sophisticated ways (like volunteering to do legal work for charities or joining clubs frequented by business people). Alcoholism and other substance abuse (particularly cocaine) are common in both hemispheres, but there is a major difference. Galvin can turn for help only to his old friend Mickey. He practices law while drunk, greatly harming his unfortunate and helpless clients. In a big firm like Concannon's, steps will be taken to prevent alcoholic or drug-abusing lawyers from harming clients, out of concern for malpractice liability if nothing else. Thus, big firm substance-abusing lawyers will be quietly placed in rehab or fired. Their ability to harm clients will be contained.

4.08.3 Contingent fees and hourly billing

In personal injury cases like the Kaye matter, Galvin will receive a contingent fee (meaning he gets a percentage, perhaps one-third or more, of any money Kaye recovers). In other words, Galvin gets a financial windfall if he wins or settles the case, but he will earn nothing if he takes it to trial and loses. That's why it is startling when he turns down the $210,000 settlement offer that would have yielded a $70,000 fee. If Galvin takes the case to trial and loses (and the Kaye case was anything but a sure winner), he would get nothing, would waste the time he worked on the case, and would have to eat any amounts he has paid out in costs (for example, to hire expert witnesses). (For further discussion of contingent fees, see ¶12.01.2)

Lawyers in the second hemisphere seldom work for contingent fees. Concannon's firm charges by the hour; they get paid whether they win or lose. Obviously, however, if they lose a case they should have won or are caught over-charging the client, they are likely to lose the client. And big business clients today don't hesitate to negotiate about hourly rates or dispute bills if they sense the lawyer has wasted time.

This "hemispheric" difference between Galvin and Concannon has great significance. Galvin does nothing to prepare for the upcoming Kaye trial, such as by taking depositions of the various witnesses. Although this is partly attributable to his alcoholism, he also needs to be very careful in spending time or money since it's his own time and money that he's spending. His mentor Mickey hoped he would settle the case for some paltry sum without doing any work on it.

In Concannon's firm the incentives are radically different. The archdiocese pays by the hour. Consequently, the firm has an incentive to maximize the time it spends on the case. Note the scene in which Concannon prepares Dr. Towler to testify in front of a huge number of associates. There is no need to have any of them present; this is just a gimmick to run up the hours that can be billed to the case.

> **The professionalism and business models of law practice.** In ¶13.05.4, we contrast two models of law practice—the professionalism and business models. The professionalism model stresses the lawyer's duty to the client and to our systems of civil or criminal justice. The business model treats law as just another profit-making business in which lawyers do anything legally and ethically possible to maximize profit. The business model is in the ascent and the professionalism model is in decline. This is true for lawyers in both hemispheres. Note the wonderful scene in which Concannon

is talking to Laura Fischer and slips her a check for her "services" in spying on Galvin. He speaks reverently about his mentor who once told him that he wasn't paid to do his best, he was paid to win. Winning pays for the firm's beautiful offices, the lawyers' fine clothes and whiskey, their pro bono cases. As we see in the film, Concannon's firm uses its superior resources and total lack of ethics to play every dirty trick in the book in order to win. This is a caricature of the business model, but a very effective one.

4.09 Storytelling in *The Verdict*

4.09.1 Narrative and narration

Storytelling seems basic to human civilization. For thousands of years, human beings have told and enjoyed stories. They tried to make sense of their world through mythological and religious stories. Stories remain a fundamental part of human communication and of the acquisition of knowledge.[10]

Consider the range of storytelling in our daily lives. There's nothing better than hearing the latest gossip around the water cooler—and gossip consists of stories about people we know or celebrities we know of. Jokes are humorous short stories with surprise endings. We tell or read stories to our children who always crave at least one more. Lawyers organize the facts of their cases into stories that favor their clients in order to persuade juries or adversaries (see ¶8.06 for discussion of story-telling in law practice.) And, of course, we consume massive amounts of story material served up by film and TV.

Most discussions about stories focus on the characters, institutions, and events represented in the cultural product. Alternatively, a story can be discussed by focusing on the way that the story is told. Thus it is important to distinguish story (or *narrative*) from storytelling (or *narration*).[11]

4.09.2 The classical Hollywood style

There are many ways to tell a story, but Hollywood has traditionally favored what is known as the "classical Hollywood narrative" or the "classical Hollywood style."[12] David Bordwell (1985, 127) describes the classical Hollywood style as

> presenting] psychologically defined individuals who struggle to solve a clear-cut problem or attain specific goals. In the course of this struggle, the characters enter into conflict with others or with external circumstances. The story ends with a decisive victory or defeat, a resolution of the problem and a clear achievement or non-achievement of the goals.

As Bordwell (1985) indicates, the classical Hollywood narrative features "psychologically defined individuals," meaning that the characters possess a set of more or less consistent traits and behaviors that reveal their underlying psychology and personality. The characters of Frank Galvin and Ed Concannon in *The Verdict* are defined in this way.

In a classical Hollywood narrative, one character will be deemed more important—and thus, more richly characterized—than the others. This character (Frank Galvin in *The Verdict)* is the *protagonist,* the character around whom the story revolves. The protagonist seeks to achieve a goal and to overcome obstacles in the path of achieving that goal. His struggle to surmount the obstacles propels the story forward. Other characters have goals too, but the story will not be structured around the pursuit of their goals. Some films do not have a clearly identifiable protagonist. In *Traffic* (2000), for instance, the film follows several distinct story lines, each with different characters, which finally are resolved together at the end of the film.

The classical Hollywood narrative establishes the protagonist's goal and the reason he strives to achieve it (his "motivation"). Galvin's original goal is to scratch out a quick settlement of the case and receive a modest fee. Later his goal shifts. He wants to win the lawsuit against the hospital; his motivation (the reason he seeks the goal) is to seek justice for his client and redeem himself. Of course, Galvin must overcome numerous obstacles (his alcoholism, Concannon's tricks) to achieve the goal.

In a classical Hollywood narrative, events are linked together by a chain of *cause-and-effect.* Typically, this chain begins with an event that causes the protagonist to desire something for the first time (perhaps Galvin's visit to the hospital where he sees his vegetative client). This event causes the protagonist to identify his goal and to pursue it. The pursuit of this aim causes the protagonist to take certain actions. In taking these actions, he causes other characters to react, and their actions, in turn, trigger his reaction.

Ultimately, the protagonist either achieves or fails to achieve his goal, and this is called *closure.* Closure brings an end to the chain of causation that comprises the film's plot. A classical Hollywood narrative almost always provides closure. Indeed, an *open ending* (that is, one that fails to provide closure) is forbidden in the classical Hollywood cinema.

A good story has a beginning (in which matters break away from the ordinary, characters are introduced, and the story is situated in place and time), a middle (in which characters struggle to overcome the obstacles that stand in the way of reaching their goals and getting out of trouble), and an ending (or "closure"; in which characters reach or fail to reach their goals and most or all of the loose ends are tied up).

In addition to having a narrative based on a cause-and-effect structure, a classical Hollywood story often has a *dual- or double-plot structure,* meaning that two plot lines are concurrently developed. The first plot line is a generic plot line, such as a mystery or an adventure story. In *The Verdict,* the first plot line is Galvin fighting Concannon in the Deborah Kaye case. The second plot line is usually romantic: the protagonist falls for another character (the relationship between Galvin and Laura Fischer in *The Verdict* is an example of a romantic subplot). At the film's conclusion, both plot lines reach closure, often simultaneously. However, *Anatomy of a Murder* employs only a single plot line—the criminal case against Lt. Manion. As pointed out in ¶3.07.2, in *To Kill a Mockingbird,* the relationship of Atticus Finch to his children is a well developed (but not romantic) secondary plot line. The dual-plot structure is also conventionally employed in television drama (see ¶7.08).

As a result, spectators of classical Hollywood narratives usually get two happy endings for the price of one: the protagonist achieves his goal and falls in love too! *The Verdict,* however, doesn't stick to this script: Galvin and Fischer don't get together at the film's end. To the contrary, the film has an "open ending" in which the fate of the characters in the secondary plot line is not fully known. It ends with a phone ringing; we do not learn whether Galvin ever picks it up.

A high percentage of films from the 1930s and 1940s end with a shot of the protagonist and his beloved kissing. Why do you think this was the case? Generally speaking, films no longer end with kissing scenes, but the dual- or double-plot structure is as pervasive as ever.

4.09.3 Variables in narration—Subjectivity and restricted narratives

Film and television (but not novels) are visual media. One implication of the visual character of film and television is that the inner lives of characters (such as their undisclosed thoughts, dreams, fantasies, desires, emotions, and feelings) are difficult to show on the screen. Yet good storytelling requires that the viewer understand the motivation of the characters. Moreover, audiences are unlikely to empathize with a character unless they understand the character emotionally. Consequently, it is necessary to convey information about the inner lives of the characters. To some degree, the characters' inner lives can be inferred from what they do and from skillful acting. Inner life can also be explicitly described in dialogue in which characters say what they are feeling, but such passages tend to slow down the action.

Narratologists sometimes refer to visual texts as *objective* (meaning that relatively little about the characters' inner life is disclosed) or *subjective* (meaning that a large amount of information about the characters' inner life is disclosed).[13] In melodrama (see ¶3.08 for discussion of melodrama), the narration typically discloses a large amount of information about the emotions of the various characters. However, in legal stories on film and television (as well as westerns, detective stories, or police stories), the stories are typically quite objective with disclosures of the character's inner lives kept to a minimum.[14]

> **Romantic subplots in legal movies.** As you may have noticed, subjective storytelling and romantic subplots are not typical in legal films. We learn little about the inner life of Paul Biegler or Atticus Finch and neither character seems to have any romantic interests at all. Why do you think this is the case?

Another variable in narration concerns the disclosure of story information to the characters and to the viewers.[15] In "restricted" narration, the viewers and the characters get access to the same information at the same time. Typically legal stories (as well as detective or police stories) contain restricted narration, meaning that neither the viewer nor the police know who the killer was. The audience acquires clues at the same time as the police. In an "unrestricted" narrative, on the other hand, the viewer knows more than the characters. For example, the audience may know before the police who the killer is or about the ticking time bomb. This creates suspense, since the audience is waiting for the characters to figure out what it already knows.

4.09.4 Narrative about narrative

In a courtroom, each lawyer is trying to persuade the fact-finder (judge or jury) to accept a particular version of disputed events. In other words, each lawyer has a particular *story* to tell that links together all of the facts presented in evidence into a plausible account with a beginning, middle, and end. (We discuss legal storytelling further in ¶8.06.)

A film also tells a story that the filmmaker hopes an audience will accept as plausible. Thus, as David Black (1999) points out, courtroom films are storytelling about storytelling, narrative about narrative. Black calls these films *reflexive*. He asserts that identifying and studying reflexive films is an alternative theoretical tool

to the more common approach, which is to define and describe the trial genre (see ¶2.02). Courtroom films like *The Verdict* and *Anatomy of a Murder* are interesting examples of storytelling about storytelling because they dwell in such detail on the events in the courtroom and the strategies used by the lawyers in getting their stories across to the jury.

4.10 Visual design in *The Verdict*

4.10.1. Interiors in The Verdict

The world inhabited by Frank Galvin in *The Verdict* is a world of cramped interiors and muted colors. In the opening shot of the film, Galvin is playing pinball while nursing a beer. The pinball machine is up against a window. Thus, Galvin is literally up against a wall. The primary source of illumination in the scene is the light coming from the window. The interior of the bar appears to be totally devoid of light. As a result, Galvin is reduced to a silhouette—making him, visually, a mere shadow of a man. Additionally, the image is almost totally devoid of color. Aside from the scarlet red credits, the only sources of color are the red and green windowpanes, the pathetic Christmas spirit of which serves as an ironic visual counterpoint. Finally, we can see that the window looks out onto an empty street and an overcast sky. Thus, far from providing a respite from the dreary, lonely interior, the window extends the loneliness and dreariness of the inside into the world outside.

In this brief shot, the film economically establishes the cramped, cold world of Frank Galvin. Almost every location Galvin is associated with is similarly confined and lacking in color. The first time we see Galvin's office it is nothing but a narrow hallway with a dirty sink. When we finally his whole office (which he ransacks), it is small, confined, and virtually colorless. Drab browns (the sofa, the desk), subdued greens (the filing cabinets), and dull blacks (the chairs) dominate.

Galvin's apartment is equally cramped and cold. The furniture is drab and almost colorless and is claustrophobically arranged. Notice, for instance, how the chair is pressed against the radiator. Lumet shoots the scene from a high angle which further reduces the size of the room. Finally, the bars on the window add an aura of entrapment. In contrast, the locations associated with Galvin's nemeses are almost palatial. Take, for instance, the massive conference room that Concannon uses to prepare for the trial. Meanwhile, Galvin prepares Dr. Thompson's testimony in the confines of his own apartment, a difference that underlines the vastly unequal resources of the two sides.

4.10.2 The use of the color red

The film is not lacking in bold colors. Notice, for instance, the brightly colored clothes the children are wearing when Galvin drops in on Kaitlin Costello Price at Chelsea Child Care. Moreover, although dominated by shades of brown and green, the film is repeatedly enlivened by bursts of red. Consider, for instance, the following examples: the credits are in red; the first funeral home Galvin visits has a red carpet; the sofa in Galvin's waiting room—which we see for the first time when client Sally Doneghy comes to see Galvin—is red; Sally Doneghy has reddish brown hair and is wearing a blouse with red sleeves when we first encounter her; the first time we see Laura Fischer she is wearing a red scarf (a bit of costuming that serves to direct our eyes to her even before we know that she will play a role in the scene); Bishop Brophy wears a red miter; the Diocese has red carpets, red chairs, and red curtains; Bishop Brophy gets into a red car; the carpet in Judge Hoyle's chambers is red; Dr. Gruber lives in a red house with a red brick driveway; Judge Hoyle's home has red wallpaper, and he is wearing a red bathrobe when Galvin visits him; Sally Doneghy is dressed in red on the first day of the trial; Dr. Towler's textbook—*Methodology and Practice in Anesthesia*—is red; and Kaitlin Costello Price not only has red hair but wears a red dress when she testifies.

Because the color red is associated with both sides, it can't be reduced to any single meaning, though it has certain obvious associations such as blood, fire, or hell. Rather, the color red is used to throw the drabness of Galvin's life into stark relief. Red colors are always associated with other characters, not Galvin. Visually speaking, therefore, the lawsuit literally brings warmth (in the form of the hot colors worn by Doneghy and nurse Price) into Galvin's life. Red is associated with the other side, too, but that only serves to underscore the fact that it is the trial itself—not just his clients—that brings Galvin back to life.

4.11 Review questions

1. The "cultivation effect" explains how works of popular culture can affect the public's beliefs and attitudes. (See ¶4.04) It suggests that the many bad lawyer movies might have contributed to the public's low opinion of lawyers. Please identify a movie or television show (other than *The Verdict*) that portrays lawyers negatively and explain why you think the portrayal is negative.

2. The "uses and gratification" or "active audience" models are discussed

in ¶4.07.6. Please give an example of a movie or television show (not necessarily about law) in which you rejected the message embedded in the narrative and created your own interpretation.

3. ¶4.02 gives polling data that indicate a sharp decline in the public's perception of lawyers since around 1980. What do you believe are the most important reasons for this phenomenon? Try asking your friends and family what they think has caused the decline.

4. The article discussed in ¶4.03 classified film lawyers as "good" if viewers of the film or TV show would want that person as a friend because of good character and social skills—*and* if viewers would find that the lawyer was professionally ethical and competent. The lawyer was "bad" if a viewer did not want the lawyer as a friend or if the viewer would regard the lawyer as unethical or incompetent. Using this methodology, how do you classify the lawyers in any movie or TV show (other than *The Verdict*) you have seen that has significant lawyer characters?

5. The text asserts that televised portrayals of lawyers are more favorable than movie portrayals (¶4.04.5). Do you agree or disagree? Give examples.

6. "A particular movie can offer a far more vivid exposure—a greater emotional impact—than does a TV show (or even a TV series)" (¶4.04.5). What are the differences between movies and television (and the experience of watching them) that might account for the greater emotional impact of a movie?

7. "Galvin and Concannon do some very bad things" (¶4.05). How many can you list?

8. Why would a plaintiff's lawyer like Galvin put as little time and money into a case as possible while a defense lawyer like Concannon would put as much time and money into the case as possible (¶4.08)?

9. Choose a movie you have seen other than *The Verdict* and explain in what respects the film fits or does not fit the "classical Hollywood style" or is (or isn't) a melodrama. The movie doesn't have to be a legal story (see ¶¶4.09.2, 3.08.1).

Notes

1. Numerous films of the last twenty-five years or so present highly negative treatment of lawyer characters. Instructors might select *Michael Clayton* (2007), *Changing Lanes* (2002), *The Rainmaker* (1997), *Devil's Advocate* (1997), *The Firm* (1993), or *Body Heat* (1981).

2. For discussions of the book and film, see Bergman & Asimow 2006, 195–99; P. Bergman 2001; Chase 2002, ch. 4; Greenfield, Osborn & Robson 2001, ch. 4.; Weisberg 2000; Mezey & Niles 2005, 153–60; Parker 2006.

3. http://www.gallup.com/poll/1654/honesty-ethics-professions.aspx

4. George Gerbner is generally credited with pioneering cultivation theory (see, generally, Gerbner 2002). For a current update, see Morgan (2009, 223–36). Cultivation theory was and remains controversial, with many theorists questioning its methodology. However, a metadata analysis of many subsequent studies indicates that cultivation theory has held up well (see Shanahan & Morgan 1999, ch. 4, 6; Yanovitzsky & Greene 2009).

5. Despite a great deal of anecdotal evidence, empirical validation of the CSI has proved to be elusive. See Shelton, Kim & Barak 2009; Cole & Dioso-Villa, 2009; Tyler 2006. There may also be a "reverse CSI effect," meaning that when forensic evidence is introduced, the jury gives it more credence than it deserves. Indeed, many forms of forensic evidence (such as hair and fiber analysis) are quite unreliable (Toobin 2007).

6. Similarly, a study by the National Center for State Courts of public opinion of judges indicated that 61.4% considered prime-time TV an importance source of information about judges and 40.5% said the same for daytime simulated courtroom shows like *Judge Judy* (Papke 2007a, 151).

7. For accessible treatments, see Mittell 2010, 363–67; Grossberg et al. 2006, 253–74; Fish 1980, Introduction, ch. 1, and ch. 13–16; Rubin 2009, 147–59; Oliver 2009, 161–77; Morley 1992, ch. 3.

8. http://www.tvb.org/trends/4705

9. See Abel 1989; Heinz & Laumann 1982.

10. Amsterdam & Bruner 2000, ch. 4; Gitlin 2002, 24–31.

11. See Bordwell (1985, xi, 49–53). The distinction between narrative and narration is similar to the distinction often drawn in theoretical work on narratology between fabula (the story) and syuzhet (the plot or the way the story is told).

12. For materials further discussing narration, see D. Black 1999; Bordwell & Thompson 2010, ch. 3; Bordwell, Staiger, & Thompson 1985; Thompson 1999.

13. See Mittell (2010, 220–23).

14. Nothing about the inner life of Perry Mason, for example, was ever disclosed. In more current TV drama, *Law & Order* (Chapter 8) is a good example of objective storytelling. Very little was ever disclosed about the personal lives or emotions of the police or Jack McCoy. However, the trend in contemporary lawyer drama is changing. Legal television shows now employ character arcs that extend over numerous episodes, as in *The Good Wife* or *Suits*. These arcs often involve romantic subplots and disclosure of more information about the inner lives of the characters. *Ally McBeal* carried this trend to a subjective extreme. Most of the screen time was devoted to disclosure of the inner lives of the characters, particularly Ally herself, and relatively little time to the analytical work of law practice (see Asimow 2013).

15. Mittell (2010, 219–20).

The Life of Lawyers

Assigned Film: *Counsellor at Law* (1933)

5.01 Elmer Rice and William Wyler[1]

5.01.1 Elmer Rice

Elmer Rice wrote the stage play *Counsellor-at-Law* (1931) and adapted the play into the 1933 film. Rice (1892–1967) was a prominent, successful, and innovative Jewish American dramatist who worked during the first third of the twentieth century. Born Elmer Reitzenstein, he grew up in poverty in New York, dropped out of high school, then took evening courses at New York Law School from which he graduated in 1912 (he found it extremely boring and mostly read plays during class). While attending law school, he clerked in a Manhattan law office (where a relative of his was a partner). After being dismissed from the firm, he wrote his first play, *On Trial* (1914), which introduced flashbacks to the theater and was a sensational success. This accomplishment enabled Rice to quit his $15 per week job and devote the rest of his working life to the theater. *On Trial* was adapted into one of the first sound films in 1928 and was remade in 1939. He wrote numerous plays about law and lawyers,

Rice was a very inventive dramatist. In *Street Scene* (1929), he recreated the life of a tenement neighborhood, representing its multicultural population with 75 characters. After the complex play was abandoned by its director, Rice directed

it himself, and the play won the Pulitzer Prize. In collaboration with Kurt Weill, Rice adapted *Street Scene* into an opera in 1947. It was made into an excellent 1931 movie directed by King Vidor.

> **Rice and censorship.** A lifelong liberal and champion of the working man, Elmer Rice (along with Clifford Odets, S. N. Behrman, and Lillian Hellman) spoke out about the rise of fascism and wrote several plays focusing on the Nazis and anti-Semitism. He worked as a regional director of the Federal Theater Project, which employed thousands of theater professionals during the Depression, but he resigned in protest over government censorship. The film *Cradle Will Rock* (1999) depicts the struggle between theater professionals and political censorship in the Federal Theater Project. In 1951, Rice withdrew *Counsellor at Law* from a television production as a protest because John Garfield, who was to play the title role, had been blacklisted and the network insisted on replacing him with another actor. The only legal work Rice ever did after being admitted to the New York Bar was to participate in an amicus brief to the U.S. Supreme Court that successfully protested censorship of a movie called *The Miracle* that had been banned in New York as "sacrilegious."

The play *Counsellor-at-Law* (the hyphens were dropped in the movie version) opened in November 1931 with Paul Muni in the role of Simon and was critically and financially successful. It ran for 412 performances on Broadway and sold out a national tour. Muni turned down the role of Simon in the film (he was trying to get away from Jewish roles), so the definitely non-Jewish John Barrymore got the part.

5.01.2 William Wyler[2]

The director of such classics as *The Letter* (1940), *The Little Foxes* (1941), *The Best Years of Our Lives* (1946), and *Ben-Hur* (1959), William Wyler (1902–1981) is one of the most acclaimed directors in film history. Over the course of his 45-year career, Wyler was nominated for Best Director twelve times and won three times.

Wyler was born in the Alsace-Lorraine region of Germany. Carl Laemmle, the president and founder of Universal Pictures, was a cousin of Wyler's mother. In 1920, Wyler's mother arranged with Laemmle to have Wyler shipped off to America

to work for Universal. Wyler started out in the mailroom but worked his way up to the rank of director by 1925. After cutting his teeth on short westerns, Wyler graduated to feature-length films in 1928. *Counsellor at Law* was the most prestigious project of Wyler's career up to that time, and his success in adapting the play elevated him to the top ranks of Universal's directors. Wyler, however, was growing restless with Universal's relatively low budgets, and he left the studio after two more pictures.

Wyler's directorial career entered a new phase when he signed with Samuel Goldwyn in 1935. Goldwyn was one of the leading independent producers of the time. Known for his lavish production values, Goldwyn gave Wyler the opportunity to direct films with budgets far in excess of those he directed at thrifty Universal. During his years with Goldwyn, Wyler established his reputation as a director of literary and theatrical adaptations, including such acclaimed literary and dramatic works as *These Three* (1936; an adaptation of *The Children's Hour*), *Dodsworth* (1936), *Dead End* (1937), and *Wuthering Heights* (1939).

Wyler first worked with cinematographer Greg Toland on the production of *These Three*. This marked the beginning of one of the most productive director-cinematographer collaborations in the history of American film. Toland, who would later photograph *Citizen Kane,* introduced Wyler to deep-focus photography. As discussed in ¶2.07.3, deep-focus cinematography is a way of photographing a scene so that objects and people in both the foreground and background of the frame remain in sharp focus. This allows a director to shoot a scene in a single take instead of cutting back and forth between the various characters. Wyler and Toland brought this technique to perfection in such masterpieces as *The Little Foxes* (1941) and *The Best Years of Our Lives* (1946).

French film critic Andre Bazin regarded Wyler as one of the great realists of American movies. In Bazin's view, instead of predigesting the scene for the viewer by chopping it up into a series of closeups and medium shots that spell out the meaning of every facial expression and hand gesture, Wyler's use of deep-focus cinematography allowed spectators to "edit" the scene for themselves. If spectators wanted to look at a minor character in the background instead of the star in the foreground, they could. Bazin believed that this allowed spectators to take a more active role in the production of the film's meaning.

Counsellor at Law is a relatively early film in Wyler's career. He had not yet signed with Goldwyn or begun collaborating with Toland. Not surprisingly, the film does not display the sort of deep-focus cinematography for which Wyler would later become famous but it is strikingly directed and well worth a close examination (see ¶5.08).

5.02 Lawyer movies of the early 1930s

During the silent film era, there were relatively few lawyer or courtroom movies (it is hard to imagine lawyers being silent). With the arrival of sound in the late 1920s, however, there was a great outpouring of movies in which law and lawyers played prominent parts. Indeed, Nevins (2005) dubs the era of 1928 to 1934 as the "first golden age of juriscinema." The first golden age ended in 1934 with the adoption of the Production Code (see ¶¶2.03, 5.05, 13.03.2, 14.03). The Code required filmmakers to sanitize stories concerning sex and crime. It required that films respect, rather than mock, law enforcement personnel such as police and judges. The result was that few powerful lawyer films were made until the late 1950s, by which time the Code was beginning to fizzle out.

Nevins's article breaks down lawyer movies in the early 1930s into two large categories: First, so-called "women's movies," whose plot revolves around women. These melodramatic films (see ¶3.08 for discussion of melodrama) tended to be slow and emotional and have often been derided as tear-jerkers. They usually featured good lawyers, all of whom were men. Second, "men's movies" featuring stories that focus on men. These films tended to be fast-paced, full of action, unemotional, and cynical about law and lawyers as well as legal and governmental institutions.

A number of the films in the men's movie category were based on the career of William J. Fallon, a notorious New York lawyer who specialized in representing mobsters and other rich clients. Fallon was a master at manipulating juries and would stop at nothing to win his cases. He employed many famous courtroom tricks and was not above bribing jurors. Some of the films inspired by Fallon's career are *State's Attorney, The Mouthpiece, Lawyer Man,* and *Attorney for the Defense,* all released in 1932. Each of these enjoyable films involves tricky, sleazy, shyster lawyers.

Nevins singles out *Counsellor at Law* for extended discussion, much of which forms the basis for this section of the book. Nevins describes it as by far the best lawyer movie of the period. Clearly the film falls into Nevins's second category—it's a man's picture as Nevins defines that category—but the personal and professional characterization of George Simon has far more nuance than any of the other lawyer films he discusses. The film is also free of the gimmicky courtroom sequences typical of other lawyer-oriented men's movies of the period.

5.03 The life of lawyers

Counsellor at Law is unique in the entire history of motion pictures in its grimly realistic depiction of the daily life of the practicing lawyer. Amazingly, the entire

film is set in Simon's office, not in a courtroom, and we are swept up in his daily routine of dealing with clients, staff, family, friends, and other lawyers.

5.03.1 A lawyer's day

George Simon is a gifted trial lawyer, but we never see him in court. At the beginning of the film, we see him basking in the glory of winning an acquittal for the grateful Zedorah Chapman who was almost certainly guilty of murdering her husband. Simon has to repel Chapman's sexual advances—probably a useful skill for lawyers. Here is Simon, the master manipulator of juries in the William J. Fallon tradition.

Consider the variety of legal matters Simon works on in the course of his day. Aside from his own legal and personal problems (which become the focus of the movie), Simon makes a phone call trying to settle the Lillian LaRue breach of promise suit against the Schuyler family. The dispute here involved breach of Schuyler's promise to marry LaRue, a legal claim that has been abolished in most states for reasons that are pretty obvious from the film. There is the Crayfield will contest, which he abandons out of deference to his wife's wishes. He bails Becker out of jail and negotiates a plea bargain that Becker rejects. He lobbies a U.S. senator concerning legislation that affects a business client. He wraps up negotiations in the Richter divorce case. He urges the local political party hack to appoint his partner Tedesco to the bench. Finally, at the end of the film, he gleefully gets involved in another high-profile murder case.

Simon's day consists of juggling numerous client and personal matters. The waiting room is full of people who need to see him. The phone is ringing off the hook. He has a law firm to manage and plenty of personal problems of his own to deal with. He is often multitasking. That is exactly the way most lawyers spend their day. Very few lawyers actually go to court (only prosecutors and public defenders spend most of their days physically trying cases in court). Almost all lawyers spend their days in the office, solving problems for clients, writing or reviewing documents, doing research, and trying to settle cases rather than taking them to court (as Simon does for LaRue, Richter, and Becker). Some of their work such as lobbying public officials does not involve legal disputes at all.

Watching this film, we cannot avoid concluding that a lawyer's work is hectic and sometimes extremely stressful. Indeed, most lawyers say that today the practice of law is even more stressful than in prior years because of advancing technology: e-mail, text messaging, mobile phones, and other methods of instant communication place them at the mercy of their clients 24–7. They must give immediate attention to the client's needs and wishes. In the old days, lawyers

communicated mostly by sending letters, and there was more time to think about problems and to manage conflicting commitments.

Sometimes a lawyer's work is personally distasteful because the clients are themselves sleazy, dishonest people or because the lawyer must try to secure a result that seems unjust or wrong. The lawyer must be harsh, sometimes cruel, toward opponents and people with whom he negotiates, even if he is by nature a kind and considerate person. On this point Simon has a revealing exchange with his wife when she tries to persuade him to give up the Crayfield will contest. Cora says that she does not see "why it isn't possible to practice law like a gentleman." Simon responds that "I never laid any claims to being a gentleman." Obviously, Simon despises Lillian LaRue and Zedorah Chapman and disagrees profoundly with Becker's politics. He is perfectly prepared to fight the Crayfield case, even though it will offend Cora's friends. Lawyers do not have the luxury of being generous to opponents, or acting like "gentlemen," or representing only clients they like or seeking only outcomes that they believe are just and fair. The film also addresses the ever-present problem of balancing a lawyer's personal and professional lives (discussed further in ¶5.04.1)

5.03.2 Lawyers and money

Lawyers must think about money all the time—and not just their client's money but their own. A law firm is a business, above all else, and it must generate revenues to pay the heavy expense of compensating the staff and, of course, to pay the lawyers themselves (obviously Simon is paying himself well). The gorgeous office suite and the huge library are very costly to maintain. These inconvenient details are omitted from almost all movies about lawyers. However, *Counsellor at Law* emphasizes that law is a business, and it often shows Simon sending bills and collecting fees. He occasionally works pro bono (meaning for free), as he did for Becker, but everyone else pays the freight. At first, he tells Rexie to send Mrs. Richter a bill for $5,000 while she is still grateful for his work; later he boosts the fee to $7,500 to compensate for a worthless loan to the deadbeat Darwin (discussed below); and he is extremely reluctant to give up the Crayfield matter, which will yield a $100,000 fee.

Today, if anything, lawyers concentrate even more intently on the business end of their practice (see ¶13.05.4 for discussion of the business and professional models of law practice). Modern-day lawyers in big firms, on average, make much more money (even after adjusting for inflation) than they did in the 1930s and later years, and they must work very hard to get it. One major difference is time sheets. Simon seemed able to set his fees more or less arbitrarily, but today a lawyer must

document and charge for every working minute, including numerous phone calls. If time is used for personal matters—a personal phone call or errand, even a trip to the bathroom—it is not supposed to be charged to clients. Most lawyer's fees are based on the number of billable hours they spend on a matter; many clients scrutinize their bills and require the lawyers to justify every meeting or other use of time. Lawyers often feel enslaved by the endless need to keep track of their time and to justify every dollar of their fees (see 13.05.5 for discussion of billable hours).

Many lawyers say that *To Kill a Mockingbird* inspired them to become lawyers. What effect did *Counsellor at Law* have on you? Did it make you want to become a lawyer, or did it make you want to look for a different career?

5.03.3 Simon & Tedesco

This law firm has two partners and numerous employees:

- Weinberg is an associate lawyer (meaning a paid employee, not a partner like Tedesco). Note that Weinberg is engaging in what we would today describe as sexual harassment of Rexie.
- Secretaries (like Goldie who apparently is Tedesco's secretary and may also be the office manager).
- Paralegals (Rexie is Simon's secretary but she seems to do work well beyond a secretary's competence).
- Bessie, the unforgettable receptionist and switchboard operator (the stage play makes clear that Bessie is pregnant, which explains her "tummy" problems).
- A variety of other clerical employees, messengers, and investigators like Charley McFaddin. There is even a shoe-shine boy.

Thus, a small three-lawyer firm is a good-sized business enterprise. Meeting the payroll requires that the lawyers must generate a constant cash flow from client fees.

In the past, the vast majority of lawyers tended to practice alone or in small firms like Simon & Tedesco. Here the lawyers know each other well and tend to have long-term business and social relationships with each other and with their staff. However, things are very different today. A much smaller percentage of the total bar practices alone or in extremely small firms, although there are still plenty of solos and small firms left. Many lawyers in private practice work in much larger firms and an increasing number work in mega-firms with hundreds or even thousands of lawyers. We discuss law firms in ¶13.05.

In the 1930s, most lawyers were generalists like Simon who seemed prepared to practice every kind of law. Today, most lawyers specialize in only one area of law (although there are plenty of solos like Simon left, especially in smaller towns, who are prepared to help every client who walks through the door).

5.04 The character of George Simon

The film painstakingly develops Simon as a lawyer and as a human being. There is no better defined lawyer character in the entire history of the movies.

5.04.1 Simon as a lawyer

What do we learn about Simon as a lawyer? He is very hard working (his mother and his wife commiserate about how hard he works). Apparently, he seldom goes home to see his wife and stepchildren. Today we would call him a workaholic (plenty of lawyers are). Simon is firmly loyal to his clients (too loyal in the Breitstein matter). He is skillful in handling the clients and winning their trust. This is an absolutely necessary skill for a lawyer. Recall his question to Mrs. Richter about the baby's cough. Although sometimes gruff, he cares deeply about his colleagues in the law firm—recall how he tells Bessie to go home when she doesn't feel well and how he tries to get Tedesco a judicial appointment and Weinberg a job as a judicial clerk.

Simon is a skillful lawyer, as we learn from the Zedorah Chapman matter. He is well connected in the New York and national legal and political establishment. He is pretty ethical most of the time. For example, he turns down an attractive piece of business representing a creditor in a bankruptcy because his partner is the receiver—a serious conflict of interest. However, he does not act ethically all the time, as discussed below. Simon thus exemplifies all aspects of what our society likes—and hates—about lawyers. He is caring, compassionate, loyal, and skillful. Yet he is also tricky, manipulative, greedy, and sometimes dishonest.

Beyond all this, Simon is a lawyer to the very bone. When he discusses his possible disbarment with Tedesco, Simon thinks for a moment that he will just retire and play golf—but only for a moment. "I'd go nuts in six months. How am I going to spend the rest of my life? I'm no golf player, and I don't know an ace from a king. I don't even know how to get drunk. All I know is work. Take work away from me and what am I? . . . a living corpse." These few sentences say it all, and Simon's insight about himself would be valid for a lot of lawyers. They have no meaningful life outside the office. If you told them to "get a life," they wouldn't know what you meant.

5.04.2 Simon as a human being

As a human being, Simon is much less successful than he is as a lawyer. Lawyers must find a way to keep their professional and personal lives in balance, and Simon has clearly failed to do so.

He is loyal to his old friends from the East Side (like Mrs. Becker) and he adores his mother, although he is fed up with his nogoodnick brother. Even so, he seems to lack normal human perception and emotions. He is oblivious to the fact that Rexie is madly in love with him. He doesn't realize that his marriage is falling apart and he seems to barely know his stepchildren (who despise him). When he finally catches on to Cora's affair with Darwin, his reaction is immature: He is about to throw himself out the window. Rexie saves him, and Simon is brought back to life by an exciting new client matter, which reveals a lot about the imbalance in his life between the personal and the professional. Today, lawyers (especially in big firms) find it difficult to have any meaningful personal life. They are required to meet billable hour requirements that keep them in the office, on average, ten hours a day, six days a week (and sometimes much more; see ¶13.05.5).

5.05 Religion, ethnicity, and class in *Counsellor at Law*

The film is loaded with conflicts arising out of religion, ethnicity, and class. For this reason, the film would have been significantly altered if it had been made after the Production Code Administration came into force in 1934 and regulated the content of all American films (see ¶5.02 as well as ¶¶2.03, 13.03.2, 14.03). Breen did not allow exploration of themes relating to religious or ethnic conflict or class struggle. In addition, Simon got away with a serious ethical lapse (as well as extortion), and Breen would not have allowed that either. Cora seemingly got away with her adultery and that also was not permitted.

5.05.1 Religion and ethnicity

Simon is clearly Jewish, even though played by a non-Jewish actor and though the film never explicitly says so. His mother is a stereotyped yiddische momma, and he occasionally drops Yiddish words (such as "gonif" meaning thief). Malone says "sholem aleichem" to Simon as he leaves (meaning "peace be with you" in Yiddish). The DVD jacket identifies Simon's "working class (Jewish) background." The stage play is more explicit about Simon's religion. Weinberg's ethnicity is more obvious than Simon's.

Hollywood moguls, who were mostly Jewish, tried to avoid the subject of anti-Semitism in the movies. They wished to avoid drawing attention to themselves and they wanted to avoid alienating a predominantly non-Jewish and often anti-Semitic audience (Gabler 1989). In addition, Germany was a prime export market for American films; by the mid-1930s, the German censors would not allow distribution of a film favorable to Jews (Gabler 1989). This reluctance to confront Jewish themes continued even into the post-World War II period. Samberg (2000) claims that the various Jewish film executives tried to dissuade the non-Jewish Darryl Zanuck from making *Gentleman's Agreement* (1947) the all-time leading film on anti-Semitism because it would "rock the boat." Thus, it is hardly surprising that the film only suggests that Simon is Jewish but never makes it explicit.

Simon clawed his way upward from the very dregs of society. He came from the old country in steerage (the packed below-decks section of a ship) and grew up on the lower east side of New York. Now he has achieved great success and even a tentative entry into upper class society. Simon is neither the first nor the last person for whom the law has served as a vehicle of upward mobility. Nevertheless, Simon remains an outsider to the New York legal establishment, which is controlled by people like Baird. Even though married to the socially prominent Cora, Simon remains a social interloper, and the power structure is delighted to seize on the Breitstein case in order to take down an upstart Jew.

Indeed, in the 1930s, and for many years thereafter, anti-Semitism was taken for granted in the world of legal education and law practice and in society generally. In the play, for example, Lillian LaRue complains that Schuyler's lawyer is trying to "Jew me down a few thousand dollars after all the pearls and Rolls-Royces he was goin' to buy me." Law schools had Jewish quotas. Jewish lawyers were respected for their skills and tolerated in areas like personal injury practice but were never hired by big city firms (on Wall Street or elsewhere) or by wealthy business clients. (See also the discussion of Jewish lawyers in popular culture in ¶5.06.)

The film is full of references to ethnic conflict. In addition to Jews, we see people from numerous immigrant groups—Irish, Italians, and Germans—all of them unified in despising WASPy people like Baird (the ill-feeling was, of course, entirely mutual). As Malone says, "Those guys who came over on the Mayflower don't like to see the boys from Second Avenue sitting in the high places."

5.05.2 The Depression

The film is set in 1931, the very darkest days of the Great Depression, which began with the stock market crash in October 1929 and continued all through the

1930s, until the American entry into World War II at the end of 1941. Today, we can hardly imagine the absolute chaos and desperation of this period. Unemployment reached about 25%, and businesses and banks failed by the thousands. There was no deposit insurance, so depositors were wiped out when their bank failed. The stock market plummeted by over 90% from its peak. Prices and wages fell steadily. Millions of people lost their homes, their farms, everything they owned. Hunger and misery stalked the land.

The Depression was a time of intense economic and political conflict. Many desperate people (like Becker) turned to communism and preached revolution. Others turned to fascism and embraced the philosophy of Mussolini, which seemed to be working in Italy. America did neither; instead, it elected Franklin D. Roosevelt during the dark days of 1932. Roosevelt's New Deal involved new systems of government regulation of the economy and help for the neediest. It seemed to offer a way out of the misery without embracing some totalitarian ideology.

NIRA. Note the "blue eagle" sign that pops up before the titles of *Counsellor at Law*. It denotes that the filmmakers were complying with the code set out for the movie industry under the National Industrial Recovery Act (NIRA). NIRA was an early New Deal measure that provided authority for government officials to reorganize the entire economy. Under NIRA, committees of business and labor for each industry were empowered to adopt codes that set wages and prices for that industry as well as all manner of other rules. NIRA was far too ambitious and quickly dissolved into chaos. It was invalidated by the Supreme Court (*Schechter Poultry Co. v. United States*, 1935). *Schechter Poultry* is often referred to as the "sick chicken" case because the code in question required retail poultry sellers to take every chicken offered to them by wholesalers even if the chickens were sick.

Amidst this period of economic catastrophe, some people did well, the law firm of Simon & Tedesco among them. The firm appears to be prosperous and earning high returns for its partners. However, now and then we glimpse the desperation in the world outside the posh law office. Bessie is distraught because she has seen someone leap from an office window. Indeed, there were countless suicides during the Depression; many people simply couldn't cope with the economic disaster that engulfed them and their families. Often these suicides were people who had

been rich and prosperous—and were then wiped out in a flash. Darwin hits up Simon for a $2,000 "loan" because a company whose stock he owned omitted its dividend. Thus, even members of the idle rich were feeling the pain. Simon's brother is so desperate that his mother has to beg Simon for a handout.

5.05.3 Class

Class struggle is also a major theme in the film, as it was in many films of the early Depression years, particularly before the Production Code became enforceable in 1934 and muted political controversy in the movies. Among many such films is *Employees' Entrance* (1933), involving the brutal management of an exclusive department store and the helpless women who worked as shop girls and were subject to exploitation and sexual harassment. In the memorable *Wild Boys of the Road* (1933), four boys hit the road looking for work and encounter every manner of brutality and repression from the ruling classes and the police.[3]

Class struggle is a major element of *Counsellor at Law*. George Simon is the epitome of American class mobility; he has risen from the lowest classes of society to the highest. His mother, who remains firmly moored in the lower class, is forced to beg him for a few dollars to support his wretched brother, who reminds Simon of everything about the lower classes and the struggle for survival he has tried to leave behind.

> **Simon and Becker**. The brilliant scene between Simon and Harry Becker dramatized the intense class conflicts that pervade the film. Simon is having his shoes shined when Becker comes into the office, his head bandaged from blows struck by the cops during a demonstration. Becker, a rabble-rousing communist, scorns Simon's help, saying "I'm on one side of the class war and you're on the other." When Simon debunks Becker's "half-baked communist bull" and reminds Becker of how he (Simon) has risen from the gutter, Becker replies: "How did you get where you are? I'll tell you! By betraying your own class, that's how! Getting in right with bourgeois politicians and crooked corporations that feed on the blood and the sweat of the workers. . . . You're a renegade and a cheap prostitute, that's what you are! You and your cars and your country estate and your kept parasite of a wife . . . and her two pampered brats! Comrade Simon of the working classes,

who's rolling in wealth and luxury while millions of his brothers starve. You dirty traitor, you." (He spits on Simon's desk and walks out.)

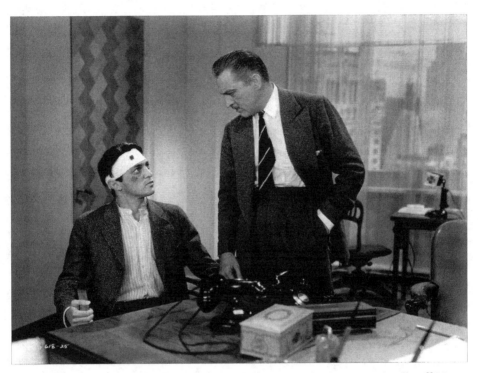

Figure 5.1. *COUNSELLOR AT LAW*: George Simon (John Barrymore) tells off Harry Becker (Vincent Sherman). Universal Pictures/Photofest. © Universal Pictures.]

5.06 Jewish lawyers in popular culture [4]

George Simon is one of many Jewish lawyers in popular culture. These representations demonstrate persistent stereotypes. The stereotype of the Jew as both more clever and more greedy than other men dates back to Genesis. In one verse, the king of the Philistines drives Isaac out of the kingdom because he has become too rich. In England, France, and Germany, Jews were allowed to work as moneylenders

(because the restrictions on usury prevented Christians from doing this work) but were barred from carrying on other careers. They were both respected and despised. In popular culture, Sir Walter Scott's *Ivanhoe* is a gripping critique of medieval anti-Semitism; two key characters are a Jewish moneylender and his daughter. Shakespeare's *Merchant of Venice* focuses on Shylock, a clever but vengeful and greedy moneylender. In Dickens' *Oliver Twist,* the Jew Fagin runs a gang of pick-pockets consisting of orphaned boys. George Eliot's *Daniel Deronda* memorably portrays British anti-Semitism during Victorian times; the protagonist is an intelligent and charming English gentleman who is studying law and learns that he was born a Jew.

George Simon exemplifies the stereotype of Jews in general and Jewish lawyers in particular. This stereotype is double-sided. The positive side is that the Jews and Jewish lawyers are well educated, crafty, clever, and loyal. The negative side is that they are greedy, exploitative, and manipulative. As in the case and Simon's case as well, the positive side of this stereotype is dangerous to the Jews; it breeds resentment and anti-Semitism. A famous episode of Norman Lear's *All in the Family* (Jan. 26, 1971) pushed this stereotype to the limit (as the show did with every taboo and stereotype). Archie Bunker, an unabashed bigot and anti-Semite, is injured in a car accident with a Jewish woman and insists on hiring a Jewish lawyer since they are smarter than gentile lawyers. He calls the firm of Rabinowitz, Rabinowitz, and Rabinowitz, but when they send him a waspy lawyer (Whitney Fitzroy IV), he throws the guy out and demands a real Jewish lawyer. When Sol Rabinowitz finally arrives, he is an older man with a classic Jewish face and glasses. Bunker, who detests Jews and all other minorities, fawns over his Jewish lawyer.

Tony Soprano, star of *The Sopranos,* also had a Jewish lawyer, Neil Mink. Mink was a trusted adviser who kept Tony's secrets. Tony relied on Mink to hold a bagful of cash and dispense it to Carmela Soprano if Tony had to disappear for a while. Also important in the series was the character of Hesh, an older Jewish friend and adviser to Tony and his father. Hesh is not a lawyer but a successful and wealthy businessman. The character of Hesh embodies traditional Jewish stereotypes—smart, crafty, nonviolent, trustworthy, protected by the power structure but not actually part of that structure. Stuart Markowitz, the Jewish tax lawyer on *L.A. Law,* fit the stereotype because he was shrewd and good with numbers, but he was less mercenary and more principled than some of the other lawyers at the firm. Jewish senior partners in the films *Changing Lanes* (2002) and *Michael Clayton* (2007), both of whom were played by director Sydney Pollack, were greedy and unethical.

5.07 Ethical issues in *Counsellor at Law*

The film is full of important and difficult ethical issues.

5.07.1 The stock tip

Simon receives a tip, apparently from someone inside the U.S. Supreme Court, that the Court is about to decide a case in a way that will benefit a particular company. He immediately buys shares in that company for himself and Tedesco. His conduct indicates that he is uncomfortable doing this and worried about getting caught. He swears Tedesco to secrecy and tells his broker to purchase the stock a little at a time (this might also have been intended to avoid driving up the price of the stock). When the news comes out, Simon sells the stock, earning a $40,000 profit for himself and Tedesco.

> **Price levels**. Note the difference in price levels between 1931 and the present: $100 in 1931 is worth about $1430 in 2012. Thus, the $40,000 profit on the stock tip was worth over half a million dollars based on today's prices. The $100,000 fee in the Crayfield will case, which Simon turned down because of Cora's objections, was worth about $1.4 million in present-day dollars.

Was Simon's action illegal? Present law prohibits the use of inside information about stocks that is passed on by a "tipper" (like Simon's source in the Supreme Court) to a "tippee" (like Simon). If the tippee knows or should know that the tipper has breached a legal duty by disclosing the information, the tippee cannot take advantage of the information by buying or selling the stock. In the film, someone at the Supreme Court has breached a legal duty by disclosing the information (Simon would surely know that Supreme Court employees are sworn to secrecy). If either the tipper or the tippee makes use of the information by dealing in the stock, he violates Rule 10b-5 of the Securities and Exchange Commission (SEC). Thus, today Simon's conduct would be clearly illegal. If caught, he would have to give up his profit, pay heavy penalties, and could even go to jail. His conduct would probably also be the basis for discipline by the bar association.

However, things were different in 1931. The legal and ethical question of whether it was proper to use inside information to make money in the stock market was not settled. In fact, there were no federal securities laws until 1933 and 1934

(Rule 10b-5 is based on a section of the 1934 Securities Exchange Act). Even under Rule 10b-5, it was unclear until recently whether a tipping situation like the one in the film, which does not involve a tip from a corporate insider, was a violation of the Rule.

Thus, Simon probably did not violate the law or legal ethics by using the tip to make money in 1931. However, there were many corporate scandals in the 1920s involving the use of inside information and millions of people blamed Wall Street excesses for the Great Depression. Thus, the movie reflects popular culture at the time in giving the impression that Simon's conduct was wrong and unethical.

> **The 1919 Supreme Court scandal.** The stock trading episode in *Counsellor at Law* was probably inspired by a real case occurring in 1919. A Supreme Court law clerk named Ashton Fox Embry leaked information about pending Supreme Court decisions to businessmen who profited from the information. Embry was fired from his job at the Court and criminally prosecuted but, for various reasons, was never tried and convicted. Owens (2000) provides a detailed account.

5.07.2 The Richter fee

Simon was planning to bill Mrs. Richter for $5,000 for services rendered in the divorce case. Her retainer had been $2,500, but Simon told Rexie to bill $5,000 while she was still grateful for the work. A "retainer," incidentally, is an amount paid in advance by the client. Normally, if the lawyer's work turns out to be worth less than the retainer, the difference will be refunded to the client; if the work is worth more than the retainer, the client will pay the difference.

After shelling out $2000 to Darwin, Simon increases Mrs. Richter's fee to $7,500 (remember, that's over $100,000 in present dollars). As stated above, Simon apparently had no fee arrangement with Mrs. Richter and was accustomed to billing whatever he thought his services were worth (lawyers seldom get away with this today, as discussed in ¶5.03.2).

Was it unethical to increase the fee from $5,000 to $7,500? Under the Canons of Professional Responsibility that were in effect in the 1930s, "Lawyers should avoid charges which overestimate their advice and services, as well as those which undervalue them. A client's ability to pay cannot justify a charge in excess of the

value of the services. . . .In fixing fees, it should never be forgotten that the profession is a branch of the administration of justice and not a mere money-getting trade" (Canon 12).

Certainly, we suspect that Simon is "overestimating" the value of his services and charging the high fee because of the client's "ability to pay." After all, the Richter divorce wasn't tried; Simon settled the dispute by negotiating the issues of property division, alimony, and child support with the husband's lawyer. It is hard to imagine how a fee of over $100,000 in current dollars could possibly be justified for these services unless Simon did a great deal more work than we know about. However, lawyers often charge affluent clients high fees in order to be able to provide low cost or even free services for clients who are unable to pay. Thus, what Simon did here is probably not so different from what many attorneys do in setting their fees.

The current rule, Model Rule 1.5, contains no statement equivalent to the last sentence of Canon 12 (in fixing fees, it should not be forgotten "that the profession . . . is not a mere money-getting trade"). Such a statement would be viewed as hypocritical in light of the prevalence of the business, profit-seeking model that now animates the profession (see ¶13.05.4).

Present-day Model Rule 1.5 states, "A lawyer's fee shall be reasonable" (ABA 2003). It then sets out a series of factors to be used in establishing reasonableness. It also provides: "When the lawyer has not regularly represented the client, the basis or rate of the fee shall be communicated to the client, preferably in writing, before or within a reasonable time after commencing the representation." This latter provision is extremely important in avoiding fee disputes. Lawyers and clients must discuss the fee in advance of doing the work. Had Simon and Mrs. Richter agreed in advance on the amount of the fee, Simon could not have arbitrarily boosted the amount. In some states (including California), a lawyer cannot collect the agreed-upon fee unless the fee agreement is reduced to writing and signed by both parties. (If there is no signed agreement, the lawyer is entitled to receive the value of his services, which might be much less than the agreed-on fee.)

5.07.3 Perjury in the Breitstein case

In the Breitstein criminal case, Simon introduced evidence of a phony alibi for Breitstein (who otherwise faced a long prison sentence because he had four prior convictions). Breitstein claimed he was at Cushman's home, but this was untrue (Cushman was in the hospital that day). Apparently Simon was well aware that the alibi was false. Putting on testimony that the lawyer knows is false is a serious eth-

ical violation and would justify severe sanctions by the Bar—possibly even disbarment. Loyalty to the client is no excuse for deceiving the court.

Present Model Rule 3.3(a)(4) is quite clear on this point: "A lawyer shall not knowingly . . . offer evidence that the lawyer knows to be false." Normally, when a lawyer knows (not just suspects but actually knows) that the client intends to commit perjury, the lawyer must try to persuade the client not to do it and, if this is unsuccessful, must withdraw from the representation. If withdrawal is not possible (because the case is too far along), and the client insists on giving perjured testimony, the Model Rules make clear that the lawyer must refuse to introduce the testimony. If the lawyer learns that perjured testimony has already been admitted, the lawyer must disclose that fact to the judge. In some states, the lawyer may allow the client in a criminal case to tell the false story in narrative form without guidance from the lawyer's questioning. (This is a clear tip-off to the prosecutor and the court that the attorney knows the narrative is false.) The lawyer is then forbidden to rely on that false narrative testimony in closing argument (see further discussion in ¶7.07).

In trying to block the Bar Association from disbarring him, Simon resorts to even more unethical, probably criminal behavior. He threatens the stuffed shirt Baird with disclosure of the fact that Baird has a hidden wife (apparently bigamous) and secret family in Philadelphia. This threat would be considered criminal extortion in most states. Extortion means obtaining property or obtaining the official act of a public officer (such as Baird who is representing the Bar Association), induced by a wrongful use of force or fear. Fear, for this purpose, involves a threat to "expose any secret" affecting the recipient. In addition, since Baird would be a witness against Simon in any subsequent proceeding by the Bar, Simon is also guilty of witness tampering and obstruction of justice. Commission of serious crimes such as extortion, witness tampering, or obstruction of justice, would itself be the basis for severe discipline, up to and including disbarment.

5.08 Composition in *Counsellor at Law*

In *Counsellor at Law,* Wyler arrays his actors so as to create multiple planes of action (meaning that several different things are happening simultaneously within the frame). He sometimes uses this technique to suggest bustle and activity. At other times, he uses it to imply the interpersonal dynamics between characters.

A striking example of the use of multiple planes of action to create the impression of bustle occurs early in the film when Mr. Moretti arrives. The camera is fac-

ing Bessie, the telephone operator, when Moretti enters the frame from the left. A conversation between Bessie and Moretti ensues. Moretti is in the center of the frame, Bessie on the left. As Moretti and Bessie converse, Henry crosses the frame behind them. On the right in the background is a woman sitting on a sofa. She plays no role in the shot. Her presence serves merely to fill screen space; Wyler is making it seem as if there is something happening in all corners of the frame.

When Moretti finishes talking with Bessie, he begins walking to his right and the camera pans with him. A previously unseen man on the right side of the frame gets up to greet Moretti. As they converse in Italian in the center of the frame, someone exits Tedesco's office, which is visible behind Moretti and the other man. Henry can be seen on the right side of the frame sorting the mail, though he plays no narrative role in the shot. Rather, Wyler uses these characters to suggest how busy and crammed with people the office is.

> **Multiple planes of action—The Becker meeting**. A memorable example of multiple planes of action to suggest the dynamics between characters occurs when Becker meets Simon in his office. Becker's profile dominates the left side of the frame in the foreground while Simon occupies the center of the frame and Joe, the shoeshine man, is barely visible on the bottom of the far right side of the frame. In this one image, Wyler nicely conveys the interpersonal dynamics of the scene. Because Simon is having his shoes shined, he is turned away from Becker. While he occasionally turns around to talk to Becker, Simon betrays his lack of interest in Becker's case by facing away. Moreover, although Simon is ostensibly the person of power in the scene, it is Becker who dominates it visually. Because he is placed in the foreground and on the left side of the frame, our eyes are constantly drawn back to his haunting countenance. By composing the shot in this way, Wyler is able to convey on a visual level the moral force of Becker's convictions and how heavily his words weigh on Simon.

5.09 Review questions

1. In ¶4.03, the text suggests distinguishing "good" from "bad" lawyers by asking whether we would want a lawyer character as our friend. It

also asks whether the public would regard the lawyer as competent and ethical. How would you classify George Simon under these two tests?

2. *Counsellor at Law* is packed with interesting signifiers (see ¶1.05.2). Identify a signifier in the dialogue, art design, costumes, or events of the film. Explain your interpretation of the signifier.

3. Does the movie make you want to become a lawyer, or does it make you want to avoid the profession at all costs? Explain.

4. Note the large number of personal relationships described in *Counsellor at Law.* Simon has relationships with his wife and her children and her friends, with his mother and brother, with lawyers and staff members at Simon & Tedesco, with numerous present and former clients, and with lawyers outside the firm. Which relationship did you find most interesting? Why?

5. Becker was harshly critical of Simon. Do you agree with his criticisms of Simon? Why or why not?

6. Most professionals or other business people are free to set the price for their services at whatever the market will bear and to charge gullible consumers unreasonably high fees. Should lawyers be prohibited from charging clients unreasonable fees (see ¶5.07.2)? Why or why not?

7. What should Simon have done when he discovered that Breitstein planned to testify to a phony alibi in his criminal case (¶5.07.3)?

8. Please discuss an example of William Wyler's direction of *Counsellor at Law* that you found interesting. You can cover art direction, sound, editing, cinematography, multiple planes of action (¶5.08), acting, or any other technical aspect of the film.

Notes

1. See Jonakait 2007. The stage play of *Counsellor-at-Law* can be found in Schiff (1995), which also contains biographical material.
2. See Herman 1995, 114–19.
3. For discussion of films showing Depression life, see Doherty 1999, ch. 3.
4. On Jewish characters in film, see Kellerman 2009; Friedman 1987; Levinson 1993; Pearce 1993; & Hornblass 1993. This section is based on Feldman 2001.

6

Legal Education

Assigned Film: *The Paper Chase* (1973)[1]

6.01 U.S. legal education

6.01.1 U.S. law school is graduate school

American and Canadian legal education is a *graduate* program (meaning that law students have already received an undergraduate degree). It lasts three years, but at part-time or night law schools it may take four or five years to graduate. After graduating from law school and passing the bar examination, U.S. lawyers can practice law on their own or as employee of a law firm or a government agency (such as a prosecutorial agency or as a public defender). No form of apprenticeship is required. In most other countries, law is an *undergraduate* major. Most students who graduate with a law degree in countries other than the United States and Canada never practice law. In order to practice law in those countries, students generally must complete some form of postgraduate training (sometimes provided by bar associations) and must apprentice with practicing lawyers.

6.01.2 Harvard Law School

Harvard Law School is depicted in *The Paper Chase* as well as in several other movies including *Legally Blonde* (2001), *Just Cause* (1995), *Reversal of Fortune*

(1990), and *Soul Man* (1986). Harvard is one of the most prestigious American law schools, always ranking within the top three in the *U.S. News and World Report* rankings (see ¶6.04.2 for discussion of the rankings).

It is difficult to get into an elite law school like Harvard. For the class entering in 2011, 7,574 people applied for admission; 833 were offered admission and 561 actually enrolled. Admittees have very high undergraduate grades and scores on the Law School Admissions Test (LSAT). In the class entering Harvard in 2011, the median undergraduate GPA was 3.89 (4.0 is a straight A average). Its median LSAT score was 173 (a perfect score is 180). The numbers at Yale (ranked as the top law school by *U.S. News*) were even higher but the school enrolled only 205 students (American Bar Association & Law School Admission Council 2012).

6.01.3 The Paper Chase *and 1L—The movies and the books*

The Paper Chase was adapted from a novel written by John Jay Osborn in 1971, which was based on his experience as a Harvard Law student during the late 1960s. James Bridges was nominated for an Oscar for his adaptation of Osborn's book and John Houseman won an Oscar as best supporting actor. *The Paper Chase* lived on as a network television series that ran for one year (1978–79) and several years on cable (1983–86). The first two seasons are currently available on DVD. Houseman continued in the Kingsfield role on TV, but James Stephens instead of Timothy Bottoms played Hart. Houseman died in 1988. Another excellent book about Harvard Law School, also written from a student's point of view, is *One L* by Scott Turow (1977). Turow's book is based on the journal he kept while enduring the first year.[2]

6.01.4 The Paper Chase—*See it before you go to law school?*

Some people think that every first-year law student should see *The Paper Chase* before starting law school. One of the authors of *Brush with the Law* (Marquart & Byrnes 2001, 22, 64) claims that *Paper Chase* (which he saw at least a dozen times) influenced him to go to law school and got him through the first day.

Legal education today is different from the world we see in *The Paper Chase* or *One L,* so different that these books and films may now be useless as a guide to aspiring law students. Those differences will be one of the themes sounded in this chapter. One superficial difference is how people dress; it would be a bit startling to see anyone wearing a jacket and tie (especially a bow tie) in today's law school classroom (except on job interview days).

One thing that has not changed much from the days of *The Paper Chase* to the present is the required first year curriculum. All, or virtually all, of the courses a first-year law student takes are prescribed. At most schools, there are no elective courses in the first year. One of the required courses is always Contract Law, the course taught by Professor Kingsfield. As in the film, first year classes are typically quite large (often between 75 and 150 students). Many schools have at least one small section during the first year so students can experience a more intimate teaching and learning environment. Harvard, however, has yet to institute small sections.

Hawkins v. McGee. On Hart's first day at Harvard, Kingsfield cold-called him from the seating chart and asked him to recite the facts and analyze the holding of *Hawkins v. McGee. Hawkins,* the famous hairy-hand case, was decided by the Supreme Court of New Hampshire in 1929. Hart was completely unprepared (he didn't know that first-day assignments are posted in advance), but Kingsfield continued to grill him about the case. This is a time-wasting and abusive teaching technique; Kingsfield should have moved on to somebody who was prepared.

Hawkins was a lawsuit by a patient against a doctor based on medical malpractice. Malpractice is normally studied (along with other harm-causing negligent behavior) in the course on torts rather than contracts. However, in this case the doctor stated: "I will guarantee to make the hand a hundred per cent perfect hand." This promise created a contract. Doctors don't normally guarantee the results of medical procedures—and this case shows one good reason why they shouldn't.

The problem in the case was the *remedy*—the measure of plaintiff's damages. Remedies in torts and contracts are not the same. In contracts, the remedy is normally "the benefit of the bargain," meaning the value of what was promised. To award plaintiff the benefit of his bargain, the court decided that the measure of damages was the value of a perfect hand less the value of the hairy hand after the surgery. Obviously, setting monetary values on perfect and on damaged hands is quite subjective, leaving a great deal of discretion for the jury. Hart guessed that the measure of damages would be the much smaller amount representing the difference between the value of the burned hand before the surgery and the hairy hand after the surgery. That was a good guess, but not what

the court said. The case is still included in some contract-law case-books and thus is taught in some first-year contract law classes.

6.02 The Socratic method[3]

Kingsfield employs what is often referred to as the "Socratic method." Based on Kingsfield's classroom style, what are the elements of the Socratic method?

Why doesn't Kingsfield give a lecture about contract law in which he lays out the rules relating to remedies for breach of contract (rather than questioning students about *Hawkins*)? Why aren't the students assigned to read a book that sets forth the rules of contract law instead of a bunch of confusing old opinions by appellate courts? Why does Kingsfield call on students from a seating chart and fire questions at them? Why doesn't he rely on volunteers instead? Why doesn't he give the answers to his questions? Why does he berate the students? It is safe to say that the extreme version of the Socratic method depicted in the film is seldom used in law schools today and that very few if any professors now berate their students.

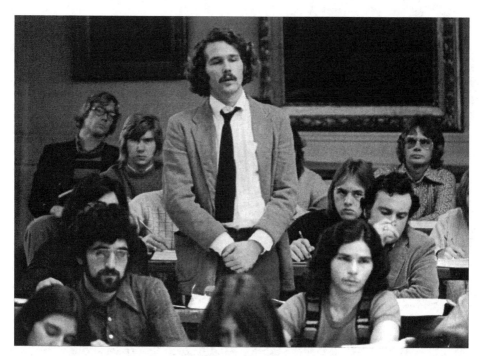

Figure 6.1. *THE PAPER CHASE*. Hart (Timothy Bottoms) doesn't have a clue when called on in class. 20th Century Fox/Jagarts/Photofest. ©20th Century Fox.

6.02.1 In defense of the Socratic method

Some legal academics support the Socratic method. Michael Vitiello, for example, defends Kingsfield's teaching methods and criticizes the kinder, gentler approaches that are now common in law school classrooms (Vitiello 2005). He thinks that the Socratic method is an effective way to teach students analytical skills that are essential for all practicing lawyers. He believes that the fear of being called on motivates students to spend more time preparing for class than they would otherwise and that they therefore learn more. He also thinks Socratic questioning is valuable preparation for the harshness of law practice.

In a gentler law school, students who bruise easily will not have training in how to deal with the inevitable frustrations of practice, including the reality that they will face judges and opponents who care little about their feelings and whose conduct will be confrontational. "My point is simply that law schools today run a far greater risk of creating too gentle an environment rather than creating too rigorous an environment." (2005, 985–86)

In *The Lost Lawyer* (1993), Anthony Kronman, a former dean of Yale Law School, offers a more tentative defense of the Socratic method (which he refers to as the "case method"). Kronman does not defend Kingsfield's bullying tactics, but he values heavy reliance on critical study of appellate court opinions. Appellate opinions are efficient teaching vehicles because they state concisely the facts of the dispute and the applicable legal principles. Kronman thinks that class time is best spent on tough boundary problems (meaning that the law is unsettled and good arguments can be made on both sides) rather than on well-settled applications of the law. Appellate opinions are better than textbooks for focusing on this type of problem. Concentration on gray areas provides excellent training for practicing lawyers who often apply unsettled law to the complex, real-life dilemmas of their clients.

In addition, Kronman claims that the case method forces students to see legal problems from many different perspectives—not just the one the student favors. In law practice, a lawyer may not personally believe in the arguments that favor a client but must make those arguments. Gradually, this habit becomes habitual and is a part of what is often referred to as "thinking like a lawyer." Kronman concludes (1993, 114–15):

> The effort to entertain unfamiliar and disagreeable positions may at first cause some awkwardness and pain. But in time it increases a person's powers of empathic understanding and relaxes the boundaries that initially restrict his sympathies to what he knows and likes....Some students find this experience disturbing and complain that the case method, which makes every position respectable, undermines their sense of integrity and personal

self-worth....This experience, which law students sometimes describe, not inappropriately, as the experience of losing one's soul, strongly suggests that the process of legal education does more than impart knowledge and promote new perceptual habits.

6.02.2 Origins of the Socratic method—And its future

The "Socratic method" is based on the technique Socrates used to teach his disciples. He engaged in a question-and-answer dialogue with them without ever furnishing answers (or perhaps without knowing the answers himself). The Socratic method was developed by Christopher Columbus Langdell, who became Dean at Harvard in 1870. Langdell believed that law was a science, like a natural science, and obeyed the laws of logic. Legal principles could be logically derived by studying actual legal cases, just as a scientist derives the laws of physics from studying empirical phenomena. The Socratic method was intended to force students to come up with those principles through logical analysis.

Few people believe this Langdellian notion today. Oliver Wendell Holmes (1881) observed that the life of the law is not logic but experience. The school of legal philosophy called "legal realism" effectively demolished the idea that legal principles and their application could be derived logically and were based on immutable principles. Instead, the realists proclaimed that law is what judges actually do. What judges do is often not what the formal law in statutes and precedents would seem to require. Indeed, the realists pointed out that many legal principles are open-ended enough to allow judges to do pretty much as they please in deciding individual cases. Despite legal realism, however, the Socratic method (or some version thereof) remains the primary method of first-year law school instruction because it can be used to show the law's indeterminacy as well to show that law is logical.

More practically, the Socratic method is efficient. It allows a single professor to teach a large class but without lecturing. Supposedly, everyone in the room is mentally engaged in the dialogue the professor is carrying on with a single student, so teachers can pretend that they are teaching the whole class rather than the student whom they are questioning. Moreover, the high ratio of students to faculty makes legal education cheaper for law schools than other forms of graduate education or tutorial systems like those employed in British universities. It also frees up the faculty to do other work such as scholarly research by minimizing their face-time with students. The same efficiency arguments justify the examination system—one final exam per course, no written assignments, no midterms. Again, this enables a small faculty to teach large classes without having to waste too much time grading homework or exams. The stressful nature of this one-exam system is well illustrated by *The Paper Chase*.

There are probably as many teaching styles as there are law teachers. Some instructors call on students but move quickly to a class discussion after asking a couple of questions. Others continue to focus on appellate cases but do so mostly through lecture and class discussions. Other instructors have abandoned the case method partially or entirely and teach from problems. Still others make use of small groups to work together on a problem or role-play exercises. Kerr (1999) found that only five of twelve Harvard professors teaching in the first year use even a watered-down version of the Socratic method.

6.02.3 Calling on students

Does Vitiello offer a persuasive justification for cold-calling students and firing questions at them without providing the answers to the questions? Would it be better to have a discussion about appellate cases but rely on volunteers? And what's wrong with lecturing?

6.02.4 Kingsfieldism

Kingsfield has become the symbol for the bullying approach to the Socratic method that Vitiello defends but Kronman does not. In past years, law professors like Kingsfield routinely berated and humiliated students in front of the class if they were unprepared or confused. This part of Socratic teaching has largely (though not entirely) passed into history. Today, most law professors conduct their dialogues with students with tact and consideration, recognizing the vast gulf in knowledge and power between teacher and student and the stressfulness of being called on in front of the class. Most law teachers disagree with Vitiello and believe that no valid pedagogic purpose is served by hazing students. Thus, someone watching *The Paper Chase* would be badly misinformed about what happens in law school classrooms today. Nevertheless, even when it is handled with the utmost tact, Socratic questioning can be embarrassing or even traumatic for students who are unprepared, panicky, or who just don't get it.

6.02.5 Teaching professional skills

All of the classes that the 1Ls in *The Paper Chase* took were doing essentially the same thing—teaching students to analyze cases for the purposes of learning and applying legal doctrines. Traditionally, classes after the first year did much the same thing.

The purpose of the Socratic method is to teach the skill of legal analysis. This means first figuring out legal principles from decided cases, then applying those principles to different but related problems. Analyzing appellate cases is important, to be sure, but it is far from the only skill (and not the most important skill) necessary to practice law at a high level. Indeed, concentrating solely on appellate cases ignores statutes and administrative regulations, even though these are generally more important in practice than case law.

Students come to law school to learn how to practice a profession and make a decent living by doing so. That profession is devoted to helping clients to solve their legal problems. Yet in the *Paper Chase* era, Harvard seems to be doing little or nothing to train its students how to function as lawyers. Medical students come quickly into contact with patients during med school, but law students in Hart's era at Harvard (late 1960s) never saw a client or learned much of anything about how to help them.

Other vital skills of successful law practice include problem solving, drafting legal documents, negotiation, fact investigation, interviewing, or trial tactics. Law school teachers never discussed how a lawyer actually makes a profit from law practice, for example, by attracting clients, getting the clients to trust the lawyer, counseling clients about how to avoid problems, and setting and collecting fees. They never discussed legal ethics, even though law practice presents lawyers with constant ethical dilemmas. There was no attempt to impart professional values, such as a lawyer's obligation to provide free services for those in need.

American legal education has been heavily criticized for failing to teach professional skills and values. The MacCrate Report in 1992 and the Carnegie Commission report in 2007[4] urged law schools to teach fundamental lawyering skills and professional values. The lawyering skills include problem solving, fact investigation, communication, counseling, recognizing ethical dilemmas, negotiation, and organization and management of legal work. The values include provision of competent representation, striving to promote justice and to improve the profession, and professional self-development.

Although the first-year curriculum has changed relatively little, most schools now offer students an array of clinical courses after the first year. The MacCrate and Carnegie reports recognized that clinical courses had become common and urged that clinical offerings be greatly expanded. Clinical courses teach practical skills and usually involve working directly with real clients. Practical skills cannot be meaningfully taught in large classes; we learn skills by actually doing things, not hearing about them.

However, clinical education presents law schools with a dilemma. Clinical courses involve one-on-one teaching and thus are much more costly than large

classes. Law schools cope with this problem by paying clinical instructors much less than regular faculty members. Many are part-time teachers. Thus the law schools with the greatest financial resources tend to have the most clinical options and the highest quality programs. On its website, Harvard boasts of having 30 different clinical programs and 70 clinical instructors.

In addition, law schools now offer students opportunities to participate in pro bono programs (that is, free legal services), which provide some practical training and should imbue students with a sense of their professional responsibility to help underserved populations. According to its website, "Harvard requires all J.D. students to contribute at least 40 hours of law-related work as a condition for graduation. Many students choose to fulfill this requirement through clinical work. Our hope is that by giving back to the community, our graduates will develop a lifelong commitment to using their education and skills to contribute to the public good." However, only a few law schools actually require students to provide pro bono services in order to graduate.

6.03 Gender and legal education

The classroom in *The Paper Chase* was almost all white and primarily male. During the 1960s, women typically formed less than 5% of law school classes (the film distorts reality by showing considerably more than 5% female law students). Ethnic minorities, including African Americans, Hispanics, and Asian Americans, were scarce.

Today the demographic picture has changed radically. Women typically approach and often exceed 50% of entering law school classes. Numerous students belong to ethnic minority groups (although the numbers of African Americans or Hispanics are far less than their percentage of the overall population). Asian Americans are well represented. This section concentrates on the issues of gender, rather than race, in legal education. It examines whether the law school experience is the same for men and women.

6.03.1 Guinier's critique

A number of scholars believe that men's and women's law school experiences are different. Professor Lani Guinier is the leading proponent of this view (Guinier 1997; Bashi & Iskander, 2006). Guinier found that men's law school grades are better than women's. For example, men were three times as likely to be in the top 10% of their class and 1.5 times more likely to be in the top half of the class. In addi-

tion, Guinier showed that women participate less in class discussion than men do and suffer more psychological harm from the law school experience than do men.[5] Guinier found that women were five times more likely to seek professional help for law school concerns.

6.03.2 Is there a gender gap?

Guinier's conclusions about law school grades have been challenged by later studies. For example, Linda Wightman's research (1996) included data from 80% of American law schools. She found that the gender difference in law school grades was only 7% of a standard deviation, and the difference disappeared in the higher reaches (that is, women were as likely to perform well as men). However, Guinier's conclusions that women participate less in class than men and suffer higher rates of depression have not been contradicted by later studies. Her findings on the issue of female law student depression are close to statistical findings about depression in the general population. These show that levels of depression in the general population levels are substantial and that women suffer disproportionately from depression.

6.03.3 Difference versus equality feminism

There are two different schools of feminist theory—"equality" and "difference." Equality theorists argue that women and men should be treated alike. Difference theory adherents assert that women are different from men in fundamental ways, and institutions should appropriately reflect these differences in the way they treat men and women (Littleton 1987). In particular, difference feminists argue that the law school environment is worse for women than for men.

Those who write about difference theory draw on the work of Professor Carol Gilligan (1993). Gilligan argues that the moral development of men and women is different. Women are more focused than men on the context of a dispute and preserving relationships. Contrasting two children, Jake and Amy, Gilligan found that Amy "uses the ethic of care" and demands more information about the persons involved instead of making an abstract decision based on universal principles. Scholars see Gilligan's work as stressing the importance of relationships in explaining attributes historically linked with women and have termed it "relational feminism."

Carrie Menkel-Meadow argues that Amy's "different voice" could alter the "adversarial model [of litigation], in which two advocates present their cases to a disinterested third party who declares one party a winner." She suggests that "the female voice of relationship, care and connection" might lead women lawyers to

adopt a different style of lawyering, in which a "more contextualized understanding" of issues might have more importance than the "creation of a precedent of universal applicability." [Menkel-Meadow 1985, 50–55] In another article, Menkel-Meadow suggests that a feminist law school classroom could employ a less "hierarchical," more participatory structure in which "[r]eactions on the feeling level are as important as reactions on the 'thinking' level." Ultimately, Menkel-Meadow's classroom would emphasize "experiential learning, collaborative teaching, and a greater range of voices [so] students might feel connected both to each other and to the parties in the cases" (Menkel-Meadow 1988, 77–79).

Similarly, Professor Jennifer Rosato (1997) urged modification of the Socratic method in ways that would improve women's experience. She suggested that instructors should provide more positive reinforcement to students, for example, by praising good answers and encouraging cooperation rather than competition in the classroom. She also suggested that faculty explain what they are trying to achieve in using the Socratic method and debrief the students after a Socratic discussion is concluded.

6.04 The economics of legal education

6.04.1 The cost of legal education—and of student loans

In the 2011–12 school year, Harvard's tuition was $47,600 plus about $25,000 in other expenses for a total of $72,600. From 1985 to 2009, resident tuition at public law schools increased by 820%, from $2,006 to $28,472, because many states cut back sharply on the amount of support provided these schools. Tuition at private law schools went up 375% from $7,526 to $35,743. These increases far outstripped the rate of inflation (Tamanaha 2012, ch. 9). Very few can pay such costs. Harvard's large endowment makes it able to provide financial aid to needy students, but most schools give merit scholarships rather than need-based scholarships in order to attract better students than they could otherwise. (The effect of competition between law schools on tuition increases is further discussed in ¶6.04.2.)

It is difficult to work during the first year of law school. After the first year, many law students work part time in law firms and full time during the summer. Even so, the cost of legal education means that most students must take on crushing debt burdens. Federal loan programs make it possible for students at accredited law schools to borrow the full costs of law school. In 2010, average law school debt was $68,827 for graduates of public schools and $106,249 at private schools—and that is on top of whatever undergraduate debt they might have accumulated (Tamanaha 2012, ch.

9–10). Once law students graduate, often owing $150,000 or more, they must take the highest paying job they can find in order to service their debt.

However, high-paying jobs at big law firms are hard to get and are open only to graduates of elite law schools. And such jobs have grown scarcer because big-firm hiring slowed sharply during the recession that began in 2008.[6] It is unclear whether big firms will ever again hire as many associates at high pay as they did before 2008 because dramatic changes in the big-law world have reduced the need for entry-level associates. Clients now resist paying for the time it takes to train associates. Routine tasks have been outsourced to foreign lawyers or to temporary lawyers who are hired at lower pay to do a specific job. Some big law firms have opened satellite offices in other states and hired non-partner track associates to work there doing routine chores at much lower salaries.

Meanwhile, the graduates of non-elite law schools must take jobs at smaller law firms at much lower compensation—if they can find a job at all. Or they may open an office as a solo—and pray that some paying clients will show up so they can learn how to practice law on the fly. It is estimated that currently the economy is generating only enough jobs for *about half* of the new lawyers pouring out of law schools. But almost all of them must figure out how to repay their debts—and educational loans are not dischargeable in bankruptcy.

Brian Tamanaha's revealing book on legal education (2012, 109–25) points to a hypothetical law grad named Sarah who wishes to pay off her $120,000 law school debt in the standard ten-year term. Assuming a consolidated interest rate of 7.25%, her monthly loan payment will be $1,400. A student loan information site advises that her annual salary should be at least $169,057 to carry such payments, but she might be able to barely swing it if her annual salary was at least $112,000. But only 15% of 2010 grads obtained salaries in excess of $100,000. The median salary for 2010 graduates was $63,000 (assuming the graduates had a job at all and a great many did not), and at that level Sarah could not come close to making her loan payments.[7]

Sarah will have to elect Income Based Repayment (IBR), a program that allows educational debtors to limit their payments to 15% of the difference between adjusted gross income and 150% of poverty guidelines. Debts subject to IBR are forgiven after 25 years (10 years in the case of employees working for public interest employers or government). A great many law school debtors have elected IBR, but because of the deferrals they will wind up paying a great deal more interest than if they had managed to pay off the debts on time. That debt will hang over them for 25 years, interfering with their ability to borrow or get a mortgage. And the loan forgiveness after 25 years creates income subject to the federal income tax.

These economic facts of life raise the question of whether law school is a good investment for students, especially if they must attend non-elite law schools. It also raises the question of whether unlimited federal loans to law students are a good investment for the government, given that many of the loans will prove to be uncollectible.[8]

Unsurprisingly, law school applications are declining sharply and many law schools are starting to reduce the size of their entering classes, but should we wait for the market to correct the overproduction of law school grads? Should the federal government reduce the amount it will loan to law students? It seems clear that law schools are producing too many lawyers, but nobody is quite sure how to reduce that number.[9] The result of rapidly declining applications and declining federal support may be a severe shake-out in the legal education world.

6.04.2 Law schools in competition

Law school deans deplore the *U.S. News* rankings mentioned in 6.01.2 as meaningless and misleading, but the rankings have become extremely significant in the world of legal education (see Tamanaha 2012, chs. 7, 8). Students use the rankings to choose which law schools to apply to and enroll in. Faculty members consider them in deciding which jobs to take, and employers use them in deciding whether to hire the school's graduates. The rankings are based on an array of factors, including the GPA and LSAT scores of entering students, the rate at which graduates pass the Bar Exam and find jobs, how much the law school spends per student, and the general reputation of the school among lawyers and law professors around the country. The general reputation factor is particularly problematic since outsiders to a school have no way of judging how good it is or whether it has improved or gone downhill.

For Harvard and other top-ranked schools, the *U.S. News* rankings are not very important. Harvard always ranks in the top three. However, a low *U.S. News* ranking (such as being placed in the bottom quarter of all law schools) is bad news. Law school deans make it their business to raise their school's ranking and this leads to intense competitiveness and game- playing. As a result of the ranking competition, law schools have hired more tenure-track faculty members and cut teaching loads while sharply increasing faculty compensation. These changes are intended to encourage faculty to do more research and publish more articles which will improve the school's reputation and therefore its ranking. The resulting increase in payroll cost is one of the most important reasons for the inflation in tuition costs discussed in ¶6.04.1. In addition, schools spend a fortune mailing out multi-colored brochures boasting of their achievements to faculty all over the country in the hope that this will improve the school's reputation and therefore its ranking (Nichol 2012).

As mentioned in ¶6.04.1, many law schools below the top tier offer merit scholarships to better applicants (in effect, a tuition discount) to induce them to enroll at a lower-ranked school than they would normally have chosen, thus raising the school's *U.S. News* ranking. However, students with lower GPAs and LSAT scores don't receive this discount (Tamanaha 2012, 96–99). Law schools increasingly admit transfer students after the first year, effectively raiding the most successful students from lower-tier schools to increase the number of tuition-paying students and improve bar passage rates (but avoiding the inclusion of these students' lower GPAs and LSAT scores in the *U.S. News* calculations which are based on entering classes). These transfer student raids force schools further down the ladder to do the same thing by raiding even lower-ranked schools.

And some schools have cheated to improve their rankings. For example, a school can raise the rate at which its graduates are "employed" by hiring unemployed grads to reshelve books in the library or some other non-professional chore. Several have been caught falsifying the job figures or the salaries of employed graduates. Numerous consumer-fraud lawsuits are underway by disgruntled law graduates against their alma maters. The plaintiffs claim that misleading or false employment figures caused them to enroll at a law school and take on massive debt to attend, only to find themselves unemployable on graduation.[10] So far, at least, the courts have been skeptical of these claims and have dismissed the lawsuits.

Many law schools engage in a bait and switch operation by offering apparently generous merit scholarships to attract students with better admission numbers than the school normally gets. However, the students must maintain a B average to keep their scholarships. Because of the grading curve, substantial numbers of students inevitably fail to get a B average and lose their scholarships after the first year—when it is too late for them to attend another school. Then the money is recycled into offering more merit scholarships to 1Ls.[11] The ABA now requires law schools to provide additional disclosures to make sure students get proper warning of what they will be up against, such as information on precisely what kinds of jobs the graduates actually have and the number of persons who lose merit scholarships.[12]

6.05 Sound design and composition in *The Paper Chase*

6.05.1 The functions of sound

Sound is an integral part of the cinematic experience. Try watching your favorite film with the sound turned off, and you'll get a sense of the importance of sound. There are three principal components of a sound track: the vocals (dialogue, voice-

over narration, and any other sounds created by a human voice), music, and sound effects (such as birds chirping or leaves rustling). When all three components are missing—that is, when the soundtrack is devoid of any sound, even background sound—we have a *dead track*. Films often use a dead track in pivotal moments (for instance, at the moment of impact in a car crash).

Sound serves a number of purposes in film. First, it conveys story information. Most dialogue serves this function. Second, sound conveys character. What actors say and how they say it (their accent and intonation) tells us about their character, but so do the sound effects that accompany the vocals (such as the grating sounds associated with Kingsfield, as discussed below). Third, sound conveys a sense of reality. Take away the sound effects in a scene (even something as minor as the sound of a teaspoon hitting the side of a teacup), and the scene will seem hollow and unreal. Fourth, sound creates mood and atmosphere. For instance, simply adding the sound of wind can add menace to an otherwise placid image; adding the sound of wind chimes can help create a serene, peaceful mood. Fifth, as discussed below, sound can be used to mask the transitions from one scene to the next.

The Paper Chase, which was nominated for an Academy Award for Best Sound, illustrates many of these uses of sound. For instance, sound is used to convey the character of Professor Kingsfield. Kingsfield is associated with loud, startling sounds. On the day that Hart intends to volunteer in class, Kingsfield's arrival is announced by a series of loud sounds—he slams the door shut and slams his book and notebooks down. In isolation, any one of these sounds would have been jarring, but the cumulative effect is particularly grating. As a result, we experience in a direct, sensory way how nerve-wracking it is to be in Kingsfield's class. (Notice, however, that the sounds associated with Kingsfield become less jarring as the film progresses, suggesting that Hart has gotten used to him).

The Paper Chase begins with a dead track. The dead track lasts nearly 40 seconds, at which point we hear ambient sound and sound effects (a door opening, feet shuffling, indistinct chatter). The ambient sound and sound effects continue for approximately a minute and forty seconds before the first word of dialogue is spoken ("Mr. Hart"). Why do you think the creators of *The Paper Chase* decided to begin the film with complete silence?

6.05.2 Sound editing

In mainstream Hollywood cinema, editing is supposed to be invisible (see ¶1.06.3). Filmmakers want audiences paying attention to the story, not cinematic technique. Sound can help an editor achieve this illusion of seamlessness. For instance,

editors often use a *sound bridge,* meaning a sound that is carried over from one shot to the next. This technique makes the transition between the shots less noticeable. In *The Paper Chase,* classical music is often used as a sound bridge. For instance, Hart and Ford's trek to the hotel to study for finals is accompanied by a classical piece that ends only when they slam the hotel door shut.

Another transitional sound editing technique is the *sound dissolve.* The sound that ends one shot fades out while the sound that begins the next scene fades in. For a brief moment, the two sounds overlap, creating the sense that the two sounds are the same sound. Generally, similar sounds are used, making the transition between them almost imperceptible. The opening scene of *The Paper Chase* contains a memorable example of a sound dissolve.

The scene ends with Hart running into a bathroom stall and vomiting. The sound that climaxes the scene is the sound of the toilet flushing (we don't hear Hart vomiting). The sound that opens the next scene is the sound of a man screaming. The sound of a toilet flushing dissolves into and briefly overlaps with the sound of the screaming, making the two sounds seem like one continuous sound and thereby smoothing the transition between the shots. In addition, because the two sounds abut one another and briefly overlap, the sound of the scream is associated with Hart in a way it would not have been had it occurred in the middle of the next scene. As a result, we get the feeling that Screamer is Hart—even though Hart does not scream in either scene.

Sound can smooth the transition between scenes, but it can also be used to make the transitions between scenes jarring. Horror films frequently cut between two dissimilar, discordant sounds in order to startle or unnerve the audience. This technique is sometimes called the *shock cut.*

The Paper Chase is not a horror film, but it uses shock cuts at several points. Consider, for instance, the scene in which Hart storms out of Kingsfield's party upon learning that Susan Fields is Kingsfield's daughter. Later that night, he shows up at Susan's house to make up with her. He jumps into bed next to her, undoes his tie, and leans over to kiss her. The film then cuts to a shot of Kingsfield slamming his casebook shut. The effect is disorienting. We go from a shot of Hart kissing Susan Fields (with a romantic melody) to a shot of Kingsfield violently slamming a book shut (with no music). The transition effectively conveys how jarring it must be for Hart to go to Kingsfield's class each day after having spent the night with Kingsfield's daughter. Moreover, the sound of the casebook slamming shut subtly suggests Hart's dread that Kingsfield has found out, or will find out, about his relationship with Fields. Other examples of jarring sound cuts include the cut from the sound of Hart, Ford, and Anderson showering to the sound of an

alarm clock ringing and the cut from Kingsfield telling Anderson that "personal comment is not necessary" to the sound of Hart springing out of the pool.

6.05.3 Composition

The Paper Chase was photographed by Gordon Willis, a legendary cinematographer. In a published interview, Willis remarked that the film's use of composition "related to who had command of the situation. We used huge close-ups of John [Houseman—that is, Kingsfield] and demeaning shots of Timothy [Bottoms, that is Hart]. Then as the movie goes along and Timothy begins to get on top of it, you'll notice the shot sizes begin to diminish on John and begin to get a little bit bigger on Timothy—until finally they are equal partners shooting back and forth" (LoBrutto 1999). Is Willis right? If so, in which classroom scene is Hart finally shown in a "huge" close-up like those used for Kingsfield? Why did the filmmakers decide to wait until that scene to show Hart in extreme close-up?

6.06 Review questions

1. Did *The Paper Chase* make you want to attend law school—or to avoid it at all costs? Why?

2. *The Paper Chase* suggests that many things are wrong with law school in the 1960s (at least at Harvard Law School). Please list three of them (other than the "Socratic method"). Are these criticisms equally valid today?

3. Vitiello and Kronman defend the "Socratic method" (¶6.02.1). If you got a law school teaching job, would you use the Socratic method? If so, would you copy Kingsfield's style?

4. What does Kronman mean by saying that law school causes students to "lose their souls" (¶6.02)? Do law students really lose their souls? If so, is this a bad thing? If it is, what strategies should law students pursue to avoid losing their souls?

5. Does law school do a bad job of teaching the skills that students will need to practice the legal profession (¶6.02.5)?

6. Several authors (¶6.03.1) argue that law school is a bad place for women. Do you agree? They argue that the law school experience should be restructured in ways that would be better for women. What are some concrete changes that might be made in legal education that would put these ideas into practice? Are you in favor of these changes?

7. Your sister is a junior in college majoring in Russian literature. She is planning to go to law school and become a lawyer because she's watched a lot of movies and TV about law and lawyers, and she has learned that law school will be a lot of fun. She wants to practice law because it is extremely interesting and she can earn a high income. She will borrow the entire cost of going to law school. What advice would you give her? (¶6.04.1)?

8. Law schools seem to be locked in destructive forms of competition (¶6.04.2). Do you agree that it is destructive? Why did this happen and what, if anything, should be done about it?

9. The text in ¶6.05.1 and .2 discusses sound design in *The Paper Chase*. Please select and discuss a particular use of sound in the film (other than ones described in the text).

10. The text in ¶6.05.3 discusses composition in *The Paper Chase*. In the first meeting of the study group, Anderson remarks: "There's no guarantee that we're all going to be here in the spring. Some of us might have nervous breakdowns. I think that we should do research on the incidence of nervous breakdowns." While the camera is on Anderson for the first two sentences, it cuts to a reaction shot of one of the other study group members for the last sentence. Did you notice which character? Why does the film cut to a shot of him?

Notes

1. Additional films on legal education at Harvard are mentioned in ¶6.01.2. Some non-Harvard films about law school include *The Pelican Brief* set at Tulane Law School or *The Socratic Method* (set at the fictitious Chester A. Arthur School of Law). Some instructors prefer to teach *Legally Blonde* instead of *The Paper Chase*. *Legally Blonde* is more contemporary and would be useful if the instructor wanted to focus on equality versus difference feminism. Instructors might also consider the politically incorrect *Soul Man,* especially if they wish to concentrate on racial issues.

2. In a law review symposium, a number of authors reprise their first year at Harvard in a celebration of Turow's book (Levit 2010).

3. See Anderson 1986 (explaining rationale for teaching methods used in law school); Davis & Steinglass 1997 (discussing what Socrates and Langdell actually did); Friedland 1996; Granfield 1992; Hess 2002 (empirical study of law school stress).

4. The MacCrate report, named after its chairman Robert MacCrate, was the product of a study by the American Bar Association's Section on Legal Education and Admissions to the Bar (American Bar Association 1992). For discussion of the controversy stirred up by the MacCrate report, see Engler 2001. The report of the Carnegie Commission for the Advancement of Teaching was written by an interdisciplinary team of education scholars

(Sullivan 2007). For analysis and criticism of the Carnegie Report, see Holmquist 2012.

5. A recent study at Yale Law School confirmed Guinier's findings on this point. Especially in classes that relied on voluntary participation, men spoke up more often than women. The students favored *more* cold-calling by professors to assure that more students participated in the discussion (Yale Law Women 2012).

6. http://www.abajournal.com/news/article/biglaw_still_hiring_fewer_newbies_second-tier_grads_dont_have_a_prayer_hiri; http://www.abajournal.com/news/article/report_finds_demand_for_biglaw_services_declining_as_headcount_grows

7. A recent graduate of Loyola Law School in Chicago told *The New York Times* that she had abandoned her plans to work as a prosecutor because of her $200,000 debt load that she couldn't pay off while working for a midsize corporation. "Right now, loans control every aspect of my life. Where I practice, the number of children I'll have, where I live, the type of house I can live in. I honestly believe I'll be a grandparent before I pay off my loans. I have yet to make even a dent in them." David Segal, "Law School Economics: Ka-Ching." *The New York Times*, July 17, 2011, p. B–5.

8. Henderson & Zahorsky 2012.

9. The blogosphere is full of passionate (and often expletive-laced) denunciations of what the writers see as the law school scam. See, for example, http://thirdtierreality.blogspot.com/2013/02/third-tier-humid-waste-howard.html

10. Cohen 2012.

11. David Segal, Law Students Lose the Grant Game As Schools Win. *The New York Times*. April 30, 2011.

12. http://www.abajournal.com/news/article/aba_committee_recommends_new_law_school_disclosure_requirements/

Law on Television

Assigned Material: *Boston Legal*, Season 1, disk 1 (episodes 1–4)[1]

7.01 Television—Business and culture

Television is enormously important. It is a big part of almost everyone's daily life from early childhood to old age.[2] We consume massive amounts of TV programming and discuss it with friends and family. Television can be analyzed from many angles—as a profitable (but regulated) business, an important facet of American democracy, a unique creative form, a mirror of our world, and a rapidly evolving technology (Mittell 2010, Introduction). Space limitations preclude us from discussing many facets of television economics, culture, and technology. We will focus on the legal television genre—its history (¶7.02), and its narrative conventions (¶7.03 and ¶7.04). We then turn to a closer look at the first season of *Boston Legal*, particularly to the issues of the representation of lawyers on television as well as sexual harassment and ethical problems (¶¶7.04 to 7.07).

7.01.1 Commercials[3]

Most American television shows are commercially sponsored and are frequently interrupted by commercial announcements. Commercials take up from one-quarter to one-third of the time available for programming. In a real sense, TV pro-

grams are simply the material that has to be supplied to keep the audience around to watch the commercials. Sponsors paid upwards of $71 billion in 2006 to buy commercial time; individual commercial spots may cost $350,000 or more just to produce. TV programs live and die based on their ratings as well as on the demographics of the audiences they attract, particularly in the prized 18–49 age range, because that's what advertisers care about. The higher the ratings, the more TV distributors like networks or individual stations can charge their advertisers.

Most commercials are concerned less with conveying information about the product to be sold and more with creating brand awareness and an emotional association between the brand and the consumer. A good example of what most commercials try to achieve is Nike's "Just Do It" ads. These commercials stress the link between star athletes and the swoosh logo, with little or no information about the specific features of the sneakers that Nike wants you to buy.

Television commercials undoubtedly have given rise to a more consumerist society than would have existed in a world of commercial-free television. As Mittell (2010) says, "Nearly all commercials rely on a basic underlying assumption: consuming goods can solve problems and foster happiness" (68). TV commercials try to tap into our consumerist and sexual fantasies as well as our social, physical, and economic anxieties—while also trying to channel them into purchasing the sponsor's products.

If you had the power to get rid of commercial TV, would you do it? If so, how would television programming be paid for? Or is the question irrelevant since we are rapidly approaching a world in which nobody will be watching commercials because everything we watch is recorded on a DVR and played back later without the commercials?

7.02 Lawyers on television [4]

Law and lawyers have been the subject of countless television dramas and comedies and form a well-established genre. (For discussion of genre see ¶2.02.) Each season brings new lawyer shows to the small screen. Millions of viewers acquire information and misinformation about law, lawyers, and the legal system from watching these shows. (For discussion of the media effects of pop culture products on consumers, see ¶¶1.04, 1.05, and 4.07.) American television shows have global distribution, teaching vast numbers of consumers all over the world about American law and lawyers. Although law office and courtroom scenes are staples of the genre, the shows are actually quite diverse. Creators of each new show always seek new approaches to refresh the genre and distinguish a new show from its many pre-

decessors. In understanding contemporary shows like *Boston Legal,* it is helpful to trace the history of the legal television genre.

7.02.1 Perry Mason [5]

Perry Mason is the most famous lawyer in the history of American popular culture. Note how lawyer Edwin Poole in "Change of Course" (episode 4 of Season 1 of *Boston Legal*) channels Perry Mason in volunteering to defend a murder case.

Erle Stanley Gardner was a lawyer who much preferred writing. He penned 82 lawyer/detective novels about Perry Mason (all of which are titled *The Case of the...*) along with a vast outpouring of other works of pulp fiction. Six of the Perry Mason novels were adapted into movies during the 1930s (four of them starring 1930s matinee idol Warren William). Mason was a very different character in those 1930s films from his later embodiment on TV. He was a wisecracking smart aleck like William Powell in *The Thin Man* (1934) and a heavy drinker. Gardner hated the films. As a result, he retained creative control over the subsequent incarnations of the Perry Mason character, such as the daily radio show that ran for an astounding 3,221 episodes in the 1940s and 1950s.

The television show *Perry Mason* ran on television from 1957 to 1966 for a total of 271 episodes. The character was also the subject of 30 made-for-TV movies in the 1980s and early 1990s. Raymond Burr played Perry Mason in the TV shows and all but the last few of the made-for-TV movies. Burr's death in 1993 finally ended the Perry Mason character, but both the original shows and TV movies are still shown frequently on cable channels.

In the radio and television series, Mason was an asexual and humorless fellow who lacked any semblance of a personal life. His persona—carefully watched over by Erle Stanley Gardner—never changed. Mason was a solo practitioner who functioned partly as a lawyer, partly as a detective. In every novel, radio show, television show, or movie, the formula was always the same. The inept Police Lt. Arthur Tragg and the hapless District Attorney Hamilton Burger prosecute an innocent person for murder. Mason and his staff (Secretary Della Street and Investigator Paul Drake) sleuth out the identity of the real killer who had usually framed Mason's client. At the preliminary hearing (see ¶8.01.4 for explanation of preliminary hearings), Mason's adroit questioning destroys the prosecution's case and reveals the truth. Generally, the real killer is on the witness stand or seated in the courtroom. The culprit breaks down and confesses to the evil deed.

Perry Mason made no attempt to describe what real lawyers actually do or how the criminal justice system functions. *Matlock* (1986–95) was a successful clone star-

ring Andy Griffith that imitated the *Perry Mason* formula in a small town Southern setting. *Perry Mason* and *Matlock* sent simple messages: The adversary system (consisting of the contest between lawyers) will produce the truth about what happened in the past—not just "trial truth" but real truth. (See ¶2.04) The guilty are always convicted and the innocent are always exonerated. Ordinary people who are wrongly prosecuted for crime can hire brilliant lawyers who invariably defeat the stupid cops and prosecutors.

7.02.2 The Defenders [6]

The Defenders was one of the best lawyer shows of all time—perhaps the best. It ran from 1961 to 1965. The show involved a two-person father and son law partnership consisting of Lawrence and Kenneth Preston played by E. G. Marshall and Robert Reed. Each week, the Prestons tackled a different social or legal issue and always from a liberal point of view. Some of their most famous shows involved issues that were never discussed on television at the time, including the anticommunist blacklist in the movie industry, abortion, the insanity defense, defending Nazi free speech, women's rights, and a whole range of criminal procedure issues. The show sent the message that lawyers could help attain justice and solve social problems. The Prestons never seemed to worry about getting paid, and the show made no pretense of trying to describe the real life of lawyers. There is little or no character development. The Prestons were always the same and almost nothing of their personal life was revealed.

Unfortunately, *The Defenders* has never gone into syndication, so the old shows may be seen only in television archives (such as the invaluable Museum of Television and Radio in New York City and Beverly Hills).[7] Showtime produced two modern-day single-show updates of *The Defenders* and these shows can be purchased. The shows were called *The Defenders: Payback* (1997) and *The Defenders: Choice of Evils* (1998). E. G. Marshall returned as the grandfather in a three-generation firm. Unfortunately, Robert Reed was dead and was replaced by Beau Bridges as Don Preston, another of Lawrence Preston's sons. In addition, Martha Plimpton plays Mary Jane Preston, Lawrence Preston's granddaughter.

7.02.3 L.A. Law

L.A. Law (1986–94) irrevocably changed the legal TV genre (see Meyer 2009). The show drew high ratings and received 89 Emmy nominations (and 15 actual Emmys). It was created by Steven Bochco and Terry Louise Fisher, a former district attorney in Los Angeles. Bochco also created *Hill Street Blues, Doogie Howser M.D., NYPD Blue,* and *Murder One. L.A. Law* pioneered the dual-story format in

the legal genre; most episodes had A and B stories, and one of the stories was often comedic (see ¶4.09.2).

L.A. Law dramatized modern law practice—in *law firms* rather than as solo practitioners or two-person partnerships (see ¶13.05 for discussion of law firms). The firm of McKenzie, Brackman, Chaney, and Kuzak consisted of numerous partners and associates (associates are lawyers employed by the firm and working for a salary rather than a share of the profits). Unlike earlier shows, many of the lawyers on *L.A. Law* were female and several were minorities (both Hispanic and African American). (See ¶13.04 for discussion of black lawyers in pop culture and in reality.) Some of the lawyers were gay. (See ¶13.03 for discussion of LGBT lawyers in pop culture and in reality.) The firm had a substantial staff of nonlawyer employees (one of whom was mentally retarded) and a beautiful suite of offices. The firm was profitable and the partners enjoyed lavish lifestyles. They spent their days working on fascinating cases. Indeed, many people believe that *L.A. Law* produced a surge of applications to law school as thousands of young people decided that the glamour of law practice should be in their future.

The show tried to illuminate the problems of working with difficult or repulsive clients, opponents, and judges, and it frequently focused on cutting-edge ethical issues. It taught that being a lawyer meant exercising judgment or discretion, sometimes cutting ethical corners or making mistakes. (We discuss ethical relativism in ¶7.06.) *L.A. Law* never forgot that a law firm is, first and foremost, a profit-making business. The firm must attract clients who can pay the high hourly rates the firm charges. The partners often clash about financial and ethical decisions and other problems of law firm management. Indeed, some of the partners in McKenzie, Brackman thoroughly dislike each other (as is often the case in real law firms). These sorts of management problems become more difficult to resolve as a law firm grows larger and spreads out across state or national borders and particularly when profits start to decline. *L.A. Law* showed that lawyers spend relatively little time in court and a great deal of time in their offices. It made clear that many matters do not involve litigation, and those that do are more often settled than actually tried.

In some respects, *L.A. Law* resembled a soap opera. It paid close attention to the personal lives of the lawyers and staff members (which were often quite unhappy). As in real life, the lawyers have love affairs with other lawyers in and out of the firm, as well as with staff members and clients. The underlying cultural message of the show was that working in a law firm is a stimulating and profitable way to make a living (even if the lawyers have unsatisfying personal lives). It transmitted a mixed message about whether lawyers were heroes or villains or whether biglaw (discussed in ¶7.02.5 and in Chapter 13) helps to promote justice or to thwart it.

7.02.4 After L.A. Law

L.A. Law cleared the way for the current sophisticated lawyer shows, including *Boston Legal*. These shows have been commercially successful not only in the United States but throughout the world. None of them are campy, formulaic nonsense like *Perry Mason* or *Matlock* or piously liberal sermons like *the Defenders*. In particular, *The Practice* (1997–2004) involved an ensemble cast in a small, struggling law firm (see Thomas 2009). The stories often dwelt on the personal lives of the lawyers, reflecting on the damage that law practice can do to a lawyer's self-esteem, psychological health, and personal relationships. Many episodes probed thorny issues of legal ethics (both of criminal defense and criminal prosecution). Often, law and justice did not coincide. In the final season of *The Practice,* Alan Shore and Denny Crane joined the firm and the show then morphed into *Boston Legal.*

Law & Order (1990–2010) ran an amazing 20 years (it tied with *Gunsmoke* for the longest-running TV drama of all time). *Law & Order* focused exclusively on police and prosecutors and spawned numerous spinoff shows. It is discussed in Chapter 8.

Ally McBeal (1997–2002) was quite different from the other shows (see Asimow 2013; Sharp 2009; Joseph 2003). Sometimes referred to as a dramedy, *Ally McBeal* was much funnier than its rather somber predecessors. It was set in a small, though upscale, law firm. Ally McBeal (Calista Flockhart) was more concerned with her love life than her work life. The shows concentrated heavily on issues relating to gender and sexuality rather than legal issues. Indeed the legal disputes that appeared in the various episodes were often selected because Ally was struggling with the same issues in her personal life. The focus was on the inner life of Ally and the other characters—their emotions, feelings, and fantasies. Often Ally's feelings were illustrated by computer-animated snippets (such as a dancing baby that symbolized the ticking of her biological clock). (For discussion of the use of graphics in editing, see Mittell 2010, 202–05.) *Ally McBeal* developed a strong following among young women who identified with Ally's struggle to balance personal and professional issues.

7.02.5 Boston Legal *and its ancestors*

Boston Legal draws from all of the previous shows.[8] Most episodes contain two or more stories. Like many earlier shows, particularly *L.A. Law* and *The Defenders,* it often considered important political and social issues, especially from the relatively liberal viewpoint of its creator, David E. Kelley. An example is the issue of endangered wild salmon in "Catch and Release" (Brinkerhoff 2009, 260–63).

Figure 7.1. *BOSTON LEGAL*. From left, Brad Chase (Mark Valley), Sally Heep (Lake Bell), Alan Shore (James Spader), Denny Crane (William Shatner), Tara Wilson (Rhona Mitra). ABC/Photofest. © ABC, Inc. 2004.

Like *L.A. Law, Boston Legal* is set in the world of law firms engaged in the relentless pursuit of profit. Unlike *L.A. Law*, however, Crane, Poole & Schmidt is portrayed as a harsh and Darwinian environment. It seems to have all of the management and political problems inherent in the big firm structure. For example, some of the partners want to fire Denny Crane immediately; others want to keep him around because his reputation brings in business. (See ¶7.06.2, which argues that Crane should be put out to pasture immediately since everything he does threatens the firm with malpractice liability.) *The Good Wife* is another contemporary show set in the law firm sector that does not gloss over rivalries and management struggles. (See Nussbaum 2012 for an appreciative review of *The Good Wife*.)

All of these shows misrepresent the types of cases that big law firms are likely to take. In the world of big law firms (or biglaw as it's sometimes called), the lawyers don't work on criminal cases (except for white collar criminal defense) or personal injury cases (except to defend corporations in major tort cases such as the mass tort cases discussed in Chapter 12). They represent big business or big institutions or very wealthy people, not ordinary individuals who could never pay their high fees. (See the discussion of the hemispheres of law practice in ¶4.08.) This kind of distortion arises from the fact that pop cultural products must be entertaining to a mass audience; most of the work done by lawyers in real big firms is undramatic, usually quite tedious. It doesn't provide story material suitable for mass media programming.

The characters in *Boston Legal* have personal lives, including sexual affairs and bitter rivalries with co-workers. There are plenty of arcs as the various characters start and finish relationships. Ethical problems abound (see ¶7.06). Like *Ally McBeal*, the show offers plenty of comedy and many of the legal stories are pretty zany. In this respect, *Boston Legal* resembles *Ally McBeal*—the law just isn't taken very seriously (Brinkerhoff 2009).

What—if anything—was new about *Boston Legal?* The show was very stylish—sassy theme music, a sleek law office set, beautiful exterior shots of Boston locations. It sought to achieve a hip, often ironic ambience. Perhaps the most distinctive element of the show was the characterization of the two protagonists, Alan Shore and Denny Crane.

The Alan Shore character seems edgier than his television lawyer predecessors. He has a bad attitude. He is cynical and often thoroughly obnoxious. He cannot be managed by his superiors. Yet he is highly competent. He flouts ethical rules with abandon and always gets away with it. He is frequently in contempt of court—and he gets away with that too. For example, in "Head Cases," Shore arranges to have Rev. Al Sharpton charge into the courtroom and deliver a rant. This was grossly improper since Sharpton had no firsthand knowledge about the case (which involved employment discrimination against a black girl who wanted to play Annie), and there was no opportunity for opposing counsel to object or to disqualify him as a witness.

(In Episode 8, in season 1, "Loose Lips," Shore calls in Sharpton again on behalf of a cross-dressing Santa Claus.) In real life, the judge would have shut down Sharpton immediately and might well have held Shore in contempt.

Denny Crane seems to have serious problems of dementia (indeed, in later episodes, he decides that he's suffering from mad cow disease). He often repeats his name, as if it is some kind of mantra. Politically, Shore is left liberal, Crane is right conservative. (This seems to be a device for Kelley to make fun of Crane's often over-stated conservative views.) Yet they're the best of friends and often conclude episodes by having drinks together as they reflect on events of the day. The Shore-Crane bond turns *Boston Legal* into a male buddy show, somewhat in the mold of the female buddy theme on *Ally McBeal,* and the appeal of the two lead characters accounted for much of the show's success.

7.02.6 Female attorneys on Boston Legal

What do you think about the representation of female attorneys Tara Wilson, Lori Colson, and Sally Heep in the episodes of *Boston Legal* you watched? (See ¶10.06 for discussion of female attorneys in pop culture.) Consider their personal lives as well as the way they act as lawyers, how other lawyers treat them, how they dress, how they treat each other.

David E. Kelley. Kelley is the most prolific creator of televised legal drama. He was a lawyer in Boston when he wrote the script for a legal movie, *From the Hip* (1987). Steve Bochco saw the script and hired Kelley as an *L.A. Law* writer. That was the end of his law practice. Later Kelley became the producer of *L.A. Law.* He created a long line of successful legal TV shows, including *The Practice, Ally McBeal, Boston Legal, Picket Fences,* and *Harry's Law.* All of the shows tackle political and social issues outside the law, generally from Kelley's liberal perspective. He also created non-legal shows, including *Chicago Hope* and *Boston Public.* Kelley (2012) wrote: "The reason I started writing about law shows, the reason I first went to law school, is because of my fascination with this legal system. This imperfect beast that we have that seeks to legislate the moral and ethical conduct of its citizenry. And the law really doesn't just tell us what we can and cannot do. It often suggests at least, how we should feel and think sometimes, and it's not with a coat of blacks and whites. As we know, when cases get interpreted it's often with shades of gray."

7.03 Narration on television

Please review the material on storytelling in the movies in ¶¶3.08 (on melodrama) and 4.12 (on the classical Hollywood narrative). The conventions described in that material apply to television as well as movies. For example, dual-plot structures are frequently employed on TV in the form of the A and B stories within a single episode (see ¶7.08). Nevertheless, storytelling on television differs in important ways from movie storytelling (see Mittell 2010, ch. 6).

7.03.1 Series and serials

A movie is a stand-alone product. Its approximately two-hour duration contains the beginning, middle, and end of the story. (Of course, successful movies often spawn prequels or sequels, but these aren't part of the original film.) Most television programs, however, are a *series,* meaning that the program is presented in weekly episodes during an entire television season; if the program is renewed, episodes continue in subsequent seasons. The series format has some important implications. Because each episode in the series involves the same characters and is set in the same time and place, less information needs to be conveyed to viewers in later episodes. Viewers are familiar with the characters after watching the first few episodes. However, the series is constantly being joined by new viewers who missed earlier episodes and who must be brought up to speed by "previously on" clips presented at the beginning of the episode.

Some television shows are *serials,* meaning they are not episodic but instead involve a continuing story that runs throughout the entire season or several seasons. Some quite successful shows have employed the serial format such as *24, Lost, Deadwood, Homeland,* and *Friday Night Lights* (see Johnson 2012, 44–50). Soap operas also employ the serial format (and the story may extend over many years). In legal shows, serials are rare but several successful ones are *Murder One* and *Damages.* A serial allows for a much richer story, intriguing plot twists, and deeper character development than a single two-hour film or a TV series consisting of one-hour episodes. A series is more like a lengthy chaptered novel than like episodic television. Often, a successful series generates a highly committed fan base because the fans identify intensely with the characters.

Damages, for example, involved complex civil litigation disputes that ran for 13 episodes in each season. In season 1, *Damages* dwelt on a single class-action lawsuit brought by Patty Hewes (played by Glenn Close) against Arthur Frobisher (Ted Danson). Frobisher had encouraged his employees to buy stock in his company—

and then he dumped his own stock just before the corporation crashed into bankruptcy. The employees were wiped out. The legal and personal intricacies of this story were developed over the entire season in ways that would not have been possible in a series format. The disadvantage of a serial, however, is that the episodes must be viewed in sequence. If viewers see them out of sequence (or miss an episode or two), they will find it difficult or impossible to figure out what's going on. This limits the ability of new viewers to join the season in progress. It also cuts down on the back-end revenues that can be derived from syndicating the show on cable. On the other hand, serials do well as DVDs.

Recently, many shows have developed a *hybrid* format. Hybrid shows are like a series, in that the story (or stories) in each hourly episode is closed at the end of the episode. However, the characters change and develop (these are often referred to as character arcs). For example, the characters may have romantic affairs with their workmates or develop nasty rivalries, as occurs on *Boston Legal* or *The Good Wife*. Viewers prefer to watch the episodes in sequence in order to track the character arcs, but this is not necessary since each episode contains one or more freestanding stories. Stories in the hybrid format tend to be more subjective (see ¶4.09.3) than stories in a series, because a successful character arc requires more disclosure of personal information and inner feelings. Compare, for example, *Boston Legal,* which is in hybrid format, with *Law & Order,* which is a non-hybrid series. (See Chapter 8 for discussion of *Law & Order.*) *Law & Order* employs objective storytelling, disclosing almost nothing about the inner life or relationships of the characters. Like *Perry Mason* and the father-son team on *The Defenders,* the cops and lawyers on *Law & Order* are exclusively about work.

7.03.2 Commercial interruptions

Another important difference between movies and network television that bears on narration is the presence of constant commercial interruptions. As discussed in ¶7.01.1, the purpose of network television shows (and many cable shows as well) is to sell advertising in the form of interruptive commercials. In contrast, the revenue stream from movies comes mostly from sources that do not require sponsorship, including the sale of tickets as well as backend revenue such as sales of DVDs and to cable channels. (Movie producers derive significant revenue from product placement, so to that degree they must please advertisers.) On TV, there may be five or more breaks for commercials in an hour-long show; these interrupt the narrative and are preceded by "hooks" that hopefully will induce viewers to suffer through the commercial and keep watching. (Of course, many viewers now record

the shows and can watch them without interruptions; nevertheless, the writing must still be structured to accommodate commercials.) Each intra-commercial unit of the episode is called an "act," and writers must be proficient at storytelling in the multi-act format (see ¶7.08).

Movies have a single director and usually a single writer (although numerous writers are often involved in rewrites). In contrast, the demands of producing multiple weekly episodes of a television program, often under intense deadline pressure, require a team of directors and writers (as well as editors, researchers, assistants, etc.). Having each episode written and directed by different people calls for coordination among members of the writing and directing teams and further constrains narrative innovation. Finally, network television shows must submit to a good deal of internal censorship and content regulation (in order to head off difficulties with the Federal Communications Commission as well as with advertisers), although cable shows avoid most such constraints.

7.03.3 Conditions of consumption

The conditions of consumption of television and movies differ in ways that have implications for narration. Television shows are consumed at home. The viewer is alone or joins with a small unit of family or friends. Typically the viewing experience is subject to interruptions from phone calls or domestic chores. People may be multitasking by eating, cooking, checking e-mail, or doing homework while the set is on. The choice of a particular TV program may be impulsive and dictated by the amount of leisure time that's available or may result from channel-surfing.

Consequently, a cardinal principle of most entertainment television shows is that the stories must be easily accessible to viewers who are not giving full attention to the TV set. In contrast, movies are consumed in a dark theater without distractions or interruptions. The audience's only task is to watch and interpret the film. Thus movie stories frequently demand greater concentration than TV stories.

It seems likely that a movie has a greater impact on its audience than a single episode of a television show, given the much larger screen size and the fact that viewers share the viewing experience with a large audience. (See also ¶4.04.5 for comparison of the effects of movies and television on consumers.) Ask yourself how well you remember a particular episode of your favorite TV show that you watched a couple of weeks ago as compared to a movie you saw in a theater a couple of weeks ago. Do you remember the movie better? However, the *cumulative* impact on viewers of the numerous episodes of a television series, often extending over several years, probably swamps the effect on viewers of any single movie.

In addition, other conditions of traditional movie consumption differentiate it from watching TV. People pay for movie tickets. In contrast, over-the-air television is free or, if consumed on cable or satellite, the marginal cost of watching an additional episode is usually zero. The average viewer consumes many fewer movies than TV shows. Viewers use the moviegoing experience as a planned social event with family or friends, see the film from the beginning, and make an informed selection of what movie to see. Of course, many movies are now consumed at home on DVDs or through other forms of modern communications technology, so that the conditions of consumption of movies are often similar to the conditions of watching television shows.

7.04 Bad lawyers on television

Recall ¶4.03, which discussed "bad lawyers" in the movies. It indicated that about two-thirds of movie lawyers during the last thirty years or so were "bad," meaning either bad human beings or bad professionals. However, this pattern does not hold on television. Most TV lawyers would probably be classified as "good," meaning that they are *both* decent human beings *and* competent and ethical professionals. However, big law firms on TV (and in the movies) are almost always portrayed as evil and profit-crazed places, as in *Boston Legal, Suits,* or *The Good Wife.* (See ¶¶13.05 and 13.06 for discussion of law firms in pop culture.)

How would you classify Alan Shore and Denny Crane on *Boston Legal* (or the lawyers on other TV shows that you've watched)? You may find that the characters are not that easy to classify on the binary bad-good scale because their characterizations are *nuanced.* Typically, recurring TV characters have good sides and bad sides, both personally and professionally. Nuanced characterizations are essential, since viewers would be bored by one-dimensional characters that are all good or all bad. Yet, on balance, the lead characters in television drama (legal or non-legal) are likely to be more good than bad.

The fact that TV lawyers seem more positively represented than movie lawyers may result from the fact that TV series are mostly character-driven. Viewers care about the characters they encounter on TV. They will keep inviting the characters back into their living rooms each week if they feel empathy with the characters and care about what happens to them.[9] This audience/character bonding is essential if a show is to develop good ratings and thus generate high advertising returns. Although the antagonists on television shows can be sleazy, the audience demands that protagonists be pretty decent human beings and (on legal shows) competent, caring, and ethical lawyers as well. Alan Shore and Denny Crane, however, don't seem

like such great people and certainly don't seem like ethical (or in Denny's case competent) professionals. In that respect, *Boston Legal* seems to depart from most legal TV shows. Shore and Crane seem like lovable rogues who often aren't very nice and get away with a lot (see ¶7.06), yet audiences seemed to respond to them quite well.

Movies, on the other hand, are two hours long. Audiences don't have to live with the characters over a lengthy period. Movies are often driven more by plot than character, and audiences can enjoy a movie with repellent protagonists if it tells a good story.

7.05 Sexual harassment [10]

"Catch and Release" tells the story of Wendy Moore's sexual harassment suit against her former boss Daniel Ralston. Moore had an affair with Ralston that she ended. Ralston continued pursuing Moore to resume the affair until she finally quit and took a lower-paying job. Shore represents Moore in an action based on sexual harassment. Christine Pauley represents Ralston. The situation is uncomfortable for both lawyers, given that Shore and Pauley were former lovers. She had tried to kill him and was committed to a mental institution. In "Still Crazy After All These Years," Shore managed to get Pauley released and served as her guardian as long as she stayed in Boston. Does Shore have a conflict of interest in either of these cases (see ¶7.06.1)?

The Civil Rights Act of 1964 prohibits sex discrimination in employment (as well as discrimination based on race, color, religion, or national origin). (For additional material on race and sex discrimination in employment, see ¶13.07.) The federal act covers discrimination by women against men as well as men against women but does not outlaw discrimination based on sexual orientation. (However, most states have their own anti-discrimination laws, and many of them prohibit discrimination based on sexual orientation.)

The ban on sex discrimination originally covered only economic discrimination, such as refusing to hire or promote women or paying them less than men. More recently, the act has been applied to other forms of sex discrimination that are broadly described as sexual harassment. The most blatant example is quid pro quo harassment. This occurs, for example, when a male supervisor threatens a female employee that she will get fired (or not promoted) unless she agrees to have sex with him (of course, the same is true of threats by a female supervisor against a male employee).

Sexual harassment also covers the creation of a hostile work environment. For example, numerous cases—like Wendy Moore's lawsuit against Daniel Ralston— involve men who make unwelcome sexual advances to women (but without the

threat of firing them). Another common form of sexual harassment occurs when men make the workplace uncomfortable for women in a sexual way by telling sexist jokes or insulting or abusing them (*Meritor Savings Bank v. Vinson*, 1986). The plaintiff must show that the harassment was sufficiently severe or frequent to alter the conditions of employment and create an abusive working environment. This is a vague test. Many cases present borderline situations in which conduct of a sexual nature, such as an occasional joke or a few rejected requests for a date, might not be sufficiently severe or frequent to violate the Civil Rights Act of 1964.

Note that Pauley offered Shore $250,000 to settle the case (meaning that Ralston was willing to pay that much to get rid of it). Shore held out for $750,000, which seems steep given that Moore found another job in her field (although it paid less). Since the jury came back with a verdict of only $125,000, the case turned out to be more a victory for Ralston than for Moore. Note that the vast majority (perhaps 95%) of civil cases are settled by the parties or dismissed by the court; very few go to jury verdict. Settlement negotiations require a great deal of skill and judgment. Shore badly misjudged the strength of his case (or perhaps he underestimated Pauley's ability to come through with a powerful closing argument).

What do you think of the conflicting closing arguments in the Moore case? Do you agree with Pauley that this sort of lawsuit demeans women who should be able to look out for themselves?

7.06 Ethical issues on *Boston Legal*

The lawyers of Crane, Poole & Schmidt—particularly Alan Shore—commit gross ethical violations. Many of these violations would be sufficient to impose severe professional sanctions on the lawyer—perhaps disbarment. Some of the violations of legal ethics are also criminal offenses and others could give rise to serious liability to clients for legal malpractice. However, nothing bad ever seems to happen to the *Boston Legal* lawyers, which sends the message that the rules of legal ethics are a farce. In reality, most lawyers play close attention to these rules and do their best to comply. They are fearful of the consequences of getting caught violating the rules or getting sued for malpractice. However, in practice, lawyers are seldom punished for ethical violations other than stealing from clients or getting convicted of a serious crime.

William Simon writes that characters in legal pop culture (including novels, especially those by John Grisham) often exhibit what he calls "moral pluck," meaning that they twist or ignore the rules of legal ethics in order to serve the interests of justice (Simon 2000). Consumers of pop culture seem to respond favorably to such ethical violations because they admire creative tactics and they like to see jus-

tice done. Simon argues that these pop culture stories indicate that the public favors a relativist view of ethical norms (rather than a strict conformist view). He also argues that these pop culture treatments suggest that the enforcers of legal ethics should stop pretending that the ethical rules can be enforced literally in all cases. He calls for lawyers to use wisdom and judgment in making moral and ethical choices rather than trying to rely on abstract ethical statements. As you consider the various ethical violations of the *Boston Legal* lawyers, consider whether they were justified in the interests of a greater good.

No clear answers. The Preamble to the ABA's Model Rules states: "Within the framework of these rules many difficult issues of professional discretion can arise. Such issues must be resolved through the exercise of sensitive professional and moral judgment guided by the basic principles underlying the Rules" (American Bar Association 2003). This is a polite way of saying that the ethical rules seldom give lawyers clear answers in solving the dilemmas arising out of law practice.

7.06.1 Conflict of interest

In "Head Cases," one of the firm's most valued clients, Ernie Dell, has learned that his wife is cheating on him. He demands that the firm hire a private investigator (PI) to trail her and find out who she is sleeping with. Denny Crane refuses to allow this—because he is the one she is sleeping with. He never discloses this to Dell, and the firm goes through various shenanigans to distract Dell from hiring the PI. Ultimately Dell hires his own PI and discovers the truth.

Crane has a gross conflict of interest because of his personal interest in concealing the information from his client. Rule 1.7 of the ABA Model Rules provides that a lawyer shall not represent a client if there is a "significant risk" that the representation "will be materially limited by the lawyer's responsibilities to another client...*or by a personal interest of the lawyer.*"[11] A lawyer may represent a client despite the existence of a conflict of interest if "the lawyer reasonably believes the lawyer will be able to provide competent and diligent representation to the client" *and* the "client gives informed consent, confirmed in writing." Note, by the way, the rule of "vicarious conflicts": If one lawyer has a conflict, no other lawyer in the firm can represent the client (ABA Model Rule 1.10).

It is obvious that Crane (and thus Crane, Poole & Schmidt) cannot "provide competent and diligent representation" to Ernie Dell in these circumstances, so that

this conflict is non-waivable. And, even if it were waivable, nobody disclosed the conflict and sought Dell's informed consent. The only thing that the firm could do ethically is to withdraw immediately from representing Dell. It is unclear whether it would have to disclose to Dell the reason for its withdrawal.

Does Alan Shore have a conflict of interest in the episode "Still Crazy After All These Years" when he represents Christine Pauley in the hearing that considered whether she should be released from the mental institution—considering that she had tried to kill him? When he opposes Christine Pauley in the Wendy Moore case in the episode "Catch and Release" after taking responsibility for her after she was released from the institution?

7.06.2 Competence

Model Rule 1.1 provides: "A lawyer shall provide competent representation to a client. Competent representation requires the legal knowledge, skill, thoroughness and preparation reasonably necessary for the representation." This rule of ethics is seldom enforced by state bar disciplinary authorities, but it is often enforced in malpractice cases brought by clients against lawyers in court (see Martyn 1981).

Denny Crane is incompetent to practice law even though he won't admit it to anyone, even himself. He appears to have Alzheimer's disease, his memory is obviously impaired, and his conduct is erratic. His colleagues are terrified whenever he does legal work (such as taking a deposition). In "Still Crazy After All These Years," Crane defends a doctor in a medical malpractice case. The patient died after the doctor performed an angioplasty. The plaintiff is the deceased patient's wife. In a deposition, Crane starts asking about her sex life after the husband's death. The opposing attorney seeks sanctions (misconduct during the discovery process can result in monetary sanctions). Crane insists on arguing the sanctions motion himself. Managing partner Paul Lewiston agrees to let Crane argue the sanctions motion, hoping that he will butcher the job. This will provide an excuse for getting rid of him. Surprisingly, Crane handles the sanctions motion capably and no sanctions are awarded.

One interpretation of this incident is that Crane is faking his disability so that his opponents (in and out of the law firm) will underestimate him. However, in Episode 5 of the first season ("Eye for an Eye"), Crane's problems are much more apparent and it is evident he isn't faking. He completely forgets to prepare for a major and complex class action defense case assigned to him until he's reminded of it the night before the trial begins. He can't understand the case when it's explained to him. He blatantly and needlessly offends the judge during a pretrial

conference. And when he stands to make his opening statement, he forgets everything. His off-the-cuff opening statement is so absurd that a mistrial is granted and he is thrown into jail for contempt.

In real life, no law firm would take the risk of a disabled partner practicing law, whether the disability is from drugs, alcoholism, or mental dysfunction. The risk of legal malpractice liability would be extreme. Even founding partners like Crane or Poole, whose names are on the door, would not be exempt from enforced retirement (or at least lengthy rehab).

ABA Model Rule 8.3 provides: "A lawyer who knows that another lawyer has committed a violation of the Rules of Professional Conduct that raises a substantial question as to that lawyer's honesty, trustworthiness or fitness as a lawyer in other respects, shall inform the appropriate professional authority." Thus all the lawyers at the firm who know about Crane's impairment are obligated to report the situation to disciplinary authorities, but none of them does so. In reality, this duty to report the misconduct of other lawyers is seldom observed in practice and, when not observed, seldom punished by disciplinary authorities.

7.06.3 Truth telling

In "Catch and Release," Sally Heep pulls a rabbit out of her hat—literally—when she tells a story during trial about her dog and the neighbor's pet rabbit. Later, Heep admits to Shore that this story is an urban legend and it had never happened to her (or probably to anyone). Heep violated Model Rule 3.3(a)(1) which provides: "A lawyer shall not knowingly: (1) make a false statement of fact or law to a tribunal...." That's exactly what Heep did.

Several other provisions of the Model Rules are also directed to truth-telling. Rule 4.1 provides: "In the course of representing a client a lawyer shall not knowingly (a) make a false statement of material fact or law to a third person...." Rule 8.4 provides: "It is professional misconduct for a lawyer to...c) engage in conduct involving dishonesty, fraud, deceit, or misrepresentation...."

Many episodes of *Boston Legal* involve blatant lies or dirty tricks by the lawyers of Crane, Poole & Schmidt. For example, in an episode aptly titled "A Greater Good" (Episode 9 of the first season), Tara Wilson runs into opposing council in a bar. He does not know her. She picks him up, pretending to be an airline hostess, and gets the poor guy to disclose confidential and damaging client information (including concealment of critical facts about his client during the discovery process). The firm uses the information to force the defendant to settle at a higher price than it had previously been willing to offer. In "Loose Lips" (Episode 8 of the

first season), Shore suggests to Lori Colson that she impersonate a psychiatrist in order to assist the client, a real psychiatrist, to evaluate whether a patient's threats to kill his ex-wife should be taken seriously. Colson's impersonation has disastrous consequences. Did Wilson or Colson violate Rule 8.4? If so, was their conduct justified by the greater good, as discussed by Simon (¶7.06)?

7.06.4 Obstruction of justice and witness tampering

In "Change of Course," Lee Tyler is a kleptomaniac charged with shoplifting a scarf. If convicted, she will lose her job as CEO of a major corporation and Crane, Poole & Schmidt will lose an important client. Managing partner Paul Lewiston asks Alan Shore to use "unconventional means" to make this unpleasantness go away. The critical testimony in the case is from store clerk Miles Tibbett who saw Tyler steal the scarf.

Shore enlists Sally Heep (associate at the firm and his lover) to pick up Tibbett in a bar and have a long talk with him. Tibbett is a pathetic fellow who has never been approached by a beautiful woman before. He makes damaging statements to her—he takes beta blockers to control anxiety, he has invited several friends to hear him testify in court, and his hobby is collecting autographs. Shore then threatens Tibbett with disclosure of this embarrassing information and he recants his testimony that he saw Tyler steal the scarf.

Paul Lewiston informs Shore that the District Attorney has lodged charges against him of witness tampering, obstruction of justice, and extortion. Shore and Heep have committed all of these serious crimes (see Model Penal Code 1985, §§223.4(3), 241.6, 242.1). Whether or not they are convicted of the crimes, they would face severe discipline from the Massachusetts disciplinary authorities. ABA Model Rule 8.4 makes this clear: "It is professional misconduct for a lawyer to:…(b) commit a criminal act that reflects adversely on the lawyer's honesty, trustworthiness or fitness as a lawyer in other respects; (c) engage in conduct involving dishonesty, fraud, deceit or misrepresentation; (d) engage in conduct that is prejudicial to the administration of justice.…"

Similarly, in "Head Cases," Shore uses tricky methods to get the father to withdraw his custody claim against the firm's client, the mother of the children who wants to move the kids out of state. Again, it's likely that Shore is guilty of witness tampering and obstruction of justice for these tactics.

As usual on *Boston Legal,* nothing ever comes of these criminal and ethical violations. In his conversation with Shore about the Lee Tyler case, Lewiston says the firm does not condone such conduct. Indeed, he says, the attorneys at the firm "conduct themselves with integrity always." Then he says "thank you."

7.07 When the lawyer is certain the client is guilty

7.07.1 Legal ethics and the guilty client

Criminal defense lawyers frequently suspect that their client is guilty, but they avoid knowing this for sure by never asking the client directly whether he or she did it. Clients normally know enough not to confess to their lawyers. In "Change of Course," however, client Warren Litch confessed guilt to his lawyers Lori Colson and (an incompetent) Edwin Poole. This situation is sometimes referred to as the criminal defense lawyer's worst nightmare because it creates an ethical crisis and drastically limits the tactics that the lawyer can employ in a trial.

Litch is charged with murdering a police officer during a traffic stop. He confessed to the police as the result of a police trick. A doctor falsely told Litch that he was dying from bullet wounds. Then a fake chaplain took his confession. This sort of police trickery probably does not invalidate a suspect's confession, provided that the suspect has agreed to waive his *Miranda* rights (see ¶¶1.05.1 and 8.01.3 on *Miranda* rights).

Litch now recants the confession and denies guilt. In her closing argument, Colson argues that Litch might have confessed to the police, thinking he was dying, in order to spare some friend or relative who was in the car and pulled the trigger. However, she knows that this is not true. It is acceptable for criminal defense lawyers to make arguments that the lawyer knows are not factually true (but without actually vouching for the truth of the argument). The idea is that it is a basic civil right that nobody (however factually guilty they may be) should be convicted of a crime unless the prosecution has proved guilt beyond a reasonable doubt—and the defense lawyer's job is to challenge the prosecution's case on this ground (Asimow & Weisberg 2009, 248).

However, there's a further wrinkle in this case. Litch wants to testify to this false story but Colson will not allow him to do so. Normally a client has the right to testify in his own defense, even over the lawyer's opposition. (ABA Model Rule 1.2(a) provides: "In a criminal case, the lawyer shall abide by the client's decision, after consultation with the lawyer, as to…whether the client will testify.") However, a lawyer is not permitted to introduce testimony that she knows is perjured. If the client insists on giving perjured testimony, the lawyer should withdraw from representing the client. However, the Litch trial had already begun and it is too late for Colson to withdraw.

Under ABA Model Rule 3.3(a)(3), "A lawyer shall not knowingly…offer evidence that the lawyer knows to be false." In *Nix v. Whiteside* (1986), the Supreme Court held

that a lawyer's threat to tell the judge about a client's plan to commit perjury was not ineffective assistance of counsel. Moreover the *Nix* decision stated that the lawyer's conduct was required by the rules of legal ethics. Therefore, in most states, Colson acted correctly when she refused to allow Litch to take the stand and commit perjury.

7.07.2 Telling false stories in narrative

Massachusetts has a special rule that applies to this situation. "In no event may the lawyer *examine the client* in such a manner as to elicit any testimony from the client the lawyer knows to be false, and the lawyer shall not argue the probative value of the false testimony in closing argument or in any other proceedings, including appeals" (Mass. Rule 3.3(e)).[12] Under this rule, if a criminal defendant insists on committing perjury, and the lawyer is unable to withdraw, the lawyer must allow the defendant to do so in *narrative form*, meaning that the client tells his (false) story without the usual question-and-answer format. The lawyer is not permitted to refer to the perjured testimony in closing argument. California also follows this approach.

Therefore, Lori Colson should have allowed Litch to give perjured testimony in narrative form (but, if he had done so, she could not have referred to his story in her closing argument). She says she refused to allow him to testify in narrative form because he would surely get tripped up on cross-examination and also because a juror might have understood why the testimony was presented in narrative rather than through question-and-answer. These are good reasons, but the decision was up to Litch, not Colson.

7.07.3 The guilty client in pop culture

The situation of the lawyer who must represent a client who the lawyer knows for sure has committed a serious crime has arisen frequently in film and television. The norms of the legal profession (and the rules of legal ethics) make clear that a lawyer owes a duty of loyalty to clients—even to terrible clients. The lawyer's job is to represent the client zealously (but *not* to introduce evidence the lawyer knows is false).

In pop culture, however, the lawyer usually *betrays* the client in a criminal case by insuring that the client gets convicted of the crime or some other crime or is killed.[13] In pop culture civil cases, the lawyer does whatever it takes to make sure the client is forced to pay for what he or she has done. In other words, pop culture teaches that a lawyer's obligation is owed *to the public* (to protect it from a vicious criminal or other wrongdoer) rather than to the client. Recent client betrayal films include *Michael Clayton* (2007) and *The Lincoln Lawyer* (2011). The classic version

is ...*And Justice for All* (1979), in which lawyer Arthur Kirkland (played by Al Pacino) says in his opening statement that his client "should go straight to fucking jail, the son of a bitch is guilty" (Asimow & Weisberg 2009, 248–51). In this respect, pop culture adopts the rules of "ordinary morality" instead of lawyers' "role morality" (see ¶7.07.4). By comparison with this pop culture crowd of client-betraying lawyers, Lori Colson stands out as the most ethical of all.

7.07.4 Defending the guilty

In "Change of Course," Lori Colson and Edwin Poole discuss the lawyer's role in defending a client when the lawyer knows with certainty that the client has committed a vicious crime. Poole says "It's hard to reconcile what we do with who we are sometimes." Lori replies: "I don't care about him. I'm just doing my job." Colson makes an important point. Lawyers must maintain *role differentiation.* Their professional role as criminal defense lawyers sometimes calls on them to represent despicable clients, even those guilty of terrible crimes. In criminal defense cases, it's the lawyer's job to make the best case possible for the client, including the argument that the state has failed to carry its burden of proof beyond a reasonable doubt. It is wrong to identify the lawyer (who may be a good person) with the client (who may be a terrible person). If lawyers were identified with their clients, it would be impossible for unpopular or hateful clients to find lawyers.

The defense of guilty clients is also an example of the gulf between "ordinary morality" and professional norms that call for lawyers to exercise "role morality." In ordinary morality, it would be inappropriate for someone to assist criminals to avoid being punished for their crimes (especially if that someone takes money for doing so). But that's exactly what lawyers are supposed to do, not because lawyers approve of criminality, but because their function is to compel the state to make a strong affirmative case that a person deserves to be punished before punishment is administered. Lawyers' "role morality" is often difficult for lay people to understand and accept (unless, of course, the lay people are in trouble themselves). For further discussion of the moral problem of representing the guilty, see ¶8.06.4.

7.08 Dual plot structure on *Boston Legal*

Generally, *Boston Legal* follows an A/B plot structure (see ¶7.03), in which the plot oscillates between two different storylines involving two different sets of characters. Careful study of the structure of a single episode shows how intricately the two plots are interwoven and fitted within the relatively short 40-plus minutes available for

the episode. It also illustrates that the writers need to create a "hook" before each commercial break so the viewer will return. The great skill of the writers and directors is obvious, once the plot is analyzed in this way.

In "Still Crazy After All These Years," there are two main storylines:

- Alan's efforts to obtain Christine's release and their relationship once she is released (the A story because it is the dominant one); and
- Brad's efforts to protect the firm from Denny and Denny from the firm (the B story).

The episode starts with a 2½ minute pre-credit sequence in which Alan meets with Christine in the mental hospital to which she has been confined. The scene sets up the A storyline, the focus of which is Alan's representation of and relationship with Christine, an ex-girlfriend who had tried to kill him.

The second scene (the first one after the credits) is an all-office meeting in which the attorneys discuss the cases they are working on. The office meeting scene is repeated in most episodes. Although contrived, the meetings serve an important narrative function by laying out the plotlines to be developed in the episode. For instance, in "Still Crazy After All These Years," the office meeting scene establishes both the A and B storylines.

The next two scenes continue to develop the A story, which now expands to include Sally, creating what is essentially a love triangle involving Alan, Christine and Sally. Finally, nearly nine minutes in, the episode shifts to the B story. Brad and Denny are the main characters in the B storyline, although Lori and Paul also participate. (As often happens in the series, Lori participates in both storylines.) The next two scenes (which together last less than four minutes) constitute the first act of the B storyline, as Denny's deposition of the medical malpractice plaintiff appears to go disastrously wrong when the plaintiff's counsel terminates the deposition and indicates he is moving for sanctions.

Following the commercial break, the A story resumes with the conclusion of Christine's commitment hearing. A scene involving Alan and Sally follows, which further develops the A story. The episode then shifts to the B story for one scene (a conversation between Denny and Brad in Denny's office), before returning to the A story for one scene (a conversation between Alan and Christine in Alan's hotel room). The next scene is the midpoint of the B story. In it, Paul initially opposes having Denny argue the sanctions motion until he realizes that an embarrassing public defeat might turn the partnership against Denny.

After the commercial break, the A story resumes with Christine leaving Alan's hotel room to go to the airport. The scene appears to bring the A story to

closure, but it does not. The next scene shifts back to the B story. In it, Lori tells Brad that the partnership wants Denny to suffer a humiliating public defeat. The next scene—in which Christine makes her reappearance—constitutes the midpoint of the A story. Christine's reappearance takes the A storyline in a new direction by suggesting that Christine is romantically attached to Alan. The next scene is the sanctions hearing (B story). It runs over three minutes, making it the longest scene in the episode. The sanctions hearing functions as the climax of the B story but occurs only 24 minutes into the episode—far earlier than the climax of the A story.

Ten additional scenes follow the sanctions hearing. All but three of them relate to the A story. Thus, the remaining 14 minutes of the episode focus almost exclusively on the A story, which is still being developed and which, in fact, continues in the next episode.

The episode climaxes with the office party, which serves as the setting for a lengthy sequence involving four different scenes of varying lengths. Only one of these scenes relates to the B story—a nearly two-minute conversation between Paul and Denny on the balcony. The other three relate to the A storyline, although the scene between Alan and Lori in Lori's office is more tangential than the other two.

Somewhat unusually for the series, the episode ends with a cliffhanger, namely, Christine's revelation that she will be staying in Boston because she has been rehired by her old firm. The episode does not resolve the Alan/Christine/Sally love triangle; indeed, the ending appears to confirm Christine's continuing attachment to Alan and underscores the threat it poses to Sally, who is shown looking distraught in cutaway shots as Christine and Alan talk.

7.09 Review questions

1. If you had the power to do so, would you ban TV commercials? If so, what financing mechanism would replace commercial sponsorship of TV programming (see ¶7.01.1)?

2. Choose a recent televised lawyer show other than *Boston Legal.* Can you trace the ancestry of the show you've chosen to *Perry Mason, The Defenders,* or *L.A. Law* (¶7.02)?

3. What do you think about the representation of female attorneys Tara Wilson, Lori Colson, and Sally Heep in the episodes of *Boston Legal* you watched? Consider their personal lives as well as the way they act as lawyers, how other lawyers treat them, how they dress, and how they treat each other (¶7.02.6).

4. Using your personal experience of watching movies in the theater and watching TV shows at home, how do your "conditions of consumption" of movies and TV differ (¶7.03.3)?

5. Do you agree that movie stories are more complex and demand more of the viewer than TV stories (see ¶7.03)?

6. The text contends that many movies have portrayed lawyers and law firms in a harshly negative light, but the treatment of lawyers and law firms on television is more favorable (¶7.04). Do you agree? Give examples of favorably portrayed TV lawyers. If lawyers are treated more favorably on TV than in the movies, what accounts for this difference?

7. Is the personal or business life of the lawyers depicted on *Boston Legal* different from the lives of the lawyers depicted in *Anatomy of a Murder* (Chapter 2), *To Kill a Mockingbird* (Chapter 3), *The Verdict* (Chapter 4), or *Counsellor at Law* (Chapter 5)? Choose one of these films and compare the personal and business life of a lawyer in that film to the personal and business life of one of the lawyers in *Boston Legal.*

8. William Simon (¶7.06) argues that lawyers should exercise "moral pluck" (or ethical relativism). This means that they should exercise discretion to make wise moral and ethical choices, rather than relying on abstract and absolutist principles of the rules of legal ethics. Consider the decisions taken by the *Boston Legal* lawyers that raised ethical issues (see ¶¶7.06.1 to .4, or you can consider other ethical issues you spotted in *Boston Legal* episodes that weren't discussed in ¶¶7.06.1 to .4). Do you think any of these decisions were justifiable under a moral pluck theory even if they violated the ethics rules?

9. Consider the need for lawyers to maintain role differentiation and the gulf between "ordinary morality" and a lawyer's "role morality" (¶7.07.2). Should a lawyer undertake the zealous defense of a person who the lawyer knows has committed some vicious and horrible crime (without introducing testimony the lawyer knows is perjured)? Could you do it?

10. Lori Colson makes an argument during her closing on behalf of her client Warren Litch that she knows is not based on the actual facts of the case. Do you think lawyers should be allowed to do this (see ¶7.07.1)?

11. Try charting the scenes and storylines of "Catch and Release" (see ¶7.08). How many scenes are there? How many storylines? What is the longest scene in the episode?

12. How does Christine's wardrobe change over the course of the episode discussed in ¶7.08? The episode climaxes with her showing up at the office party in a stunning cocktail dress. How does the episode use her wardrobe in earlier scenes to build to this scene?

Notes

1. The episodes on *Boston Legal,* Disk 1, Season 1, are entitled "Head Cases," "Still Crazy After All These Years," "Catch and Release," and "Change of Course." The discussion in this chapter largely concerns those four episodes. Each one runs about 42 minutes, so students are assigned to watch about 168 minutes of programming to prepare for this class. For instructors with limited time (such as those who show the episodes during class), one or more of the episodes can be cut.

 Instructors have a good choice of television shows available on DVD that can be used as alternatives to *Boston Legal.* Consider *Perry Mason, L.A. Law* (the first two seasons are presently available on DVD), *The Practice,* or *Ally McBeal.* Newer shows, including *The Good Wife, Harry's Law,* and *Suits,* among others, are available. Many of these shows are also available from streaming video services. Other instructors may want to assign DVDs of *Judge Judy* and structure the class around the important subject of daytime courtroom reality shows.

2. On average in 2010, Americans watch over 34 hours of television each week (not counting hours spent watching television content on other platforms such as mobile devices). See http://blog.nielsen.com/nielsenwire/wp-content/uploads/2011/04/State-of-the-Media-2011-TV-Upfronts.pdf

3. For a readable and comprehensive treatment of the history and economics of commercials, see Mittell 2010, ch. 2. The material in ¶7.01.1 is based on Mittell's discussion.

4. For collections of essays on legal television, see Robson & Silbey, eds. 2012; Asimow, ed. 2009; Jarvis & Joseph 1998. For discussion of British legal television, see Robson 2007; Greenfield, Osborn & Robson 2009. For a survey of the history of legal television through 2005, with emphasis on whether it reinforced dominant ideologies, see Mezey & Niles 2005, 114–33.

5. See Nevins 2009; Bounds 1996; Rosenberg 1998.

6. See Papke 1998; Stark 1987; Ginsburg 2009.

7. One episode, "Iron Man," is available on YouTube. http://www.youtube.com/watch?v=oMqPM0txZoY

8. Episodes of *Boston Legal's* five seasons are summarized at http://www.imdb.com/title/tt0402711/episodes. In recent years, numerous TV series based on law firm life have arrived and swiftly disappeared. They include *Century City, The First Years, The Girls Club,* and *Eli Stone.* Some of these series, like *Century City,* portrayed the firm as a decent place to work. Others, like *The Girls Club,* were harshly negative.

9. The relationship between viewer and television protagonist can be described as parasocial and bears a strong resemblance to actual social relationships (Cohen 2009, 223–36).

10. The film *North Country* (2005) is an excellent treatment of sexual harassment (see Korzec 2007). Perhaps the best film on the subject is *Brilliant Lies* (1996), in which an Australian tribunal has to resolve what actually happened in a typical he-said-she-said situation. David

Mamet's *Oleanna* (1994) is a good example of the damage that a false accusation of sexual harassment can do to the accused.

11. The ABA Model Rules are on line at http://www.americanbar.org/groups/professional_responsibility/publications/model_rules_of_professional_conduct/model_rules_of_professional_conduct_table_of_contents.html. See discussion of the Model Rules at ¶2.05.

12. http://www.law.cornell.edu/ethics/ma/code/MA_CODE.HTM

13. An interesting exception to this generalization occurs in *Counsellor at Law*, discussed in chapter ¶5.08.3. In representing Breitstein, lawyer George Simon allows Breitstein to introduce alibi testimony that Simon knows is perjured. When Simon gets caught, he is in a world of trouble.

PART II
Criminal Justice

The Criminal Justice System

Assigned Television Show: *Law & Order*
(Season 5, episodes 1–4) [1]

8.01 The U.S. criminal justice process [2]

This section provides explanatory material on the criminal justice process. (Law students who are already familiar with criminal procedure may wish to skip this part.)

8.01.1 Goals of the criminal process

The criminal process embodies three conflicting goals. First, the government has a monopoly on the legal use of force. We don't want the victims of crime to engage in personal vendettas. Instead, we want the police to catch criminals and prosecutors to convict them. Second, we want to protect individuals from being convicted of crimes they did not commit. Third, we want these two goals to be realized within a framework of limited government power.

This last point is particularly important. Most of the limits on the power of police and prosecutors are contained in constitutional amendments called the Bill of Rights (see ¶9.04). Others are contained in state constitutions, federal and state statutes and rules of criminal procedure, and judicial decisions. For example, the police could uncover evidence of law-breaking if they randomly searched one home on every block, but they are not allowed to do it because of the Fourth

Amendment's prohibition on unreasonable search and seizure. As a society, we prefer that crime go undetected than to allow the government such arbitrary power.

8.01.2 Investigation and searches

The criminal process begins with a police investigation, often including a search of the suspect's home, business, or car. The Fourth Amendment to the U.S. Constitution provides: "The right of the people to be secure in their persons, houses, papers, and effects, against unreasonable searches and seizures, shall not be violated, and no warrants shall issue, but upon probable cause, supported by oath or affirmation, and particularly describing the place to be searched, and the persons or things to be seized." These brief words have been interpreted and applied in countless judicial decisions. Essentially, the Fourth Amendment protects people's reasonable expectations of privacy. Thus, it applies not only to physical searches of their home or car but also to wiretapping or other electronic surveillance. Search and seizure law is complex, is constantly changing, and is politically controversial (conservative judges often try to narrow Fourth Amendment protections while liberal judges resist such narrowing).

The police can legally seize evidence through a search warrant, as they do when they search Martha Bowen's apartment in "Blue Bamboo" and find books about battered woman syndrome (BWS); when they search Steve Martell's home in "Family Values" and find Laura Madsen's blood in the bathroom and Martell's thumbprint next to it; and when they search Michael Dobson's house in "Coma" and find a blood-stained jacket. To obtain a search warrant, the police must apply to a judge or a magistrate and demonstrate the presence of "probable cause." Probable cause means facts within the officer's knowledge that would cause a reasonable person to believe that the items described in the officer's affidavit will be found in the place to be searched. This is a vague standard and, as we see in several episodes, the police or prosecutor must sometimes talk a judge into issuing the warrant. The same probable cause standard applies when the police or the district attorney seek a court order requiring a suspect to provide physical evidence such as a blood sample or pubic hair as in "Blue Bamboo."

The police can conduct a search without a warrant when it is "reasonable" to do so, and it is not practical to seek a warrant. A warrantless search is permitted at the time the police arrest a suspect. They can also search the area within the arrestee's control and the immediately adjacent area (such as a closet). Many warrantless searches also occur after the occupant of a house or driver of a car consents to it.

What happens if the police have engaged in an illegal search and seizure, such as occurs when a judge issued a warrant without probable cause or a warrantless search was unreasonable? The evidence produced by an illegal search *must be excluded,* meaning that the prosecution cannot introduce it into evidence. The "exclusionary rule" is controversial, since it may allow a guilty defendant to go free because the police made an error—and search and seizure law is so complicated and changes so rapidly that such errors are inevitable.

Those who favor the exclusionary rule argue that it is the only effective *deterrent* against police misconduct and thus is worth its costs. However, the effectiveness of the rule as a deterrent is questionable. Many violations occur in good faith. In these cases, the police are trying to comply with the law, but they misunderstand it or the case presents a borderline issue. In other cases, the police know the rules but decide to ignore them. In these situations, police officers are not deterred by the exclusionary rule.

8.01.3 The first appearance and the process of questioning a suspect

After arrest, the suspect, who is often referred to as the *defendant* or the *accused,* will generally be taken to the police station to be processed (*booked*). In order to question a suspect in custody, the police must give the *Miranda* warnings (see ¶1.05.1), as we see them do in virtually every episode of *Law & Order* (*L&O*). The police must stop questioning if the suspect requests a lawyer. The *Miranda* rule is intended to protect the suspect's constitutional right to a lawyer as well as to guard against coerced confessions. If the police violate *Miranda,* any statements made by the defendant while in custody must be excluded from evidence. However, many suspects *waive* their *Miranda* rights and agree to talk with the police without the benefit of legal counsel.

A suspect must be taken before a judicial officer *without unnecessary delay,* usually within 24 to 48 hours. An attorney is appointed if the suspect can't afford one, and the suspect will be informed of the charges against him. In some states, the defendant is asked to enter a plea during the first appearance (guilty or not guilty), but in other states the defendant enters a plea at the arraignment (discussed below).

Bail. At the first appearance, the judge will set *bail,* meaning an amount the defendant must pay to be released from prison prior to trial. Usually bail is advanced by a bail bondsman in return for a premium of about 10% of the total. If the defendant fails to

appear for trial, the bail is forfeited. Generally, bail will be denied if the defendant is a flight risk or in the case of very serious crimes such as murder. In the case of minor crimes, the suspect may be released "on his own recognizance" ("OR"), meaning without bail.

Obviously, getting out on bail prior to trial is vital for defendants who need to carry on with normal life as long as possible and to assist in the preparation of their defense if the case goes to trial. On the other hand, bail is a risky proposition. A defendant on bail may flee or steal money to pay attorney's fees. In "Coma," the defendant apparently tampers with a key witness, his seven-year-old daughter, by getting her to "forget" a fight between the defendant and the victim on the night of the shooting.

8.01.4 Preliminary hearing or grand jury

The judge at the first appearance normally schedules a *preliminary hearing*. At the preliminary hearing the judge will rule on defense motions, such as suppression of evidence because it was unlawfully seized. At the preliminary hearing, the prosecution must introduce sufficient evidence to persuade a judge that there is *probable cause* to believe that a crime was committed and the defendant committed it. The defense lawyer can cross-examine the prosecutor's witnesses but often will not do so to avoid tipping the defense strategy. The legendary Perry Mason (see ¶7.02.1) won every case by demonstrating (almost always during the preliminary hearing) that the inept prosecutor had the wrong man.

The grand jury. The prosecution may choose to seek an *indictment* by the *grand jury* instead of a preliminary hearing. In some states and in the federal courts, a grand jury indictment is mandatory for serious offenses. The prosecutor presents evidence to the grand jury in a closed session, and the defense has no opportunity to question witnesses. Sometimes prosecutors use the grand jury as an investigative tool (by compelling witnesses to show up and provide testimony) and often secure a grand jury indictment *before* arresting the suspect.

Following the preliminary hearing or indictment, the defendant is *arraigned.* If the defendant did not enter a plea at the first appearance, the judge will ask the defendant to plead guilty or not guilty at the arraignment.

Plea bargains. In the great majority of cases (well over 90%), the prosecutor and the defense lawyer negotiate a *plea bargain,* in which the defendant agrees to plead guilty (often to a reduced charge or in return for a reduced sentence). We see plea bargains in "Second Opinion" and "Family Values," in which Dr. Haas and Steve Martell plead guilty to voluntary manslaughter. Sometimes a defendant will agree to testify against other defendants in return for a reduced sentence.

Plea bargaining is controversial, but it serves the interests of both sides. Because resources are limited, the criminal justice system would grind to a halt if every case were tried. In a real sense, plea bargaining *is* the criminal justice system, since most criminal cases are disposed of through negotiated plea bargains. In the system of plea bargaining, guilt is determined by a prosecutor's discretion rather than by a jury. As a result, the Supreme Court has held that a plea bargain can be overturned because of incompetent assistance by the defendant's lawyer (*Missouri v. Frye,* 2012; see also Salzmann 2011).

8.01.5 The criminal trial

At a criminal trial, the defendant has the right to be represented by a lawyer in any case in which imprisonment could occur. In most cases, defendants cannot afford to pay a lawyer and are represented by a *public defender.* Defendants have the right to represent themselves if the judge rules they are competent to do so.

The defendant has a right to trial by jury for any crime carrying a potential punishment in excess of six months. Traditionally, there are twelve jurors, but the Supreme Court has allowed the states to use six-person juries. In federal criminal cases and in almost all the states, the jury must be unanimous to either acquit or convict. Anything short of unanimity is called a *hung jury;* the prosecutor can choose to dismiss the case after a hung jury or can try the case over again. (A couple of states permit non-unanimous verdicts in criminal cases, and many permit non-unanimous verdicts in civil cases).

The prosecution in a criminal case must establish the defendant's guilt *beyond a reasonable doubt.* This is a much higher standard than the *preponderance of the evidence* test used in civil cases (meaning a more-than-50% probability). (See ¶¶8.05 for further discussion of burden of proof in criminal cases, 12.01.7 for burden of proof in civil cases.) The most common defense argument is that the prosecution has failed to prove its case beyond a reasonable doubt.

The first step at a trial is choosing a jury; in most states, the lawyers question potential jurors (this is called *voir dire)* and can move to dismiss them *for cause* (for example, if the juror has made up her mind about the case) or without cause (a *peremptory challenge*). (Peremptory challenges are further discussed in ¶9.09.2.) The next steps are opening statements, the prosecution case, the defense case, sometimes rebuttal by each side, and closing arguments. The types of evidence used to establish the prosecution or defense case (eyewitness testimony, circumstantial evidence, expert testimony, and physical evidence are discussed in ¶8.05). The judge instructs the jury about the law and the jury retires, deliberates, and reaches a verdict.

In the U.S. system, a defendant is not required to testify because the Fifth Amendment provides that no person "shall be compelled in any criminal case to be a witness against himself." The jury is instructed not to draw any negative inferences about the defendant if he or she does not testify (but they often do so anyway). However, the defendant may choose to testify as part of the defense case. Whether the defendant should testify presents difficult tactical choices. The jury wants to hear the defendant testify in order to make judgments of the defendant's credibility. However, if the defendant chooses to testify, he becomes vulnerable to cross-examination by the prosecution which may destroy his credibility. In addition, the defendant's credibility can be impeached by his prior criminal convictions (which is normally not possible if the defendant does not testify). The decision to testify is up to the client, not the lawyer, but defense lawyers usually counsel the defendant not to take the stand. Did Martha Bowen's testimony help or hurt her in "Blue Bamboo"?

If the defendant is convicted, the judge will impose a sentence, usually at a separate hearing after reviewing relevant information. If the prosecutor seeks the death penalty, there is a separate "penalty phase" at which each side presents evidence as to whether the death penalty should be imposed (see ¶11.06). Defendants who are found not guilty by reason of insanity are normally committed to a psychiatric facility and kept there until the professionals decide that they are no longer a danger to society or themselves (this did not happen in *Anatomy of a Murder,* apparently because the insanity was temporary). Defendants can appeal to a higher court (sometimes all the way to the state or U.S. Supreme Court), arguing that legal errors were made so that the verdict cannot stand.

8.02 *Law & Order*—the television show

One reason that we chose *L&O* as the vehicle to study the criminal justice system is that its twenty-year run on TV is remarkable (see ¶8.02.2). Another reason is that most legally oriented movies and TV shows focus on defense lawyers. For balance, we wanted a chapter that looks closely at the work of police and prosecutors. The shows tell great stories and pay meticulous attention to the details of investigation and prosecution. In the first four episodes of Season 5 (which we chose because the first episode introduces Sam Waterston as Jack McCoy), the prosecutors lose a couple of cases ("Blue Bamboo" and "Coma"), which is typical of the unpredictable nature of criminal justice.

Notice that the typical criminal law story in pop culture focuses on defendants who are charged with crimes of which they are factually innocent, such as *To Kill a Mockingbird* (Chapter 3) or *12 Angry Men* (Chapter 9), or who have valid legal or moral excuses, as in *Anatomy of a Murder* (Chapter 2) or *A Few Good Men* (Chapter 10). *L&O* episodes typically are quite different. Here, the defendants are usually factually guilty of committing murder, but the prosecutors confront difficult issues of whether they should be prosecuted (as in "Second Opinion") or serious obstacles in proving guilt (as in all four episodes assigned for this chapter). "Coma" is unusual for an *L&O* episode, in that the prosecutors charged the wrong person as the killer—or did they?

8.02.1 Dick Wolf

Dick Wolf is a writer, producer, and creator of film and televised drama (most of it about lawyers or police). He is one of the most creative and successful TV producers of all time. Born in 1946, Wolf started out in advertising and wrote and produced over 100 commercials. He got a job as a script consultant for *Hill Street Blues* in 1985. When that show was cancelled, he started his own production company, Wolf Films, in 1988. He went on to create *L&O*, which premiered in 1990. The show had numerous successful spinoffs, including *Law & Order: Criminal Intent*, *Law & Order: Trial by Jury*, and *Law & Order: Special Victims Unit*. Take a look at Wolf's filmography on the Internet Movie Database. You'll be surprised by the number of feature films and television shows in which Wolf has been involved.

8.02.2 The puzzling success of Law & Order

L&O tied for the longest running drama in television history, running twenty years from 1990–2010. *Gunsmoke* also ran twenty years (1955–75). In addition to its long

run, *L&O* has been hugely successful in syndication, with numerous cable channels showing *L&O* reruns every day. Each episode stands on its own, without character arcs (see ¶7.03.1), so that viewers can enjoy an episode without knowing anything about prior shows. In contrast, *Boston Legal* (Chapter 7) has character arcs, so that viewers who haven't seen prior shows will feel they have missed something. Serials like *Damages* or *Murder One* are unsuitable for syndication (but work well on DVDs). *L&O* is one of the most respected television shows of all time; it received eleven consecutive Emmy nominations for outstanding drama, winning the award in 1997.

Perhaps the inspiration for *L&O* came from an earlier series called *Arrest & Trial,* which ran from 1963–64 and starred Chuck Connors and Ben Gazzara. Like *L&O, Arrest & Trial* was split into two segments, the first of which concerned a police investigation and the second of which involved a trial. The difference, however, was that the second half concentrated on criminal defense rather than prosecution, so that the cops caught a bad guy in the first half-hour, and the defense lawyer tried to get him off in the second half-hour. The *L&O* formula, which involved police and prosecutors who are on the same side, worked much better.

The twenty-year tenure of *L&O* seems to defy conventional wisdom about what is likely to succeed on television. Its plots are complex and fast moving. They require the audience to pay close attention. If you get up to go to the bathroom, you're likely to lose the thread of the story. The writers try hard to get the criminal law and procedure right, and the cops and the lawyers often engage in serious discussions about technical legal issues. The stories are morally ambiguous and the audience is often not sure which side it should be rooting for.[3] Many of the shows dwell on conflicts between the criminal law and the common-sense requirements of justice, as well as the prosecutors' attempts to reconcile the two (Keetley, 1998). This is not easy material for a mass television audience to understand and appreciate. The show rolled right along, even though all of the cast members were replaced by other actors—often, several times. *L&O* episodes have no sex or violence (except sometimes for a brief clip at the beginning of the episode showing the crime) and reveal little about the personal life of its characters. The real star of the show is the criminal justice system, rather than any of the people who work in it. Given all this, what was it about *L&O* that attracted a large enough viewing audience to keep the show on the air for twenty years?

8.02.3 *The politics of* Law & Order [4]

Before it became indelibly associated with the TV show, the phrase "Law & Order" was better known as a campaign slogan—one that Republican presidential nom-

inees used with considerable political success. To its liberal critics, the slogan "law and order" consisted of racist code words.[5] By the late 1980s, however, liberals had begun to recognize that dismissing the desire of voters for "law and order" was not a recipe for electoral success.

L&O was conceived and born during this changing political climate. The pilot was filmed in 1988, and the first episode aired on September 13, 1990. The politics of *L&O* are often dismissed as strongly conservative (see Rapping 2009; Podlas 2008). However, the show features villains that include anti-abortion protestors, greedy doctors and business executives, and right-wing militiamen, which makes this claim a bit hard to swallow. And as Dick Wolf told *The New York Times* in 1992, "You'd have a hard time finding anybody who associated with this show who would identify himself as a conservative Republican."[6]

Early in the evolution of *L&O*, the prosecutors were liberals of various stripes. Later, more conservative characters joined the prosecution team, such as Assistant District Attorneys (ADAs) Alexandra Borgia and Abbie Carmichael, Executive Assistant District Attorney (EADA) Mike Cutter, and District Attorney (DA) Arthur Branch. The police, however, remained largely conservative. All this was a deliberate attempt to reconfigure the politics of the crime drama by fusing the generally conservative politics of the cop show with the liberal politics of lawyer shows.

Robert F. Kennedy appears to have been the inspiration for *L&O*'s two principal characters, EADA Ben Stone, played by Michael Moriarty (seasons 1–4), and Jack McCoy, played by Sam Waterston (seasons 5–20). Robert F. Kennedy (RFK) was attorney general of the United States for three years while his brother John F. Kennedy (JFK) was president. He initially came to public attention through his relentless pursuit of Jimmy Hoffa while working as a staffer on Capitol Hill. At least in liberal legend, RFK transcended the political polarization of the Sixties by magically winning the support of both working-class whites and inner-city blacks with a tough-guy liberalism that fused liberal compassion with conservative rhetoric about law and order and personal responsibility. In the characters of Ben Stone and Jack McCoy—both Irish Catholics—*L&O* attempted to re-create the RFK myth by creating characters who practiced tough-guy liberalism. But the series changed dramatically between its first season (when Stone first appeared) and the fifth season (when McCoy appeared).

8.02.4 Ben Stone and Jack McCoy

In the first five seasons of *L&O*, New York City is constantly on the edge, with racial and ethnic tensions threatening to boil over at any time. Ben Stone served as the soft-spoken, calming voice of reason in a city gone mad. His role was that of a moral

Figure 8.1. *LAW & ORDER*. Season 5 cast (left to right):—Lt. Anita Van Buren (S. Epatha Merkerson), Det. Mike Logan (Chris Noth), Exec. ADA Jack McCoy (Sam Waterston), Det. Lennie Briscoe (Jerry Orbach), ADA Claire Kincaid (Jill Hennessy). NBC/Photofest. © NBC.

arbiter who, through dispassionate argument and analysis, convinces a jury to render the legally and morally correct verdict.

With his lanky frame and large flop of sloping hair, Jack McCoy bears a distinct physical resemblance to RFK. Their temperaments are also similar. Driven to win at nearly any cost and possessed by a moral fervor that can strike others as arrogant and self-righteous, McCoy embodies the moral passion and ruthless competitiveness of RFK. However, McCoy is a more down-to-earth figure than RFK. The son of a long-time police officer, McCoy is no child of privilege. He lacks Stone's brooding, introspective quality. He is a man of action, not reflection.

McCoy's character emerges in the first episode of season five ("Second Opinion"). Among other things, we learn that he (1) had romantic relationships with the three previous ADAs who worked under him (marrying one of them), (2) works lying down (we see him reading documents while stretched out on his sofa), (3) changes into jeans before leaving work (and disrobes with Claire Kincaid in the room), (4) enjoys a drink with his colleagues (or at least his female colleagues) after work, and (5) rides a motorcycle (we see him leaving the office with a motorcycle helmet under his arm). In short, he is more casual, sociable, and relaxed than Ben Stone. (This, by the way, is more personal information about McCoy than is revealed in the following fifteen years.)

We also learn in that first episode that McCoy is a relentless prosecutor who will employ whatever legal theory he has to in order to prosecute a defendant who offends his moral sensibilities. Over the opposition of DA Adam Schiff and Claire Kincaid, he prosecutes Dr. Nancy Haas for murder. In contrast to the seemingly affectless Stone, McCoy marshals the full range of affect—from a raised voice to raised eyebrows—to instill in the jurors the moral outrage he feels.

8.02.5 Adam Schiff: The Voice of Moral Realism

On paper, DA Adam Schiff seems a bit clichéd—the crusty old-timer who sees the world through seasoned and somewhat cynical eyes, like Lou Grant (Ed Asner) in *The Mary Tyler Moore Show*. But thanks in part to deft writing and Steven Hill's richly detailed performances, Schiff emerges as the voice of moral realism—a veteran prosecutor who recognizes the practical and political realities of criminal prosecution (e.g., plea bargaining, getting a favorable judge, maintaining the public image of the DA's office) without falling prey to an easy cynicism about the criminal justice system. With a portrait of Oliver Wendell Holmes prominently displayed on his office wall, Schiff has clearly taken to heart Holmes' (1881) famous dictum that the "life of the law has not been logic; it has been experience."

8.03 Criminal law on *Law & Order*

Every *L&O* episode contains references to criminal law issues, a few of which we discuss here.

8.03.1 Degrees of homicide

The vast majority of criminal cases in pop culture concern homicide and the question is usually "who-dun-it." However, even if we know the killer's identity, there is always an issue about what type of homicide the killer is guilty of. As we descend the homicide ladder, the penalties become less severe.

At the top of the ladder is first degree murder, meaning a killing with premeditation. First degree murder attracts the heaviest sentence (sometimes the death penalty), because we believe that a planned murder is the most worthy of blame. The next rung down the ladder is second-degree murder, often described as killing "with malice aforethought." Generally second-degree murder describes a killing that is deliberate and blameworthy, but in which the prosecutor can't prove premeditation. Third on the ladder is voluntary manslaughter (often referred to on *L&O* as "man 1"), meaning a killing that was deliberate but caused by some form of provocation. For example, a killing resulting from a bar fight or from the discovery of a spouse committing adultery qualifies as voluntary manslaughter. Fourth on the list is involuntary manslaughter ("man 2"), which is a killing caused by reckless behavior. In addition, numerous other statutes (such as vehicular homicide) punish conduct resulting in death.

As discussed above (¶8.01.4), homicide cases are often plea bargained, so that the defendant pleads guilty to a lesser degree of homicide than the one originally charged by the prosecution. In addition, juries have power to find the defendant guilty of a *lesser-included offense,* so that, for example, they can find the defendant guilty of voluntary manslaughter even though the prosecutor charged the defendant with first or second-degree murder.

8.03.2 Self-defense and the battered woman syndrome

Often, the key issues in a homicide case concern either justification for the killing (such as self-defense or the defense of others) or excuse (such as insanity, entrapment, or duress). In self-defense cases, defendants must establish that they used a *reasonable amount of force* against an adversary and *reasonably believed* a) that they were in *imminent danger* of unlawful bodily harm and b) that the use of force was necessary to avoid the danger (LaFave 2010, §10.4). Note that the "reasonably

believes" standard is a double test—defendants must actually believe that they are in imminent danger that requires the use of deadly force (a subjective test) *and* a hypothetical reasonable person in the defendant's shoes would also have believed the same thing (an objective test).

In "Blue Bamboo," Martha Bowen claimed self-defense as a justification for killing Shiunro Hayashi. She cannot meet the normal elements of the defense—she did not believe she was in imminent danger of harm from Hayashi when she voluntarily went to his hotel room (or she wouldn't have gone there), and a reasonable person would not have believed it either. She also contends that she was afraid that Hayashi would hunt her down in New York because she had gotten him in trouble with the Tokyo police, so she had to kill him first, but again this situation did not present imminent danger of harm. Bowen claims her fear was at least subjectively reasonable because she suffered from battered woman syndrome (BWS), which rendered her unable to make a reasonable judgment about whether she was in imminent danger.

BWS is frequently asserted by women who have been the victim of domestic violence and have killed men because they fear additional violence although it is not imminent (frequently the man is sleeping when killed). This defense is based on psychological studies that seek to explain why women do not leave abusive relationships. There is a cycle of violence in which a man abuses a woman, then apologizes and promises it won't happen again. Also, abused women often seem unable to contemplate available escape routes (such as battered women's shelters). Considerable case law and academic literature support the BWS defense (Burke 2002).

If you had been on Bowen's jury, would you have voted to acquit her on the basis of self-defense and BWS? Or did the jury in the Bowen case have a different reason for acquitting her?

8.04 Prosecutorial discretion

Prosecutors have discretion to decide whether to prosecute a particular case brought to them by the police, how to investigate the crime, what charges to bring against the suspects, or whether to enter into a plea bargain. Obviously, not every person that the police suspect of committing a crime is actually charged (or could be, given the limited resources of the criminal justice system). Prosecutors must allocate resources to the most serious offenses and the most culpable defendants, to cases in which justice would be served through criminal prosecution (as opposed to some other method of remediation), and to cases in which they have better evidence and thus a better chance of securing a conviction. In contrast to defense lawyers—whose

job is to defend a particular client—the prosecutors owe a duty to do justice as well as to convict the guilty (see Griffin 2001; Zacharias 2001).

Rules relating to prosecutorial discretion. ABA Model Rule 3.8(a) provides that a prosecutor "shall refrain from prosecuting a charge that the prosecutor knows is not supported by probable cause." The comment to this rule states: "A prosecutor has the responsibility of a minister of justice and not simply that of an advocate. This responsibility carries with it specific obligations to see that the defendant is accorded procedural justice and that guilt is decided upon the basis of sufficient evidence." The ABA's Standards for Criminal Justice (which set forth nonbinding professional obligations) emphasize that a prosecutor's charging decision should take account of "the prosecutor's reasonable doubt that the accused is in fact guilty."

In practice, there are virtually no checks on prosecutorial discretion. In our criminal justice system, there is no private prosecution. If a prosecutor refuses to charge someone with a crime, the victims are out of luck. If a prosecutor irresponsibly charges someone with a crime despite a lack of supporting evidence, there is little the accused can do about it except fight the charges in court or agree to a plea bargain. Prosecutors are immune from liability for damages brought by persons they might have wronged. They are rarely subjected to professional discipline by state ethics boards or through internal proceedings in the DA's office.

Some of the best episodes of *L&O* center on prosecutorial discretion. Did Jack McCoy abuse his discretion by prosecuting Nancy Haas for murdering Ann Bennett in "Second Opinion"? Bennett had terminal breast cancer. Perhaps she would have lived longer if she had a radical mastectomy plus chemotherapy instead of consuming Dr. Haas's concoction, but she obviously didn't want her breasts removed. Claire Kincaid urged that Haas was not criminally responsible because, as she saw the case, Haas was offering women an alternative therapy to breast cancer surgery. Indeed, Haas did not kill anyone with a gun or other weapon, only with a lie. DA Adam Schiff thought Haas was guilty only of larceny. McCoy thought Haas was guilty of murder because she claimed that therapy would cure breast cancer and because Bennett might have lived longer if she had breast cancer surgery instead of the apricot seed therapy. Ultimately, Kincaid came around to this view also.

Did McCoy violate prosecutorial ethics when he prosecuted Maggie for the murder of her mother Laura in "Family Values"? McCoy did not know who killed Laura and dumped her body in the river. It could have been Maggie or her stepfather Steve Martell, or both of them. McCoy's tactic was to prosecute Maggie, thus forcing Steve Martell to testify under oath against her. This tactic assumed Maggie would abandon Martell and tell the truth about what actually happened after Martell betrayed her on the stand.

In "Coma," the victim Sandra Dobson was in an irreversible coma with a bullet lodged in her brain. McCoy wanted to get the bullet in hopes of matching it to Michael's gun. Surgery to remove the bullet was more dangerous to Sandra than installing a shunt in her brain. The attending physician advised against the surgery. Sandra died after the surgery (which enabled McCoy to up the charge from attempted murder to second-degree murder). The bullet did not match Michael's gun. Of course, Sandra could not consent to the surgery, so someone else had to consent, but everyone involved had a conflict of interest. Michael refused consent to the surgery. Obviously he had a conflict. The prosecutors wanted to get critical evidence rather than lengthen Sandra's life, so they had a conflict also. Sandra's sister, Kathleen O'Brien, hated Michael and feared he would get custody of Sandra's children if he was acquitted (he would also get all of Sandra's money), so she had a conflict. Did the prosecutors and O'Brien act unethically in this case?

8.05 The indeterminacy of past facts

A fundamental reality of both the criminal and civil justice systems is that we cannot know with certainty what happened in the past. The primary purpose of a trial is to determine the truth about past events. In "Second Opinion," did Dr. Haas tell Ann Bennett that Haas' concoctions could cure breast cancer or did she merely offer it as an alternative to conventional therapy? In "Coma," who shot Sandra Dobson? In "Family Values," who killed Laura Madsen? In "Blue Bamboo," what was Martha Bowen's state of mind when she shot Hayashi? Nobody except the defendant knows (sometimes, even the defendant can't be certain, especially when the issue is his or her own state of mind). Everyone else must guess—the police, the prosecutor, the judge and the jury. In a trial, we seldom know anything for sure. Witnesses and suspects often lie to the police and, despite being under oath, they lie in court as well. Even if they want to tell the truth, their memories about an event that occurred in the past have faded. Even a suspect's confession can be fictitious if the conditions of police questioning are coercive or the suspect is mentally ill.

Since there is no way to actually uncover the truth about past events, the job of skillful lawyers in any civil or criminal trial is to discover a plausible narrative that fits the provable facts and that leads to the desired result (conviction or acquittal, or judgment for plaintiff or defendant) and then to tell that story persuasively (or to attack the opponent's story). Under this theory, jurors assess the evidence holistically, using their own experience and common sense, to decide which of the competing story lines best fits with what they've heard. It helps, obviously, if a narrative served up by the lawyers is familiar to the jurors from the news or from pop culture. (For discussion and criticism of the story model, see Sklansky 2012.) It also helps if the story can somehow be told visually through a video or computer animation because visual images seem to have greater persuasive and emotional power than spoken or written words (Sherwin 2012).

"Blue Bamboo" is an example of lawyers telling competing stories—was Martha Bowen's killing of Shiunro Hayashi the result of an act of self defense by a terrified and battered woman or did was it simply a revenge killing? Did the jury buy into yet another narrative—Japanese men abuse women and Hayashi had it coming? In *Anatomy of a Murder,* was Lt. Manion's killing of Barney Quill the result of temporary insanity from learning that Quill had raped Laura Manion, or was it an act of revenge against Quill for having an affair with Laura?

The rules about burden of proof tell us how certain the fact-finder must be of the decision in this world of indeterminacy. In a civil case, the rule is preponderance of the evidence; the judge or jury only needs a more than 50% probability to find a fact in favor of either the plaintiff or the defendant. If it's exactly 50–50 (as in some he-said-she said situations), the defendant wins. In criminal cases, however, the rule is that guilt must be proved "beyond a reasonable doubt." Nobody knows exactly what probability is required to satisfy that standard, but it probably means something like a 90% probability. In other words, even if the jury scrupulously respects the "beyond a reasonable doubt" standard (which they often don't), there's still a chance (perhaps 10%) that a judgment that the defendant is guilty could be wrong.

There are four types of evidence used at trials and all four are fallible, though in different ways. Direct evidence means eyewitness testimony of what happened. But it is well known that identifications by eyewitnesses are often mistaken (especially in cross-racial identifications). In addition, eyewitnesses are often wrong in relating exactly what they saw occur. The same witnesses, who are entirely truthful, will often have quite different accounts of what they saw in a shooting or a traffic accident. The famous film *Rashomon* (1950) is a cinematic example of this—a series of witnesses to the crime tell conflicting stories of what they saw. In addition,

eyewitnesses are notoriously subject to suggestions by the police that the person they saw was the suspect the police want to convict.

Circumstantial evidence requires us to draw an inference of what happened. If the cops catch someone fleeing from the house where a murder was committed, the odds are pretty good that he committed the murder, but it is not certain. He might have found the dead body and fled to avoid getting involved. If Michael Dobson knew that Sandra wanted a divorce and had discovered the location of his safe deposit box, those facts raise an inference that Michael killed her to avoid a costly divorce. But it's only an inference—a probability—and it could be wrong, as it was in "Coma." (Or was it?) In "Family Values," a good deal of circumstantial evidence pointed to Victor Connor as the killer of Laura Madsen, but the cops ultimately determined that he was not involved in her death. Many times, the prosecution has only circumstantial evidence as proof of guilt (that is, there were no eyewitnesses). That accumulation of circumstantial evidence is often sufficient to satisfy the reasonable doubt standard (despite defense counsel's standard argument that "it's all a bunch of circumstantial evidence"). It helps if there are a number of independent bits of circumstantial evidence that all point in the same direction.

The third type of evidence is expert testimony which is necessary when the factual issues to be resolved require knowledge that a lay jury or even a judge would not possess. For example, experts had to testify about BWS in "Blue Bamboo," about insanity in *Anatomy of a Murder* (Chapter 2), about medical malpractice in *The Verdict* (Chapter 4), or about water pollution in *A Civil Action* (Chapter 12). But, as we see in "Blue Bamboo," experts frequently differ, so they are certainly not infallible. Indeed, experts are sometimes for sale. It is often possible to find experts to testify to anything you want if you pay them enough. The fourth type of evidence is physical evidence, such as photographs of a dead body, DNA tests on semen, fingerprints, a gun registered to the defendant, or a courtroom demonstration. Generally physical evidence is helpful in proving a case, and sometimes, as in the case of DNA, it can prove guilt beyond a reasonable doubt all by itself.

8.06 Prosecutors and defense lawyers on *Law & Order*

8.06.1 Crime control on Law & Order

As discussed above (¶8.02.3), *L&O* projects a tough-guy liberalism that fits well with the public's concern about crime and its desire for harsher punishment of criminals. Because of the show's phenomenal tenure (both on network and in syndica-

tion), its consistently expressed messages undoubtedly had a substantial impact on the viewing public. As discussed below (¶8.07), the show appears to be "realistic," in part because its stories are often "ripped from the headlines," and it employs precisely identified New York locations and a documentary feel. This enhances its impact on viewers.

What messages does the show send to its consumers about prosecutors? As we see it, the prosecutors are clearly and consistently represented as the good guys in the endless struggle against crime. The viewer is taught to trust the prosecutors' judgments about guilt and moral responsibility and to assume that they have exercised their discretion wisely. If their conduct is at times ethically questionable (see ¶8.04), it is in a good cause—convicting the guilty. If McCoy or Stone decided to prosecute, the viewer can safely presume the defendants to be guilty, rather than innocent until proved guilty. The various statutory and constitutional protections for the defendant—such as the Fourth Amendment's prohibition on unreasonable searches or the various evidentiary rules and privileges that prevent the prosecutors from introducing some incriminating evidence—are often treated as unpleasant technicalities that obstruct the search for justice.[7]

8.06.2 Prosecutors in popular culture

The majority of pop culture prosecutors have been negatively portrayed. On television, the classic example was *Perry Mason,* in which prosecutor Hamilton Burger *always* prosecuted the wrong person (see ¶7.02.1). Only inspired detective work and crafty cross-examination by Perry Mason spared the innocent person from being convicted (and probably executed). Because the great majority of legal movies and TV shows concern criminal cases and feature defense lawyers as underdog protagonists (often representing unjustly accused clients), the audience usually roots for the defense rather than the prosecutors. This was true of *Boston Legal* (Chapter 7) as well as *L.A. Law, The Practice, Harry's Law, The Good Wife,* and countless others (Asimow 2012). Prosecutors in most films and TV shows tend to be politically driven, overzealous, and thoroughly immoral.[8]

Similarly, numerous movies portray prosecutors in a bad light. Recall *Anatomy of a Murder* (chapter 4) as well as *A Few Good Men* (chapter 10). The same is true of countless other films. Consider these examples of bad prosecutors:

- *Conviction* (2010)—prosecutor refuses to release an innocent prisoner;
- *Night Falls on Manhattan* (1997)—overzealous and dishonest prosecutors;
- *A Time to Kill* (1996)—prosecutor cheats in numerous respects;

- *Primal Fear* (1996)—prosecutor is deeply involved in the crime;
- *Indictment* (1995)—prosecutor in sex abuse case is unethical and vindictive;
- *The Client* (1994)—unscrupulous and politically driven prosecutor is indifferent to child witness;
- *Presumed Innocent* (1990)—prosecutors are liars and bumblers, and the murder victim was a prosecutor who slept her way to the top.

A minority of movies have treated prosecutors favorably, however. Think of The Accused (1988) in which a prosecutor goes after spectators who cheered on a gang rape, and Ghosts of Mississippi (1996) in which a prosecutor made great personal sacrifices to retry the killer of Medgar Evers

The enormous success of *L&O* has probably swamped all of this pop cultural negativity toward prosecutors. The show ran for so many years and featured such powerfully and consistently positive portraits of prosecutors that most viewers could only have come away with positive opinions of prosecutors. In addition, most contemporary police and forensic shows are positive toward law enforcement, which would include prosecutors as well as police and forensic scientists.

Recall the discussion of the cultivation effect in ¶4.04.3 and 4.04.4. Cultivation effect comes into play when television shows transmit the same broad messages over and over again; inevitably, many viewers absorb these messages and treat them as moral truths. The positive portrayal of prosecutors in *L&O* may have produced a powerful cultivation effect that enhanced the public's opinion of prosecutors (Podlas 2008).

8.06.3 Criminal defense lawyers

Historically, movies and TV shows have represented criminal defense lawyers in a positive, even a heroic light. However, *L&O* often portrays them negatively. Their job is to interfere with the righteous process of putting violent criminals behind bars. As portrayed on *L&O*, defense lawyers are tricky and push ethical boundaries. Do you see examples of the negative treatment of defense lawyers in the *L&O* episodes you've watched?

8.06.4 Defending the guilty

In the traditional courtroom narrative, criminal defense lawyers are represented as courageous defenders of the victims of police or prosecutorial misconduct (Asimow 2012). Often, their clients are innocent, as in *To Kill a Mockingbird*. Indeed, all of

Perry Mason's clients were innocent. These stories misrepresent the nature of criminal defense practice. The vast majority of criminal defendants are guilty of the crimes with which they are charged. As a practical matter, the defense lawyer's job is to negotiate the best plea bargain possible.

Even when criminal cases go to trial, the defense lawyer usually understands that the client is probably guilty of the crimes charged, but the prosecution did not offer an acceptable plea bargain or the client decided to roll the dice instead of taking the prosecutor's offer. The defense lawyer's job is to come up with a story that fits the facts and leads to an acquittal but without introducing evidence that the lawyer knows to be false (see ¶¶7.07.1 and .4). *Anatomy of a Murder* is a good example of a well-conducted defense of a probably guilty client.

Many people ask how lawyers can represent clients who the lawyers believe are probably guilty or even who they know are certainly guilty. People also wonder how lawyers can cross-examine and discredit (even humiliate) witnesses, who the lawyer knows have testified truthfully. These are actions that are contrary to what we might call "ordinary morality" but are required by a lawyer's "role morality" (see ¶7.07.4).

> **Representing unpopular clients.** A basic principle of legal ethics is that a lawyer can and should take on the defense of unpopular clients, especially those who cannot afford to pay. As ABA Rule 1.2 states: "A lawyer's representation of a client…does not constitute an endorsement of the client's political, economic, social or moral views or activities." Thus, it is possible for the most honorable of lawyers to represent the most despised or depraved clients because the mere fact of representation does not indicate that the lawyer approves of the client's views or actions.

Under the norms of the legal profession and the rules of legal ethics, the defense of the guilty is perfectly appropriate. ABA Rule 3.1 provides that a lawyer generally should not bring or defend a proceeding unless there is a non-frivolous basis for doing so. However, the rule for criminal defense lawyers is different. "A lawyer for the defendant in a criminal proceeding…may nevertheless so defend the proceeding as to require that every element of the case be established."

An earlier ABA Canon of Professional Ethics stated this well-accepted principle: "It is the right of the lawyer to undertake the defense of a person accused of crime, regardless of his personal opinion as to the guilt of the accused; otherwise

innocent persons, victims only of suspicious circumstances, might be denied proper defense. Having undertaken such defense, the lawyer is bound, by all fair and honorable means, to present every defense that the law of the land permits, to the end that no person may be deprived of life or liberty, but by due process of law."

This is a key idea: In a government of limited powers, nobody can be convicted of crime and punished by the state unless the proper *procedures* have been followed. One of those procedures is that government must prove the accused guilty beyond a reasonable doubt in front of a jury. This is what might be called "procedural justice." Of course, procedural justice may conflict with "substantive justice," which calls for convicting and punishing the guilty. (See ¶2.04.1 for discussion of substantive and procedural justice.) The basis for procedural justice is that we often are not sure who is guilty and who is innocent, who is telling the truth and who is lying. Another key justification for criminal defense arises from the great power of the state. The police and the prosecutors have enormous power, which they sometimes abuse. Criminal defendants deserve to have a capable, zealous defender at their sides to help offset the imbalance between the power of the state and the lack of power of the individual.

Thus it is clearly ethical to defend clients that the attorney knows are guilty. However, is it moral? From a *moral* point of view, how can an attorney justify taking action that might return a vicious criminal to the streets? How can an attorney justify discrediting a witness on cross-examination that the lawyer knows is telling the truth? In other words, should there be a difference between "ordinary morality" and lawyers' "role morality?"

8.07 Realism on *Law & Order*

The issue of realism in visual media such as film and television is a notoriously complicated one. Several film movements have claimed the mantle of realism—Italian Neo-Realism, English Free Cinema, *Cinema Verité*, and Direct Cinema, to name just a few. Aside from claiming the mantle of realism, however, these movements, have little in common. They adopt different cinematic techniques and narrative strategies in their quest for realism. What is and what is not "realistic" remains a subject of great debate within the media world.

8.07.1 The ordinary filmgoer's conception of realism

When average filmgoers describe a film or TV show as "realistic," they generally mean "true to life" (see ¶1.06.1). Realism, in this sense, is a question of natural-

ism or verisimilitude: is the world depicted in the film or TV show a close analogue of the world it claims to be depicting—both in terms of how things look and how people behave? *L&O* is naturalistic in its story-telling style, and this, no doubt, contributed to its twenty-year tenure on television. The viewer is supposed to believe that the cops and prosecutors they see in each episode are acting like real-life cops and prosecutors. The use of New York locations, as well as the constant references to precise addresses where the cops are interviewing witnesses, makes the shows feel like documentaries. Hand-held cameras are used for many shows and the unsteady look conveys a sense of gritty realism and spontaneity. The stories seem somehow familiar since many of them are "ripped from the headlines," suggesting a sort of docudrama approach.

8.07.2 How the spectator arrives at a conception of the real world

How do we arrive at our notions of whether a film or TV show is "realistic" when it concerns events we have never experienced? For instance, *Saving Private Ryan* (1998) was praised as the most realistic war movie ever by critics who had never served in the military. Similarly, *Schindler's List* (1993) was perceived as realistic by millions of filmgoers whose knowledge of the Holocaust came from film or television shows or documentaries.

Saving Private Ryan and *Schindler's List* seem realistic because they employ cinematic techniques that are associated with prior representation of World War II and the Holocaust. Very few viewers directly experienced World War II or the Holocaust. Instead, their only "experience" of those events has been through movies, television shows, documentaries, or newsreel footage. Thus *Schindler's List* may seem realistic in part because it was filmed in black and white, and most World War II-era newsreel footage was shot in black and white. Similarly, the grainy film stock and jittery handheld camera work in *Saving Private Ryan* may give the impression of "realism" because World War II-era newsreels and documentaries were shot without the use of tripods and with light-sensitive fast film stock that produced a grainy image. The police sequences in *L&O* may also feel realistic in part because they use many of the techniques popularized in prior police dramas like *Hill St. Blues,* such as the use of handheld cameras, a preference for close shots with frequently busy compositions (multiple people moving back and forth and into and out of the picture), and the use of overlapping on- or off-screen dialogue. Sidney Lumet's police dramas such as *Serpico* (1973) and *Prince of the City* (1981) also familiarized viewers with these techniques for filming police work.

Realism in film is as much a question of style and technique as it is a question of substance. Indeed, the techniques that filmmakers employ to create the impression of realism can differ dramatically from one culture to another or from one time period to another. In post-World War II Italy, realism in film was equated with naturalistic images of daily life and the use of non-actors. In contrast, in post-World War II America, realism was equated with the New York stage and a theatricalized form of acting (referred to as Method acting) that emphasized the projection of inward mental and emotional states. Similarly, in the post-World War II era, realism in film was associated with long takes and a slow, deliberate pace. In contrast, realism is now associated with rapid cutting and a frenzied, manic pace. In the 1950s, *Dragnet* was widely praised for its realism. Today, the very techniques that made *Dragnet* seem realistic to contemporary audiences—the voice-over narration, the listing of dates and times, the flat, unadorned visual style—seem artificial and even campy. (See ¶1.05.1 and .4 for discussion of *Dragnet*.)

8.07.3 What seems realistic—Some generalizations

Some generalizations about pop culture realism are possible. First, realism has traditionally been associated with films about traumatic historical events or contemporary social and political issues such as street crime, race relations or drug addiction—the very subjects of each *L&O* episode. Second, realism has traditionally been associated with films that subordinate style to content. Thus, films that adopt a florid cinematic style (like *Natural Born Killers* or *Moulin Rouge*) are typically viewed as highly unrealistic. *L&O*, of course, always seems to subordinate style to content. Third, realism has usually been associated with certain genres—in particular, the social problem film, the war film, the gangster film, and the docudrama. Fourth, realism has traditionally been associated with leftist politics or political causes. Fifth, realist films typically adopt a rhetorical mode of address, meaning that they are constructed like arguments: They are trying to persuade viewers, not just entertain them. And *L&O* episodes often center around morally based arguments between the prosecutors.

Thus, in watching an apparently realistic TV show like *L&O*, it is important to keep in mind that realism is a question of style and attitude, not just substance. A film or TV show can be realist in style and yet be completely untrue to real life. Furthermore, it is important to keep in mind that realist films are making arguments about reality, not simply depicting reality. Thus, instead of asking whether or not a realist film or TV show is true-to-life, you should ask such questions as: What techniques is the film or TV show using to convince me that it's true to life?

Why do these techniques carry connotations of realism? What argument is the film or TV show trying to make? Do the techniques it uses advance this argument?

8.08 Narrative structure on *Law & Order*

Each of the assigned episodes of *L&O* lasts between 46 and 47 minutes. In those 46–47 minutes, there are 40 or more scenes. That means the average scene lasts a little over one minute. (In "Blue Bamboo," the average scene lasts less than a minute.) In viewing and analyzing *L&O*, it is important to realize that each episode fits a well-established narrative structure. This simplified the problem of writing each of the hundreds of *L&O* episodes over a twenty-year period.

Each episode begins with a pre-credit sequence lasting about two minutes in which the crime victim is discovered and the investigation begins. (In "Family Values," the victim's body is not initially discovered.) The credit sequence follows, usually lasting about 45 seconds. Three minutes have now elapsed.

The police investigation typically lasts until about 18 to 22 minutes into the episode. (In "Family Values," it lasts an unusually long 25 minutes.) During this time, the two lead detectives interview witnesses and consult with other investigatory personnel, such as lab techs or the medical examiner. An enormous amount of narrative information is packed into these 20 minutes. To help the audience keep track, every third or fourth scene involves a conversation with the detective's superior officer (or between the two lead detectives themselves) in which the key facts are recapitulated and various theories are floated.

One of the "witnesses" interviewed by the police turns out to be defendant (typically at about 12–14 minutes). In some cases, the defendant was interviewed earlier—but before enough facts were known to make it clear he or she is a suspect (as in "Coma" and "Family Values"). The police frequently interview a character who turns out to be a false lead (or "red herring"). The police often interview the red herring at around 5 minutes into the episode, as in "Second Opinion" or "Blue Bamboo."

About 20 minutes into the episode, the defendant is charged and the story shifts to the prosecutors. Usually, there is a transitional scene in which the lead detectives meet and confer with the junior prosecutor in order to advance the investigation—either by obtaining a search or arrest warrant or conducting a lineup. Generally, slightly more than half of each episode is devoted to the prosecutors. Most shows follow a similar trajectory:

1. There is a pre-trial hearing, a meeting with defense counsel, or a team meeting in which certain legal or evidentiary problems with the case are identified.

2. The prosecutors conduct their own follow-up investigation by interviewing witnesses or conferring with lab techs or staff psychologists.
3. There is another pre-trial hearing, meeting with defense counsel, or team meeting in which each side's theory of the case is recapitulated.
4. Trial begins. Various fact or expert witnesses are questioned.
5. The prosecutors meet to discuss how the trial is progressing. Certain weaknesses in the case are flagged.
6. Trial continues with the questioning of the defendant. Often the prosecutors conduct additional off-site fact investigation to tie up loose ends. Typically, this scene or sequence is the climax of the episode and occurs between 40 and 44 minutes into the episode.
7. There is a jury verdict or plea bargain which ends the case.
8. A coda of one minute or less (sometimes referred to as the "denouement") in which the prosecutors reflect on the meaning of the case as they leave the courtroom or the office.

Of course, many episodes depart from this structure—sometimes dramatically so. But that doesn't mean there is no structure. To the contrary, it is precisely because viewers were so familiar with the show's structure that made the show's departures from it so effective.

8.09 Review questions

1. Please comment on the strategy and the ethics of the prosecutors and the defense lawyers in one of the four assigned episodes. (Instructors may wish to assign class members to discuss a specific episode.)
2. Choose one of the following rules of criminal law and procedure and discuss whether we should retain, change, or abolish the rule. (Instructors may wish to assign class members to discuss a specific rule.)
 a) The exclusionary rule (that is, the rule that prohibits the prosecutors from introducing evidence that resulted from an illegal search). ¶8.01.2
 b) The *Miranda* rule (that is, the rule that the police must give warnings to suspects after arresting them and must stop questioning suspects if they demand a lawyer). ¶8.01.3 and 1.05.1.
 c) Plea bargains (that is, prosecutors and defense lawyers can make a deal to avoid a trial if the defendant agrees to plead guilty to a lesser

offense than originally charged and receive a lower sentence). ¶8.01.4.

d) The right of a defendant not to be compelled to incriminate him or herself (meaning that the defendant can elect not to testify at the trial and that the jurors are not allowed to infer anything from the defendant's failure to testify). ¶8.01.5

e) The battered woman syndrome (that is, the rule applied by some courts that allows a woman to claim self-defense when she kills a man who has abused her). ¶8.03.2.

3. *L&O* episodes are different from the typical criminal law stories told in pop culture (¶8.02). In what ways are they different?

4. Whether the defendant should testify in a criminal case presents a difficult tactical choice for defense lawyers. Did the defendant's decision to testify help or hurt her in "Blue Bamboo" (¶8.02.5)?

5. What accounts for the twenty-year life span of *L&O*? Why was the show so popular (see ¶8.02.2)?

6. According to the text: "[Dick Wolf's plan for *L&O*] was a deliberate attempt to reconfigure the politics of the crime drama by fusing the generally conservative politics of the cop show with the liberal politics of lawyer shows" (¶8.02.3). Do you agree?

7. "McCoy marshals the full range of affect—from a raised voice to raised eyebrows—to instill in the jurors the moral outrage he feels" (8.02.4). Do you agree?

8. Discuss prosecutorial discretion in one of the episodes of *L&O* that you viewed. Do you agree that the prosecutors acted ethically and morally in that episode (see ¶8.04)?

9. McCoy and Kincaid discuss the role of feminist theory in the decision whether to prosecute Nancy Haas for murder in "Second Opinion." What are the arguments made by each of them and who has the best of the argument?

10. Lawyers use a trial to tell a persuasive story that fits the facts and leads to the desired outcome (¶8.05). Give an example of a movie or TV show (other than (*L&O*) in which the lawyers are spinning competing narratives.

11. If you had no source of information about prosecutors except for popular culture, what would your opinion of the character, competence, and behavior of prosecutors be? Does *L&O* present a different picture of prosecutors from other criminal law stories on film or television? Please give examples (¶8.06.2).

12. If you had no source of information about criminal defense lawyers except for popular culture, what would your opinion of the character, competence, and behavior of defense lawyers be? Does *L&O* present a different picture of defense lawyers from other criminal law stories on film or television? Please give examples (¶8.06.3).

13. Criminal defense lawyers frequently represent clients whom they know to be guilty of serious crimes. Do you believe that such action is unethical or immoral (¶8.06.4)?

14. Does a prosecutor have to believe that someone is guilty in order to prosecute that person (¶8.04)?

15. A "realistic" film or TV show seems "true to life" to spectators. Choose a "realistic" film or TV show (other than *L&O*) and indicate whether it fits the "generalizations" set forth in ¶8.07. What techniques are used to make the film or TV show seem "realistic"? Is the creator of the film or TV show trying to sell a particular point of view or political ideology?

16. Do any of the four assigned episodes depart from *L&O*'s typical narrative structure (¶8.08)? In what ways does it depart?

17. In "Blue Bamboo," attorneys argue over the jury instructions and the judge reads one of them to the jury. Most *L&O* episodes do not mention jury instructions. Why did the writers focus on jury instructions in that one episode and ignore it in the others?

18. Sentencing plays almost no narrative role in *L&O* episodes. In reality, a case is not over once a defendant is found guilty. Sentencing is a long and complicated process. Why doesn't sentencing play a more important role in *L&O*'s narrative structure?

Notes

1. The first four episodes on the DVD of Season 5 of *Law & Order* are entitled "Second Opinion," "Coma," "Blue Bamboo," and "Family Values." Each runs about 47 minutes, so instructors may wish to assign fewer than four episodes. Some instructors may prefer to use a movie rather than TV shows to teach about criminal justice. We used *Indictment* (1995) in the previous edition of this book. It's an excellent movie, made for television, about the McMartin sexual abuse case. Other good criminal justice movies include *Night Falls on Manhattan* (1996) which shows all aspects of the process and treats both prosecutors and defense lawyers in nuanced fashion), *Presumed Innocent* (1990) which provides excellent treatment of criminal law and is very tough on prosecutors and judges, or *...And Justice for All* (1979) which presents a caricatured view of the process. Other good possibilities include *A Time to Kill* (1996) or *The Lincoln Lawyer* (2011). *The Lincoln Lawyer* is excellent if you want to focus on the gritty realities of what criminal defense practice is like.

2. For additional details, see LaFave 2010 and Dressler 2010. For treatment of the criminal process in film, see Rafter 2001.
3. Dick Wolf said that the first half of each episode "is a murder mystery. The second half is a moral mystery" (Keetley 1998, 33).
4. A more detailed treatment of the politics of *Law & Order* appears in Mader 2009, ch. 10.
5. John Herbers, "McGovern Urges Drive on Slums; Says 'Law and Order' Pleas Have Racist Undertone," *The New York Times,* August 16, 1968, at 1 (quoting Senator George McGovern).
6. Bruce Weber, "Television; Dick Wolf Breaks and Enters with 'Law and Order' on NBC," *The New York Times,* March 1, 1992.
7. Podlas analyzed the content of 35 episodes from the fourth to the sixth seasons of *Law & Order.* Her analysis of these shows confirms her thesis that *Law & Order* transmitted a consistent ideological message of crime control, respect for prosecutorial discretion, and criticism of defense lawyers and of statutory and constitutional rules that interfere with admission of probative evidence in criminal cases (Podlas 2008).
8. Other than *Law & Order,* prosecutors have been favorably portrayed in a number of other relatively short-lived TV series, such as *Conviction, Close to Home,* and *Shark.* Prosecutors also appear in positive roles in many police and forensisc shows. On *The Practice* and *L.A. Law,* although the protagonists were usually on the defense side, favorably portrayed prosecutors were repeated characters.
9. See Hallam & Marshment 2000; Nichols 1991; K. Thompson 1988, 197–244; Grossberg et al. 2006, ch. 7; Stam 2000, 140–45.

The Jury

Assigned Film: *12 Angry Men* (1957)[1]

9.01 *12 Angry Men*—Prequel and sequel

The movie *12 Angry Men* was based on a critically acclaimed television drama of the same name. Written by Reginald Rose (1920–2002) for CBS's live-drama anthology series *Studio One, 12 Angry Men* aired on September 20, 1954 (the *Studio One* TV drama is available on DVD). The show garnered Emmys for Rose, director Franklin Schaffner, and lead actor Robert Cummings. Rose also wrote and produced the lawyer-centered television series *The Defenders,* which ran from 1961–65 (see ¶7.02.2). A strong civil libertarian, Rose expressed his political views in his work. Many interpret *12 Angry Men* as an attack on conformity, the Hollywood anti-communist blacklist, and McCarthyism.

The motion-picture version of *12 Angry Men* was directed by Sidney Lumet (see ¶4.01 for additional discussion of Lumet) and starred Henry Fonda. The film received three Academy Award nominations (it won none) but sputtered at the box office. The future delivered a different verdict than the viewers and critics of the 1950s. In 2012, the Internet Movie Database ranked it as the sixth best movie of all time, based on rankings provided by thousands of its registered user-jurors, far ahead of any other lawyer film (*Paths of Glory* came in 49th; *To Kill a Mockingbird*

came in 61st). In 2007, a law review devoted an entire issue (about 350 pages of text) to commemorate the film's fiftieth anniversary (Marder 2007).

The many lives of *12 Angry Men.* *12 Angry Men* is the best-known movie about juries. Sequences from it appear for comic effect in *Jury Duty* (1995) starring Pauly Shore. It was spoofed on *The Simpsons* (Landsman 2007, 756). In the 2002 Masterpiece Theater mini-series *The Jury* (see ¶9.03, fn. 3), the jurors select a foreman because he looks like Henry Fonda. *12 Angry Men* itself was remade for television in 1997 by Showtime, with Jack Lemmon assuming the crucial role earlier played by Cummings and Fonda. The remake closely follows the original script, but casting changes distinguish it from the 1957 version. The judge is a woman and the jury is ethnically diverse. Indeed, the most bigoted member of the jury is an African American nationalist who hates Hispanics. The jury remains all male (although theater companies sometimes perform a Rose-adapted script entitled *12 Angry Jurors* containing jurors of both sexes). And the Russian film *12* (2007) is a loose remake of *12 Angry Men.* Bogira (2005) recounts a Chicago trial in which the jury split 11–1 with the dissenter citing *12 Angry Men;* however, he couldn't swing the other eleven and the result was a hung jury. See ¶9.06.2 for discussion of hung juries.

9.02 Fonda's "star" image and intertextuality in legal films

Henry Fonda had been a major Hollywood film star for more than twenty years before making *12 Angry Men* and had appeared in a number of other legal movies. Most famously, he starred in an earlier courtroom drama, *Young Mr. Lincoln* (1939), in which (as Abraham Lincoln) he represents two boys who, like the defendant in *12 Angry Men,* were on trial for murder.

Movie stars such as Fonda, John Wayne, Paul Newman, and Clint Eastwood become "iconic" or "representative" figures. As they move from role to role, film stars accumulate meanings that travel with them. Iconic figures such as Fonda,

argues the media theorist S. Paige Baty (1995), help people see their nation's institutions and values in action. Baty suggests that representative figures can offer consumers of popular culture "a common means of relaying stories" and can "incorporate citizens into a representational nation," in which fictional tales and powerful images about law continually circulate.

The iconic Clint Eastwood. William Ian Miller (1998) argues that Eastwood might be seen as the popular, iconic embodiment of the heroic individual who acts alone in order to compensate for the supposed inability of the legal process to produce justice. As *Dirty Harry* (1971) or the aging gunfighter William Munny in *Unforgiven* (1992), Eastwood's character invariably does justice, even if he has to break legal rules and use violence to get there.

Over his long Hollywood career, Henry Fonda became another iconic figure who often confronted the apparent limitations of the law (see N. Rosenberg 2002). Fonda portrays a kind of a populist everyman, a commonsense character who sees issues more clearly than other people and who will stand up, alone if necessary, to address potential legal wrongs. In addition to young Abe Lincoln, Fonda portrays Tom Joad, the idealistic, justice-seeking young "Okie" in John Ford's *The Grapes of Wrath* (1939). In *The Ox-Bow Incident* (1943), he is the only person willing to confront a lynch mob (though he is unsuccessful). The year before *12 Angry Men*, Fonda starred in Alfred Hitchcock's *The Wrong Man* (1956), portraying an innocent man trapped in a vast legal bureaucracy that nearly convicts him of armed robbery. Near the end of his life, he portrayed the famous defense lawyer Clarence Darrow in a one-person play and another wrongly convicted criminal defendant in the made-for-TV docudrama *Gideon's Trumpet* (1981). Today, many viewers of *12 Angry Men* cannot help but see Fonda's performance in light of the iconic character he constructed during more than forty years of motion-picture stardom.

In contrast to the characters played by Clint Eastwood, those portrayed by Henry Fonda confronted injustice mostly with words rather than violence. Fonda's famous speech in *The Grapes of Wrath*, where Tom Joad promises to "be around in the dark," standing up against illegal acts by the powerful, has become a classic argument on behalf of a populist idea of justice. In this view, ordinary people are responsible for preserving legal forms and protecting rights. Fonda's role in *12 Angry Men* updates his earlier portrayals of young Abe Lincoln and Tom Joad and anticipates his roles as Clarence Darrow and Clarence Earl Gideon.

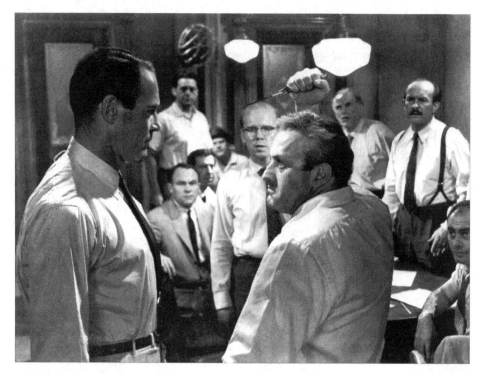

Figure 9.1. *12 ANGRY MEN*. Juror #8 (Henry Fonda) confronts Juror #3 (Lee J. Cobb). United Artists/Photofest. © United Artists.

Thus, it is not simply Juror No. 8 but Henry Fonda who steps forward in *12 Angry Men*. Regular movie-viewers expect his character to defend fundamental legal principles, such as the presumption of innocence and the necessity for evidence of guilt beyond a reasonable doubt. From the outset, viewers receive a powerful cue as to how this narrative will end.

9.03 The jury in the trial film genre[2]

In most courtroom films and TV shows, the jury must decide the defendant's fate. Every good story needs suspense—and the uncertainty of how the jury will decide the case is a reliable way to create suspense. The jury verdict comes at or near the end of the film and provides a logical climax to the hard-fought trial that preceded it. As Carol Clover (1998) points out, the genre calls upon us—the viewers of the film— to serve as the "thirteenth juror." We may or may not know more than the jury does about what actually happened, but the story always calls on us to decide for ourselves

whether we would find the defendant guilty or not guilty. However, we seldom learn anything about the personality or background of our "fellow" jurors.[3]

12 Angry Men brilliantly overturns these genre conventions (Papke 2007b). The film devotes virtually all of its screen time to jury deliberations and focuses intensely on the personalities of the twelve jurors. At the start, the movie encourages us to agree with the eleven jurors who vote guilty. The evidence against the defendant seems overwhelming. However, when Juror No. 8 and, later, some of the other jurors raise doubts about various elements of the prosecution's case, we begin to waver—just like the jurors in the film. In fact, the arguments made by the various jurors serve the same function as the prosecution and defense presentations in the typical trial movie. Henry Fonda's Juror No. 8 justifies this substitution of jurors for lawyers by arguing that the defendant's lawyer seemed to have little interest or faith in his client's case. For this reason, the film is more like a typical courtroom drama than it might seem at first glance.

Do you think the jury did the right thing by conducting a vote before discussing the evidence (see Marder 2006)?

12 Angry Men suggests that we are more likely to get justice from a jury than from a judge—the judge we saw at the beginning of the film had trouble staying awake and surely thought the question of guilt was open and shut. Certainly, the idea that the jury system promotes justice is a bedrock principle of our legal system. *12 Angry Men* and countless other films and TV shows have sent that message to generations of pop culture consumers. *Philadelphia* (Chapter 13), for example, features a jury that does a great job of sorting out truth from falsehood and achieving a just result. But is the jury as good as pop culture suggests? We examine arguments on both sides of that issue in ¶¶9.05 and 9.06.

Did the jury in *12 Angry Men* deliver the right result? Wasn't there more than enough circumstantial evidence against the defendant to meet the reasonable doubt standard, even if the eye-witness testimony against the defendant is discredited? Did Juror Number 8 talk his fellow jurors into acquitting a guilty man (Asimow 2007b; Vidmar et al. 2007).

9.04 Constitutional role of the American jury

The American legal system relies on juries as fact finders more than any other country in the world. In part, the reason for this is constitutional. The 6th Amendment provides: "In all criminal prosecutions, the accused shall enjoy the right to a speedy and public trial, by an impartial jury of the State and district wherein the crime shall have been committed...." In addition, the 7th Amendment, which deals with civil

lawsuits, provides: "In suits at common law, where the value in controversy shall exceed twenty dollars, the right of trial by jury shall be preserved...." Both amendments were approved in 1791 as part of the Bill of Rights (the first ten amendments to the Constitution) to meet concerns of the Antifederalists that the original Constitution failed to protect basic rights and freedoms. The Bill of Rights was originally applicable only to the federal government, but the Supreme Court has applied most of its provisions to the states. The Court has not applied the Seventh Amendment to the states, but virtually all state constitutions protect the right to trial by jury in both civil and criminal cases.

As a result, most civil or criminal cases must be tried by a jury unless both sides agree to waive the jury and have the case heard by the judge (a "bench trial"). (In some states, the defendant alone has power to waive a criminal jury.) The constitutional right to jury trial does not apply to "petty" criminal cases ("petty" means potential confinement of six months or less) or to civil cases that are not "suits at common law" (meaning a type of litigation different from the traditional suits for money damages recognized at the time the Constitution was written). Generally, under state and federal law, juries are still available even in "petty" criminal cases, although the Constitution does not require it. Even when criminal cases are plea bargained or civil cases are settled rather than tried (as the vast majority are), the lawyers who negotiate the deal are vividly aware of how a jury would likely size up the facts. In short, the jury is fundamental to any study of American law.

9.05 Conflicting visions of the jury—The brighter vision [4]

Beyond the constitutional imperative, the jury is deeply rooted in American consciousness as a bulwark against abuse of power by the state. The jury is supposed to be the conscience of the community. *12 Angry Men* offers an eloquent brief for the American faith that the jury system is the best way to achieve justice. Many people think that the jury system confers legitimacy on the criminal and civil decisions of the courts (meaning that people are more likely to accept the idea that our courts deliver justice if the jury makes the call rather than a judge).

> **Polling data.** A survey commissioned for the American Bar Association (1999) showed that 78% of respondents agreed with the statement, "The jury system is the most fair way to determine the guilt or innocence of a person accused of a crime." Only 12%

disagreed. Sixty-nine percent of respondents thought that juries are the most important part of our judicial system. In contrast, only 30% of respondents had confidence in the U.S. justice system, 32% had confidence in judges, and 14% had confidence in lawyers.

The jury system seems an admirable example of deliberative democracy in action. Most government decisions are made by elites—governors, presidents, judges, legislatures—or by powerful government employees like the police or prosecutors. Ordinary people are represented only indirectly, if they are represented at all. The jury is quite different. Nowhere else in our society (except perhaps in a town meeting of a small town) do we find ordinary people, often of very different backgrounds (including class and ethnicity), deliberating with one another to resolve a vitally important government function—how the laws will be executed. (In the nineteenth century, this was more true than it is today, since juries decided questions of law as well as fact.) Recall the remarks of Parnell McCarthy in *Anatomy of a Murder:* "Twelve people, with twelve different minds, with twelve different sets of experiences…and in their judgment they must become of one mind—unanimous. That's one of the miracles of man's disorganized soul, that they can do it, and in most instances do it quite well. God bless juries!"

9.06 Conflicting visions of the jury—The darker version

9.06.1 Rationality of jury verdicts

There is a darker vision of the jury system, one illustrated by the racist jury verdict in *To Kill a Mockingbird* (Chapter 3). Subscribers to the darker vision portray juries as irrational decision makers who are governed by emotion, whimsy, prejudice, or by irrelevant considerations such as the ethnicity of the defendant or the victim or the personalities of the contending lawyers. Many of the statements by jurors in *12 Angry Men* show how race or class prejudice can enter jury deliberations. In addition, juries sometimes have difficulty keeping straight all the testimony they have heard in a long trial or understanding the judge's instructions about the law, so they must rely on their gut feelings in deciding the case. This is particularly a problem in complex civil cases involving difficult technical or scientific material, such as those involving computer software, patent infringement, toxic torts (see Chapter 12), or product liability disputes. Should there be a complex case exception to the right to a jury trial in civil cases?

Jerome Frank was an astute federal appeals judge and a respected legal scholar. In *Courts on Trial* (1963, 130, 132), Frank expressed deep skepticism about juries:

> Many juries in reaching their verdicts act on their emotional responses to the lawyers and witnesses...they like an artful lawyer for the plaintiff, the poor widow, the brunette with the soulful eyes, and dislike the big corporation, the Italian with a thick, foreign accent....Now I submit that the jury is the worst possible enemy of this ideal of the "supremacy of law." For "jury-made law" is, par excellence, capricious and arbitrary, yielding the maximum in the way of lack of uniformity, of unknowability....The jury system, praised because, in its origins, it was apparently a bulwark against an arbitrary tyrannical executive, is today the quintessence of governmental arbitrariness. The jury system almost completely wipes out the principle of "equality before the law" which the "supremacy of law" and the "reign of law" symbolize—and does so, too, at the expense of justice, which requires fairness and competence in finding the facts in specific cases.

Jury skeptics say that on the whole we would be more likely to achieve correct results if judges rather than juries found the facts (or if the facts were found by a panel of judges and lay assessors as described in ¶9.06.3). Had there been no Juror Number 8 (and usually there is no such person), the jury in *12 Angry Men* would certainly have rushed to judgment. In addition, many people criticize the jury verdicts in several high-profile criminal cases, such as those of O. J. Simpson, Robert Blake, or Casey Anthony, or the jury's decision in the famous McDonald's hot coffee case.[5] Who knows how many irrational jury verdicts are never discovered or publicized?

9.06.2 Efficiency of the jury system

The jury system is costly and inefficient and is partly responsible for the delays and backlogs in the civil and criminal justice systems. The process of selecting and instructing juries, the complex rules of evidence (which are primarily designed to keep certain types of evidence, such as hearsay testimony, away from jurors), and the time taken for jury deliberations all greatly slow down the trial process.

Because the jury must be unanimous in criminal cases, hung juries are not uncommon. A hung jury requires the case to be tried all over again. Perhaps 5% of criminal juries are hung—in some areas many more (Abramson 2007, 598–99). Some writers have blamed apparently biased single holdout jurors for causing hung juries. Rosen (1997) singles out African American women as the culprits in four cases he studied. Unlike Juror Number 8 in the movie, these holdouts refused to deliberate. They dug in their heels and withdrew from the discussion. (Abramson 2007, 602–05, disputes Rosen's anecdotal findings.)

Does the hung jury phenomenon suggest that the unanimous vote requirement in criminal cases should be eliminated? (It could be—unanimity is not constitutionally required, and ten votes are sufficient in Oregon and Louisiana). Or does *12 Angry Men* illustrate the wisdom of the unanimity requirement?

Impact of the jury system on the jurors. Most jurors are conscripted to serve against their will. The pay for jury service is a pittance. Jury service pulls the jurors away from their jobs, their businesses, and their lives, sometimes for an extended period. Often, jurors suffer serious inconvenience and occasionally real financial hardship. The burden on individual jurors is worst if the jury is sequestered (meaning kept overnight in a hotel for the duration of the trial), as can occur in notorious cases. As a result of all this, most people ignore the summons for jury duty, so good citizens who show up must bear the entire burden. Potential jurors must sit around the courthouse for hours or even days while waiting to be called for a jury panel. Then they sit around for many more hours during the interminable process of voir dire. Many are disqualified through *peremptory challenges* by either lawyer. Lawyers don't have to give reasons for their peremptory challenges which, in effect, unfairly dispute the ability of the challenged juror to be impartial (see ¶9.09.2 for criticism of peremptory challenges). Finally, if jurors survive all these hurdles, they have to sit through trials that may be unbearably tedious and suffer through jury deliberations which are often quite stressful.

9.06.3 Juries worldwide[6]

In Britain and Commonwealth countries, the jury is in decline. Some countries (such as Canada, Australia, and Great Britain) use juries but only in serious criminal cases. In Britain, for example, about 25% of criminal trials are heard by juries, in Australia and Canada far less. However, some countries (especially those with troubled histories) have introduced the jury system in order to involve ordinary people in the administration of justice and assure that community values are taken into account. Spain and several countries in the former Soviet Union, including Russia, have recently adopted the jury system for serious criminal cases. We understand, however, that jury trials are still quite rare in these countries.

Most European countries (as well as Japan) use a mixed system in which professional judges and non-lawyer judges ("assessors") decide criminal cases together. In Germany, for example, in serious criminal cases, the decision makers consist of three professional and two non-lawyer judges. A two-thirds vote is needed to convict. The non-lawyer judges sit for several months (and thus hear numerous cases), unlike American jurors who hear only a single case. In France, serious criminal offenses are tried by panels of three professional judges and nine non-lawyer jurors; conviction requires eight votes. Would you favor a system like that in France or Germany instead of the U.S. system in which the decision is made by 12 non-lawyer jurors?

9.07 Empirical research on juries[7]

How likely is it that a single holdout can turn the other jurors around? The most famous empirical study of criminal juries was conducted by Harry Kalven and Hans Zeisel (Kalven, 1964; Kalven & Zeisl, 1966). They found that "with very few exceptions, the first ballot determines the outcome of the verdict" (Kalven & Zeisl 1966, 488). The jury's deliberations after taking the first ballot had no effect on the final verdict in nine of every ten cases. When there were seven to eleven votes to convict on the first ballot, the ultimate verdict was guilty in 86% of cases, acquittal in 5%, hung jury in 9%. Where the first vote was lopsided (especially where it was 11 to 1), peer pressure almost always forced the holdouts to agree with the majority. However, Kalven and Zeisel found that in about 10% of cases, the minority eventually succeeded in reversing the initial majority or in hanging the jury. Even so, these ultimately successful minorities usually had four or five votes, not just one[8] (Abbott 1999; Hans 2007).

Would the results change if judges found the facts instead of juries? Kalven and Zeisel (1966) found that judges would have reached the same verdicts as the jury about 80% of the time. This is an impressive consensus, given that the only cases that go to jury trials involve difficult factual questions (remember, 90–95% of both civil and criminal cases are settled or plea bargained). According to Kalven and Zeisel, in criminal cases, the judges were more likely to disagree with jury decisions to acquit the defendant than to convict the defendant. In civil cases, the differences between judges and juries split evenly between plaintiffs and defendants. However, juries awarded damages of about 20% more than judges would have in civil cases. (Robbennolt 2005 summarizes numerous additional studies comparing decisions by judges and jurors.)

9.08 Jury passivity

The jury's job is to find the facts and apply the law (as explained in the judge's instructions) to those facts. (In the nineteenth century, juries could find the law as well as the facts which gave them vastly more power than they have today.) The jury cannot consider information that was not presented during the trial. Thus, Juror Number 8 committed serious misconduct by investigating the neighborhood where the killing occurred and buying a knife and using it in jury deliberations (see Gershman 2005).

In previous eras, jurors could be expected to know the litigants. In *To Kill a Mockingbird,* for example, the jurors obviously were well acquainted with the Ewells and with Tom Robinson. This has now changed, at least in big cities and larger towns. Jurors are disqualified if they know the litigants or the attorneys or if they have any personal knowledge about the dispute—although they sometimes lie about this knowledge in voir dire (McDonough 2006). Thus, the jurors must depend on what they hear and see at the trial rather than their own personal knowledge.

Historically, the jury was expected to be totally passive during a trial. Many judges even prohibited jurors from taking notes. Jurors could not ask a witness any questions and were not allowed to discuss the case with one another (or with anyone else) until jury deliberations began. Because jurors have nothing in common with each other except for the case they are hearing, it is likely that the no-discussion rule was violated frequently.

These extreme "passivity rules" are beginning to change. Jurors are allowed to take notes. Many judges give jurors notebooks containing copies of the trial exhibits. Often judges give instructions about the law at the beginning of the trial, so jurors know what they're supposed to be looking for. Some jurors are given written copies of the judge's instructions. Increasingly, judges' instructions are written in plain English rather than inscrutable legalisms. In some states, jurors are allowed to discuss the case during the trial provided that all of them are present for the discussion and they avoid committing themselves to a particular outcome. Finally, in some states, jurors are permitted to submit questions to the judge to be asked of witnesses.

9.09 Race and gender discrimination in jury pools

9.09.1 Historic discrimination in selection of jury pools

The jurors in *12 Angry Men* are all male and apparently of European ancestry. Historically, American and British juries were composed exclusively of white males

(in many places jurors were also required to be property owners and sometimes to be members of a particular religion). There is no recorded instance of a black juror in any state, North or South, until 1860. Women were ineligible for jury service in every state until 1898 when Utah allowed them to be jurors. The general consensus was that the sordidness of many trials made them unsuitable for women. Indeed, all-male juries were still common in the 1950s when *12 Angry Men* was made. In New York, until 1975, women could claim an automatic exemption from jury service (Kaye 2007). Today, equal numbers of men and women serve as jurors and, at least in big cities, members of minority groups are well represented.

For many decades, the Supreme Court tolerated all-white jury panels as long as the law did not explicitly require that jurors be white. One key case in the Court's move toward requiring nondiscriminatory jury pools was its second encounter with the Scottsboro Boys case in 1935 (see ¶3.02.2); the Court reversed the convictions on the basis that no blacks had ever served on juries in the Alabama county where the trials took place (*Norris v. Alabama,* 1935).

Blue-ribbon juries. Until recently, state and federal jury commissioners had great discretionary power to decide whose names would be in the jury pool. In many states and in most federal courts, the commissioners chose people that they knew were educated and responsible (so-called blue-ribbon juries). This process, of course, tended to keep minorities, women, and working people off of juries. In 1968, a federal statute required that federal court jurors had to be drawn randomly from a pool that would constitute a cross-section of the community; that was the end of the blue-ribbon jury in federal courts.

Finally, in *Taylor v. Louisiana* (1975), the Supreme Court extended this rule to the states. *Taylor* held that the pool from which the names of jurors are randomly drawn (ordinarily voter registration lists and sometimes driver's license lists) must represent a fair cross-section of the community, including women, minorities, and working people. In particular, women could not be excluded from the pool. *Taylor* expressed the idea that the legitimacy of our system of justice depends upon the representation of all segments of the community on juries.

9.09.2 The Batson rule

In 1986, the Supreme Court prohibited lawyers from using their peremptory challenges (see ¶9.06.2) to strike jurors because of their race (*Batson v. Kentucky*). *Batson* was later extended to cover civil as well as criminal cases, to prohibit race-based challenges by the defense as well as the prosecution, and to prohibit sex-based challenges as well as race-based challenges. Prior to *Batson,* it was common for prosecutors to exercise their peremptory challenges to strike all black jurors, particularly in cases involving black-on-white crime. As a result, such defendants faced all-white juries. Certainly *Batson* and subsequent cases are a giant step toward legitimizing the jury system (see Marder 2002).

Batson **in practice.** The *Batson* doctrine is difficult and time-consuming to administer. Consider this example. A prosecutor challenges several black jurors in a case of black-on-white crime. The prosecutor denies that her challenges were based on race. One juror, she claims, seemed hostile to law enforcement because he had been in trouble with the law himself. Another was poorly educated and might have trouble following DNA evidence in the case. Another was extremely young, and young people are likely to be rebellious. A trial judge must decide whether these were the real reasons for striking the jurors rather than pretexts for what was really a racial challenge. Obviously, it is difficult for a judge decide whether a stated reason is truthful or merely a pretext and it appears that *Batson* is not very effective in preventing racial strikes. Note also that *Batson* and later cases do not prohibit many kinds of discrimination in peremptory challenges. For example, it is permissible to strike a juror based on religion, national origin, education, political views, age, disability, sexual orientation, or economic class. In fact, these kinds of discrimination are quite common because the lawyers entertain stereotypical beliefs about how various classes of jurors are likely to vote. As a result of all this, there have been many calls for eliminating peremptory challenges entirely (Marder 2012).

9.09.3 Jury consultants

Jury consultants have become increasingly common (Hudson 2007; Lane 1999). They are employed both in major criminal cases (either by prosecutors or by defendants—if they can afford to hire a consultant) and in high-stakes civil cases as well. Indeed, jury consulting is a significant growth industry (with revenues estimated at upwards of $200 million per year).

The consultants assist the lawyers in deciding how to exercise their peremptory challenges. The consultants may do studies of the backgrounds of potential jurors in the jury pool if this information is available. They also form opinions about which ethnic group, class background, age, occupation, or gender is good or bad for one side or the other in a given case. They help lawyers frame questions to be asked during *voir dire,* hopefully predisposing the jury panelists toward the arguments the lawyers will make during trial. They also assemble mock juries on which the lawyers can test out arguments before actually using them at the trial. They help the lawyers in preparing witnesses to testify. *Runaway Jury* (2003) features Gene Hackman playing Rankin Fitch, the jury consultant from hell. Does the practice of jury consulting enhance the public's respect for the criminal and civil justice processes—or just the opposite?

9.10 Seeing the witnesses, finding the facts

The most important task for jurors is to resolve credibility conflicts between witnesses. Frequently, witnesses will tell contradictory stories; one of them has to be lying (sometimes both of them are lying). Are juries good at figuring out who is telling the truth? Obviously, one of the rationales for adversarial trials is that the finders of fact (whether judge or jury) have seen and heard the witnesses, so they can make an informed judgment about which ones are truthful.

However, this premise for the adversary system is questionable. Evidence in the psychology literature suggests that people who hear and see witnesses are not good at resolving credibility conflicts. These studies are discussed by Wellborn (1991). One ingenious study relied on the old television show *To Tell the Truth.* On this show, three contestants each claimed to work at a specific and unusual job, such as a snake charmer. One was telling the truth, the other two were lying. A panel of celebrities questioned each of the contestants and then decided which one was the real snake charmer. The experimenters obtained tapes of the show. They showed the tapes to one group of experimental subjects and asked them to decide who was telling the truth and who was lying based on their observations of the demeanor of the people answering the questions asked by the celebrities. The sec-

ond group of subjects did not see and hear the tapes; instead, they read written transcripts of the questions and answers.

Which group do you suppose had a better record of deciding who was telling the truth and who was lying? The second group (who read transcripts but had not seen the tape) did much better! How can this be? The experimenters explain that the first group was thrown off by misleading visual clues. Whether someone fidgets, sweats, or fails to make eye contact actually tells you nothing about whether that person is telling the truth. Skillful liars look you in the eye and sound great; nervous truth-tellers look like they are concealing something. What are the implications of this research for the jury system?[9]

9.11 Jury nullification

A criminal jury has the power to acquit the defendant regardless of the law and facts of the case, because the prosecution cannot appeal a jury verdict for the defense. The term *jury nullification* refers to a jury's ability to refuse to enforce the law against a defendant because it believes the law or the particular prosecution is unjust—or for any other reason.

There are celebrated examples of jury nullification in American history, both before and after the Revolution (see Carroll 2012). In 1735, for example, a jury struck a blow for freedom of the press by refusing to imprison New York printer John Peter Zenger for publishing libelous attacks on royal officials, even though Zenger was clearly guilty of the crime of seditious libel. Zenger's lawyer, Alexander Hamilton, admitted that his client had published the libelous material, but Hamilton explicitly urged jurors to engage in nullification. Two centuries later, in 1990, a Washington, DC, jury acquitted Mayor Marion Barry of one drug charge, convicted him on a minor charge, and deadlocked on twelve other charges, despite overwhelming evidence, including a videotape of the mayor smoking cocaine. Jury nullification was clearly at work here.

> **The ugly face of jury nullification.** For many years, white jurors in the South regularly refused to convict whites of committing violent crimes (including lynching) against blacks or against civil rights workers. As late as 1954, as the celebrated case of 14-year-old Emmett Till suggested, it was impossible to get an all-white jury to hand down a murder conviction against a white who killed a black, even a white defendant who all but admitted guilt.

As mentioned above (¶9.08), jurors used to have the power to determine the law as well as the facts of a case. The Supreme Court finally decided in 1895 that jurors did not have power to determine the law. When jurors could determine both law and fact, jury nullification was clearly appropriate. Once jurors lost that power, jury nullification became legally dubious; and it acquired a bad name because of its role in sustaining southern racism.

Present law strongly discourages nullification. Jury instructions never state that the jurors have the power to ignore the law, so many jurors are unaware of this power. In addition, each juror must take an oath to follow the law. If, during jury deliberations, a juror appears to be violating this oath, the other jurors can approach the judge. If the judge interviews the juror and agrees that he or she intends to ignore the law and practice nullification, that juror will be kicked off the jury and replaced by an alternate juror (or if the alternates have been dismissed, the jury can continue with eleven members (*United States v. Thomas* 1997). Nevertheless, it is likely that jury nullification occurs quite frequently in courts all over the country. Should jurors be instructed that they have the power to nullify? In what situations (see Marder 1999)?

9.12 Direction and cinematography in *12 Angry Men*

9.12.1 Camera placement and movement

As mentioned above (¶9.01), *12 Angry Men* originated as a televised drama on *Studio One* in 1954. Many TV shows of the 1940s and early 1950s, including *Studio One,* were broadcast live. As a result, they gravitated toward material that could be shot in studio with a limited number of set changes (usually three or less). Rose tailored his script to these constraints: The teleplay was set indoors and required only a single set. Normally, Hollywood "opens up" stage plays when it adapts them to film. (An example of a play that was opened up in the movie version is *A Few Good Men,* Chapter 10.) Most moviemakers feel that their work would lack "cinematic quality" if the action remained static and was confined to two or three settings.

However, the film version of *12 Angry Men* did not open up the teleplay. (The same is true of the film of *Counsellor at Law* [Chapter 5], which was also adapted from a play and was not opened up.) Except for a three-minute pre-credit sequence, a brief interlude in the men's restroom, and a closing sequence on the courthouse steps, the film version takes place entirely in the jury room. We don't even see the jury verdict delivered in the courtroom. One explanation for this unusual decision is that director Sidney Lumet had worked in live television and was comfortable

with its constraints. In addition, Rose and Lumet confronted budgetary limitations that kept the film inside. They produced the film independently; it was released through United Artists.

Still, *12 Angry Men* distances itself from the earlier live television drama. Lumet orchestrates elaborate, intricate camera movements that would have been impractical on live television. Consider, for instance, the extraordinarily long take—six and one-half minutes—that follows the pre-credit sequence. The camera begins the scene perched at a high angle above a fan on the wall. The camera remains in this position for the minute that it takes for the credits to roll. Then, after the jurors have filed into the small, hot room, the camera plunges viewers into the thick of things, roaming from character to character, picking up little snippets of conversation. Lumet returns to this roving-camera technique throughout the film as a way of isolating the brief, quasi-private exchanges that intermittently take place between the jurors. Although these exchanges do little to advance the story line, they flesh out the character and personalities of the jurors and create a sense of intimacy between them and the audience. Additionally, with its camera almost constantly on the prowl, *12 Angry Men* seeks to counteract the sense of stasis that might otherwise pervade a movie filmed in such a confined setting.

Lumet also uses camera movement and placement to create a sense of spatial variety. Although the size of the room remains constant, Lumet expands and contracts screen space through camera movement. Scenes typically open wide, with several characters visible in the frame, but as the scene progresses, the camera slowly closes in on one of the characters until that character occupies the entire frame.

Take, for instance, the scene in which Juror Number 10 (Ed Begley, Sr.) describes children from the slums as "real trash." Despite the fact that Juror Number 10 is speaking for most of the scene, Lumet shoots the scene from behind him. The characters facing the camera are Juror Number 4 (E. G. Marshall) and Juror Number 5 (Jack Klugman). As the scene proceeds and Juror Number 10 continues his racist rant, the camera slowly closes in on Juror Number 5, who becomes progressively more perturbed by the tirade. The scene reaches a climax when Juror Number 5 finally speaks up. Lumet tries to convey the rising tension, as well as Juror Number 5's escalating indignation, by having the camera slowly close in on him until he occupies the entire frame in a medium closeup. What was once a two-shot of Jurors Number 4 and 5 thus becomes, almost imperceptibly, a one-shot of Juror Number 5. For discussion of cinematography and the many options available to the director in preparing each shot, see Bordwell & Thompson 2010, ch. 5.

9.12.2 Focus on one character while another speaks

This sequence also illustrates another technique used throughout the film. The camera focuses on one character while another is heard talking off-screen. For instance, at one point, the normally level-headed Juror Number 1 (Martin Balsam) loses his cool when he is called a "kid" by Juror Number 10. After being coaxed back into his chair, Juror Number 1 sits down, turns his back to the others, and pouts. At this point, Juror Number 8 (Henry Fonda) offers to explain his reasons for voting to acquit the defendant ("Well, if you want me to tell you how I feel about it, it's all right with me"). This is an important dramatic moment as Fonda's character has previously refused to state the reasons for his "not guilty" vote, leaving it to the others to convince him to support a conviction. But instead of cutting to Fonda at this crucial moment, Lumet allows the camera to linger on Juror Number 1. We can hear what Fonda is saying, but we *see* Juror Number 1. This is an interesting choice that illustrates Lumet's use of screen space as a way of conveying the psychological distances that separate these men from one another.

9.12.3 Closeups and editing

Lumet makes extensive use of tight closeups. When Juror Number 9 (Joseph Sweeney) announces that he has changed his vote to "not guilty," his face is framed in a tight closeup. (Tight closeups are sometimes known as "choker closeups.") Later, when Juror Number 3 (Lee J. Cobb) is forced to explain why he is the sole remaining vote for conviction, he is also framed in tight closeup. The use of choker closeups at such moments provides a visual way of communicating the psychological isolation that the characters are then feeling. Choker closeups also suggest a certain level of intensity and passion, which may explain why the mercurial Juror Number 3 is so frequently framed in choker closeups while Fonda's icy, more rational Juror Number 8 is not. Although Fonda is no less intransigent than Juror Number 3 (indeed, he is more so!), his character, even in closeups, is framed less tightly than Juror Number 3.

In contrast to *Anatomy of a Murder,* which relies heavily on long takes, *12 Angry Men* relies in almost equal measure on long takes and editing. (Notice, for instance, how the jury's voting is sometimes filmed in a long take and sometimes in a series of short shots.) In general, however, the film tends to rely more heavily on long takes early in the narrative and more heavily on editing later in the film. In both instances, however, these techniques translate a rather static teleplay into a more dynamic cinematic experience.

9.13 Review questions

1. ¶9.02 discusses intertextuality and the way that movie stars "accumulate meanings that travel with them." Please select an example (different from the ones in ¶9.02) in a film you have seen in which a particular star plays a role similar to earlier movies (or, if you prefer, an example in which a star plays "against type"). Did the earlier film influence your interpretation of the later one?

2. Did the jury reach the right verdict in *12 Angry Men?* Why or why not (¶9.03)?

3. What were the twelve men "angry" about?

4. Would you favor a constitutional amendment to restrict or abolish the right to jury trial in criminal cases? If such an amendment were adopted, what fact-finding mechanism should replace the jury (see ¶¶9.04 to 9.08)?

5. Should the jury be allowed to jump into a trial and ask questions to the witnesses during the trial (¶9.08)?

6. Would you favor abolishing peremptory challenges of jurors or limiting them to one or two per side (¶¶9.06.2, 9.09.2)? This question assumes that if peremptory challenges were abolished, the court would still entertain challenges to jurors "for cause," meaning that the judge would disqualify jurors who knew the lawyers or parties to the case, had personal knowledge of the facts, or could not judge the issues fairly.

7. Suppose you are strongly in favor of legalizing the possession and use of marijuana. You are selected as a juror in a case involving criminal prosecution of a defendant who possessed a small amount of marijuana. The defendant (who has been convicted of drug charges in the past) faces many years in jail if convicted. Would you practice jury nullification in this case (¶9.11)? Should jurors be instructed that they have the power of jury nullification?

8. ¶9.12 discusses camera work in *12 Angry Men*. Select a particular scene in the film (aside from the ones mentioned in the text). Explain how the camera is used in this scene or how the scene was edited. Give a possible reason why the director, cinematographer, or editor made this choice.

Notes

1. Instructors may wish to choose a different (and more modern) film about the jury system, such as *Runaway Jury* (2003), *Jury Duty* (1995), *The Juror* (1996), *Trial by Jury* (1994), or the television show *The Jury* (2002).
2. The ideas in this section were suggested by Clover 1998.
3. Among the few exceptions to the rule that legal pop culture ignores the personalities of the individual jurors are *The Jury* (2002), a TV miniseries presented by Masterpiece Theater that focused more on the murder-trial jurors than on the trial, and several films involving jury tampering or juror misconduct—*Runaway Jury* (2003), *The Juror* (1996), *Trial by Jury* (1994), and *Suspect* (1987).
4. See Haddon 1994; Abramson 1994; Vidmar et al. 1998; Lenz 2003, 54–66; Carrington 2003.
5. In that case, a jury awarded $2.7 million in punitive damages to a woman badly burned by hot coffee that she was holding between her legs. However, the McDonald's case was severely misrepresented by the media. McDonald's kept its coffee scalding hot despite numerous previous injuries and warnings. The plaintiff tried to settle the case for $20,000 to cover medical expenses, but McDonald's turned it down. The judge reduced the award to $480,000 and the case was settled for an undisclosed but probably much lower amount to avoid an appeal. See Vidmar et al. 2003.
6. See http://www.kentlaw.edu/jurycenter/bibliography/comparative-jury-systems.html for a bibliography of articles about the jury system worldwide. For an extensive collection of comparative articles, see Marder 2011.
7. See also Abbott 1999, 21–5; Adler 1999.
8. Yet the *12 Angry Men* scenario can occur. Barbara Babcock asserted an insanity defense in Washington, DC, on behalf of an African American defendant. She felt that Juror Number 6, who was Caucasian, was against her all the way and deeply regretted that she had not challenged the juror. After the jury delivered a verdict of not guilty by reason of insanity, Juror Number 6 told Babcock that the jury had been 11–1 for conviction, but she had single-handedly turned them around (Babcock & Sassoubre 2007, 641).
9. A subsequent article agreed that people who read the transcript do a better job of detecting falsehood than people who see the witnesses. However, it contended that people who *hear* the testimony without seeing the witnesses (through an audio feed) do better than both people who see the witnesses and people who read their testimony. Apparently, we do better in distinguishing truth from falsehood by picking up auditory clues than we do from picking up visual clues (Blumenthal 1993).

Military Justice

Assigned Film: *A Few Good Men* (1992)[1]

10.01 The film and the play

A Few Good Men is based loosely on an incident that took place at Guantanamo Bay in 1986. An unhappy Marine (sometimes referred to as Willie A in accounts of the case) sought to transfer and threatened to report a colleague who had fired his weapon over the fence line. About ten Marines then conducted a Code Red "blanket party." They woke Willie A, shoved a pillowcase down his throat, and gave him a severe haircut. Willie A lapsed into a coma but survived. Guantanamo brass allegedly refused to transfer Willie A and authorized the hazing. The character of Daniel Kaffee appears to be based on a composite of a number of different JAG lawyers who were involved in the trial of the ten Marines (many of the lawyers claimed they were the model for Kaffee).[2] JAG stands for Judge Advocate General and refers both to the commanding officer of the legal branch of each of the services as well as to the lawyers who work for that officer. The JAG corps handles all manner of legal chores and includes military judges, prosecutors, and defense lawyers.

Three Marines went to trial. They were found guilty of assault and sentenced to time served but allowed to remain in the Corps. The other seven alleged assailants entered pleas and received less than honorable discharges. JAG lawyer Deborah Sorkin represented one of the ten Marines. She told her brother Aaron

about the case and he used it as the inspiration for a stage play (which he wrote on cocktail napkins while bartending[3]) and later for the film's screenplay. The film was successful commercially, grossing about $237 million on a production budget of about $40 million. The film was nominated for four Academy Awards—best picture, best supporting actor (Jack Nicholson), as well as best editing and sound, but it didn't win any.

10.02 The military justice system

10.02.1 The Uniform Code of Military Justice (UCMJ)[4]

The UCMJ was adopted in 1950. It defines military crimes and prescribes the procedures for administration of military justice. The UCMJ applies to millions of people in the armed services, including those enrolled in the service academies, members of the National Guard when federalized, and members of the reserves when on active duty. The UCMJ was a vast improvement over previous military justice practices and in many respects military and civilian justice practices are now similar. The trial in *A Few Good Men* was a *general court-martial* (which has unlimited punishment authority depending upon the offense charged).

A general court-martial is convened by the defendant's commanding officer (the "convening authority"). An "investigating officer" conducts a preliminary hearing (called an "Article 32 hearing") at which the defendant can cross-examine the witnesses against him. The trial judge must be a lawyer and is chosen by the JAG of the defendant's military branch (not by the convening authority). There must be a jury (called "members") of at least five persons. The jurors are chosen by the convening authority (not by the JAG). If the defendant is an enlisted man (the references to male gender here include the female), he can request that one-third of the members be enlisted men rather than officers. Decisions by courts-martial involving serious sentences are automatically reviewed by the military Court of Criminal Appeals for the service branch in question and may also be reviewed by the civilian United States Court of Appeals for the Armed Forces (CAAF). The U.S. Supreme Court has discretion to review decisions of the CAAF but seldom does so.

10.02.2 Command influence

An enduring problem of military justice is "command influence," meaning interference by superior officers with the witnesses, judge, or jury of a court-martial. The UCMJ firmly prohibits command influence. "No person subject to this chapter

may attempt to coerce or, by any unauthorized means, influence the action of a court-martial…" (Art. 37(a)). The CAAF has stated that unlawful command influence is "the mortal enemy of military justice" (*United States v. Thomas*, 1986).

Yet military officers (such as the convening authority, who is the defendant's commanding officer) aren't lawyers, and they sometimes resent the court-martial system. As a result, court-martial judges (and the military appellate courts) have decided numerous cases dealing with cases of command influence. When it appears, the military judge must fashion an appropriate remedy which might involve a new trial or even dismissal of all charges. (See *United States v. Douglas* [2010], which involved efforts by the defendant's commanding officer to intimidate the defendant and the witnesses) While one hopes that this kind of blatant interference with courts-martial is infrequent, the reality is that there are many opportunities in the military justice system for the exercise of subtle forms of command influence (see ¶10.02.3).

10.02.3 Why is there a separate military justice system?[5]

A Few Good Men raises the fundamental question of whether there should be a separate system of military and civilian justice for crimes committed in time of peace. Dawson and Downey were on trial for murder committed during peacetime at a military base. If they had been civilians who killed a service member, they would have been tried in an ordinary civilian court, not a court-martial (*Reid v. Covert*, 1957). Why should they be tried in a court-martial under military law? Does military necessity justify a separate system of justice in such cases? Or is this an example of what social scientists call "path dependence" (meaning that we have a separate system of military justice because we have had one for a very long time and, even if it is inferior, it is too difficult to change)?

The question of whether there should be a separate system of military justice has been a source of controversy since the earliest days of the Republic (and long before that in English law as well). The historical record is somewhat murky. There has been a constant push and pull between the norms of civilian justice and the military's need for discipline of its members. At least until the Civil War, however, ordinary crimes such as rape or murder committed by members of the armed services during peace time were usually tried in civilian rather than military courts. In any event, the Supreme Court has kept its hands off the military justice system.

At numerous points, military justice is superior to civilian justice. For example the rights to a warning under Article 31 are broader than *Miranda* rights and the rights of the accused at a preliminary hearing under Article 32 are superior to

grand jury procedures in civilian justice. Nevertheless, there remain a number of points at which military justice seems inferior to civilian justice. Consider a few of the differences:

- The convening authority: The "convening authority" investigates the case and makes the decision to convene a court-martial. That officer has command authority over the defendant, the witnesses, and members of the jury. These various roles could create serious conflicts of interest (Turley 2002, 669–71).

- Military judges: Military judges do not have life tenure (like federal judges) and are not elected or appointed for long periods (like state court judges). They are appointed to hear a particular court-martial. While they are not under the control of the convening authority, JAG judges are career officers who rotate through numerous assignments. They must consider the repercussions of every decision on their career path.

- Trial counsel: A staff judge advocate, who is directly responsible to the convening authority, selects the prosecutor (known as "trial counsel" in the military justice system). Trial counsel has greater power than a civilian prosecutor. For example, the defense lawyer must submit a request to subpoena a witness to the trial counsel with a statement of the expected testimony from the witness. Trial counsel then determines whether the request is reasonable in terms of relevance and necessity.

- Defense lawyers: JAG defense lawyers are not under the control of the convening authority. Defense lawyers are supplied whether or not the defendant can afford to pay private counsel, and the defendant can request a particular defense counsel who will serve if "reasonably available." In many cases, JAG defense counsels are relatively young and inexperienced, yet they may be assigned to serve even in death penalty cases, as occurs in *A Few Good Men* (Turley 2002, 673).

- Jurors: The jurors (known as "members" in the court-martial system) are selected by the staff judge advocate who is responsible to the convening authority. Jurors are not randomly selected, as in the civilian sector, and they do not represent a cross-section of the community. The members may well be biased, in the sense that the jurors (particularly officers) may feel a strong affinity for the prosecution. Enlisted men can request that up to one-third of the jurors be enlisted personnel (but that still leaves two-thirds officers; see Behan 2003).

The number of jurors is not uniform. In a general court-martial there must be at least five jurors, but there may be more (in a death penalty case there must be 12 jurors). A smaller jury is less likely to bring out conflicting voices and probably more likely to convict than a larger jury. The defendant has only one peremptory challenge and a challenged juror is not replaced (unless it would cause the number of jurors to fall below 5). Therefore a challenge reduces the size of the panel, which is usually considered a disadvantage to the defense. Finally the verdict need not be unanimous; in a non-capital case, a two-thirds vote is sufficient for conviction and for establishing the sentence up to 10 years. However, a sentence of more than 10 years up to life imprisonment requires a vote of three-fourths of the jury panel. In a capital case, there must be a unanimous vote to convict and to sentence the defendant to death.

- Witnesses: Witnesses are frequently under the command of the convening authority and thus may fear that their testimony will reflect on their career. As already mentioned, the prosecutor can veto defense requests for particular witnesses.

10.02.4 Accusing superior officers of crime

A number of people warn Kaffee that he will be court-martialed for unethical conduct if he accuses Jessep of giving an illegal order and falsifying records and can't back it up. Technically this advice is incorrect. As a JAG officer, Kaffee is independent of the chain of command. He would not be subject to discipline simply because he contested the word of a superior officer or accused a superior officer of improper activities.

In practice, however, Kaffee and the rest of the defense team were right to be concerned about going after Jessep and probably would never have called him. It is unlikely that the officers on the court-martial jury would disbelieve Jessep who was a highly regarded and often decorated officer. It certainly didn't figure that Jessep would lose his cool and confess to having ordered the Code Red or lying about Santiago's transfer, even if Kaffee pushed all his buttons. In addition, the Marine Corps and Naval JAGs are small clubs and it would not pay for defense lawyers to be disrespectful to superior officers. Somehow, an unfavorable performance rating might show up in the files. This was a greater concern for Galloway and Weinberg, who were career officers, than for Kaffee who apparently was in the service only for a short term.

10.03 Military justice in popular culture

There have been many fine military justice movies, both before and after *A Few Good Men* (see Kuzina 2005). *The Caine Mutiny* (1954), which was Humphrey Bogart's last film, is particularly outstanding. Many of these pictures make the point that the term "military justice" is a contradiction in terms, because a court-martial is used to divert blame from military superiors and transfer it to lower-ranking soldiers. One constant in the movies is the presence of "command influence" in which the brass tell the court-martial judges and jurors what to do (see ¶10.02.2).

Breaker Morant (1980) was based on a real trial that occurred during the brutal Boer War in South Africa around 1900 (see Kershen 1997). Morant and Handcock, who were Australian soldiers fighting for the British against the Boers (the white South Africans now referred to as Afrikaners), were guilty of shooting prisoners and a German missionary. Their defense was that the commander, Lord Kitchener, had ordered his troops to shoot prisoners, but the order was unwritten and thus deniable. It was obvious that the court-martial judges were under orders to convict and execute the prisoners as quickly as possible. Morant and Handcock were scapegoats to appease the Germans who were backing the Boers and threatening to enter the war. Despite heroic efforts by their inexperienced lawyer, Morant and Handcock are convicted and shot at sunrise.

Another fine picture based on command influence over a military tribunal is *Paths of Glory* (1957). This film involved a French court-martial condemning a few soldiers chosen at random to punish them for the failure of a hopeless assault on a German position. The scapegoating theme has occurred in other rather mediocre films involving military justice, such as *Rules of Engagement* (2000), in which the system seeks to pin the blame for civilian casualties on a Marine officer who ordered his men to fire when fired upon, and *High Crimes* (2002), in which a soldier's wife defends him in a court-martial intended to cover up the guilt of another officer.

On the whole, the modern military justice system is portrayed in a fairly favorable light in *A Few Good Men*. However, do you sniff a bit of command influence in the JAG Corps' decision to assign Kaffee to the Dawson/Downey case rather than a more experienced trial lawyer? (Normally, like any legal offices engaged in either prosecution or defense, JAG would assign only an experienced litigator to such an important case.) Did the brass want a quiet settlement in this sensitive and important case to prevent embarrassment of the Corps and figure Kaffee was more likely to settle it without trial than other JAG lawyers (such as Galloway)?

The military justice system (and the military in general) was favorably portrayed in the long-running television show *JAG* (1995–2005). The episodes focused on

two JAG lawyers, Harmon Rabb and Sarah MacKenzie, who were strongly attracted to each other but never quite got together (see also ¶10.06.6 for discussion of MacKenzie as a female lawyer). They tried a variety of cases (many torn from the headlines) and confronted many difficult problems of military justice.

10.04 The following-orders defense

10.04.1 The law of following orders

The murder trial in *A Few Good Men* is a springboard for questions about when a soldier should be held responsible for following an illegal order issued by his superior (see Minow 2007 for discussion of the following-orders defense). The Nuremberg trials after World War II established that the accused German officials and military officers could not claim a following-orders defense to prosecution for genocide and other war crimes. Nevertheless, the entire structure of military discipline depends on soldiers following orders from superior officers without question. Consequently, soldiers are likely to follow orders without challenging their legality because they are trained to do so, and because the consequences of refusing to follow an order can be very serious. This situation is confusing to both officers and enlisted men alike. Telling soldiers they face punishment unless they disobey illegal orders means telling them to think for themselves and question authority, yet directing them to question the legality of their orders undermines their training and group discipline and risks the lives of all concerned.

The issue of the legality of orders in military law comes up in two contexts. First, a soldier might be prosecuted for failing to follow orders but could assert the defense that the order was illegal. Second, a soldier might be prosecuted for other crimes and defend by claiming he was following orders, but the defense might not be accepted if the orders were illegal. This was the situation in *A Few Good Men.*

10.04.2 Following orders in A Few Good Men

If Dawson and Downey had refused to administer a Code Red to Santiago, they could have been punished for disobeying Kendrick's order. In theory, they could have defended by arguing that the Code Red was illegal under U.S. law because the Marines had banned them. However, they would have taken an enormous risk in refusing to follow Kendrick's order, given the stern disciplinary practices at Guantanamo and Kendrick's prior punishment of Dawson for failing to follow his orders in the Carter Bell case.

However, Dawson and Downey did follow Kendrick's order. The question is whether they have a following-orders defense to the murder charge against them. Under military law, "it is a defense to any offense that the accused was acting pursuant to orders *unless the accused knew the orders to be unlawful or a person of ordinary sense and understanding would have known the orders to be unlawful*" (Manual for Courts-Martial §916(d)). Although the jury acquitted Dawson and Downey of murder, it convicted them of the so-called "general offense," meaning "disorders and neglects to the prejudice of good order and discipline in the armed forces [and] all conduct of a nature to bring discredit upon the armed forces. . . ." Therefore the jury rejected the "following-orders defense" and ordered the Marines to be dishonorably discharged—the penalty that Dawson most feared. At the end of the film, Dawson accepts blame for his conduct. He tells Downey, "We were supposed to fight for people who couldn't fight for themselves. We were supposed to fight for Willie." Should Dawson and Downey have been found not guilty of the "general offense" because of the following-orders defense?

10.04.3 Abu Ghraib and the war on terror

The following orders defense arose in the notorious Abu Ghraib prisoner abuse case of 2003. An army reserve military police unit was in charge of Iraqi detainees who were awaiting interrogation. The unit included Privates Charles Graner and Lynndie England who had a sexual relationship. Photos of detainee abuse rocketed around the world and caused enormous damage to the U.S. war effort in Iraq.[6] Graner and England (and several other reservists) were convicted at general courts-martial of prisoner abuse[7] and sentenced to lengthy prison terms (10 years for Graner, 3 years for England) and dishonorably discharged.[8]

Graner raised the following-orders defense. He claimed that members of the military intelligence unit had ordered him to "soften up" the prisoners prior to interrogation. These claims were supported by a report by Major General Anthony Taguba.[9] A number of witnesses testified to having received these oral orders but the court-martial jury rejected the defense. Graner also testified that he had ordered England to abuse prisoners. It is unclear whether the following-orders defense was rejected because the jurors found that no orders had been given or because Graner and England knew or should have known the orders were illegal. In 2012, the Court of Appeals for the Armed Forces upheld Graner's conviction, but the court issued no written opinion.

The prosecutions for prisoner abuse stopped there (See Amann 2005). There has been no punishment of intelligence investigators who engaged in the torture

of prisoners under interrogation in Iraq, Afghanistan, or Guantanamo Bay.[10]

In 2002, President Bush was advised by his lawyers (the Office of Legal Counsel in the Justice Department, known as OLC) that non-uniformed detainees in Iraq and Afghanistan were not protected by the Geneva conventions against torture of prisoners. The OLC memoranda permitted extremely harsh methods of interrogation (such as waterboarding) that are widely regarded as torture. The OLC later withdrew these memos and the U.S. Supreme Court rejected their reasoning, but the authors of the memoranda were not punished.

If illegal activities occur in the course of fighting the war against terror, who should be punished for them? The soldiers carrying out illegal orders or their superiors who issued them? And how high up the chain of command should responsibility go?

10.04.4 The Milgram experiments

Can ordinary soldiers resist following blatantly illegal orders? The famous Milgram experiments suggest that they can't (Milgram 1974). Milgram set up an experiment in which volunteers thought they were administering electric shocks to students who were supposed to be learning a list of words. They were told to turn up the voltage when the students made a mistake. Of course, the "students" were actors who were not actually receiving shocks. In the experiments, about two-thirds of the volunteers followed orders to keep turning up the voltage despite screams of agony from the "students."[11] Milgram showed that ordinary people will follow morally repellent orders if the person giving the orders seems to be legitimate and authoritative and states that he will take responsibility if any of the "students" are harmed. Of course, these circumstances are present in the case of military orders, and, in addition, the soldiers receiving the orders know they can be punished if they don't follow them.

10.05 Daniel Kaffee

The character of Daniel Kaffee is interesting in several respects. He is fresh out of law school and has never tried a case before being assigned to the Dawson and Downey case (because his superiors expect him to settle it). But he turns out to be a gifted trial lawyer with great rhetorical skills. He is also very lucky.

Kaffee is part of a long tradition of youthful and inexperienced pop culture lawyers who turn out to have great natural instincts for the courtroom. For example, in *Legally Blonde* (2001), law student Elle Woods proves that she is anything but an airhead when she works on a murder case. In *The Rainmaker* (1997), Rudy

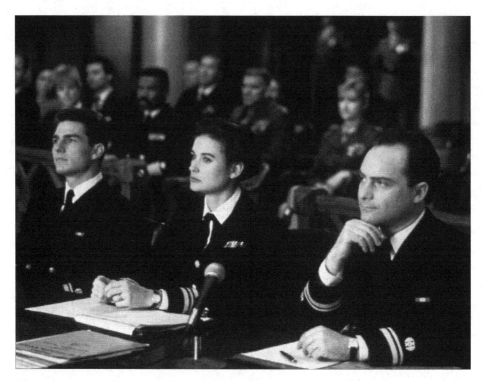

Figure 10.1. *A FEW GOOD MEN*. The defense team—Lt. Daniel Kaffee (Tom Cruise), Lt. Cdr. JoAnne Galloway, and Lt. Sam Weinberg (Kevin Pollak), Columbia Pictures/Photofest. © Columbia Pictures.

Baylor gets dumped by his prospective employer and joins an ambulance chasing firm. He wins a resounding verdict against a giant insurance company defended by a huge law firm. The reality, however, is that law school does not prepare young lawyers to try any kind of case, much less a difficult murder case (see ¶6.02.5). The assignment of such an inexperienced lawyer to handle such a difficult case generally guarantees an incompetent defense.

As a young military lawyer, Kaffee has settled 44 cases and never tried one. He's obviously a skillful bargainer (as we see in an early scene in the movie where he settles a drug case during softball practice). That skill set isn't very helpful if the case goes to trial. Nevertheless, negotiating skills are extremely valuable to a lawyer, because over 90% of all criminal and civil cases settle before trial (see ¶¶8.01.4, 12.01.1). Litigators prize the opportunity to actually try a case before a jury because it so rarely occurs. (District attorneys and public defenders get far more trial opportunities than private lawyers.)

Kaffee appeared to those who knew him as a lightweight lawyer who cared more about softball than his clients. His father was a famous JAG lawyer who ultimately became Attorney General of the United States. Kaffee, who went to Harvard Law School, joins the Navy JAG Corps when he graduates. It looks like he's trying to fill his father's shoes, and fill them he does with his passionate defense of Dawson and Downey. He has found himself as a lawyer and can look forward to a great career in the law.

10.06 Female lawyers in the movies [12]

Women now fill about half of the law school slots and perform every professional role. In the aggregate, they are no more or less competent, no more or less ethical, than their male counterparts. Nevertheless, movie representations of female lawyers abound with negative stereotypes.

10.06.1 Female lawyers—Yesterday and today

Until recently, female lawyers were a rarity. During the 1800s, women were excluded from the legal profession entirely. In 1873, the U.S. Supreme Court upheld the exclusion of Myra Bradwell from the Illinois Bar with the statement, "The family organization, which is founded in the divine ordinance, as well as in the nature of things, indicates the domestic sphere as that which properly belongs to the domain and functions of womanhood. The harmony, not to say identity, of interests and views which belongs, or should belong, to the family institution is repugnant to the idea of a woman adopting a distinct and independent career from that of her husband" (*Bradwell v. Illinois* 1872).

Until just a few years ago, the small scattering of female law students and lawyers encountered a heavy dose of educational and employment discrimination, sexism, and ridicule. Supreme Court Justices Ruth Bader Ginsburg and Sandra Day O'Connor couldn't get jobs as lawyers after graduating from law school. The rapid increase in female enrollment in law school did not begin until the 1970s and really took off in the 1980s and 1990s.

Even today, women lawyers have more difficulty than men in getting ahead. The ABA Commission on Women in the Profession documents that female lawyers earn about 76% as men do with similar experience and in similar positions (American Bar Association 2006). Men are at least twice as likely as similarly qualified women to obtain law firm partnerships. Women receive less mentoring and are often subject to sexual harassment. Women with parental responsibilities are seldom accommodated by flexible work schedules.

10.06.2 Favorable portrayals of women lawyers in the movies

Women lawyers in the movies got off to a wonderful start in the delicious comedy *Adam's Rib* (1949). Amanda Bonner (Katharine Hepburn) took a criminal case pro bono because she thought it raised an important issue of women's rights. Her client had shot her husband after finding him with his mistress. Amanda contended that a man would not be prosecuted in such circumstances so a woman should not be either. (See ¶2.06.1 for discussion of the "unwritten law.") Thus, the film is a disguised attack on the sexual double standard.

Amanda did a great job but infuriated her husband Adam (Spencer Tracy), who was prosecuting the case. (Incidentally, the district attorney would never have assigned Adam to the case, because it is improper for a married couple or lawyers in a non-marital relationship to oppose each other in court.) Amanda was a loving wife in a marriage of equals; however, she was also a dedicated and skillful lawyer. She risked her marriage in order to represent her client. This movie probably made legions of little girls want to go to law school (see Lucia 2005, ch. 1).

A few female lawyers are treated favorably in modern movies. Maggie McPherson in *The Lincoln Lawyer* (2011) is a capable prosecutor. Similarly, Kathryn Murphy in *The Accused* (1988) is a committed prosecutor who goes all out to secure justice for a rape victim. Reggie Love in *The Client* (1994) accepts a child's case pro bono and outsmarts all manner of wicked adversaries. In the film *In the Name of the Father* (1993), Gareth Peirce works tirelessly to free the wrongly imprisoned Guildford Four. Claire Kubik does a decent job representing her husband in *High Crimes* (2002), a contrived court-martial drama.

Women who represent clients while in law school (or just after passing the Bar) are also favorably portrayed. For example, in *Conviction* (2010), bartender Betty Ann Waters slogs her way through law school in order to free her wrongly imprisoned brother. Other positively represented female law students or new lawyers include Elle Woods in *Legally Blonde* (2001) and *Legally Blonde 2* (2003), Ellen Roark in *A Time to Kill* (1996), and Darby Shaw in *The Pelican Brief* (1993).

10.06.3 Female lawyers in film—Rita Harrison

Nevertheless, the majority of women lawyer characters in the movies are represented negatively. A typical example is Rita Harrison (Michelle Pfeiffer) in *I Am Sam* (2001). Harrison, a big-firm lawyer, is unethical, deceitful, and greedy. Her family life is a mess. True, she does change in the course of the narrative (as filmmakers say, she describes an arc). She is shamed into taking a pro bono child custody case for

a mentally disabled man (Sean Penn) and ultimately does a good job on his behalf. However, the movie's message is that female lawyers (except in the unlikely event that they are ensnared by a lovable pro bono client) are a complete disaster.

Rita Harrison's portrayal will resonate with many woman lawyers who are trying to succeed in the law firm environment while also nurturing a marriage (or other intimate relationship) and raising children. In order to meet the demand for billable hours, attorneys often find themselves spending 12 hours a day, six or seven days a week, in the office (see ¶13.05.4). Nobody can sustain a satisfying relationship with a spouse or a lover or do an adequate job of raising children while working these kinds of hours. Given that the main child-care responsibility generally falls on the shoulders of women in our society, the life of many female lawyers is a disorderly and frustrating mess, not unlike Harrison's. The same is true, obviously, of men who have or who share child-care responsibilities.

10.06.4 Negative treatment of women lawyers in contemporary film

The harshly negative treatment of Rita Harrison is typical of modern films involving female lawyers. As Corcos (2003) shows, women lawyers are almost always professional or personal failures or both and are portrayed much more negatively than male lawyers.

Women lawyers in the movies are usually beautiful but personally unpleasant. Often, they are nasty, cold-hearted, and overambitious. They have poor judgment in the selection of sexual partners. Some are sleeping with their clients, which is ethically prohibited as in *Jagged Edge* (1985) or *Defenseless* (1991). Others are having doomed affairs with their law firm superiors as in *Class Action* (1991). Sometimes, the narratives about female lawyers seem less concerned with their work and more with how they might find a man and thus become fulfilled human beings. This storyline occurs in numerous films such as *Suspect* (1987), *The Big Easy* (1987), *Physical Evidence* (1989), or *Legal Eagles* (1986).

The ethics of female lawyers are often horrendous. Karen Crowder, in *Michael Clayton* (2007), is general counsel of an agri-business company called U-North. U-North had decided to market a weed-killer despite knowing that it causes cancer. Crowder's job is to delay and obstruct a huge class action against U-North, in particular by withholding documents. Crowder thinks nothing of ordering the murder of Arthur Edens, a renegade lawyer who plans to leak the document. She also tries to murder lawyer-fixer Michael Clayton, and when that fails, she tries to pay him off to keep quiet.

In *The Verdict* (Chapter 4) a female lawyer acts as a sexual spy to steal information from the opposing side. The lawyer in *Defenseless* (1991) fails to disclose that she was a witness to the murder in question, and the female lawyer in *Liar Liar* (1997) is busy arranging for perjured testimony when she is not sexually harassing associates. Some have slept their way to the top, as in *Presumed Innocent* (1990). Many are incompetent. In *Philadelphia* (discussed in Chapter 13), Belinda Conine has an unpleasant condescending attitude and makes serious courtroom blunders. They are overly emotional and act irrationally in critical situations, as in *The Music Box* (1989) or *Jagged Edge* (1985). They do not know how to talk to ordinary people, like Theresa Dallavale in *Erin Brockovich* (2000). Erin herself is terrific, of course, but she is a paralegal, not a lawyer.

How is Lt. Cmdr. JoAnne Galloway represented in *A Few Good Men?* Is she incompetent and humorless? Or is her tenacity critical in getting Kaffee to take the Dawson/Downey case seriously?

10.06.5 Difference versus equality feminism

Feminist scholars split into two major camps. The "equality" faction believes that men and women are basically alike (aside from physiological differences) and should be treated alike. For decades, equality feminists lobbied for passage of the Equal Rights Amendment, which would guarantee legal equality for women.

The "difference" group, however, asserts that women are different from men. The law should take account of the differences between men and women, not ignore them. For example, law firms should treat lawyers (primarily women) with child care responsibilities differently from lawyers without such responsibilities. In addition to the obvious differences—women can bear children—many studies have shown that women are more nurturing than men with greater focus on connections and relationship rather than on competition and aggression (see ¶6.03.3 for discussion of difference theory and ¶14.06.1 for an example of the way these two versions of feminism play out in child custody law).

Supporters of difference feminism should consider the model of the female lawyer presented in *Legally Blonde* (2001). Elle Woods is a law student, but she functions during the second half of the film as a lawyer. Initially portrayed as a rich airhead, she turns out to be smart and clever. Her characterization is highly favorable, but it stresses her *difference* from male law students and lawyers, the ways in which she employs her femininity (and specialized female knowledge of fashion and hair dressing) in the interests of her client. She has emotions and does not try to suppress them in her personal or professional life. The film also contains strong portrayals of supportive female friendships—between Elle and her sorority sisters, her

beautician, a female professor, and her client. Elle Woods harks back to Amanda Bonner in *Adam's Rib*. Bonner was a great lawyer but still feminine. *Legally Blonde* says that women should not have to become like men to succeed as lawyers.

10.06.6 Female lawyers on television

On television female lawyers are normally treated in a sympathetic manner. A number of positively portrayed female lawyers appear in non-lawyer shows, such as *The Cosby Show*, *Sex and the City*, *Hill Street Blues*, and *The West Wing*. The women cops and lawyers on *The Practice*, *L.A. Law*, *Law & Order*, *Judging Amy*, *Family Law*, *The Good Wife*, *Harry's Law*, and many other shows, are all decent human beings and competent, dedicated lawyers. They confront ethical and personal dilemmas but handle them at least as well as their male counterparts. Most relevantly, the long-running television show *JAG* (1995–2005), discussed in ¶10.03, co-starred JAG Marine Lt. Col. Sarah MacKenzie, who was an extremely high-functioning and competent lawyer (Smith 2009.)

There are exceptions, of course. *Damages,* starring Glenn Close as Patty Hewes, is the most dramatic. Hewes could be one of the nastiest, most hateful, and least ethical lawyers in the history of pop culture. Ally McBeal, in the show of the same name, was unhappy in love and often incompetent in court, but the show was much more of a workplace comedy than a legal show (see ¶7.02.4; Asimow 2013). By and large, however, female lawyers on TV are treated much more favorably than their treatment in film. Indeed, the same is true of male lawyers (see ¶4.04.5).

10.06.7 Understanding the negative treatment of female lawyers in the movies

The field of feminist film criticism is huge (Stam 2000, 169–79; Haskell 1987). Feminist film analysis often begins with a famous article by Laura Mulvey (1975). In this article, Mulvey (drawing heavily on the work of Freud and Lacan) proclaimed that she wants to deconstruct and destroy the pleasure we take in watching movies. She argued that film produces pleasure by privileging the masculine "gaze." This gaze combines "scopophilia" (by which Mulvey meant viewing and eroticizing the female form) and identification by the viewer with the male figures in the film, who are acting upon the female.

As Mulvey sees it, films usually make men the active subject of the narrative and the female the passive object who is acted upon. Visual pleasure in film reproduces a structure of male looking and female to-be-looked-at, a binary structure

that mirrors the asymmetrical power relations operative in the real world. Women spectators have the unpleasant choice of identifying either with the active male protagonist or with the passive, objectified female antagonist.

Does Mulvey's analysis help us understand *A Few Good Men* and other negative-female-lawyer films? In many scenes, Galloway is portrayed beautifully, allowing her to be the subject of an eroticized male gaze. She is "acted upon" and manipulated by her JAG superiors, by Jessep, and by Kaffee. This sort of analysis applies to many of the negative female lawyer films.

What other explanations might be offered for the prevalence of negative female lawyer films?[13] Do these movies reflect public sentiment that women don't belong in the legal profession—that the jobs lawyers do are more appropriate for men? That doing such jobs will destroy the feminine side of women? (Recall the Supreme Court's *Bradwell* decision quoted in ¶10.06.1.) Discomfort with the meteoric increase in the number of female lawyers in the last few decades? Do they reinforce the dominant ideology that women should be subordinate to men?

Is the stereotypical way in which women lawyers are treated a backlash against feminism and the political, social, and economic gains women have made since the 1960s and 1970s? Does it reflect suspicion and distrust of smart, tough, aggressive, powerful women? Women who can make enough money to avoid dependence on men?

Is it a desire by filmmakers to appeal to a male demographic among ticket buyers, or is it an inability to see females as other than sex objects? From still another perspective, does it reflect the views of filmmakers (predominantly white males at all levels of the production process) that women should stay in the domestic sphere rather than the professional sphere? Do all these negative treatments of female lawyers have an impact on the way people in the world (such as male or female lawyers, judges, jurors, or clients) actually behave? (Recall discussion of the "cultivation effect" in ¶4.04.3.)

10.07 Cinematic technique in *A Few Good Men*

10.07.1 Sound editing

At about 1 hour and 38 minutes into *A Few Good Men* it starts to rain. During that time, thunder is used several times for dramatic effect. For instance, thunder introduces and climaxes the scene in which Markinson commits suicide. The scene opens with a shot of Markinson's Marine Corps uniform laid out on the hotel room bed. A soft but ominous clap of thunder opens the shot. The scene ends with Markinson placing his gun in his mouth. Instead of hearing the sound of the gun being fired,

we hear a loud clap of thunder. The clap of thunder is used as an aural analogue for the sound of a gun being fired, but it is also used as an editing device. Markinson is standing in front of the hotel room window when he commits suicide. Just as he is about to pull the trigger, there is a burst of lightning outside of the window. The film then cuts to a shot of the courtroom window, at which time we hear the clap of thunder. Thus, what otherwise might have been a jarring transition between scenes, is smoothed over through the use of the thunder.

Thunder is also used to underscore Private Downey's testimony. Under intense questioning by Capt. Ross, Downey admits: "Yes, Captain. I was given an order by my squad leader, Lance Corporal Harold W. Dawson, United States Marine Corps, and I followed it." A clap of thunder immediately follows. It is not a loud clap of thunder. Instead, it is a long, rolling clap of thunder, allowing the film to cut to reaction shots of Ross, Kaffee, and Galloway. The thunder is even used to transition into the next scene.

10.07.2 Rack focus in A Few Good Men

Rack focus is a widely used technique in film and television in which the focus of the lens is changed such that the visual focus of a scene changes from a previously out-of-focus object in the background to a previously in-focus object in the foreground, or vice versa.

A particularly complex example occurs during the reading of the jury's verdict. As the jury's verdict is read, the camera focuses on the reactions of Kaffee, Galloway, Weinberg, Dawson, and Downey. However, rather than cut from one face to another, the camera captures their reactions in a single take through the use of three changes in a focus and a slowly moving camera that smoothly but continuously reframes the composition. The shot begins with Kaffee in the extreme foreground, Galloway next to him, Weinberg next to her, and Downey and Dawson in the extreme background. For the first "not guilty," Kaffee is in focus. Everyone else is out of focus. As a result, we get to see his reaction without any distractions. For the second "not guilty," the camera glides past Kaffee so that only Galloway, Weinberg, Downey, and Dawson are in the frame. Galloway is in focus; everyone else is out of focus. As a result, we can absorb Galloway's reaction. For the third and final verdict (guilty"), the camera glides past Weinberg and settles on Dawson and Downey. When the guilty verdict is read, they are alone in the frame. Therefore, the focus is entirely on their reaction as they take in the verdict. Interestingly, although it is a bravura piece of filmmaking, the shot does not stand out as such. Instead, it comes across as an almost perfect melding of form and content.

10.07.3 Lighting

Strong overhead lighting is generally considered to be unflattering and harsh. At the same time it can be used for dramatic effect. For instance, in *film noirs,* overhead lighting is often used to create an oppressive, claustrophobic atmosphere. *A Few Good Men* uses overhead lighting in the scene in which Kaffee interrupts Cpt. Ross to tell him that Downey and Dawson were given a Code Red. Why do you think the filmmakers decided to use overhead lighting in the scene? Is it effective?

10.08 Review questions

1. Should the trial of ordinary crimes (such as murder) committed by members of the armed services be conducted in civilian courts rather than in military courts-martial (see ¶10.02.3)?
2. Should the Uniform Code of Military Justice be amended to bring the procedures in military trials more in line with the civilian model? What specific changes would you suggest (¶10.02.3)?
3. Do you think the court-martial was right or wrong in acquitting Dawson and Downey of murder but convicting them under the "general article" of the UCMJ (¶10.04)?
4. Do you regard the film's portrayal of JoAnne Galloway as positive or negative? Why (¶10.06.4)?
5. Pick any female lawyer who you've seen on television. The lawyer might have appeared on any dramatic legally themed show (like *Law & Order* or *The Good Wife* or *Harry's Law*) or on a soap opera or in any other kind of TV show such as *Sex and the City* (but not a reality show like *Judge Judy*). You can use characters from any of the shows mentioned in ¶10.06.6. Compare this character to JoAnne Galloway on both the personal and professional levels.
6. Apply the analysis of Laura Mulvey (10.06.7) to any female character in the movies—not necessarily a lawyer (but other than JoAnne Galloway). Does Mulvey's analysis help us understand the representation of the female character? Do you agree with Mulvey's theory?
7. What is your explanation for the prevalence of negative portrayals of female lawyers in the movies (¶10.06.7)?
8. When the "guilty" verdict is read, Privates Downey and Dawson are standing next to the window. Sunlight is pouring in, bathing them in a warm glow. In many ways, the decision to bathe the courtroom in

the warm glow of sunlight seems like a strange aesthetic choice. But is it? What purpose is served by ending the film with a lighting scheme that gives the impression of dawn breaking?

9. *A Few Good Men* uses shots of Washington, DC's most famous monuments to transition between scenes. However, because the shots are frequently used to introduce scenes involving Kaffee and the defense team, the shots create an associative link between Kaffee and the defense team and these icons of America's civil religion. Is that fair? Is Capt. Ross acting any less patriotically by prosecuting the case?

10. *A Few Good Men* begins with a lengthy montage of a United States Marine Corps drill team. What is the purpose of the scene? Is out of place in a film that is critical of the USMC?

Notes

1. See ¶10.03 for discussion of additional films about military justice. Instructors might select one of them instead of *A Few Good Men*. Our thanks to Professor Scott Silliman for assistance with this chapter.

2. http://www.nytimes.com/2011/09/16/nyregion/4-lawyers-claim-to-be-the-hero-in-a-few-good-men.html. See also the Wikipedia entry for the film for additional references.

3. http://westwing.bewarne.com/credits/sorkin.html

4. The UCMJ is available at http://www.military-network.com/main_ucmj/main_ucmj.htm

5. The information and ideas discussed in this subsection are drawn from Turley 2002.

6. For some of the photos, see http://www.antiwar.com/news/?articleid=8560

7. Art. 93 of the UCMJ bans cruelty and maltreatment of prisoners.

8. http://www.nytimes.com/2005/09/27/national/27england.html?_r=1&ref=lynndierengland

9. http://www.newyorker.com/reporting/2007/06/25/070625fa_fact_hersh

10. http://www.npr.org/templates/story/story.php?storyId=103281803

11. Many people raised ethical objections to the Milgram experiments. The experiments are often cited as giving the impetus to the federal law requiring universities to create Institutional Review Boards (IRBs). IRBs must approve any experiment on human subjects. Burger ran a similar experiment in 2008, in which he came up with approximately the same results as Milgram. See http://www.eurekalert.org/pub_releases/2008-12/apa-rmr121708.php

12. For a website listing all female lawyer roles in the movies, see http://faculty.law.lsu.edu/ccorcos/lawhum/womenlawyersinfilms.htm

13. Various writers (Lucia 2005; Graham and Maschio 1995–96; Miller 1994; Caplow 1999; Shapiro 1994 and 1998) offer different explanations for this peculiar phenomenon.

The Death Penalty

Assigned Film: *Dead Man Walking* (1996)[1]

11.01 The book and the movie[2]

The film *Dead Man Walking* was adapted from the book of the same name published by Sister Helen Prejean (1994). The character of Matthew Poncelet is a composite of two different death row prisoners with whom Sister Prejean worked in New Orleans. Susan Sarandon won an Oscar for best actress. Sean Penn was nominated for best actor, Tim Robbins for best director, and Bruce Springsteen for best song. Considering how dark it is, the film did well at the box office, grossing about $39 million on an original budget of about $11 million. (For discussion of adapting books into movies, see ¶12.02.3.)

11.02 Death penalty movies

11.02.1 Political stance of death penalty movies[3]

From the earliest times, films have expressed the political views of their creators. These views may be conservative or hegemonic (in favor of the status quo and its various economic, gender, or ethnic power relationships), but they may also be liberal or even radical (in favor of moderate or drastic social change). Legally themed

films are particularly well suited to transmit political messages. Many of the films discussed in this book pack a powerful political charge: *To Kill a Mockingbird* (Chapter 3) criticizes racialized criminal justice process; *12 Angry Men* (Chapter 9) glorifies the jury system; *A Civil Action* (Chapter 12) takes on water pollution and the civil justice system; *Philadelphia* (Chapter 13) is about discrimination against AIDS victims. Whether consumers of these films accept, reject, or modify the political message is, of course, quite a different matter (see ¶¶1.05.5 and 4.04.6).

The numerous films about the death penalty may be the most political of all. Some death penalty films take the popular stand in favor of society's right to claim retribution from those who committed terrible crimes. Older films were governed by the Production Code (see ¶¶2.03, 5.05, 13.03.2, 14.03), which mandated that crime must never pay. Many such films ended with the villain going to the chair and treated this punishment as wholly appropriate. A classic example is *Angels with Dirty Faces* (1938), in which James Cagney plays a hardened mobster. To avoid influencing his youthful followers to adopt a life of crime, he pretends to "go yellow" when he is dragged off to the chair. Some modern law-and-order based films also seem to favor the death penalty. A good example is *Just Cause* (1995), in which a Harvard law professor is shown to be a naïve do-gooder in trying to block his client's execution. Countless vigilante pictures, such as *Dirty Harry* (1971), *Unforgiven* (1992), or *A Time to Kill* (1996), applaud the death penalty as administered by the police or by crime victims or their surrogates.

Nevertheless, many modern films assume a political stance against the death penalty. The message is most overt when innocent people are executed (or spared just in time). *The Green Mile* (1999), *The Life of David Gale* (2003), and *A Lesson Before Dying* (a made-for-television film from 1999) are prominent examples of movies involving the execution of prisoners whom we know to be innocent. *I Want To Live* (1958) shows (in excruciating detail) the execution of a woman in the California gas chamber; the film suggests she may well have been innocent. The outstanding documentary, *The Thin Blue Line* (1988), made by Errol Morris, concerns an innocent man sentenced to death; the documentary was responsible for his release. In *The Green Mile,* John Coffey seems to be a Christ-like figure and his electrocution resembles the Crucifixion. (The other convicts executed in *The Green Mile* were undoubtedly guilty.) Two powerful British films involving innocent defendants are *10 Rillington Place* (1971) and *Let Him Have It* (1991). These two films are based on true stories and were instrumental in persuading the British to abolish capital punishment. Several of the military justice movies, such as *Breaker Morant* and *Paths of Glory,* also fall into this category of innocent death penalty victims (see ¶10.03).

The anti-death penalty message is more subtle in films involving the execution of *guilty* prisoners such as *Dead Man Walking, The Chamber* (1996) and *Last Dance* (1996). In these films, viewers encounter a criminal already condemned to death for having committed a horrible crime. An intermediary comes to death row, forms an empathetic relationship with the suspicious prisoner, and assists the prisoner to achieve personal redemption. The condemned person takes responsibility for the crime, expresses remorse, acknowledges the agony of the victims, and apologizes to their families. The usual appeals fail, the governor denies clemency, and the prisoner is executed.

Many death penalty movies involve similar casts of characters and recurring themes—all of which seem designed to influence viewers to adopt an anti-death penalty stance. The defense lawyer at the trial is incompetent, unprepared, and uncaring. Prosecutors are bloodthirsty and politically ambitious. Biased judges influence the jury to vote the death penalty. Sadistic guards abuse helpless prisoners. Governors deny clemency because it would be political suicide to grant it. Dedicated post-conviction lawyers frantically push every possible legal button as the seconds tick off; sometimes there is a last minute stay, which is then lifted so execution can proceed. At the prison, pro- and anti-death penalty demonstrators stage a vigil. All of these are familiar moves and convey an unmistakable anti-death penalty message.

In your view, what is the political stance of *Dead Man Walking*—anti-death penalty or pro-death penalty? Or does the movie provide ammunition for both sides? Sarat (1999) sees the movie as anti-death penalty, but Shapiro (1996) reports that many viewers interpret it as being in favor of capital punishment.

11.02.2 Redemption of the condemned

Recall the explicit treatment of the issue of responsibility in *Dead Man Walking*. Sister Prejean tells Poncelet: "Don't blame [your accomplice]. You blame him. You blame drugs. You blame the government. You blame blacks. You blame the Percys. You blame the kids for being there. What about Matthew Poncelet? Is he just an innocent, a victim?" Finally, Poncelet takes responsibility. "The boy. Walter. I killed him." Later, asked if he will take responsibility for both deaths, Poncelet says "Yes ma'am." Just before dying, Poncelet says to Delacroix: "I ask your forgiveness. It was a terrible thing I did taking your son away from you. I hope my death gives you some relief."

Austin Sarat (1999), writing primarily about *Dead Man Walking* and *Last Dance,* speculates that these films are intended to be powerful statements against the death penalty. In Sarat's analysis, these films place us in the same position as

jurors at the penalty phase of the trial (see ¶¶8.01.5 and 11.06). We are called upon to make the same decision as the penalty phase jurors. One of the elements of that decision is a moral judgment about whether the death penalty is appropriate in this particular case. On that point, we have knowledge that the original jury didn't—the prisoner's death row epiphany. We have discovered that the prisoner has taken responsibility for the crime, expressed remorse, become human rather than a vicious monster, so we may be disposed, as surrogate jurors, to vote against the death penalty. Nevertheless, we see the prisoner executed—something we might now believe to be a mistake. This leaves us more doubtful about the morality of the death penalty than when we entered the theater. However, we might have the opposite reaction. Because the imminence of execution caused a prisoner to take responsibility and achieve personal redemption, we might decide that the moral case for the death penalty is strengthened.

11.02.3 Transformation of the intermediary

In many death penalty films, particularly those involving redemption of the guilty condemned, an intermediary is also transformed by the experience. Sister Prejean becomes a committed death penalty opponent. Similar personal transformations occur in *The Chamber, Last Dance, The Widow of St. Pierre,* and *The Life of David Gale.* Transformation of the intermediary also occurs in innocent prisoner films, such as *The Green Mile.* Death row guard Paul Edgecomb never works another execution and takes up work with youthful prisoners. The same thing happens to death row guard Hank Grotowski in *Monster's Ball* (2001), a film premised on the execution of a guilty and unrepentant prisoner, and to Cpt. Fred Allen in Werner Herzog's documentary *Into the Abyss* (2011). After presiding over more than 100 executions, Allen realized he was opposed to the death penalty.

Sarat speculates that the personal transformation of the intermediary is also an anti-death penalty move by the filmmakers. To most of us, the death penalty is abstract; we don't know anybody who has been condemned to death and we have never set foot on death row. However, when confronted by the ghastly reality of the capital punishment process, these empathetic intermediaries have changed—some into death penalty opponents, some into new levels of personal maturity, some into a withdrawal from working on death row. Perhaps we identify with these intermediaries and ask ourselves whether we could show as much understanding and compassion as that person. Perhaps we too will be transformed in a way that makes us doubt our support for the death penalty. Aside from its use as a political tactic by filmmakers, are there other reasons why the makers of death penalty films repeat-

edly use as thematic material the personal redemption of the condemned and the personal transformation of the intermediary? In short, why do we care about the redemption of vicious killers or the transformation of those who befriended them?

11.03 Pictures at an execution

Historically, executions in America and many other countries were public spectacles. In the nineteenth century, enormous, often festive crowds attended public hangings. In a number of countries, public executions still occur; perhaps such ceremonies are intended to demonstrate the power of the state and to terrify the citizenry into obedience. Ultimately, the states abolished public executions. The last known public execution in America occurred in 1937. Normally, executions today are viewed by a relatively small group of witnesses, mostly the press, prison officials, and families of victims, and photographs are prohibited.

Thus the only way that the general public can "witness" an execution is by viewing films or TV shows about the death penalty. As in *Dead Man Walking* and numerous other films, we witness, in excruciating detail, the bureaucratized process and the numerous mechanical steps necessary to perform an execution by electrocution, in the gas chamber, or by lethal injection. We see the condemned prepare for death, walk to the place of execution, and suffer the death agony. Indeed, we see far more than the official witnesses to the execution. In *The Green Mile,* we witness no less than three electrocutions, one of them horribly botched.

Why do filmmakers show the executions in such gory detail? Is this depiction another political move or is it intended to respond to the same craving that once caused crowds of people to attend public executions?

We could, of course, return to a form of the public execution by televising executions (see Lesser 1993). Should we?

11.04 The voice of the victims

In many death penalty films, especially including *Dead Man Walking,* we hear extensively from the families of the victims who are usually clamoring for the execution of the condemned. Once more, the movie serves as a retrial of the penalty phase of the trial—with us as the surrogate jurors. This time, we are receiving evidence that might cause us to vote in favor of, rather than against, imposing the death penalty. How do you interpret the scenes at the end of the film involving Earl Delacroix and Sister Prejean?

In fact, victim testimony is now routinely admitted during the penalty phase of death penalty cases. In *Payne v. Tennessee* (1991), the Supreme Court (overturning a case decided only four years earlier) held that the families of murder victims could testify during the penalty phase. The jury is allowed to consider the magnitude of the survivors' loss and the victim's suffering as aggravating factors. Permitting the voice of the victims to be heard in a criminal prosecution fundamentally changes the proceedings. The victims testify in a very emotional manner about their loss (whereas most trial testimony is cold and unemotional). In addition, the use of victim statements changes a death penalty case from an action by the state to redress a violation of the norms of society into an action by the victims for revenge.

11.05 Purposes of the death penalty

11.05.1 Deterrence

Many people who support the death penalty believe that it deters criminals from committing murder. They argue that if the death penalty saves the lives of innocent victims, it enhances net social welfare and is thus justified. This is a utilitarian or consequentialist justification for the death penalty.

Obviously, it is difficult to prove the existence of a deterrent effect because it requires a guess about how many murders were *not* committed because potential killers were deterred by the possibility of receiving the death penalty. Are there people who make a rational calculation and decide *not* to kill because their state has the death penalty but who *would have* killed if the only penalty for murder were life imprisonment?

Many homicides will not be deterred even by a strongly enforced death penalty because they are committed by people who are not making rational calculations at the time (such as barroom brawls or domestic abuse). Other homicides result from the felony murder rule (such as an unplanned death that occurs during a burglary or armed robbery), and many are committed by people who do not think they will get caught. Moreover, there are so many murders and so few executions and such lengthy delays in administering the death penalty (see ¶11.07.6) that it is hard to believe that rational persons considering whether to commit murder would really change their plans because of the remote possibility that they might be sentenced to death, and the sentence might be carried out, as opposed to receiving life without the possibility of parole.

11.05.2 Studies of deterrence

Numerous statistical studies measure the presence or absence of a deterrent effect. Unfortunately, there are serious methodological problems in attempting to correlate murder rates and execution rates. The results depend heavily on fine points of statistical methodology as well as on the data set used by the researcher and the various assumptions the researcher makes. There are so many homicides and so few executions that it is impossible to make firm predictions about the effect of the death penalty. Thus in 2010, there were about 15,000 murders but only 43 inmates were executed.

The statistical studies about deterrence conflict. It is difficult for non-experts in statistical methodology to make firm judgments about the validity of the various studies and their conclusions. Some studies indicate that homicide rates are *higher* where the death penalty is imposed (a possible result of the so-called "brutalization" effect of constant media discussion of the death penalty). For example, Harries and Cheatwood (1997) studied differences in homicides and violent crime in 293 pairs of contiguous counties. The counties were matched in pairs based on geographic location, regional context, historical development, and demographic and economic variables. The authors found no support for a deterrent effect at the county level. The researchers compared matched counties inside and outside states with capital punishment, with and without a death row population, and with and without actual executions. The authors found *higher* violent crime rates in death penalty counties.

Conversely, some econometric studies do find a deterrent effect. For example, Dezhbakhsh, Rubin, and Shepherd (2003) studied murder rates in 3,073 counties before, during, and after the suspension and reinstatement of capital punishment because of the Supreme Court decisions in 1972 and 1976 that are discussed in ¶11.06. The homicide rate rose sharply during the moratorium period and fell after capital punishment was restored in 1976. The authors tried to crank into their equations every possible variable concerning demographics, gun ownership, and the probabilities of arrest, conviction, and execution in each county. They identified a strong deterrent effect. In their opinion, every execution results in between eight and 18 fewer murders.

However, these econometric studies have been severely criticized. Donohue and Wolfers conducted an in-depth analysis of the econometric studies and found them to be statistically invalid. The increase in homicides during the moratorium period and the drop in homicides after the end of the moratorium period paralleled a similar pattern in Canada—which had no capital punishment during this period. This suggests that the increase in U.S. homicides was due to other factors than the moratorium and restoration of the death penalty. The same is true in states that never had the death penalty at the time of the moratorium and did not adopt

it when the moratorium ended. The trend of homicides in these states was similar to the trend in states that employed the death penalty before and after the moratorium. Donohue and Wolfers (2005) conclude:

> Our key insight is that the death penalty…is applied so rarely that the number of homicides it can plausibly have caused or deterred cannot be reliably disentangled from the large year-to-year changes in the homicide rate caused by other factors. Our estimates suggest not just "reasonable doubt" about whether there is any deterrent effect of the death penalty, but profound uncertainty. We are confident that the effects are not large, but remain unsure even of whether they are positive or negative. (p. 794)

In a later article, Donohue and Wolfers (2009) deepen their methodological criticisms and also point to an interesting comparison between similar city-states, Hong Kong and Singapore. Singapore had an execution rate of about 1 per million until 1994–96 when the execution rate increased twenty-fold. Then the rate declined by about 95%. Hong Kong abolished capital punishment in 1993 and had no executions for many years prior to abolition. Homicide rates were remarkably similar in these two city-states over the 35 years after 1973, with neither the surge in Singapore executions or the following steep drop producing any impact that was different from the pattern in Hong Kong.

11.05.3 Incapacitation

Another consequentialist justification for the death penalty is that it prevents the offender from ever killing again. A prisoner sentenced to life imprisonment might ultimately get out of jail (either through parole or by escaping) and kill again. Also, a prisoner might kill another prisoner or a guard while serving a life sentence in the general prison population. Obviously, a prisoner who is confined to death row and ultimately executed is unlikely to be able to kill anyone.

The incapacitation rationale is weakened if a killer is sentenced to life without the possibility of parole, which is possible in most states. Nevertheless, death penalty proponents are skeptical about these statutes. The prisoner might still persuade the authorities to commute the sentence or the prisoner might escape. In addition, prisoners sentenced to life without parole might still kill another prisoner or a guard although modern super-high security prisons make this unlikely.

11.05.4 Moral opposition to the death penalty and retribution

Most arguments about the death penalty are based on one of two moral views. Many of those who favor the death penalty base their opinion on theories of retribution (and we hear from some of them in *Dead Man Walking*). In this view, jus-

tice requires that society punish by death a person who has killed, reserving the most extreme punishment for the most heinous crime. Biblical texts such as "an eye for an eye" are sometimes cited to support this view. This retributivist approach is based not on the consequences of punishment (such as deterrence or incapacitation), but on the non-consequentialist rationale that the evildoer deserves it or that society must express its sense of communal outrage by exacting the ultimate penalty from the worst of the worst.

Others, like Sister Prejean, take an opposing moral view. They argue that retribution is a primitive urge that has no place in modern society; they believe that killing is wrong, whether it is done by a criminal or by the state.

11.06 Judicial flip-flops on the death penalty

In *Furman v. Georgia* (1972), the U.S. Supreme Court held that the death penalty, as administered in Georgia, was unconstitutional because it violated the cruel and unusual punishment clause of the Eighth Amendment. Although the justices differed somewhat in their reasoning, the primary rationale was the arbitrariness of imposition of the death penalty. Juries were given no guidance in deciding whether to condemn a defendant to death, and imposition of the penalty was highly unpredictable. The result of the *Furman* decision was to spare 629 persons then on death row.

However, Georgia and many other states were determined to retain the death penalty. They restructured their procedures by furnishing more guidance to the jury. The new death penalty statutes involve a double trial before the same jury. In the first trial, the jury must find the defendant guilty of murder. The second trial is called the "penalty phase." The statutes spell out specific aggravating factors (such as whether the defendant killed a policeman, whether the killing occurred in the course of a terrorist act, whether the defendant lay in wait, or whether the killing occurred during an armed robbery). During the penalty phase, the jury must find beyond a reasonable doubt that at least one of these aggravating factors is present before it can impose the death penalty. During the penalty phase, the defendant is entitled to introduce any mitigating evidence, such as evidence about character, personal history, mental ability, youth or psychological factors, evidence concerning the defendant's culpability in the particular crime, or evidence that defendant took responsibility for the crime. Supposedly this process guides the jury's decision making and reduces the chances of an arbitrary decision. Faced with a death penalty judgment imposed under a modern two-stage statute, the Supreme Court reinstated the death penalty (*Gregg v. Georgia*, 1976).

The *Gregg* decision made the federal courts the ultimate authorities of the fairness of state death penalty procedures. As a result, the Supreme Court has been called on to decide numerous death penalty cases. In *Roper v. Simmons* (2005), the Supreme Court held (by a 5–4 vote) that it is unconstitutional to execute a person who was under 18 when the crime was committed. Controversially, it relied in part on international practice. In *Atkins v. Virginia* (2002), the Court held (again 5 to 4) that the state could not execute mentally retarded prisoners. A few days later, it held (7 to 2) that the aggravating factors must be found by a jury, not the judge (*Ring v. Arizona* 2002). This important decision set aside procedures in a number of states that allowed the judge to impose the death penalty, even if the jury had refused to do so.

An important aspect of death penalty law is that the courts, state legislatures, and Congress have severely limited a prisoner's ability to seek judicial review after exhausting direct appeals in the state courts (followed by a request for a hearing—called certiorari—from the U.S. Supreme Court). After this process is completed, a state prisoner gets into federal court by seeking a writ of habeas corpus. Habeas is the ancient writ that requires government to establish a legal reason for confining a prisoner. Habeas applies if the state committed a procedural error of constitutional dimensions or, in some cases, if new evidence proves the prisoner was innocent. The law relating to federal habeas is too complex to summarize here. However, as a result of various federal statutes and court decisions, all of which were designed to limit the number of death penalty reviews, relatively few prisoners will secure any relief either through the appeal process or through federal habeas, even in cases in which they present new evidence of innocence.

11.07 The death penalty in the United States—Law and practice[4]

Following the Supreme Court's decision in *Gregg* that reinstated the death penalty, capital punishment became popular. It is now available in 33 states and for numerous federal crimes. The peak number of states that imposed the death penalty was 38; New York repealed its death penalty in 2004 and Connecticut in 2012, but the Connecticut repeal was prospective only, leaving a number of prisoners still subject to execution.

Since 1976 (the year of the *Gregg* decision) until the end of 2011, 1,284 prisoners were executed. In the fall of 2011, 3,220 prisoners sat on death row. However, a trend away from the death penalty seems to be in process. The peak rate for exe-

cutions was 1999 when 98 prisoners were executed. Only 43 were executed in 2011. In 1998, 294 persons were sentenced to death; in 2011, only 78 persons were sentenced to death. The decreased number of prisoners sentenced to death reflects declines in the homicide rate, but it probably also reflects the difficult practical problems with the death penalty discussed below in this section.[5]

The death penalty is popular with voters, but the support level is dropping, in part because of publicity about innocent defendants wrongly sentenced to death. The Gallup Poll indicated that 61% of respondents favored the death penalty in 2011 (down from 80% in 1996). Support drops to 49% when the alternative is life without possibility of parole. In the Gallup Poll, only 32% thought that the death penalty effectively deters murder.[6] In 2012, an initiative on the California ballot to abolish the death penalty failed by a narrow 52–48 margin.

Regardless of one's feelings about whether the death penalty is an effective *deterrent* or whether it is *morally* appropriate (see ¶11.05.4), most people agree that there are troubling problems with the way it works in practice. In theory, the death penalty should be reserved only for "the worst of the worst," but it often fails to achieve that goal. Many of these practical problems are addressed in *Dead Man Walking* and in some of the other death penalty films released during the last decade. These practical and administrative problems might cause a utilitarian to oppose the death penalty *even if* that person is a retributivist and has no moral objection to executing "the worst of the worst."

11.07.1 The risk that an innocent person will be put to death

The problem that has received the most publicity is the significant number of apparently innocent people who have been sentenced to death and the possibility that some innocent people have been executed. Recently DNA evidence has proven the innocence of some condemned prisoners, and numerous others have been proven innocent by dedicated student and journalistic investigators. Since 1977, 140 people in 25 states have been freed from death row on proof they were probably or at least possibly innocent.[7]

11.07.2 Clemency

In theory, the state's clemency process provides one last chance for the defendant whose guilt is questionable or whose case merits a lesser punishment than death. However, the political realities of the death penalty discourage governors who might otherwise be disposed to grant clemency. A decision to grant clemency

would be political poison in a state where the death penalty is popular with voters and the governor plans to stand for re-election. We see the uselessness of the clemency process in *Dead Man Walking*.

11.07.3 Racial disparities

One serious problem with the death penalty involves racial disparity. Statistics show that blacks who kill whites are far more likely to be executed than other combinations (whites who kill blacks, whites who kill whites, or blacks who kill blacks). Of the persons executed for *interracial* murder from 1977 to 2000, 172 were black defendant/white victim, and only 12 were white defendant/black victim. Over 80% of decisions imposing the death penalty involve white victims, even though nationally only 50% of murder victims are white.

In *McCleskey v. Kemp* (1987), the U.S. Supreme Court held that a strong statistical showing of this sort was insufficient to establish that the death penalty in the aggregate denies equal protection of the law. Only a showing of intentional racial discrimination in the particular case would suffice. The Court was apprehensive that if it granted relief in a capital case based on a showing of aggregate racial discrimination, it would soon have to do the same for prison sentences; and it might also have to grant relief in the case of nonracial but equally arbitrary forms of discrimination.

Except for *The Green Mile* and *A Lesson Before Dying*, both of which involved innocent black men accused of black on white crime, the various films on the death penalty downplay the racial concern. In most of them, as in *Dead Man Walking*, the crime was white on white.

11.07.4 Class discrimination

Another problem is the class distinction in administration of the death penalty. Affluent defendants who can afford excellent lawyers and can mount a strong legal defense are seldom executed. The death penalty films accurately portray this element of the crime. Matthew Poncelet is exactly the sort of lower-class person who is the typical death penalty target.

11.07.5 Quality of legal defense

Another troubling problem is the poor quality of legal defense, particularly in much of the South. In many southern counties, there is no public defender system. Some public interest organizations, such as the Southern Center for Human

Rights, do an excellent job of pro bono legal defense in capital cases, but their resources are far too small to cover all of the cases.

Instead, in many southern counties, the judge simply appoints local counsel to defend defendants in capital cases. However, the amount of money available to pay them is quite small (sometimes pitifully small—in Alabama, $20 per hour, not to exceed $1,000, for out of court preparation). A lawyer wins no friends for vigorously defending a despised death penalty defendant—in fact he may be loathed. There are very few lawyers like Atticus Finch available to handle death penalty cases in the South. As a result, the lawyers are often incompetent and, even if competent, cannot afford to spend time investigating the crime or preparing for trial.

Burdine. In *Burdine v. Johnson* (2001), the federal Court of Appeals reversed a decision imposing the death penalty because the lawyer slept through much of the case. The Texas courts had upheld the conviction. The sad fact is that this same lawyer had slept through numerous capital trials; at least a dozen of his former clients were executed. Matthew Poncelet's lawyer wasn't that bad, but he was a tax lawyer who had never tried a capital case. He spent only four hours on jury selection (a process that if done well sometimes takes weeks), and he raised only a single objection during a five-day trial.

11.07.6 Delays

Another problem with the death penalty is the delay in actually carrying it out. In the year 2010, the average time spent on death row between sentence of death and execution was 178 months (or nearly 15 years).[8] During this time, the prisoner is typically isolated in a small cell with little chance for exercise, visitors, or even contact with other human beings. A considerable number of death row prisoners die of natural causes before their executions. These delays result from a number of factors. Obviously, there are numerous appeals between the time of conviction and the time of execution. Many times, there are stays of execution while counsel pursues new approaches or reversals for retrial of the penalty phase. Often there is great difficulty in even finding lawyers who are willing and able to handle the appeals to which the prisoner is legally entitled.

11.07.7 Error rates

Liebman and his collaborators looked at every death penalty conviction between 1973 and 1995 (Liebman 2000a, 2000b, 2000c). It found that 68% of death penalty verdicts were reversed by appellate courts for serious errors. Of these reversals, 76% were because defense lawyers had been egregiously incompetent, police and prosecutors had suppressed exculpatory evidence or committed other professional misconduct, jurors had been misinformed about the law, or judges or jurors had been biased. Of the cases sent back for retrials of the penalty phase, 82% ended in sentences of less than death.

The study blamed these results on overuse of the death penalty. The higher the rate at which a state imposes death verdicts (that is, uses it for less heinous murders), the greater the probability that any given death verdict will be reversed because of serious error. Some of the reasons for overuse of the penalty involve factors relating to race, politics, and poorly performing law enforcement systems. As to the last factor mentioned, the lower the rate at which homicides are solved in a state, the higher their reversal rates. With regard to judges, the more often and more directly they are subject to popular election and the more partisan these elections are, the higher the state's rate of serious capital error. (See discussion of judicial elections in ¶12.05.4.)

11.07.8 Costs and strains on the criminal justice system

Contrary to what most people think, it is more expensive to execute a prisoner than to keep that person in prison for life. The death penalty costs North Carolina $2.16 million per execution over the costs of a non-death penalty murder case with a sentence of imprisonment for life. In Texas, a death penalty case costs an average of $2.3 million, about three times the cost of imprisoning someone in a single cell at the highest security level for 40 years.

> **The strain on the criminal justice system.** Prosecutors, judges, and defense lawyers must spend far more time on death penalty cases than on any other kind of criminal prosecution. The taxpayers pick up all the costs. In California, for example, anyone condemned to death receives two assigned public defenders and an automatic appeal to the state Supreme Court (without an intervening stop in the court of appeals). The California Supreme

Court has to spend a huge proportion of its time on death penalty cases, but every year its backlog increases and it falls further behind. Since 1978, when the death penalty was reinstated, the costs of administering it in California total $4 billion, yet only 13 people have been executed. The 714 prisoners now on California's death row will wait over 20 years before their cases are resolved (many of them dying of natural causes).[9]

11.08 The death penalty outside the U.S.[10]

Although the United States is committed to the death penalty, the rest of the world is moving strongly in the opposite direction. At the end of World War II, almost all countries practiced capital punishment. Beginning in the 1970s, an abolition movement took hold. The death penalty has been abolished in all of the countries with which we frequently compare ourselves, including Canada, Australia, and Western Europe. A total of 139 countries have abolished the death penalty or placed a moratorium on executions. The European Union (EU) treaty prohibits the death penalty and requires any country that wishes to join the EU to abolish it. Indeed, many people around the world regard the death penalty as a human rights violation.

The number of executions carried out in countries that retain the death penalty is not entirely certain. China may have executed thousands of people in 2010 but the number is not known. Other countries that executed large numbers of people in 2010 were Iran (252), North Korea (60), Yemen (53), and the United States (46).[11] Generally, most countries that have abolished the death penalty (including Britain, the countries of the EU, and Canada) will not extradite a criminal suspect to the United States unless American prosecutors agree not to seek the death penalty in the particular case.

11.09 Filmic analysis of *Dead Man Walking*

11.09.1 Camera placement in Dead Man Walking

A challenge every filmmaker faces is how to communicate visually the emotional and mental states of the characters. A character's emotions and thoughts are communicated through dialogue and performance, of course, but filmmakers also try to communicate them through visual means.

In the 1920s, the German Expressionists experimented with using set design and lighting to convey emotional and mental states. Perhaps the most famous example of German expressionism is *The Cabinet of Dr. Caligari* (1920), which visualized the madness of its main character through the use of sets that were painted and constructed in odd, irregular shapes and angles. In American cinema, such non-naturalistic devices are anathema (except in animated films, fantasy films, or dream sequences). Instead, American filmmakers generally visualize their characters' thoughts and emotions without radically altering or distorting the physical world around them. Thus, American filmmakers typically employ unbalanced camera angles or lighting schemes to convey unbalanced emotional and mental states. Even more typical is the use of camera placement and movement to convey the characters' mental and emotional states. *Dead Man Walking* contains a particularly subtle but effective illustration—the scene in which Sister Helen first breaks through to Poncelet.

The scene begins with Poncelet talking about his father getting him drunk at an early age. Poncelet is filmed with the wire mesh cage between him and the camera. At first, the mesh is quite visible and partially obstructs our view of Poncelet. As the scene progresses, however, the camera slowly zooms in on Poncelet, causing the wire mesh to become less visible. Finally, when Poncelet asks Sister Helen about her lack of romantic and sexual experiences, the mesh finally begins to disappear. "I've never experienced sexual intimacy," she tells Poncelet, "but there's other ways of being close. You sharing your dreams, your thoughts, your feelings."

As Sister Helen says these lines, the film cuts to a closeup shot of Poncelet. For the first time, he is filmed without the mesh cage between him and the camera. The sudden disappearance of the mesh conveys Poncelet's emotional state in a concrete and visual way. Without this visual element, Poncelet's response to Sister Helen— "We got intimacy right now, don't we Sister?"—would lack emotional resonance. But by placing mesh between us and Poncelet and then removing it, director Tim Robbins is making us *experience* the sense of closeness that Poncelet and Sister Helen experience at this moment.

11.09.2 Collision montage in Dead Man Walking

The Soviet filmmaker Sergei Eisenstein was one of the most important figures in the history of cinema. Among Eisenstein's works are such masterpieces as *The Battleship Potemkin* (1925), *October* (1928), and *Strike* (1925). In particular, Eisenstein was an important innovator in film editing and is particularly known for a technique known as *collision montage*.

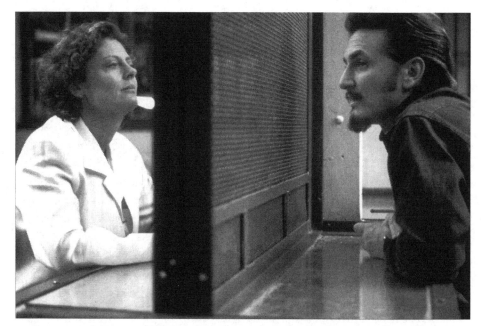

Figure 11.1. *DEAD MAN WALKING*. Sister Helen Prejean (Susan Sarandon) talks to Matthew Poncelet (Sean Penn) through a wire mesh screen. Gramercy Pictures/Photofest. © Gramercy Pictures.

In a collision montage, shots with contrasting formal or thematic properties are edited together. For instance, a sequence that cut back and forth between black-and-white and color shots would be an example of collision montage with contrasting formal properties. In contrast, a sequence that cut back and forth between soldiers dying on a battlefield and greedy industrialists on the home front counting their money and living high on the hog would be an example of collision montage with contrasting thematic properties.

Eisenstein believed that collision montage produces an intellectual and visceral reaction on the part of the spectator. First, the spectator (who is accustomed to continuity between shots) is jolted and taken aback by the discontinuity between the two shots. Second, the contrast produces an intellectual reaction as the spectator tries to intellectually grasp the meaning of the contrast. In the example involving the juxtaposition of the soldiers and the rich industrialists, for instance, the spectator realizes that the filmmaker is trying, somewhat heavy-handedly, to make the point that the industrialists are getting rich off of the war.

In American movies, collision montage is rarely used. When it is employed, it generally consists of contrasting thematic properties, not contrasting formal prop-

erties. A famous example occurs in Francis Ford Coppola's *The Godfather* (1972). At the film's climax, Coppola cuts between shots of a baptism that Michael Corleone is attending and shots of Corleone's gangland enemies being gunned down by his henchmen. The sequence is powerful because Coppola is contrasting images of birth and death. The meaning that many spectators glean from the contrast is that Michael Corleone is a hypocrite. He pretends to be a pious Catholic while presiding over a murderous rampage. But the contrast also suggests Michael's "baptism by blood" into the Mafia.

Dead Man Walking also features an example of collision montage. At its climax, the film cuts back and forth between Poncelet's execution and the raping and killing of his two victims. Although both scenes involve killing, there is an obvious contrast. Poncelet dies a bloodless, painless death that is meticulously planned, while the two young people die bloody, painful deaths perpetrated in a chaotic frenzy. Poncelet's execution takes place in an execution chamber that is sterile and blindingly white while the murders of the two young people occur in a muddy forest at night. There is a potent visual contrast here: clean and white versus dirty and dark. Notice, too, that there is a contrast between an artificial, man-made environment (the glass and machinery of the execution chamber) and a natural one (the foliage and mud of the forest).

Finally, there is a contrast in form. Poncelet's execution is filmed primarily in closeup—closeups of Poncelet and Sister Helen, as well as closeups of the needle being inserted, belts being buckled, arms being bound, buttons being pressed, and lights flashing. The murders of the two young people, on the other hand, are filmed mainly in long shot. Trees are used to obscure our vision of the murders. The effect is one of distance: We are removed from the murders and the victims.

The contrast between the two killings obviously provokes a strong visceral reaction in the spectator, but what is the intellectual reaction that it provokes? What reaction do you think Tim Robbins was trying to provoke?

11.10 Review questions

1. What political stance does *Dead Man Walking* take on the morality of the death penalty? How do you know? How does the film attempt to influence the spectator's opinion on this issue (¶11.02.1)?

2. *Dead Man Walking* and other death penalty movies frequently involve a personal transformation of both the condemned prisoner and the "intermediary"—the person who befriends the prisoner. Why do filmmakers consistently include this element in their stories (¶¶11.02.1 to .3)?

3. Do you favor televising executions? Why or why not (¶11.03)?

4. Do you favor allowing the relatives and friends of a murder victim to testify about their loss during the penalty phase of a capital case (¶11.04)?

5. What is your interpretation of the scene involving Sister Prejean and Earl Delacroix at the end of the film (¶11.04)?

6. Where do you come down on the question of whether the death penalty effectively deters people from committing murder (¶11.05.1)?

7. Both death penalty proponents and opponents are troubled by various practical problems in the way the death penalty is administered. What changes should be made in the administration of the death penalty (¶11.07)?

8. "A character's emotions and thoughts are communicated through dialogue and performance, of course, but filmmakers also try to communicate them through visual means." Please give an example from *Dead Man Walking* (other than the example given in ¶11.09.1).

9. What is your interpretation of the collision montage near the end of *Dead Man Walking* in which the filmmaker cuts back and forth between Poncelet's execution and the murder of the two teenagers (¶11.09.2)?

Notes

1. There have been many outstanding death penalty films, most of which are referred to in the text. (See ¶11.02.1) Instructors may wish to select one of them to discuss the death penalty rather than *Dead Man Walking*.

2. For discussion of *Dead Man Walking*, see Sarat 1999; Shapiro 1996.

3. See discussion of death penalty movies, see Papke 2012b ; Dow 2000; Sarat 1999.

4. For discussions of death penalty law, practice, and history, see Banner 2002; Abramson 1994, ch. 6; Yunker 2001.

5. All statistics are provided by the Death Penalty Information Center. See http://www.deathpenaltyinfo.org/home.

6. *The Death Penalty.* See http://www.gallup.com/poll/1606/death-penalty.aspx

7. http://www.deathpenaltyinfo.org/documents/FactSheet.pdf

8. http://www.deathpenaltyinfo.org/time-death-row

9. Alarcon & Mitchell 2011.

10. See Steiker 2002 (this issue of *Oregon Law Review* contains numerous valuable articles about the death penalty).

11. http://www.amnesty.org/en/library/asset/ACT50/001/2011/en/ea1b6b25-a62a-4074–927d-ba51e88df2e9/act500012011en.pdf

PART III

Civil Justice

The Civil Justice System

Assigned Film: *A Civil Action* (1998)[1]

12.01 The civil justice process

This section (¶12.01) describes the process of civil litigation, meaning judicial resolution of disputes that do not involve criminal sanctions. Law students who are already familiar with civil procedure may wish to skip this part.

12.01.1 Civil cases

In a civil case, the *plaintiff* goes to court to seek a remedy (usually money) from the *defendant*. The vast majority of civil disputes (well over 90%) are *settled* by the parties out of court or resolved by pretrial motions. Only a small minority of civil disputes actually result in trials. In many cases, professional *mediators* assist the parties in finding a mutually agreeable settlement. However, the settlement process broke down badly in the Woburn litigation described in *A Civil Action* (see ¶12.06).

The majority of civil claims arise out of *torts* or *contracts*. A tort case is based on an injury done by defendant to plaintiff. Examples of tort cases are a routine auto accident case, a "toxic tort" case as in *A Civil Action,* a "product liability" case like the exploding gas tank in *Class Action* (1990), a medical malpractice case as in *The Verdict* (Chapter 4), or a civil rights case as in *Philadelphia* (Chapter 13). Contract cases arise out of deals and broken promises.

One of the plaintiffs in the Woburn case, Anne Anderson, tells Schlichtmann that she doesn't care about money, she wants to know who's responsible for her child's death, and she wants to receive an apology. But there was never any chance that the defendants would apologize, since that would be an admission of wrong-doing that might trigger many more lawsuits against them. Personal injury cases are about money, not apology.

Schlichtmann (together with a public interest firm called Trial Lawyers for Public Justice—see ¶12.02.5) sued on behalf of eight Woburn families who had lost a child to leukemia. Many mass tort cases (but not the Woburn case) are filed as class actions. A class action is brought by one or more plaintiffs to recover damages on behalf of an entire class of people who were injured in the same way. After recovery of damages or a settlement, the funds are split up among class members (after subtracting the costs of suit and attorney fees). Class actions are efficient because the common issues (such as the environmental issues) need to be tried only once. However, class actions are unwieldy since it is necessary to communicate with the entire class (which may be very large) and to allow class members to opt out of the lawsuit if they choose to.

12.01.2 Lawyers in civil cases

In most civil cases, the parties are represented by lawyers, although they can represent themselves (in small claims court they must represent themselves). In America, each side normally must pay its own lawyer, but in Britain the losing party must pay both lawyers. In most tort cases, as in *A Civil Action,* the plaintiff's lawyer agrees to work for a "contingent fee," meaning that the lawyer is paid a percentage of whatever the plaintiff recovers. If the plaintiff loses, the plaintiff's lawyer gets nothing. As a practical matter, the lawyer who loses a personal injury case also has to eat the costs of bringing the suit such as amounts paid for investigation or expert witnesses. (See ¶4.08.3 for further discussion of contingent fees.)

A complex personal injury case (whether or not brought as a class action) is an immense gamble for the plaintiff's lawyer. Even if the plaintiff wins a big judgment, it often will take many years before the appeals are exhausted and the lawyer gets paid. Meanwhile, the costs of bringing the suit—arranging for expert witnesses, investigating, perhaps conducting scientific research—must be paid currently. Personal injury lawyers need to have many cases in the pipeline, and it is folly to bet the farm on a single case, as Schlichtmann's firm does in *A Civil Action.* In reality, most lawsuits, particularly class actions, are settled before trial (see ¶12.06), and the settlement includes payment of a fee for the plaintiffs' attorney.

The defense lawyers in personal injury cases are paid by the hour, win or lose. Many times, as in the Woburn case, they come from big firms that represent big corporations or insurance companies. These firms have the ability to deploy large numbers of lawyers to work on big cases, which can overwhelm the small firms on the plaintiff's side. This occurred in the Woburn case, where each of the defendant law firms had over a dozen lawyers working on the case (Harr 1995, 241).

12.01.3 Pleadings in civil cases

The term *pleadings* refers to the documents filed at the beginning of a civil case. The plaintiff initiates the process by filing a *complaint* which must be *served* on the defendant. The defendant files an *answer.* Frequently, the defendant also files a *motion to dismiss* the case (this pleading is sometimes called a *demurrer*) because the defendant contends that even if everything the plaintiff alleges in the complaint is true, the plaintiff still has no legal claim. The judge will rule on this and many other motions before the trial begins.

Most cases are filed in state courts. To file in federal court, the plaintiff and defendant must be from different states (this is called a *diversity* case) or the case must involve a federal question (one arising under federal statutes or the federal constitution). Schlichtmann filed the Woburn case in Massachusetts state court. However, the defendants *removed* it to federal court, since they met the diversity requirement, and they thought that federal judges would be more likely than state judges to be hostile to personal injury cases (and perhaps less subject to popular pressure favoring the families of dead children). (See ¶12.05.4 for discussion of election pressures on state court judges.)

Cheeseman filed a motion under Rule 11 of the Federal Rules of Civil Procedure because there seemed to be so many holes in Schlichtmann's case. Rule 11 empowers a judge to award sanctions against attorneys who file frivolous cases, including a case where the factual allegations have no evidentiary support. Judge Skinner summarily rejected the motion, because Schlichtmann had an Environmental Protection Agency (EPA) report about pollution in Woburn and a study on the Woburn leukemia cluster by the Center for Disease Control, although at that point he had no evidence of who dumped the chemicals.

Before trial, one or both parties may file a *motion for summary judgment.* This is a motion based on sworn affidavits of experts or other witnesses. If the affidavits show that there is no factual dispute, the judge will decide the case based on the affidavits. However, if the affidavits reveal that factual matters are in dispute, there must be a trial. Cheeseman did file a summary judgment motion in the Woburn

case, claiming there was no evidence that TCE caused leukemia. Skinner denied the summary judgment motion without even holding a hearing, since the question of whether TCE caused leukemia was obviously in dispute (Harr 1995, 134–41).

12.01.4 Discovery

Discovery helps lawyers prepare for trial by eliminating the surprise factor and learning about their opponent's case. Often, the case can be settled once each side knows what evidence the other side will introduce at the trial. The discovery process can be very costly, and so it tends to favor well-heeled litigants such as big corporate defendants.

One type of discovery is called a *deposition.* In a deposition, a lawyer takes the sworn testimony of an opposing party or of a witness who is expected to testify at the trial. Generally, the lawyer is hoping to tie the witness down to a particular version of the facts (or, in the case of an expert witness, to the details of the expert's opinion). Witnesses who testify differently at the trial will be *impeached* by their prior inconsistent deposition testimony and their credibility will be damaged. Although lawyers can object to deposition questions (in order to preserve the same objection to the testimony if it is used at the trial), generally the deponent must answer the question. A deposition of Richard Aufiero, whose son died in the car on the way to the hospital, persuaded Facher that the jury should never hear from those parents. As a result, Facher successfully moved to trifurcate the trial so that the jury had to decide the scientific issues before the parents could testify (see ¶12.01.5).

The film runs depositions of various witnesses together to give the sense that they went on for a long time and were repetitious and tedious. Lawyers feel they must depose anybody who might possibly testify, including all of the experts who worked on the case. The deposition process was critical for Schlichtmann because he used it to get sworn testimony that Grace had in fact dumped TCE on its land (Harr 1995, 160–80). The problem of keeping up with all the depositions and properly preparing witnesses for them overwhelmed Schlichtmann and his partners. Schlichtmann became exhausted and lost his temper frequently, which hurt him with the judge and the magistrate who ruled on discovery issues (Harr 1995, 222).

In addition to depositions, each party can require the other to furnish any requested document or to answer written questions. These are called *interrogatories.* Responding to a huge set of interrogatories can be very burdensome (young lawyers spend a lot of time drafting and responding to interrogatories). In most cases today, discovery includes the production of thousands or even millions of electronic documents, such as e-mails or texts.

12.01.5 Managerial judges

In the adversary system (see ¶2.04.2), lawyers make the decisions about how a case is tried. Judges have little to do except rule on evidence objections, keep order in the courtroom, and instruct the jury. However, in modern complex civil litigation, judges actually play a much more active role than is traditionally assigned to them (Resnik 1982). Judges supervise the discovery process and try to facilitate settlement negotiations to get cases off of their dockets. Especially in complex cases, they exercise substantial control over a variety of major issues, such as joining or severing claims or expanding or contracting the parties to the case.

In *A Civil Action*, Judge Skinner *trifurcated* the case, meaning he divided it into three parts. (He actually made this decision before the trial started, not, as in the film, after Schlichtmann had presented his geological evidence.) In phase 1, the plaintiff had to establish whether defendants dumped chemicals and whether the chemicals had reached the wells, and, if so, when. The jury answered no as to Beatrice, which ended the case against Beatrice, but yes as to Grace, which allowed the case against Grace to proceed to the phase 2. In phase 2, the jury had to determine whether the defendants' actions caused the plaintiffs' injuries. If the jury answered yes, phase 3 would determine how much the plaintiffs could recover in damages. The movie portrays Skinner's trifurcation ruling as evidence that he was biased against the defendant (because it kept the sympathetic plaintiffs like Aufiero off the stand in phase 1). However, rulings splitting up the issues for separate jury determination are routine in complex cases, because they can save a lot of time and expense by shortening trials.

12.01.6 Jury trial

In most civil cases, the parties are entitled to a jury trial unless both sides agree on a judge trial. In *A Civil Action*, a jury had to decide extremely difficult environmental and medical issues. If the case had made it to phase 3, the jury would fix the amount of each plaintiff's damages. These damages would include the pain and suffering of the deceased children and the parents. Needless to say, establishing damages for emotional injuries is a highly subjective process. The jury could also award *punitive damages* in order to punish the defendants for intentional misconduct and to deter them (and other corporations) from repeating the offense.

Many people question whether ordinary lay juries are up to the job of deciding highly complex and disputed scientific or environmental issues like those in the Woburn case. Lay jurors often resolve such cases by using intuition or extraneous

factors such as sympathy for the plaintiffs (which the trifurcation of issues occurring in the Woburn case prevented them from doing—see ¶12.01.5) or how they feel about the attorneys or the defendants or who is telling the best story. (See further discussion of jury decision making in Chapter 9.) People also wonder whether it makes sense to let juries determine damages for intangible injuries like pain and suffering or whether to impose punitive damages.[2] We discuss whether the right to jury trial should be limited in ¶9.06.

12.01.7 Witnesses and evidence

The *burden of proof* is critical in civil litigation. Generally the plaintiff must establish its right to recover by *a preponderance of the evidence*—meaning by a probability of more than 50%. If the evidence seems to be a 50–50 tossup, the defendant wins. By contrast, in criminal cases, the prosecution must prove the defendant guilty beyond a reasonable doubt, which is a much more difficult burden to satisfy.

At a trial, the parties establish their case by putting witnesses on the stand and taking their sworn testimony. A *percipient* witness observed some of the events that gave rise to the lawsuit. For example, Al Love witnessed the dumping of toxic waste behind Grace's factory. An *expert witness* is used to establish other elements of the case, such as whether TCE causes leukemia. In a case like Woburn (and in many civil and criminal trials), the centerpiece of the trial is a battle of *expert witnesses* who testify about technical issues that the jurors cannot resolve based on their own knowledge. Expert witnesses must be qualified by experience or training to give opinions in court. In *The Verdict* (Chapter 4), the plaintiff had to use an expert witness to testify about the standards of medical practice, and in *Anatomy of a Murder* (Chapter 2), psychological experts testified about insanity. Experts are well paid for their testimony. Many people think expert witnesses are hired guns, because it is usually possible to get an expert to testify to almost anything.[3]

> **Junk science.** Before admitting expert testimony, a trial judge must assess whether the underlying reasoning or methodology employed by the expert is scientifically valid in light of such factors as testing, peer-review, publication and acceptance in the scientific community. So-called junk science is inadmissible (*Daubert v. Merrell Dow Pharmaceuticals* 1993).

In addition to witnesses, the parties will also introduce documents or other items that serve as evidence to support their case. These will be marked as *exhibits*.

In most trials, the parties dispute whether particular items of evidence are admissible under the *rules of evidence.* For example, certain evidence is *privileged,* meaning that it cannot be introduced. For example, an attorney cannot disclose what the client told the attorney in confidence. Evidence may be inadmissible as *irrelevant* because it would not assist the trier of fact to resolve the issues in the case. *Hearsay* is also inadmissible. Hearsay is a statement by a witness of what someone else said or wrote outside of court (there are numerous exceptions to the hearsay rule that allow the introduction of many out-of-court statements).

If one lawyer asks a question that the other lawyer thinks violates the rules of evidence (because it calls for an answer that is privileged, irrelevant, or hearsay), the other lawyer will *object.* The court will rule on the objection, either *overruling it* and allowing the witness to answer or *sustaining it.* In *A Civil Action,* we see Facher lecturing a class at Harvard Law School about the need to make constant objections to keep the other side off balance.

The Woburn case illustrates a fundamental point. Trials that involve many percipient and expert witnesses are very time consuming. Thus phase 1 of the Woburn case consumed 76 trial days (Harr 1995, 371). Such lengthy trials are very costly to the parties who must pay attorneys' fees and to the public that must pay for judges and courtrooms. They create long delays that prevent other litigants from getting their own cases tried and decided. They are tough on jurors who are involuntarily taken away from their jobs and families. And finally, they are murderous for the attorneys because such trials are extremely stressful and exhausting.

12.01.8 Trial procedure

Each party makes an *opening statement* summarizing what the party intends to prove at the trial but is not supposed to consist of arguments. Then the plaintiff calls witnesses. After each witness gives *direct testimony,* the opposing lawyer can *cross-examine* the witness. Cross-examination is limited to the issues raised on direct examination and is designed to reduce the impact of the direct or to raise doubts about whether the witness is reliable. The plaintiff's lawyer can then conduct *redirect* examination of the witness to repair the damage done on cross.

One practical rule of cross-examination is to ask short questions to which the lawyer knows the answer and to which the witness has to answer yes or no. Jan breaks that rule when he ineptly asks Riley *why* he is upset that his 15 acres are polluted. That allows Riley to give a speech about how this is hallowed land, thus suggesting to the jury he would never dump toxics on it.

When the plaintiff is finished presenting evidence, the defense puts on its case and the process is repeated. Note that the attorneys are only supposed to ask questions, not make arguments or speeches (a rule that is often ignored in movie trials). The lawyers then give their closing arguments which sum up the evidence that has been introduced at the trial and are the lawyers' last chance to persuade the jury that their side of the case should prevail.

The judge then *instructs* the jury as to the law. In *A Civil Action,* the judge's instructions on the environmental issues in phase 1 of the trial were complex and confusing. The jury couldn't possibly answer those questions (such as establishing the exact date that TCE entered the wells). The jury retires to the jury room and discusses the case until it reaches a *verdict.* In most civil cases, a unanimous verdict is not required. For example, in many states, the jury consists of 12 persons, and a verdict can be supported by nine votes. The jury in the Woburn case consisted of only 6 persons. If the jury is deadlocked, this is called a *hung jury* and the case has to be retried.

12.01.9 After the trial

The losing party may decide to *appeal.* In many states and in the federal system, there are two levels of appeal. The losing party is entitled to have the case considered by a three-judge panel in an intermediate appellate court. In federal court, this court is referred to as the Court of Appeals. There are eleven of these, distributed geographically. If appealed, Schlichtmann's case would have gone to the First Circuit, headquartered in Boston. The movie says Schlichtmann never appealed but he did—with mixed results (see ¶12.02.5). The losing party before the intermediate appellate court can seek to appeal to the state supreme court (or in federal cases, the U.S. Supreme Court). However, supreme courts consider only a small fraction of the cases brought to them. On appeal, each side files a *brief,* and there is usually an *oral argument* before the justices (appellate judges are often referred to as justices). No new evidence can be introduced on appeal. The best chance to win an appeal is to argue that the trial judge made a serious error of law or procedure. Because the appellate court must affirm any reasonable jury verdict, it's difficult to overturn a trial court decision because the jury got it wrong.

If the plaintiff wins a money judgment, plaintiff will try to collect it from the defendant (or, in many cases, the defendant's insurance company). If the defendant does not pay voluntarily, the plaintiff can seize the defendant's assets or *garnish* part of the defendant's paycheck until the judgment is paid. If the defendant cannot pay the judgment, the defendant may have to file *bankruptcy.* In bank-

ruptcy, the bankrupt person's assets are sold to pay off creditors, including judgment creditors. Schlichtmann had to file bankruptcy, as we see in the sad hearing at the end of the film.

12.02 The book and the movie—the real case against Beatrice and Grace [4]

12.02.1 The docudrama form [5]

The film *A Civil Action* can be described as a *docudrama,* that is, a dramatic production based on real events but not in documentary form. A documentary shows the real events or the actual persons involved in them, normally with an explicit narrator, whereas a docudrama tells a fictionalized story in dramatic form but based on actual events. Both documentaries and docudramas express the filmmakers' perspective on real events and should never be treated as an indisputable account of what actually occurred. Indeed, there are an almost infinite number of ways to tell a story about events that actually occurred. "Truth," in other words, is constructed by the filmmaker, even when the film describes real events.

Docudramas about trials are reality twice removed—they re-enact a trial that is itself a re-enactment of actual events. The issues addressed by the documentary or docudrama filmmaker are not what the jury will decide but other issues, such as the effect of the events on the people involved in them, the historical impact of the events, and whether the law and the legal system promoted or subverted justice (Silbey 2007).

There have been numerous legal docudramas, some (but not all) adapted from books describing real events. A few of them include *Inherit the Wind* (1960), based on the Scopes Monkey Trial; *Judgment at Nuremberg* (1961), which concerned the war crimes trials of Nazi judges; *Compulsion* (1959), based on the Leopold and Loeb murder case (see Silbey 2007 discussing two radically different docudramas based on that case); *Reversal of Fortune* (1990), which involved the notorious Claus von Bulow murder case; *The People v. Larry Flynt* (1996), about First Amendment protection for parodies of public figures; *The Hurricane* (1999), about the murder trial of boxer Rubin "Hurricane" Carter; *Dead Man Walking* (Chapter 11), about a real death penalty case; and *Conviction* (2010), about a woman who becomes a lawyer in order to free her wrongly convicted brother. The actual Woburn case was described in gripping detail in the best-selling book written by Jonathan Harr (1995).

12.02.2 The importance of films based on actual events

Why do films and TV programs based on actual events remain so popular? Somehow viewers find that true stories and real characters are more believable and empathetic than fictitious stories and characters. Indeed, a film based on real events can tell a story that might seem implausible if it were fictitious. (Mark Twain once wrote that the difference between fiction and reality is that fiction has to be credible.) Advertising for television docudramas or miniseries that boasts "based on a true story" seems to attract viewers. Top actors seek roles in which they play real people; in turn, the interest of a marquee actor can help a film get made. Finally, films based on real events and people often seem to take on additional importance and this makes them contenders for awards.

Films based on true stories are important for another reason: They are extremely powerful teachers. They put flesh and blood on historic events that are dryly described in books or history classes. Many people have acquired all of their information (or misinformation) about historic events (including World War II and the Vietnam War, the Holocaust, slavery, the Kennedy assassination, Watergate, or the sinking of the *Titanic*) or people (including the lives of Malcolm X, Henry VIII, Shakespeare, or Virginia Woolf) from movies or television.

Obviously, as Rosenstone (1995) argues, a feature film is not a book or a documentary. Films and TV shows are made to entertain and to attract a mass audience. In order to capture the interest of viewers and create empathy for the characters, filmmakers must take liberties with the basic factual material to compress it, make it visually compelling, and impose a narrative line on historic fact. When films that are "based on a true story" are gross distortions of historic reality, however, and are employed to sell the filmmaker's political agenda, there are legitimate grounds for concern.

All this said, does a filmmaker have *any* responsibility to be faithful to historic facts about the subject matter of a film? Films like *A Civil Action* begin with the words "based on a true story." However, the film diverged from the actual facts of the Woburn case in many respects (see ¶12.02.5). Should these words mean anything at all?

Criticism of *A Beautiful Mind* and other recent films. The film *A Beautiful Mind* (2001) was not faithful in many respects to the life of John Nash as described in Sylvia Nasr's biography. It was heavily criticized for this reason, largely by competing studios which ran an unsuccessful public relations campaign to prevent the film from winning the "best picture" Oscar. People with personal or political agendas also were critical of the departures from

historic fact in *Lincoln* (2012), *The Hurricane* (1999), *Amistad* (1997), *The Insider* (1999), and *People v. Larry Flynt* (1996), just to mention some controversial legally themed docudramas.

12.02.3 Adapting a book into a film

One of the problems of adapting a true story into a screenplay is concern about challenges to the accuracy of the movie. Such challenges might come from people who disagree with the movie (feminists thought that the film about Larry Flynt glorified a pornographer) or from real people who don't like the way they are portrayed (as occurred in the Woburn case). If word gets around that a film "based on a true story" badly misrepresents that story, this is bad for the box office. Thus the writers should try to get it as right as possible. However, it is impossible to really get it right. There is too much complexity, too many characters, too many details, to tell the story accurately in a docudrama that lasts two hours and has to be entertaining to a mass audience.

Suppose you were assigned to write the screenplay of *A Civil Action*. You'll need to boil down a dense 500-page book into a two-hour movie. You must simplify the hugely technical and complex environmental and medical issues so the audience can grasp what's at stake. You have to get rid of many of the characters and most of the details. You'll need to find a way to come up with exciting visuals (since the actual work of lawyers is anything but visually entertaining). You'll need to keep the story moving right along, even though it concerns litigation that stretched over a period of many years.

Moreover, the complex story of the Woburn litigation must be reframed so that it fits the classical Hollywood style (see ¶4.09). Those conventions require that the story be driven by an empathetic and richly motivated protagonist who opposes an equally well-characterized antagonist. The audience needs to care about what happens to those characters. The characters must have goals and seek to overcome the obstacles that stand in the way of achieving the goals. Each event of the story must be connected by a plausible chain of cause and effect. It must contain a strong and at least somewhat unexpected ending that resolves the conflicts between the protagonist and antagonist. Most Hollywood movies have happy endings (meaning the protagonist wins) but many have tragic endings (meaning the protagonist loses). The story must be suspenseful and somehow worth telling—and if the audience can relate to it ethically and politically, so much the better.

As observed in ¶3.03, a large number of movies take the form of melodrama. Melodramas feature downtrodden characters (often the client in courtroom movies) who ultimately confront and defeat powerful enemies. It was quite challenging to

reframe Harr's book to satisfy the conventions of the classical Hollywood style and of melodrama.

The film accurately describes the major themes in the book, including the fact that the case was a disaster for Schlichtmann and his firm. The downer ending of *A Civil Action* didn't exactly help the film at the box office. The film's budget was estimated at $60 million and its box office gross was about $56 million (as of May 1999).[6] As one reviewer (David Denby in *The New Yorker*) noted, "Unfortunately, the big confrontation between Duvall and Travolta that the entire movie appears to be working toward never arrives…I think one can safely state that a movie that reaches a climax with the hero writing a letter to the Environmental Protection Agency has landed in a certain amount of trouble" (Waldman 2005, 218). Indeed the titles at the end of the film, suggesting the EPA ordered the two firms to clean up the Woburn mess, was probably intended to make the audience feel a little better about what happened to Schlichtmann and his clients.

12.02.4 The lawyers

The movie's characterizations of Schlichtmann and Facher are reasonably close to those in the book. Schlichtmann was materialistic, spent everything he earned, and often exercised questionable judgment. Surprisingly, the movie leaves out his girlfriends, thus sacrificing the usually mandatory romantic subplot (like the lawsuit, the relationships also ended badly). Facher was a fine lawyer who taught a trial practice class at Harvard. He had once been married but now his life was his work. He had tried 70 cases and won most of them. Big firm litigators usually spend their days working on big cases, doing discovery, filing motions, then settling the cases; unlike Facher, they rarely try one. As in the film, Facher hid out in the storage room at Hale & Dorr and was very frugal. He ate leftovers and hated going to restaurants. Generally only one or two associates worked with him on cases and he was often harsh in dealing with them, yet they deeply respected and admired him (Harr 1995, 85–91). Cheeseman was a highly competent lawyer and the movie unfairly makes fun of him. Cheeseman did not try the case for Grace; another lawyer from his firm with more trial experience got that job.

12.02.5 What really happened?[7]

While the film is broadly faithful to the book, there are many differences, caused by the need to simplify the complexities of the real events, compress long periods of time, make an analytical story into a more visual one, and reframe it as a tradi-

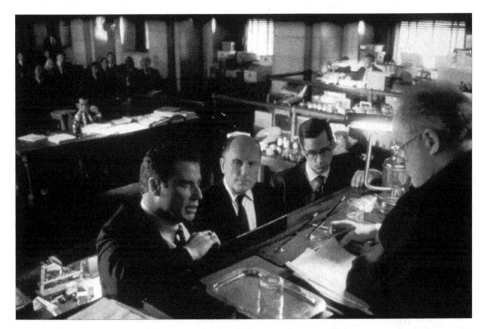

Figure 12.1. *A CIVIL ACTION*. Jan Schlichtmann (John Travolta) argues his point to Judge Walter Skinner (John Lithgow) as his opponents Jerome Facher (Robert Duvall) and William Cheeseman (Bruce Norris) listen. Touchstone Pictures/Photofest. © Touchstone Pictures.

tional Hollywood-style entertainment vehicle (see Waldman 2005, 203–16). There were many people involved who are decentered, turned into composites, or dropped entirely (including Charles Nesson, a Harvard Law School professor who gave Schlichtmann invaluable assistance). The movie suggests that Schlichtmann had to start from scratch, but in fact the EPA had already investigated pollution in Woburn and ranked the site 39 out of 418 on the Superfund list of polluted areas that urgently needed cleanup. Schlichtmann didn't select the defendants while walking around the messy area after getting a speeding ticket.

Schlichtmann originally filed the complaint as co-counsel with a nonprofit legal organization, Trial Lawyers for Public Justice (a group he had helped to establish). When that group bailed out because of the high costs of trial preparation, he was left holding the bag. (But when the case was settled, the group demanded a large payment of attorneys' fees for the work it had done on the case—see ¶12.06.1.)

The most important way that the movie deviates from the book concerns events after the trial. The movie says that Schlichtmann discovered a key document showing that Riley had cleaned up the mess on his property. That led him to

Granger who had removed the polluted soil at night but had been told to keep quiet about it. The movie has some nice visuals about kids throwing firecrackers at the property that set the river on fire. According to the film, Schlichtmann was too worn out to appeal the case but sent the file to the EPA. This in turn triggered an EPA investigation that ultimately resulted in a cleanup order and a criminal indictment of the two companies.

There actually was an EPA cleanup order against both companies. It will cost $69.4 million, although the aquifer is so polluted that the cleanup will take at least 50 years to complete. But the story of the post-trial events was much more complicated than as depicted in the film (see Harr 1995, 456–86). Gordon actually found the document in question at the local EPA office. It was a 60-page consulting report from Yankee Engineering that Riley had ordered in 1983 (three years before the trial). The report indicated that the tannery had dumped waste on its land and it had flowed to the east toward the city wells. This document was never produced in discovery, but it could have been the smoking gun that Schlichtmann needed to show that Beatrice had engaged in toxic dumping.

After finding the Yankee Engineering document, Schlichtmann went back to work on the case. He accused Facher of discovery abuse by withholding a requested document and demanded a new trial. Facher admitted seeing the report. Riley's personal lawyer, a woman named Mary Ryan, had shown it to him. He thought it was insignificant. Judge Skinner rejected Schlichtmann's petition for a new trial, saying that the document would have made no difference.

The movie says that Schlichtmann never appealed the Beatrice verdict but he did. On appeal, the federal Court of Appeals for the First Circuit upheld the decision against Beatrice on the merits, but it criticized Skinner's decision on the discovery issue. It remanded the case back to him to conduct a full hearing about whether discovery abuse had occurred (*Anderson v. Cryovac, Inc.* 1988).

The full hearing conducted by Judge Skinner disclosed a great deal of new information. Schlichtmann was able to use the Yankee report to come up with additional witnesses who testified to Beatrice's dumping, including Granger who had removed the polluted topsoil. Beatrice's in-house lawyer Mary Ryan confessed to withholding the Yankee Engineering report and testified that Facher and his associates were well aware of it. Riley confessed that he had perjured himself at the original trial. However, Skinner again refused to order a new trial. He said Mary Ryan was guilty of deliberate misconduct, but the judge exonerated Facher. He said Schlichtmann was equally to blame for filing the original lawsuit without any proper basis in fact. In effect, he now imposed the Rule 11 sanction that he had earlier declined to order (see ¶12.01.3) by saying that the misconduct on both sides cancelled out.

The First Circuit affirmed Skinner's order and the case was finally over. Harr's account strongly suggests that Skinner was biased against Schlichtmann in the post-trial proceedings. It is unclear why the movie glided past these interesting and highly significant events. Perhaps there was just no time to squeeze it all in. Perhaps the additional story was considered anti-climactic. Perhaps it makes the downer ending of the movie even more depressing and frustrating to viewers. Or perhaps the filmmakers were afraid of getting into a fight with Facher who took these post-trial proceedings very personally.

12.02.6 The counter-attack

There have been a number of counter-attacks against the film from those who felt that they were unfairly portrayed. W. R. Grace mounted a public relations campaign against the film and created a website called "Beyond a Civil Action: Woburn Issues and Answers" (unfortunately, the site no longer exists). The site defended the company's environmental record and took issue with many of the film's assertions (see Waldman 2005). (Beatrice Foods no longer existed at the time the film came out, so it wasn't around to defend itself.) Various corporate defense lawyers also went on record praising Judge Skinner and asserting that he provided a fair trial. Conservative commentators blasted the quality of Schlichtmann's evidence.[8]

On the other hand, many environmental action groups rallied around the film. They used it as a vehicle to talk about the problems of ground water pollution and, more generally, the problem of whether corporate America could be held responsible for various environmental disasters. Disney, in marketing the film, steered clear of these political themes that it felt might detract from the box office (Waldman 2005, 217–18). This welter of counter-attack and reinterpretation of the film shows that that consumers of pop culture often come up with interpretations of the work that are quite different from the ones encoded in it by its creators (Waldman 2005, 218–23; see ¶4.04.6).

12.03 Litigation problems in toxic tort cases

12.03.1 Complexity of toxic tort cases

Most tort cases turn on the question of *fault*. In a car accident, for example, the question is whether the defendant was *negligent,* meaning that the driver failed to drive in a reasonable manner. In mass tort cases, the issues are different and much more complex. First, the plaintiff must establish that the defendants illegally

exposed them to the toxic chemical (for example, by burying toxic waste). However, if the defendants' actions were legal, the plaintiff would have to establish that the defendant should have known that the chemicals would be harmful. Even these basic issues were highly disputed in the Woburn case where the two defendant corporations denied having buried any of their waste. But these issues are just the beginning of what the plaintiff has to prove. Consider the remaining complex and debatable environmental and medical issues:

- Did TCE in the ground percolate into the aquifer, and, if so, did it migrate to wells that were about half a mile away from Grace's factory? What about the fact that the Aberjona River flowed between Beatrice's factory and the wells—how would TCE in the aquifer get around the river? This hydrological issue caused Schlichtmann and his experts extreme problems (Harr 1995, 325–40). And when did the TCE enter the water supply? (This issue also caused great difficulty since the jury found that it entered in September 1973, after some of the children had developed leukemia.)

- Remember that the Woburn area had many factories (many of them tanneries). Many of those factories probably disposed of waste by burying it. Other chemicals besides TCE polluted the well water and there was an enormous amount of toxic pollution in the ground around Woburn (Harr 1995, 39, 352). How can we tell whether waste dumped by these defendants (as opposed to other wastes in the water or wastes buried by other factories or dumped into the river upstream) had polluted the well water? What if the injuries resulted from the interaction of many different chemicals dumped by many different companies?

- What was the concentration of TCE in the well water at the time the plaintiffs drank it? There are no records prior to 1979 when the wells were shut down for good. Leukemia has a long latency period, so the leukemia in question could have resulted from ingestion of chemicals many years ago.

- Does drinking water contaminated with TCE at this level cause leukemia? This is an unresolved scientific question.

- Childhood leukemia often occurs for no known environmental reason. How can we know whether the leukemia cases in Woburn resulted from drinking contaminated water or from other unknown causes? There was a "cluster" of childhood leukemia cases in Woburn,

particularly in the area near the wells, but such a cluster could occur by pure chance.

In addition to all these problems, there are additional concerns with addressing toxic pollution cases through the traditional tort system. What about all the other victims we don't know about yet who will get leukemia in the future? How about other diseases that might be caused by TCE? The Harvard Health Study found that people in Woburn exposed to water from the two wells had many other illnesses besides leukemia (Harr 1995, 133). What if the damages are so immense that they drive the defendants into bankruptcy, as occurred in the asbestos cases? If the defendants go bankrupt, the plaintiffs will wind up with very little (or the ones who make the early claims will get paid and there will be nothing left for plaintiffs whose illnesses appear in the future).

What if the insurance companies deny liability? Or what happens if the various defendants start suing each other (we call these cross-claims) trying to shift the liability to someone else? This actually happened in the Woburn case. Cheeseman filed a cross-complaint against Unifirst, another factory near Grace that cleaned uniforms. Unifirst settled with Schlichtmann, and its presence so complicated the case that Cheeseman dismissed his cross-complaint against it. The involvement of other defendants can make a complex mass tort case much more complex.

12.03.2 Alternative ways to compensate victims of toxic torts

As the movie shows, the process of determining these disputed geological, scientific, and medical facts is time consuming and produces a long and confusing trial. The process is stunningly expensive for both sides, but especially for plaintiffs because of the difficulties of proof and the fact that the lawyers must pay the various costs out of pocket as they are incurred (the defense's costs of investigation are paid by the deep-pocketed clients).

Is there a better way to resolve mass tort cases than by traditional tort litigation? The message of *A Civil Action* is that adversarial trials and the existing tort system are gravely inadequate to figure out what happened and compensate victims of toxic torts, much less to punish the defendants and impose cleanup obligations. As Facher aptly says in the film, "The courtroom isn't a place to look for truth…if you're really looking for the truth, Jan, look for it where it is—at the bottom of a bottomless pit."

Other cases in which the tort system proved unable to handle the problem of serious harm to huge numbers of people include asbestos injuries, injuries caused

to troops in Vietnam by Agent Orange, and the many cases involving injuries from pharmaceuticals and medical devices. Often the attorney fees and administrative and investigative costs eat up most of the money that should have gone to victims— if there is any recovery at all. There have been some ad hoc solutions to providing compensation in mass disasters—such as the funds set up to compensate victims of the 9/11 terrorist attack on the World Trade Center or the BP Gulf oil spill, but nobody has yet come up with an acceptable method of resolving mass disaster claims outside the traditional tort system.[9]

12.04 Litigation financing [10]

The Woburn case depicted the economic problems that a small personal injury firm encounters when it tackles a complex mass tort case against well funded and determined adversaries. Because Schlichtmann's firm is working only for a contingent fee, it must front all of the immense cost of investigation and discovery. The firm ran out of money and had to accept Grace's lowball settlement out of sheer desperation. In some cases, such as the tobacco litigation, numerous well-funded plaintiffs' firms joined together to tackle the defendants. But Schlichtmann had no allies (after being abandoned by the Trial Lawyers for Public Justice; see ¶12.02.5).

Some lenders (like Uncle Pete of the Bank of Boston) make loans to plaintiffs' lawyers in order to finance litigation. Such loans are expensive, often calling for interest of 20% a year or more. These high interest rates indicate that the lenders think the loans are quite risky. The lawyers must repay the loans whether they win or lose the case in question. Generally they must secure the loans with all of the law firm's assets as well as their personal property—houses, cars, and the like, as the lawyers in *A Civil Action* did.

Another group of lenders specialize in lending to clients who are waiting for their lawsuits to pay off. For example, injured plaintiffs sometimes have a strong claim but desperately need funds for living expenses while waiting for the case to settle. These are relatively small loans (perhaps a maximum of $20,000) and are repaid only out of the proceeds from the lawsuit (that is, they are *non-recourse* loans, meaning that the borrower won't get sued if the case is lost). Such loans also bear a high interest rate to compensate the lender for the risk that they won't be paid back.

Direct lender investment in pending cases is a relatively new and important form of litigation financing.[11] Investors may be prepared to invest as much as $15 million in return for a percentage share of the recovery. Most such investors are interested only in commercial litigation (such as antitrust, contract, or intellectual property cases) rather than personal injury cases like Woburn. The loans go to the

clients rather than to law firms. Clients are interested in such investments because they must pay their attorneys currently by the hour and must reimburse the lawyers for all litigation costs. If the client loses the case, all that money is down the drain. Having an investor in the lawsuit reduces the client's need for working capital and enables it to share the risk of loss of the case with the investor.

Since law firms in commercial cases are paid fees and expenses currently, they don't need financing in the same way that Schlichtmann did. In the future, however, investors may begin purchasing an interest in the *attorney's contingent fee in* personal injury cases (rather than simply making loans to the lawyers as occurred in *A Civil Action*). In that case, the investors will be in partnership with the lawyers rather than the clients. The lawyers may find that this form of financing is better than borrowing the money because they won't have to pay back the investors if they lose the case. At present, however, such investments violate ethics rules that prohibit a lawyer from sharing legal fees with a non-lawyer and prohibit non-lawyers from forming partnerships with lawyers (ABA Model Rule 5.4).

Investors in either the client's litigation recovery or the attorney's contingent fee must make a careful evaluation of the merits of a particular lawsuit. They may insist that the clients and lawyers disclose confidential client information to enable them to make this judgment. This is risky, however, because information disclosed to the investor is no longer protected by the attorney-client privilege, meaning that the information must be disclosed in discovery or trial. Such deals also may interfere with the lawyer's exercise of independent judgment and may create various conflicts of interest. The investors may well have the right to control litigation decisions, including the right to compel the client to accept a settlement offer or refuse to allow the client to accept a settlement offer.

12.05 Judges[12]

12.05.1 Judges in popular culture

Most courtroom films and TV shows focus heavily on the attorneys and decenter the judge. This seems appropriate, given that in pop culture trials the jury makes the ultimate call, not the judge. Normally the judge sits on an elevated bench, rules on evidentiary objections, and threatens to clear the courtroom if the spectators won't behave. Perhaps the judge is allowed to deliver some good lines (as in *Anatomy of a Murder,* discussed in Chapter 2) but usually little more than that. *Judgment at Nuremberg* (1961) is the rare exception; it is a film about judges judging judges. It explores in considerable depth the psychology of both the judges who

implemented Nazi laws and the American judges who were called on to determine their fate.

Many recent films and TV shows have portrayed the justice system and the lawyers in a strongly negative light. Judges have not escaped this harsh scrutiny. Numerous films have involved crooked, arrogant, lazy, or biased judges, as in *The Verdict* (discussed in Chapter 4). Some judges have been criminals themselves, as in ...*And Justice for All* (1979), *The Star Chamber* (1983), or *Suspect* (1987). Judges are negatively portrayed in most of John Grisham's novels and many of Scott Turow's as well (Papke 2007a, 140–42). People will differ about whether *Judge Judy* and her many clones on daytime television reality shows portray judges positively or negatively. In our minds, however, these reality judge shows are quite negative. The daytime judges berate and humiliate the people who appear before them, express inappropriate moral judgments about how people should behave, and seem to decide cases off the top of their heads rather than in accordance with legal principles (Marder 2009).

On television dramatic series, judges are often portrayed quite negatively, such as Roberta Kitelson, the nymphomaniac judge on *The Practice,* or numerous weirdos who have appeared as judges on *The Good Wife.*[13] One exception, however, was Judge Amy Gray in the TV series *Judging Amy* (1999–2005); Judge Gray handled juvenile cases and was conscientious, fair, and decent. John Deed, in the British show *Judge John Deed,* is far more interesting than any of the American TV judges. Deed is highly political, cares nothing for judicial restraint, and sleeps with every woman in sight. He always tries to bend the law to secure justice for those who come before him.

12.05.2 Judge Skinner

In *A Civil Action,* federal district judge Walter J. Skinner comes across as biased in favor of the defense. His hostility toward Schlichtmann and friendly feelings toward Facher are apparent in their first encounter when he decided Cheeseman's Rule 11 motion. His decision to trifurcate the action (so that Schlichtmann had to prove the scientific issues first—see ¶12.01.5) appears to be intended to derail the lawsuit.

In a *Boston Globe* interview, however, Jonathan Harr deplored the negative treatment of Skinner in the movie. "When I heard that people felt Skinner was the villain of this piece, I was pretty distressed," says Harr. "He's a good judge and a smart man, and he's a credit to federal judges. I regret not being able to get inside his mind." Skinner was the only one of the major Woburn protagonists who refused

to discuss the case with Harr.[14] Despite his comment to the *Globe*, Harr's book makes clear that Skinner was strongly biased against Schlichtmann, particularly in the post-trial proceedings relating to discovery abuse (§12.02.5). In Harr's book, the magistrate judge who ruled on various discovery disputes (whom Harr does not name) was also biased against Schlichtmann and in favor of Facher and Cheeseman (Harr 1995, 216–18).

12.05.3 The rule of law

The idea underlying our system of justice is captured by the phrase "the rule of law," as opposed to the "rule of man." The rule of law posits that law must be made by a democratically responsible legislature. The law must be applied by independent and impartial judges without fear or favor. The rule of law is embodied by the figure of Justitia, discussed in ¶1.05.3—the traditional statue embodying the blindfold, the sword, and the scales. We expect our judges to seek justice, above all. We revere judges who are willing to apply the law in the face of pressure to bend or ignore it. Many judges qualify as quiet heroes, following the law when it is unpopular to do so or using the law to protect the civil liberties of unpopular people. Of course, judges, like everyone else, have their own political biases and beliefs. They may be liberal or conservative or they may dislike personal injury lawyers or unions or big corporations. We expect, however, that judges will set aside these biases in judging individual cases, but they cannot always do so.

12.05.4 Political appointment and elections

Many judges are qualified and competent, but the process of selecting them does not guarantee this outcome. In a few states, judges are appointed through a form of merit selection that minimizes political considerations. In most states, however, judges are appointed by the governor, a system that generally requires that their political views be compatible with the governor's. Indeed, the governor's staff may well exact commitments from potential judges about how they will decide politically sensitive issues (such as the death penalty or abortion). It is not uncommon to require that aspiring judges have been politically active and have contributed to the governor's campaign. Other judges may be political hacks who are appointed to the bench in return for past political favors; they may be the dregs of the profession. Moreover, if trial court judges want to be elevated to the appellate bench (and many of them do), their judicial record will be closely scrutinized. Politically unpopular decisions may be the death knell for the prospects of elevation.

Almost all of the states employ some kind of electoral check on judges. In these states, accountability to the voters is considered more important than judicial independence or objectivity. Those who believe in the accountability model stress the fact that American judges are frequently policy makers and law creators, not just people who mechanically apply existing law. Also, they observe that judges have so much power that they sometimes tend to become autocratic and start acting in an arbitrary or haughty manner or pursuing personal agendas. Under the accountability view, the voters should be able to elect and throw out judges, just like governors and legislators.

In many states, judges are directly elected, sometimes in partisan elections. Lawyers can run against each other for open seats or against incumbent judges. Such campaigns often lead to all-out (and often quite vicious) debates about the judge's record on the bench as well as personal issues.

Retention elections. In many states, the law requires that voters be asked whether they wish to retain a judge in office; if they vote no, the judge is off the bench. This system provokes citizens who are angry about a judge's decisions to mount a non-retention campaign against the judge. In a particularly notorious example, three justices of the California Supreme Court were removed by the voters in 1986. The voters perceived the justices as hostile to capital punishment (which they definitely were), but the money that fueled the campaign came from business interests angered by the justices' rulings in tort cases against big business and insurance companies.

The result of subjecting judges to an electoral check is that they must consider the political implications of their decisions. This is contrary to the basic ideal of the rule of law. Another problem with judicial elections is the cost of campaigning, which is rising rapidly. Judges often have to solicit and accept campaign contributions when they are running for election or re-election. They must take money from lawyers or other groups (such as plaintiffs' trial lawyers or big business or insurance companies), who may well have cases before them in the future. This creates a huge potential for conflict of interest. Moreover, when judges campaign for election or re-election, they may take strong policy positions about legal matters that they later have to decide.

The evils of judicial elections came before the U.S. Supreme Court in *Caperton v. A. T. Massey Coal Co.* (2009). In that case, Caperton won a $50 million judgment against a coal company. The president of the coal company contributed $3 million to the campaign of Brent Benjamin who was running for the West Virginia Supreme Court. Benjamin defeated the incumbent justice. He was the swing vote in a 3–2 decision that overturned the trial court's decision. The Supreme Court decided that these disproportionately large contributions violated the constitutional guarantee of due process of law. Since there are campaign contributions to every judicial election, it is unclear how far the *Caperton* decision will be extended.

12.05.5 Federal judges

The president appoints federal judges who must be confirmed by majority vote of the Senate. Judge Skinner was appointed by President Nixon in 1973. This system has produced many well qualified judges who are satisfactory to both political parties. However, in recent years, the confirmation process has become highly politicized. When the president comes from one political party and the Senate is controlled by a different party, the president's choices are often delayed, sometimes indefinitely; some of them are voted on and defeated by the Senate. A single Senate member can place a hold on a nomination, delaying its consideration indefinitely. Other nominations have been filibustered (under Senate rules it takes 60 votes to close debate so a determined minority can often prevent a vote). Some confirmation fights have become extremely bitter (the charge that Clarence Thomas sexually harassed Anita Hill was the ultimate example of a dirty confirmation fight).

Once confirmed, however, federal judges have life tenure. Their pay cannot be decreased while they are in office, and they cannot be removed from the bench except through the cumbersome process of impeachment by the House and conviction by the Senate (a few federal judges have been successfully removed through the impeachment process). Thus, federal judges are more likely than state judges to ignore popular sentiment and render politically unpopular decisions. Still, the desire of lower-court federal judges to be elevated to the Court of Appeals or the Supreme Court may tempt the judge to make politically popular decisions.

Judges in other countries. The American system of appointing judges should be contrasted with the systems in other countries. In most European countries, a judge is on a separate career track from that of lawyers. Judges are civil servants who have been promoted to the judiciary on the basis of merit and competitive examinations. Indeed, law graduates compete heavily to become judges or prosecutors (because these are lifetime jobs); only those with the best exams are admitted into the training program for judges. Judges receive extensive training (a minimum of twenty-eight months in France). In Britain, judges are not a separate career track, but the judges are selected from the most distinguished and able barristers. No other country appoints judges in a fashion that remotely resembles the politicized way Americans select their state and federal judges.

12.06 Settlement negotiations

The ability to negotiate is one of the most critical skills a lawyer must have. The vast majority of legal disputes are settled. Most of them are settled before a lawsuit is ever filed. Of lawsuits that are filed, over 90%, perhaps 95%, are settled. Similarly, about 95% of criminal cases are settled through plea bargains. Each settlement required a negotiation between the contending parties. In addition, a great deal of the transactional work that lawyers do consists of negotiating deals of one kind of another.

12.06.1 Schlichtmann's negotiations in the Woburn case

A Civil Action accurately describes the failed settlement negotiation that occurred in the Woburn case. Schlichtmann had been successful with his settlement strategies in the past. He settled a major hotel fire case by bringing all the attorneys and experts together in an expensive hotel conference room (Harr 1995, 123). He used the same approach against Unifirst, a defendant in the Woburn case that Cheeseman had dragged in (see ¶12.03). At the beginning of the film, we see him settling a case for $2 million (on behalf of a client in a wheelchair) before his opening statement. The terrified defense lawyers keep raising their offer while jurors begin sobbing just looking at the plaintiff.

Schlichtmann tried to settle the Woburn case the same way. He invited Facher and Cheeseman to an expensive hotel with lavish food and drink, but he made a critical error. He demanded far too much—about $410 million over 30 years. The present value of the present and future payments was about $175 million. His partners stared at him in astonishment, since he far exceeded what they had agreed to demand. This account is not quite accurate—all of Schlichtmann's partners and advisers agreed with his demand at the settlement conference except Conway who thought it was insane (Harr 1995, 272–80). Facher and Cheeseman walked out without even bothering to counter-offer.

At an earlier point, Facher tried to settle for the amount Schlichtmann had invested in the case (about $1 million at that point), but Schlichtmann didn't counter-offer, so negotiations never got off the ground (Harr 1995, 231). Later Beatrice tried again; Schlichtmann met with the lawyers and Beatrice's general counsel. Beatrice offered $8 million. Schlichtmann came down to $18 million and Beatrice never responded (Harr 1995, 288–90). In the film, Schlichtmann turns down a $20 million settlement offer from Facher in the courthouse hallway while the jury is deliberating. This incident was fictitious; Facher never offered any settlement during jury deliberations.

Ultimately, Schlichtmann negotiated with Al Eustis of W. R. Grace when he was desperate. He was completely broke, yet he was looking at an imminent and very costly new trial against Grace. Eustis made a lowball offer of $6.6 million. He later raised it to $8 million and Schlichtmann reluctantly accepted, because at that point he had no choice. (His unrealistic bottom line had been $25 million; Harr 1995, 405–48). Although Schlichtmann declared in a voice-over that trials are crazy and the goal of litigating is to achieve settlement, his negotiation strategy in the Woburn case was a complete disaster.

After payment of $2.6 million in expenses and a $2.2 million attorney fee, the settlement resulted in a payout of $375,000 to each family plus an additional $80,000 in 5 years (Harr 1995, 453). However, the $2.2 million in fees swiftly evaporated since part had to be paid to the attorney who originally brought in the case (Schlichtmann's former partner) and to the Trial Lawyers for Public Justice who worked on it (see ¶12.02.5). Ultimately, Schlichtmann wound up with only $30,000. And the firm confronted huge debts, including one to the Internal Revenue Service because the firm had skipped payment of its payroll taxes (Harr 1995, 454–56).

12.06.2 Negotiation theory

Most people see negotiation only in *positional* terms.[15] That is the typical way we negotiate at the flea market. The seller wants $100 for an antique. We offer $15.

We then haggle with the seller until we finally arrive at some number between $15 and $100 that reflects how much we want the item, how much the seller wants to part with it, and our respective negotiating skills. Or we walk away without a deal. Before engaging in positional negotiation, it's important to determine your "squeal point"—that is, the point where you will walk away because no deal is better than any possible negotiated outcome.

This kind of hardball negotiation is expected at the flea market but it takes a lot of time. It tends to lock people into their positions and makes it hard for them to back off. When this tactic is used in a negotiation between friends or family members, or even between people with a pre-existing business relationship, it can engender a lot of hard feelings. If one person is a hardball negotiator and the other one is a softball negotiator who just wants a deal without conflict, the softball negotiator is going to get taken.

Better negotiators use a different strategy. Before the negotiation begins, they try to come up with creative ways to solve the problem rather than just splitting the difference. Good negotiators seek to de-personalize the process, rather than getting embroiled in all of the emotions and resentments that parties bring to the table. They try to put themselves in their opponents' shoes, understand their interests, and find ways to accommodate those interests. Rather than haggling in traditional positional bargaining, they seek to arrive at a *principle*. A principle is some kind of objective standard that will determine the negotiated outcome. Then they discuss the application of the principle to the problem at hand.

The principle might be substantive (like market value, cost, tradition, precedent, or a scientific standard) or procedural (like finding a trusted third party to set the price). The goal is to find a solution that satisfies the underlying interests of all of the parties, not to haggle over bargaining positions or split the difference. Oftentimes, creative negotiators come up with a win-win result that makes everyone better off and leaves everyone feeling good about the process.

Many times, the parties are unable to come up with a negotiated solution, owing to their emotional investment in the problem or inept negotiating strategies. Then it's time to bring in a mediator—a neutral third party whose job it is to facilitate the negotiations (but who does not have power to impose a solution on a party unwilling to accept it). The mediator works with both parties to bring them closer together, cool out their emotions, and come up with a creative solution. Schlichtmann should have attempted mediation after the disastrous breakfast negotiation failed to move the parties toward a negotiated solution.

12.07 Big business in the movies

A Civil Action vilifies the defendant corporations, Beatrice Foods and W. R. Grace. Both companies have illegally buried toxic wastes in the ground, with little concern about the environmental effects of doing so. Then they lied and cheated to avoid cleaning it up or paying damages for the personal injuries they caused. Rather than enter into a reasonable settlement of these claims, they hired big law firms to conducting scorched-earth litigation against an underfinanced plaintiff's firm.

Most films about the civil justice process (whether they are docudramas based on true stories or whether they are purely fictitious) similarly demonize big corporate defendants or other large institutions. *Erin Brockovich* (2000) depicts the big utility Pacific Gas & Electric as a heartless, profit-maximizing polluter and killer. The same is true of U-North, a big chemical company, that made a killer herbicide and is trying to avoid paying for it in *Michael Clayton* (2007). In *Class Action* (1999), an auto company covers up the design defects in a car whose gas tank blew up after a collision; it could have prevented the problem for a few dollars but thought it was cheaper to just pay claims. *The Rainmaker* (1997) trashed a heartless insurance company that denied all claims, while *Runaway Jury* (2003) attacked a gun company. *The Verdict* (Chapter 4) went after the Boston archdiocese that operated a large hospital. *Philadelphia* (Chapter 13) describes a heartless and dishonest big law firm sued for firing a lawyer with AIDS. *The Insider* (1999) went after tobacco companies; *The Constant Gardener* (2005) pursued pharmaceutical companies. *Silkwood* (1983) and *The China Syndrome* (1979) vilify the nuclear power industry. *Norma Rae* (1979) attacked garment companies. *Wall Street* (1987) demonized—guess what? And the list goes on.

But there's a puzzle here. Most dramatic movies are made by very large corporations (even independently produced pictures have to get distribution deals with big corporations). Many traditional analyses of the pop culture industry suggest that pop culture defends and reinforces hierarchies and dominant ideologies. The idea that large, profit-seeking multinational corporate entities are appropriate and even beneficial in our capitalist system would seem to qualify as a dominant ideology (Mezey & Niles 2005). If that's true, why are these big corporations making and selling pop culture products that relentlessly attack them?

The answer, of course, is that movies have to please their audiences by telling stories that the audience likes and accepts. These stories typically follow the conventions of melodrama, as discussed in ¶3.03. In melodrama, the downtrodden hero has low status. The villain has high status, and is powerful and prosperous,

often arrogant. An example would be the defendant polluters in *A Civil Action* as well as Facher, who's a senior partner in a rich Boston firm and is depicted as weird, austere, and heartless. (See ¶13.06 for further discussion of the demonization of big law firms in the movies.) The families of Woburn leukemia victims definitely qualify as the downtrodden.

In such stories, obviously, the big corporate defendant has to be the villain. Nobody wants to go to the movies to watch a big bully beat up on the little guy (or even defeat another equally powerful corporation). This explains the let-down feeling of the audience in watching *A Civil Action*. The defendants mostly got away with their evil deeds; the clients got a pittance and their lawyer went bankrupt. It's not supposed to be that way in melodrama!

Another example of a departure from melodramatic form occurs in *The Sweet Hereafter* (1997). In that film, an aggressive and rather obnoxious personal injury lawyer comes to a small town to sign up plaintiffs after a deadly accident in which a school bus skidded off the road and into a lake. But in that movie, there was no clear-cut villain (nobody ever figured out who, if anyone, was at fault for the crash), and the community essentially rejected the litigation and drove the plaintiff's lawyer out of town. However, *A Civil Action* and *The Sweet Hereafter* are outliers. They form exceptions to the prevailing melodramatic, evil-corporate-defendant canon.

12.08 Framing in *A Civil Action*

Schlichtmann, Facher, and Cheeseman are all portrayed in somewhat stereotypical terms. Schlichtmann is the flashy, larger-than-life personal injury lawyer. Facher is the old-school trial attorney—low-key, self-effacing, but lethal. Although he is a partner at major national law firm, Facher cultivates a Columbo-like image that is endearing to judges and juries and disarming to opponents. Cheeseman is the book-smart, big-firm attorney who lacks practical judgment and cannot make a personal connection with judges, juries, opposing counsel, or his own witnesses. (See ¶12.02.4, which suggests that the filmmakers treated Cheeseman unfairly.)

The film's portrayal of Cheeseman is particularly negative. The first time we see Cheeseman he is reading the complaint. He is visibly and audibly distressed. In a panic, he calls Facher. The brief exchange that follows defines the two characters. Both are framed by desk lamps. Cheeseman is framed by a modern desk lamp. The silver, metallic lamp appears in the foreground, slightly out of focus. The stand of the lamp bisects the frame, with Cheeseman's head and shoulders to the left of the stand. The lamp's umbrella-like shade fills the top of the frame, obscuring the top of Cheeseman's head. Visually, the lamp dominates the frame, with Cheeseman's body

seemingly dwarfed by its dome-like shade. As a result, the framing of these scenes leaves an impression that Cheeseman is weak and easily dominated.

Facher is also framed by a desk lamp. But it's a more traditional desk lamp with a translucent shade. The lamp is turned on and casts a warm light on Facher. Like Cheeseman's, Facher's desk lamp is in the foreground. But unlike Cheeseman's, Facher's lamp does not dominate the frame. It is out of focus—almost to the point of imperceptibility. As a result, Facher—who is leaning back in his chair and bouncing a ball against his office wall—dominates the frame. Indeed, because he is leaning back, Facher occupies more of the frame than he would if he were sitting straight up.

12.09 Review questions

1. Does *A Civil Action* satisfy the rules of the classical Hollywood style (¶4.09.2) and of melodrama (¶3.03)? How does it depart from these rules?
2. If you had power to impose reforms on the tort system described in *A Civil Action*, how would you change it (see ¶12.03)?
3. Identify a judge in pop culture, other than the ones mentioned in ¶12.05.1. How is the judge represented?
4. Suppose an investor came to Jan Schlichtmann at the time that the firm was running out of money to finance the Woburn case. The investor offered to provide a loan of $2 million in return for a 50% share in the contingent fee that Schlichtmann's firm might earn from Woburn. The loan is non-recourse (meaning that if Schlichtmann loses the case, the loan need not be repaid). Why would this deal be attractive to the lawyers? Do you see any problems with it (see ¶12.04)?
5. If you had advised Schlichtmann before the big negotiating session at the hotel, what would you have suggested (see ¶12.06)?
6. Name a big corporation that appeared in pop culture (other than those mentioned in ¶12.07). How is it represented?
7. *A Civil Action* used a muted color scheme—one that borders on the monochromatic at times. Why did the filmmakers limit the range of colors?
8. Notice the differences in the decor of the three law firms (Schlichtmann's, Facher's, and Cheeseman's). In particular, notice the differences between Facher's and Cheeseman's. Facher's law firm has

a traditional law firm decor. Cheeseman's has a modern decor. Why do you think the filmmakers decided to use different decors for the two law firms?

9. There are numerous images of water in the film, which seems appropriate since it's about water pollution. Note especially the half-full/half-empty glass of water on the table when the jury announces its split decision and Facher leaves. Please select a different image of water in the film and discuss the filmmaker's purpose in using that image.

Notes

1. Instructors may wish to consider other films that illustrate different aspects of the civil justice process. *Michael Clayton* (2007) concerns litigation against a chemical company for producing a weed killer that kills people; *Class Action* (1990) is about an exploding gas tank; *Erin Brockovich* (2000) concerns toxic tort issues similar to those in *A Civil Action; The Verdict* (in Chapter 4) concerns medical malpractice; *The Rainmaker* (1997) involves an insurance company's bad faith refusal to pay claims; *Philadelphia* (Chapter 13) concerns employment discrimination against an employee with AIDS.

2. In *State Farm Mutual Insurance Co. v. Campbell* 2003, the U.S. Supreme Court limited the ability of juries to award punitive damages that seem out of proportion to the amount of compensatory damages in the case.

3. For discussion of expert witnesses in the movies, see Caudill 2008.

4. For photographs of the real people involved in the Woburn case, including Schlichtmann, Facher, and Judge Skinner, as well as jurors and plaintiffs, see http://www.law.seattleu.edu/Centers_and_Institutes/Films_for_Justice_Institute/Lessons_from_Woburn/About_the_Case/Participants.xml. Schlichtmann, in particular, looks nothing like John Travolta.

5. See Bernstein 2000; Shale 1996; L. Butler 1995; Sayles 1995; Greenfield et al., 2001, ch. 3; LeBel 2002 (discussing *Amistad* and *JFK*); Mnookin & West 2001; Rosenstone 1995.

6. This information comes from the invaluable Internet Movie Database: http://www.imdb.com.

7. For Jan Schlichtmann's account of the events, see Schlichtmann 2000. For other analyses of the film, see Waldman 2005, 205–30; Chase 2002, chapter 4; Asimow 1999.

8. See http://walterolson.com/articles/civilact.html#beam.

9. There have been numerous discussions of alternatives to the tort system in the case of mass disasters resulting from environmental pollution as well as pharmaceuticals. See Gilles 2012; Rabin 1993; Abraham 1987. It is fair to say that these authors are dubious about whether such schemes would work.

10. See Yeazell 2012.

11. http://dealbook.nytimes.com/2012/04/30/looking-to-make-a-profit-on-lawsuits-firms-invest-in-them/; Steinitz 2012; Lyon 2010.

12. See Papke 2007a.

13. Kaufman 2011.

14. Alex Beam, "Has Judge Been Judged Too Harshly?" *Boston Globe,* January 29, 1999.

15. The discussion of negotiation is based on Fisher and Uri 1991.

Civil Rights

Assigned Film: *Philadelphia* (1993) [1]

13.01 *Philadelphia*—The cases and the film

13.01.1 The real-life inspiration of Philadelphia

The film was based primarily on the case of a New York City lawyer named Geoffrey Bowers who was fired by the mega-law firm of Baker & McKenzie. Seven years after his death from AIDS at the age of 33, Bowers' family won a $500,000 award from the New York State Department of Human Relations. Baker & McKenzie appealed the decision, but the dispute was settled in 1995 for an undisclosed sum.

Meanwhile, Bowers' relatives sued Tri-Star, claiming that the filmmakers had promised to compensate the family members for providing details of Bowers' life. Tri-Star contended that the film was based on several cases, including Bowers, and that the details had come from sources in the public domain. Producer Scott Rudin supported the Bowers family. Rudin had interviewed the Bowers family members in 1988 and later sold the project to Mark Platt at Orion. In 1996, five days into the trial, Tri-Star settled the case for a figure in the "mid-7 figure range" and acknowledged that the film was inspired in part by Bowers' life.

Cain v. Hyatt. The film was also based on a second case that was decided by the federal district court in Philadelphia: *Cain v. Hyatt* (1990). The case concerned a provision in the Pennsylvania Human Relations Act that prohibited discrimination on the basis of disability if an employee is competent to do the job despite the disability. *Cain* held that this provision protected an attorney with AIDS from being discharged when he was capable of performing his responsibilities. The employer was Hyatt Legal Services, a law firm with 150 offices offering low-cost, standardized legal services to low and moderate-income clients. In 1987, Cain's supervisors discovered that he had AIDS; they believed that he would be able to work only part-time and that he would soon die. In addition, they thought that Cain might communicate the disease to others in the workplace (such misinformation on the transmission of HIV was common at the time). The court's pathbreaking opinion declared that being HIV-positive or having full-blown AIDS qualified as a disability under the Pennsylvania act and declared that prejudices and misinformation about how the disease is spread could not be the basis for discrimination.

13.01.2 Philadelphia—the film

Philadelphia grossed over $200 million worldwide on a production budget of about $26 million. Tom Hanks won the Oscar for Best Actor and Bruce Springsteen won Best Song. The film was nominated for three other awards—Best Makeup, a second Best Song composed by Neil Young, and Best Original Screenplay (Ron Nyswaner). Undoubtedly, the film conveyed a powerful message of compassion for AIDS victims and for treating HIV as a disability that employers must accommodate. The decision to cast a top-drawer actor like Tom Hanks, who is known to be heterosexual and usually plays heroic roles, in the role of Andrew Beckett, greatly magnified the power of this message. (See discussion of intertextuality in ¶¶1.06 and 9.02.)

13.02 Clients and lawyers—access to justice[2]

Beckett desperately needed a lawyer to help him sue Wyant, Wheeler. He was too sick to do it on his own. However, nobody in the Philadelphia legal community wanted

to touch the case since it obviously would be difficult to win and because they didn't want to antagonize the influential Wyant, Wheeler law firm. Besides, most of them (like Miller) were probably scared of AIDS and didn't want to be publicly associated with gay clients. For those reasons, Beckett was fortunate to get Joe Miller to represent him.

Needless to say, the vast majority of ordinary people who need a lawyer cannot afford to pay one by the hour. Under the so-called American rule, each side of a lawsuit must pay its own attorney's fees, even if the case results in important benefits to the public (*Alyeska Pipeline Service Co. v. Wilderness Society*, 1975). On the other hand, in Britain, the loser has to pay the winner's fees, which allows a poor but worthy plaintiff to take on a well-funded defendant. However, the British rule makes a lawsuit a risky proposition for plaintiffs since they are stuck with the defendant's fees if they lose. Therefore, it undoubtedly discourages a lot of litigation. Should the United States adopt the British system of loser pays?

Because of the high cost of lawyers, there are enormous unmet needs for legal services in the United States. In personal injury cases, that need is largely met by the prevalence of contingent fee arrangements. These enable ordinary people who have suffered injuries to get legal representation because the lawyer is paid a fraction of the amount received in a judgment or a settlement, but clients pay nothing if they lose (see ¶¶4.08.3 and 12.01.2.) However, contingent fees are not common outside the area of personal injury cases. For large and difficult personal injury cases, like toxic torts (see Chapter 12) or medical malpractice (see Chapter 4), the stakes may be too low and the risk of losing too high for a contingent fee lawyer to tackle the case. Also, such cases are often very costly to investigate and bring to trial and they may take many years to be finally resolved. These factors also discourage contingent-fee lawyers.

There are some important exceptions to the "American rule." In certain types of cases, statutes require the defendant to pay the plaintiff's fees if the plaintiff wins. These include federal and state civil rights cases including race, sex, and disability discrimination. In *Philadelphia,* Beckett's lawsuit was brought under Pennsylvania state law prohibiting employment discrimination against disabled persons. That law requires a losing defendant to pay the plaintiff's reasonable attorneys fees.[3] A wide range of other federal and state statutes (such as environmental laws) provide for fee shifting if the plaintiff wins.

In criminal cases, defendants who can't afford a lawyer have a constitutional right to an attorney at public expense (*Gideon v. Wainwright,* 1963). In most states, such defendants are represented by public defenders. Public defenders tend to be skillful and dedicated but often have enormous caseloads. As a result, they cannot take most of their cases to trial but must plea bargain them (see ¶8.01.4).

Some states have no public defender system; instead, courts appoint local lawyers to represent indigent clients. The fees paid to appointed lawyers are low and the quality of such representation is often poor (see ¶11.07.5).

In some situations, free or low cost legal services are available at publicly funded legal clinics, particularly in cases of evictions or welfare disputes. During the War on Poverty of the 1960s, substantial resources were devoted to federally funded clinics and public interest law firms; such firms still exist but the amount of federal funds has been sharply reduced. Some legal clinics are operated by law schools or by private charities. Free legal service clinics are usually limited to low income clients. They often have huge caseloads and must turn away many qualified applicants. Veterans who seek to obtain benefits from the Veterans' Administration receive free assistance from non-lawyer advocates employed by veterans' organizations such as the American Legion.

Attorneys sometimes take on a particular case pro bono, meaning without charge, because the attorney thinks it is his or her social duty to do so or because some principle important to the attorney is at stake. Lawyers often consider their pro bono experience as the most satisfying of their entire professional careers. In many big firms, lawyers are encouraged to spend time on pro bono cases and they may be allowed to meet part of their billable hour requirement (see ¶13.05.5) by working pro bono.[4] Increasingly law schools provide pro bono opportunities for students, and a few law schools require students to engage in pro bono service (see ¶6.02.5).

For the most part, middle class people can't get free legal services. As a result, vast number of people with worthy legal claims or defenses cannot afford to pay for attorneys. In the small claims court (involving disputes below a certain dollar value such as $5,000), attorneys are not allowed and both parties must represent themselves. However, people also represent themselves in many other types of legal disputes. Self-representation is referred to as "in propria persona" or "pro per" for short. In many family courts, for example, a majority of the litigants seeking divorce or child support are representing themselves as best they can. Most owners fighting mortgage foreclosure represent themselves in an unequal struggle against the lender's lawyers. The same is true of eviction and deportation cases. There are many written and on-line resources available to people who want to represent themselves[5] and some courts have staff members to assist pro pers. In some cases, private paralegal services are available to help pro pers draft the necessary papers to get into court, but the paralegals cannot actually appear with them in court.

Should there be a constitutional right for low income people to have a lawyer appointed at public expense to represent them in serious non-criminal cases, such as divorce, eviction, or deportation?

Clients need lawyers, but lawyers need clients too. Obviously, law is a business and lawyers earn fees from providing legal services. Joe Miller reluctantly takes on the case of Andrew Beckett and skillfully wins a great victory. How does Miller's work for Beckett affect Miller (aside from paying him a fee)? For discussion of lawyer redemption, see ¶4.07.

13.03 LGBT lawyers in the movies

13.03.1 LGBT lawyers

An increasing number of law students and lawyers are openly LGBT (meaning lesbian, gay, bisexual, or transgender). According to 2011 statistics assembled by the National Association of Law Placement,[6] the number of openly LGBT lawyers at law firms is quite small. About 2.43% of associates and 1.44% of partners are openly LGBT. Sixty percent of the total were in San Francisco, Los Angeles, New York, and Washington, DC. These figures should be compared to the year 2002, when less than 1% of law firm lawyers were openly LGBT. The number of students and lawyers who are LGBT but conceal their sexual orientation is unknown, but the numbers must be quite substantial.[7]

These statistics do not necessarily mean that major law firms are homophobic. Indeed, most major law firms prohibit sexual orientation discrimination (or are situated in states that do so by law). Most law schools require firms to sign a pledge that they will not discriminate on this basis. There are undoubtedly many LGBT partners and associates who, like Andrew Beckett, prefer not to identify themselves as openly LGBT at work even though they lead otherwise uncloseted lives. One study found that although 70% of gay attorneys did not come out on their resume, nearly 88% were out to some coworkers (Rubenstein 1998, 394).[8]

13.03.2 The representation of LGBT characters in film[9]

The Hays Code contained a strictly enforced provision prohibiting any treatment of "sex perversion." The Hays Code was a system of movie industry self-censorship that went into effect in 1934 and was strongly enforced until the mid-1950s; it remained in effect but in a weakened form until 1968. (We discuss various aspects of the Hays Code in ¶¶2.03, 5.05, and 14.03.) The ban on "sex perversion" in the movies prohibited any treatment of homosexuality. As a result, all explicit treatment of homosexual themes was removed from the movies for about 30 years.

During this period, film adaptations of plays or novels that dealt with homosexuality had to skirt explicit references to that theme, as in Lillian Hellman's *The Children's Hour* (released in 1936 as *These Three* and again in 1961 as *The Children's Hour*), Robert Anderson's *Tea and Sympathy* (1956), Mayer Levin's *Compulsion* (1959), and Tennessee Williams' *Cat on a Hot Tin Roof* (1958). Of course, characters could still be coded as gay (the term "coded" means that characters could be endowed with traits perceived as stereotypically gay or with traits that gay viewers would pick up on). In addition, oblique references to homosexuality could occasionally be slipped past the censors. Russo (1987) discusses many gay characters and themes in the movies of this era. The references were subtle and were usually overlooked by the censors and by straight audiences, but gay audiences understood them. Russo's book was made into an outstanding documentary on gays in the movies entitled *The Celluloid Closet* (1995).

In 1961, the Hays Code provision proscribing "sex perversion" was changed. Homosexuality and other sexual "aberrations" became permissible subjects if treated with "care, discretion, and restraint." By that time, Joseph Breen had retired from the Production Code Administration (PCA), and his successors were more flexible about depicting sexual matters in the movies. Besides, the studios were pressing the PCA to allow them to deal openly with gay themes because homosexuality had become a hot topic. *Suddenly Last Summer* (1959) was released prior to the change, and several other high-profile studio films were waiting in the wings. These included *The Best Man* (1964), *Advise and Consent* (1962), and *The Children's Hour* (1961).

Victim. A British film called *Victim* (1961) made it onto American screens before release of the American gay-themed films of the early 1960s. *Victim* is widely considered to be a breakthrough in the frank portrayal of homosexuality on the screen. It starred Dirk Bogarde as an English barrister trying to expose a ring of extortionists who blackmailed closeted gays like himself. The film was widely acclaimed and is often credited with triggering the movement to reform England's homosexuality laws. Until *Philadelphia,* however, Bogarde's character in *Victim* was the only important gay lawyer in the movies.

In 1968, the Production Code was repealed and replaced with the ratings system that is still in effect. The following year, gays and lesbians resisted harassment by the New York police at the Stonewall Rebellion. The late 1960s and 1970s wit-

nessed the most explicit portrayals of LGBT characters in the history of American film up to that time. Films such as *The Staircase* (1969), *The Fox* (1968), *The Killing of Sister George* (1968), *The Boys in the Band* (1970), *Sunday, Bloody Sunday* (1971), *Cabaret* (1972), and *Dog Day Afternoon* (1975) were among the many movies that featured explicitly gay characters.

However, not all portrayals of gay people were sympathetic. One downside of the new freedom to portray homosexuality was the ability to depict LGBT people in crudely homophobic terms. Gay characters were often used for comic relief or portrayed in grossly stereotypical terms. Moreover, a surprising number of movies featured LGBT killers. In films such as *Freebie and the Bean* (1974), *Looking for Mr. Goodbar* (1977), and *Windows* (1980), gays were portrayed as murderous psychopaths.

The late 1970s and early 1980s witnessed the emergence of campaigns by feminists against films perceived to be misogynistic or antifeminist. Following their example, gay activists began orchestrating their own campaigns against films perceived to be antigay. *Cruising* (1980) and *Windows* were among the most notorious of the films they targeted. In 1992, the smash hit *Basic Instinct* (1992), which involves a lesbian killer, inspired a similar campaign.

These campaigns were successful and the portrayal of gay people became decidedly less offensive. The AIDS epidemic also had something to do with raising the consciousness of filmmakers and changing the way that gays were represented. The 1980s saw the release of several important and sympathetic films, including *Victor Victoria* (1982), *Personal Best* (1982), *Lianna* (1983), *Making Love* (1982), *Prick Up Your Ears* (1987), *Maurice* (1987), and *Torch Song Trilogy* (1988).

In the 1990s, gay characters entered the cinematic mainstream in such features as *Longtime Companion* (1990), *The Adventures of Priscilla, Queen of the Desert* (1994), *The Birdcage* (1996), and, of course, *Philadelphia*. In the first decade of the 21st century, countless mainstream films featured homosexual characters, often highly sympathetic ones as in *Rent* (2005), *Brokeback Mountain* (2005), *Milk* (2008), *A Single Man* (2009), and *The Kids Are All Right* (2010).

Gay characters were once controversial on television dramas and sitcoms. When Ellen DeGeneres came out as a lesbian in 1997, both in real life and on her show *Ellen,* there was a major uproar. However, gay characters on television are now mainstream. Pioneered by *Will & Grace* (1998–2006), contemporary shows such as *Modern Family, Glee,* or *Happy Endings* feature favorably portrayed gay characters and provoke no controversy.

The New Queer Cinema.[10] Of equal importance to the emergence of mainstream gay characters was the emergence of a gay

independent cinema. The "New Queer Cinema," as it is usually termed, is a film movement spearheaded by gay independent filmmakers who make gay-centered films for largely gay audiences. In the 1990s, gay independent films like *Longtime Companion* (1990), *Swoon* (1992), *Go Fish* (1994), *The Incredibly True Adventures of Two Girls in Love* (1995), and *Love and Death on Long Island* (1997) became a fixture of the gay independent film market that thrived in major metropolitan areas. Finally, the 1990s also witnessed the emergence of a number of important openly gay directors, including Gus Van Sant (*My Own Private Idaho, Even Cowgirls Get the Blues*), Todd Haynes (*Poison, Far from Heaven*) and the defiantly non-mainstream Gregg Araki (*The Living End, The Doom Generation*).

13.03.3 Queer Theory[11]

The 1990s also witnessed the emergence of queer theory in film and literary studies. Queer film theory is different from gay film studies. Queer film theorists are not primarily concerned with the representation of gays in film. Indeed, one of the objectives of queer theory is to resist attempts to construct a stable category called "gay." For queer theorists, categories such as "homosexual" and "heterosexual" are constructs that fail to capture the instability of gender and sexual identities. Thus, a film such as *Philadelphia* might not be of interest to a queer theorist since the film has a stake in creating a stable category called "gay." Queer film theorists are particularly interested in issues of reception and spectatorship: How are ostensibly gay and ostensibly straight films received and consumed by gay and non-gay spectators?

The basic tenet of queer film theory is that a surprisingly large number of Hollywood films elicit "queer" responses from gay and non-gay spectators alike. What queer film theorists mean by a queer response is one that calls into question the stability of sexual and gender categories. Thus, queer film theorists will seize on seemingly straight films that are consumed in a non-straight way by gay (or even non-gay) audiences.

For instance, a queer film theorist might write about the way in which gay audiences responded to seemingly straight characters such as Bela Lugosi's Dracula in *Dracula* (1931), the Maximus and Commodus relationship in *Gladiator* (2000), and Captain Kirk and Mr. Spock in the TV series *Star Trek: The Original Series* (1966–69). By the same token, queer theorists might try to problematize the seemingly straight image of stars like Doris Day or Marilyn Monroe by writing

about the ways in which gay men and women (it is important here to distinguish between them) responded to them.

Conversely, queer film theorists might draw attention to the non-straight ways in which straight audiences respond to seemingly straight films. For instance, a queer theorist might argue that straight audiences respond to characters like Anthony Hopkins's Hannibal Lecter or Jack Nicholson's The Joker in a way that can only be characterized as queer or non-straight. Finally, queer film theorists might explore the ways in which gay women sometimes respond to films in a way assumed to be more characteristic of gay men (e.g., by admiring the body of a muscular male actor) and the ways in which gay men sometimes respond to films in a way assumed to be characteristic of gay women (for example, by being attracted to Madonna).

The underlying project of queer theory is to challenge the naturalness of the heterosexual-homosexual distinction. Queer theorists want to question this distinction by drawing our attention to cultural phenomena that belie the distinction either by destabilizing it or by revealing the multiplicity of sexual identities and positions that it obscures.

13.04 Black lawyers in the movies

13.04.1 African Americans and the legal profession

Within the last four decades, the number of African Americans entering law school and law practice has increased sharply. However, relatively few black lawyers work in large law firms. Thus, it is not surprising that Joe Miller is a solo attorney specializing in personal injury cases. Undoubtedly, there are few black associates and even fewer black partners at Wyant, Wheeler (although we do see one black lawyer seated at the counsel table). It is estimated that about 6% of practicing lawyers are black, but in 2011 blacks constituted only about 4.3% of associates in law firms and 1.7% of partners.[12] By one estimate, close to one-third of all black lawyers work for government agencies (Wilkins & Gulati 1996).

13.04.2 Black lawyers in the movies and television

While there are numerous prominent and talented black actors, few of them have played movie lawyers. Joe Miller (Denzel Washington) is probably the most prominent African American trial lawyer in movie history. Samuel L. Jackson played a trial lawyer in *Losing Isaiah* (1995), and Howard E. Rollins played a tough Army

lawyer in *A Soldier's Story* (1984); Laurence Fishburne played backup to Gene Hackman in *Class Action* (1991), and there have been a handful of others. One finds even fewer Hispanic or Asian American attorneys. For whatever reason, filmmakers don't seem to think that audiences will accept non-whites as lawyers. There are plenty of minorities in legally themed movies—as defendants, witnesses, police, investigators, journalists, secretaries, or judges as in *Primal Fear* (1996) or *Presumed Innocent* (1990)—but few attorneys.

Note, however, that black lawyers have been more prominent on television than in the movies. Eugene Young (Steve Harris) and Rebecca Washington (Lisa Gay Hamilton) had leading roles on *The Practice* and Jonathan Rollins (Blair Underwood) had a long-time role on *L.A. Law*. Victor Sifuentes (Jimmy Smits) on *L.A. Law* was one of the few Hispanic actors to appear as a TV lawyer.

13.04.3 Blacks in the movies and television—1930 to 1970[13]

The underrepresentation of black lawyers in film mirrors the way that blacks have historically been represented in film as well as on radio and television. In older films, black characters were played by talented actors, but the roles almost always represented painful stereotypes derived from the days of slavery. They often spoke in what was supposed to be a Negro dialect rather than correct English.

Typically black actors played oversexed savages as in *Birth of a Nation* (1915), idiotic buffoons, or happy, loyal servants. (Bogle 2001b exhaustively documents these endlessly repeated stereotypical roles.) The classic slave roles were played by Hattie McDaniel as Mammy and Butterfly McQueen as Prissy in *Gone with the Wind* (1939). (McDaniel, who won a Best Supporting Actress Oscar for her portrayal, is reported to have said, after people criticized her for accepting roles as maids, that considering the unavailability of better roles, she would rather play a maid than be one.) However, according to Cripps (1993), producer David Selznick went to great lengths to avoid the negative racial material contained in Margaret Mitchell's book. The roles played by black actors in *Gone with the Wind* were considered at the time as some of the most favorable toward blacks in movie history; there was hardly any criticism of these roles, even in the black press.

Stepin Fetchit was the most successful black comedian of the 1930s. He played a supporting role in John Ford's legally themed *Judge Priest* (1934). The publicity releases for one of Stepin Fetchit's films said: "Baffled and bewildered by the mere thought of moving fast, shuffling and mumbling his way to resounding laughter at every appearance . . ." (Doherty 1999, 177–78). In addition, there were numerous minstrel-style films in which white actors in burned cork makeup played

black characters. Minstrel characters continued to be popular up to about 1950. Indeed, the very first black character in the movies, Uncle Tom in *Uncle Tom's Cabin* (1903) was a white man with a blackened face.

Guess Who's Coming to Dinner. In this 1967 film, Sidney Poitier plays a handsome black doctor who is engaged to marry a white woman. The woman's relatively progressive parents (played by Katharine Hepburn and Spencer Tracy in his last film) are completely unable to deal with this event for which nothing in life has prepared them. The film had a major impact because Poitier's character (a sophisticated black professional) was unusual even in films of the late civil rights era, as was the theme of interracial marriage. Poitier played a number of roles of this kind as the token dignified black making it in a white institution. In fact, he won an Oscar for the inspirational *Lilies of the Field* (1963), playing a handyman in a convent.

Even where black characters have dignity and substance in older films, they are often passive; their fate is determined by whites (the character of Tom Robinson in *To Kill a Mockingbird* is an example). In another group of movies, such as *Pinky* (1949) and *Imitation of Life* (1934, remade in 1959), light-colored Negro characters (usually women) shed their undesirable racial identity and pass as whites, usually with tragic results. In the 1970s, however, the "blaxploitation" films challenged the notion that blacks were either passive or respectable.

Amos 'n' Andy. On the radio and early television, one of the most popular and successful programs was *Amos 'n' Andy* (1951), a racist comedy that emphasized every sort of vicious stereotype, portraying blacks as lazy, stupid, and greedy. Although African American actors appeared often on television series in the 1960s and 1970s (many of them in comedy roles), perhaps not until *The Cosby Show* in the 1980s was a mainstream, primetime television series built around a successful and appealing upper middle-class black family.

Undoubtedly, all these constantly repeated stereotypical roles in the movies as well as television became a powerful signifier of black inferiority and white superiority. The portrayals of blacks in the movies reinforced the ideology of racism and

thus were damaging to the prospects for racial equality. They must also have negatively affected the picture that blacks had of themselves.

13.05 Law firms[14]

13.05.1 Philadelphia *and the hemispheres of law practice*

If your only source of information about law practice was movies like *Anatomy of a Murder, Counsellor at Law, The Verdict, The Lincoln Lawyer,* or *To Kill a Mockingbird,* you would probably conclude that most lawyers practice by themselves or with one or two other lawyers. This arrangement is still true of criminal defense lawyers who mostly practice solo or in very small partnerships. Like Jan Schlichtmann in *A Civil Action* or Joe Miller in *Philadelphia,* most plaintiffs' personal injury lawyers also practice alone or in small firms. Today, however, most lawyers, especially those in big cities, practice in significantly larger law firms. Indeed, the law firm has come to be the dominant vehicle through which legal services are delivered, especially to corporate clients.

Recall the discussion of the "hemispheres" of law practice in ¶4.08. The first hemisphere consists mostly of small firms or solos that handle the problems of ordinary individuals or small business. Joe Miller is definitely located in the first hemisphere. The second hemisphere consists mostly of large firms that represent big business or big institutions—like Wyant, Wheeler in *Philadelphia*—otherwise known as "biglaw."

13.05.2 Economics of biglaw

During the last thirty years or so, second-hemisphere law firms have become much larger and more profitable. In 1950, the 50 largest U.S. firms had 2,000 lawyers (or about 1% of the total). In 1979, the 50 largest firms had 9,000 lawyers (or 2% of the total). In 2007, the 50 largest firms had 43,000 lawyers, or about 6% of the total. Thus the percentage of the total number of lawyers working in very large firm doubled from 1950 to 1980 and tripled from 1980 to 2007.[15] Today, there are law firms with thousands of lawyers, some with offices all over the world. In many large firms, average profits per equity partner exceed $1 million per year (some firms average $2 to $4 million per partner).

Incomes in the biglaw sector are much higher than in the past. Starting salaries at top firms for young lawyers just out of law school often approach the amazing figure of $160,000 per year. Salaries of more senior associates rise sharply from that level, and many partners make more than $1 million per year. Both partners and

associates hop from one firm to another far more often than in the past. Associate attrition rates at big firms have also risen sharply (some firms lose 25% of their associates every year). Partners who bring in lots of business ("rainmakers") are often compensated at much higher rates than other partners who actually do most of the work. Many firms go for quick growth by lateral hiring of partners who have large books of business and paying them much more than other partners—a risky strategy if firm profits start to decline.[16]

As a result of these high salaries and partner profit shares, billing rates to clients have increased sharply. One survey indicated that law firm partners billed an average of $661 in 2011 and associates averaged $445 per hour. Billing rates of $1000 per hour are not uncommon.

Starting in 2008, the rapid increases in big-firm employment, revenue, and profit stalled. The hiring of associates slowed and many firms shed unproductive partners.[17] More big firms are in distress and some have failed. Many say that the "new normal" will include outsourcing of routine legal work (perhaps to lawyers abroad who will work much more cheaply than U.S. lawyers, or to low-paid associates in satellite offices outside the big cities, or to non-lawyers), use of technology to substitute for lawyers and paralegals doing routine chores, more client pressure to reduce fees, and more movement of legal work from firms to lawyers employed by corporate clients.[18] This is not a happy prospect for biglaw or for those who hope to work there.

13.05.3 Why big law got so big

There are a number of reasons why law firms have grown so large. These include *specialization, flexibility, economies of scale, and leverage*. Specialization means that a large firm employs an array of lawyers who specialize in many different niches of law practice. This huge staff enables the firms to offer clients quick access to sophisticated, experienced lawyers covering the entire range of the clients' needs. Economies of scale means that large firms can afford to purchase costly technologies and employ large staffs of non-lawyer staff members (such as word processors and paralegals). Flexibility means that the firm is prepared to handle the largest matters brought to them by clients, anywhere in the United States or the entire world, even those requiring the immediate services of dozens or hundreds of lawyers, without having to involve other firms. Specialization, economies of scale, and flexibility give the large firm a major competitive advantage over smaller firms.

The most important reason why firms are so large is leverage. Leverage means that the partners profit from employing associates, who work for a fixed wage but

who bill their time at a much higher rate. Suppose, for example, that Firm F pays Associate A $150,000 per year. Associate A's time is billed at $400 per hour and A manages to bill 2,000 hours a year. That means that A brings in $800,000 per year but is only paid $150,000. After taking account of overhead costs (such as the rent on A's office, wages of her assistant, and all the other costs of operation), Firm F is still making a substantial profit on Associate A. This profit is divided among the partners. The broader the pyramid at the bottom (that is, more associates) and the narrower on top (that is, fewer partners), the larger the profit shares of the partners arising out of leverage.

A certain number of associates must make partner each year; otherwise, most of the best associates would leave and the firm would have difficulty replacing them. As a result, the firm must hire more associates each year to replace those who have left or those who made partner in order to keep the bottom of the pyramid much broader than the top. It seems like a good deal for the associates; those who make partner will become rich and those who don't get excellent training and can usually switch to good jobs at smaller firms. The whole process is described with analytical precision in Galanter and Palay (1991).

13.05.4 Two models of law practice: Professionalism and business

The switch to ever-bigger law firms was accompanied by fundamental changes in the legal profession. Scholars of the legal profession identify two competing models of law practice: professionalism and business. Many observers think there has been a definite swing away from the professionalism model and toward the business model.

Historically, law was considered a *profession,* meaning that lawyers had specialized training and knowledge and were protected from competition by nonlawyers. Lawyers had an obligation to place the interests of the client ahead of their own interests, were governed by a code of ethics (including many aspirational, non-binding rules) and were self-regulated rather than government-regulated. Professionalism means a certain degree of autonomy and independence, both from government and from clients, and includes some form of public service responsibility. It is assumed that lawyers will make a living practicing law, but extreme profitability is not part of the professionalism model.

Under the competing *business* model, law is a profit-making business, no different from any other service business such as advertising. The business model predicts that lawyers will seek profit by any means short of violating civil or criminal laws or

binding rules of ethics. Lawyers and law firms compete to provide the services clients want most. Under this model, lawyers have no public responsibilities and no autonomy from clients. A lawyer is simply a skilled technician, a hired gun paid to do what the client wants (short of actually violating the law). (See Hermann 2012, which uses numerous movie lawyers to highlight the professional/business divide.)

Of course, these models are oversimplified. The practice of law always has and always will have strong elements of both professionalism and business. However, many observers think that the business model is more prominent than in years past. Today, law firms compete vigorously (often ruthlessly) for clients and prune partners who don't bring in new business or work hard enough.

13.05.5 Billable hours

During the last twenty or thirty years, the number of hours lawyers are expected to work has increased dramatically (although it fell somewhat as the result of the recession that started in 2008 and continued for the next several years). The increase in work hours is a function of the economic trends discussed in ¶13.05.3 and 4—the higher starting salaries of lawyers, the need to pay senior associates more than junior associates, and the ever-increasing profit demands of the partners. Aside from raising billing rates (which quickly runs into client resistance), the only way to generate the necessary cash flow is for the lawyers to work more hours.

The lawyers at the biggest firms work the longest hours. For example, in 2010, lawyers at firms with more than 700 lawyers billed 1,859 hours on average. Such firms on average required 1,918 billable hours (but 15.9% required at least 2,000 hours). Obviously, the average lawyer was failing to achieve the billable hour requirements in 2010. Billable hour requirements declined slightly from 2006 to 2010 (in 2006, 25.9% of firms required at least 2,000 billable hours), possibly because the recession made it impossible to require associates to bill the maximum amounts when business was declining.[19]

This is not the whole story. Generally, in order to bill two hours, most lawyers must spend close to three hours in the office. The extra hour consists of things that cannot be billed to clients—personal needs and phone calls, keeping up on the law, recruiting new lawyers, trolling for new clients, mentoring, attending management meetings, or just schmoozing with colleagues.

Hours at work. To bill 2,000 hours per year, a lawyer typically must spend close to 3,000 hours in the office (or 60 hours a week for 50 weeks). To work 60 hours a week, the lawyer must be in

the office *10 hours a day, six days a week* (and that does not count commuting time or lunch). In other words, a typical lawyer who has a 30-minute commute each way and takes no lunch break (she eats lunch at her desk while working) must leave the house at 8 a.m. and return at 7 p.m., *Monday through Saturday,* 50 weeks a year. If she does not want to work a full day Saturday, she must be out of the house even longer hours during the week or work Sunday as well. When there is a crisis, lawyers work 24/7, and crises occur frequently and unpredictably in the life of lawyers. No time is left for a personal life, much less a lifestyle.[20]

With these kinds of work demands, it is no wonder that young lawyers report serious problems of physical illness, alcohol or drug abuse, and depression (Schiltz 1999). In the view of many young lawyers who feel trapped in the biglaw environment, their high salaries do not compensate for the lack of personal time. They must stay, however, because they need the big bucks to pay their student loans.

13.05.6 Quality of work life

Researchers have conducted numerous studies of lawyer job satisfaction. Most lawyers report they are satisfied with their career choice. A large-scale study of lawyers who were admitted to the bar in 2000 indicated that 79% are moderately satisfied or extremely satisfied with their choice of careers (Dinovitzer & Garth 2007). These results are consistent with numerous studies showing that most lawyers are relatively satisfied with their work (Organ 2011).

However, the job satisfaction levels of lawyers at big firms are sharply lower than those of other lawyers. Big-firm lawyers, despite their higher incomes, are the least satisfied with their jobs and the most likely to change jobs (a measure of dissatisfaction with the existing job). Dinovitzer and Garth (2007) trace these results to the fact that graduates of top law schools (who gravitate toward big-firm jobs) tend to come from higher social classes than graduates of lower-tier law schools. Lawyers whose families come from higher social classes tend to have higher expectations for their careers than lawyers from lower social class families. The lawyers whose families were in lower social classes tend to be happy to have achieved upward social mobility. Thus, of the graduates of the top ten law schools in 2000, only 27% were extremely satisfied with their choice of careers, and 57% expected to leave their employers within two years. In contrast, of the graduates of the bottom rung of law schools who entered practice in 2000, 43% were extremely satis-

fied with their choice of careers and only 41% planned to change jobs within two years (Dinovitzer & Garth 2007, 12).

There are other reasons why lawyers at big firms are unhappy with their work lives despite high salaries and nice offices. Working for large organizations can feel dehumanizing and bureaucratic; you don't know many of the people you work with and they don't know you. Levels of stress can be extremely high, given the tight deadlines and high stakes involved in many of the matters the firm works on. Big-firm lawyers seldom experience the satisfaction of interacting with ordinary people and helping them solve their problems. Most of the work lawyers do in big law firms helps corporate clients, not ordinary people, and much of the work is anything but challenging or glamorous. Big firms thrive on major litigation and major corporate transactions, and each of these involves massive amounts of sheer drudgery.

The life of a young associate in a prestigious New York firm was described by Keates (1997). Keates (not his real name) left the firm after less than two years of high-paid misery, totally burned out and disillusioned. His book, most of which is in diary form, was written to warn law students about what they are letting themselves in for if they choose the biglaw path.

Keates says he became a lawyer because of the influence of TV shows like *L.A. Law* and *Perry Mason* and books and movies like *To Kill a Mockingbird* and *The Firm*. In fact, he discovered, the actual practice of law is nothing like these pop culture representations. Among the various myths he shatters are that the work is exciting (he found it unbearably tedious most of the time) and that it achieved some useful social goal (in fact, he represented mostly polluters trying to get somebody else to pay the cost of cleaning up toxic sites). He worked unbearably long hours (often all night or right through the weekend) and found that the partners and associates could not care less about him as a person.

13.06 Law firms in the movies

Since 1980, almost all the law firms shown in the movies have been very bad places. Their lawyers are vicious, greedy, and dishonest. In *Philadelphia*, for example, a big firm fires a hardworking, loyal, and highly competent associate who has contracted AIDS. The partners are intensely homophobic and they commit perjury to cover up their illegal discrimination. Virtually the only good law firms in recent films have been small ones up against much larger ones, as in *A Civil Action* (1998), *Erin Brockovich* (2000), or *Class Action* (1991). Let's look at the litany of bad law firms in the movies:

- In *Michael Clayton* (2007), a law firm engages in all sorts of evildoing to cover up the truth about its client U-North whose product killed people as well as weeds. As senior partner Marty Bach remarks, everybody knew the case "reeked from day one," and there's nothing wrong with covering up the critical evidence.
- In *Changing Lanes* (2002), a law firm loots a charitable trust and covers it up with forgery and perjury.
- In *Devil's Advocate* (1997), a big firm engages in sleazy deals such as weapons smuggling, drug dealing, and document shredding. The managing partner is Satan himself and many of the lawyers are devils.
- In *The Rainmaker* (1997), a firm defending an insurance case makes employees disappear before their depositions are taken, taps the phones of the plaintiff's lawyer, and turns over manuals with the critical pages removed.
- In *The Firm* (1993), a tax law firm turns out to be an arm of the mob. Any associates who want to leave the firm are murdered.
- In *Regarding Henry* (1991) a law firm defending a malpractice case against a hospital knowingly puts on perjured testimony.
- In *Class Action* (1991) a firm defending an automaker whose gas tanks exploded first hides, then destroys, a critical memo that would have helped prove the plaintiff's case.
- In *The Verdict* (1982; Chapter 4), a law firm defending the Boston archdiocese employs a sexual spy and pays the plaintiff's expert witness to disappear before trial.

What could account for the consistent trashing of big law firms in the films of the last thirty years? Which of these explanations, if any, do you agree with?

- About two-thirds of all lawyers portrayed in the movies are negative, whether they practice alone or in firms (see ¶4.03). Because law firms are just collections of lawyers, it is not surprising that law firms would be portrayed even more negatively than individual lawyers.
- Historically, the movies have used big business as a punching bag (see ¶12.07). Films like *The Insider* (1999), *Silkwood* (1983), or *Runaway Jury* (2003) illustrate filmmakers' long-time antagonism toward business. The depictions of coldhearted corporate killers in *Michael Clayton* (2007), *The Constant Gardener* (2005), *Erin Brockovich* (2000), or *A*

Civil Action (1998) are also good examples. The anti-big business slant of the movies is a double whammy for big law firms because they mostly represent big business (and thus share in the hostility filmmakers feel toward their clients) and because large law firms have become big businesses themselves.

- Movies hold up a mirror to the beliefs and attitudes of ordinary people (see ¶¶1.04.1, 4.04.1). Polls show that most people despise lawyers and that they distrust law firms even more than individual lawyers. Thus, the Harris Poll each year asks about the public's opinion of the leadership of various institutions. In 2010, law firms came in third from the bottom, ahead only of Congress and Wall Street. Only 13% of respondents had a great deal of confidence in law firms. In contrast, 31% had a great deal of confidence in the Supreme Court, and 24% had a great deal of confidence in courts and the justice system. Thus the public has much lower confidence in law firms than in other legal institutions.[21]

Big law firms on television are treated in a more balanced fashion than law firms in the movies[22] (see ¶7.02.3 and .4). *L.A. Law* glamorized big firm practice. *The Good Wife* treats a large law firm in a reasonably favorable light, although it does not gloss over management difficulties and rivalries between the lawyers. The same is true of *Boston Legal* (Chapter 7) and *Suits*. Why do you think that law firms on television are treated more favorably than law firms in the movies (see ¶4.04.5)?

13.07 Employment law and civil rights

Philadelphia is about a civil rights action arising out of employment. A brief summary of employment and civil rights law may clarify the legal issues raised by the film.[23] (Law students who are already familiar with the basics of employment and discrimination law may wish to skip this part.)

13.07.1 At-will employment

A large number of jobs in the United States are "at-will." This means that the employer can fire the employee for any reason at any time—or for no reason at all. Similarly, the employee can quit at any time. Andrew Beckett's job as a law firm associate was an at-will job. He had no protection if firm decided to fire him (unless the decision to fire him was based on an illegal reason as discussed in ¶¶13.07.3

or .4). The same thing is true of most jobs in the service sector (particularly in retail stores or restaurants).

At-will employment emerged as the background norm in England and America around the end of the nineteenth century. Many writers have tied the emergence of the at-will rule to the Industrial Revolution and the rise of capitalism. It gave employers maximum flexibility in choosing their labor force and allowed them to immediately get rid of any employees who failed to please the employer (particularly any who seemed to be trying to organize a union).

Interestingly, the at-will rule is not followed in most countries. Throughout Europe and Latin America, just the opposite is true. Once an employee has worked for a probationary period (say, six months), the employee cannot be fired without good cause. The result is that, in most cases, once employees are hired, they can keep the job until retirement, regardless of whether the employer wants to get rid of them. Thus, employees in these countries have far more job security than do employees in the United Kingdom or the United States, but employers have much less flexibility in changing their labor force to adjust to altered market conditions or in getting rid of poorly performing employees.

13.07.2 Exceptions to the at-will rule—Good cause discharge

Many employees are not at-will. If an employee is represented by a union, the contract between the union and the employer undoubtedly protects employees from discharge without good cause. Under civil service laws, government employees cannot be discharged without good cause. Civil service laws were first enacted to get rid of the "spoils system" in which a new administration would fire all the workers and hire new ones from the political party of the winners. Today, civil service laws make government jobs secure, but they also make it difficult for governments to get rid of poorly performing employees. Similarly, teachers at all levels, up through and including universities, are protected by a tenure system. Finally, many employees are protected from discharge by an employment contract with their employer. This is particularly true of senior managers but may apply to other employees as well.

13.07.3 Public policy and at-will employment

Another important exception to the at-will rule is that an employee cannot be discharged for reasons that violate public policy. For example, the employer may tell the employee to lie to federal inspectors about environmental violations and fire her if she refuses to do so, or the employer may fire a whistle-blowing employee

(meaning one who discloses that illegal activities have occurred). These are examples of discharges that violate public policy. In many states, employees who are subject to this sort of discharge can get their jobs back and can also get damages (including punitive damages) for the violations.

13.07.4 Civil rights protection

A variety of antidiscrimination laws modify the at-will rule. If an employee (even an at-will employee) is discharged because of a forbidden form of discrimination, the discharge is illegal. Employment discrimination is prohibited by both federal and state laws, but these laws are not always identical. For example, the primary federal civil rights laws—Title VII of the Civil Rights Act of 1964 and the Americans with Disabilities Act—cover only employers with fifteen or more employees. The law of most states fills the gap by covering employers with fewer than fifteen employees. Wyant, Wheeler had far more than fifteen employees and thus was covered by both federal and state antidiscrimination laws.

Under federal law and the law of most states, an employer cannot discriminate in hiring, promotion, or discharge by reason of:

- Race
- Gender
- Religion
- National origin
- Pregnancy
- Disability
- Age

Under the laws of many states, discrimination on the basis of sexual orientation is prohibited. However, Title VII (the primary federal civil rights law) does not prohibit discrimination because an employee is homosexual (or, for that matter, because an employee is heterosexual).

Notice that this list does not exhaust all forms of discrimination. For example, it is legal to discriminate on the basis of obesity (unless the obesity is so severe as to constitute a disability as discussed below) or on the basis of personal appearance. If an employee is at-will, the employee remains vulnerable to many forms of discrimination that may seem objectionable but are still legal.

Employees who believe they have been the victim of prohibited discrimination must report it first to an administrative agency—either the federal Equal Employment Opportunity Commission (EEOC) or a state antidiscrimination

agency. The agency will investigate the claim and attempt to mediate the dispute by working out some compromise. If that fails, the employee can generally choose to go to court (as in *Philadelphia* and in *Cain v. Hyatt*) or have the dispute adjudicated by the state agency (as in the Geoffrey Bowers case, discussed in ¶13.01.1; see ¶13.01.1 for discussion of *Cain* and *Bowers*). However, the EEOC is not empowered to adjudicate complaints under federal law (except against the federal government). Thus, the victims of nongovernmental employment discrimination who proceed under federal law must go to court if the case cannot be settled. (Increasingly, employees are required to sign arbitration agreements in which they agree that all claims, including those relating to discrimination, will be determined by arbitrators rather than by the courts).

Figure 13.1 *PHILADELPHIA*. A deathly ill Andrew Beckett (Tom Hanks) testifies at his trial. TriStar Pictures/Ohotofest. © TriStar Pictures.

13.07.5 Disability discrimination

Wyant, Wheeler discharged Beckett not because he was gay but because he had AIDS. This form of discrimination is prohibited by the federal Americans with Disabilities Act of 1990 (ADA) and by most state anti-discrimination laws. A disability means a medically recognized physical or mental impairment that substantially limits a major life activity. Because a person who is HIV positive cannot have unprotected sex without risk to a sexual partner or to an unborn child, the person is limited in a major life activity; thus being HIV positive or having full-blown AIDS counts as a disability.

To qualify for protection under ADA, a disabled employee must be able to perform "essential" job duties, with or without reasonable accommodation of the disability. If the employee can do the job with reasonable accommodation, the employer must provide such accommodation. At the time he was fired, Beckett was still capable of performing as a lawyer. However, if he could not have worked the hours expected of a full-time lawyer, Wyant, Wheeler probably would not have been required to provide a reduced work schedule for him. Conversely, if Beckett could work full time but needed some time to see the doctor or receive medical therapy, Wyant, Wheeler would probably have been required to provide a more flexible work schedule.

Wyant, Wheeler could have legally fired Beckett for reasons other than disability, such as doing sloppy work. Thus, each side of the case spun a competing story. Miller's story was that Beckett had done excellent work and was fired for having AIDS. Conine's story was that he was fired for mediocre work, topped off by losing the Hi-Line complaint.

In the jury room. The brief scene in the jury room in *Philadelphia* was telling. The juror who spoke was involved in military aviation. Conine undoubtedly thought this juror would be good for the defendant side because he would probably be conservative in outlook and likely to distrust discrimination claims. However, the juror heaped scorn on Wyant, Wheeler's story. He asked—would you send a pilot in whom you lacked confidence on a dangerous combat mission as a test? Of course not—you would send your best and most trusted pilot. Consequently, the jurors simply did not believe that the firm assigned the important Hi-Line case to Beckett to see whether he could cut the mustard. This fatally undermined Wyant, Wheeler's case.

Wyant, Wheeler made a disastrous tactical error by deciding to take this high-visibility and deeply embarrassing case to trial rather than settling it quietly before trial. As a result, the firm is stuck with a huge punitive damages award and boatloads of terrible publicity. Bob Seidman urged Wheeler to settle the case in the hallway of the basketball arena immediately after Wheeler was served with a summons, but Wheeler blew him off. Yet Wheeler was a lawyer who ordinarily had great judgment in dealing with the problems of his clients. Beckett was sincere when he testified to his admiration of Wheeler's skills as a lawyer. Wheeler's poor decision in the Beckett case suggests that lawyers often make poor judgments in matters where they lack objectivity and distance.

13.07.6 Race and sex discrimination

Although it was not involved in *Philadelphia*, we should not leave the subject of civil rights without some comments about how the law protects employees against discrimination on the basis of race or of gender. This kind of discrimination remains rampant in the work force (although it is usually concealed). The federal and state laws that protect employees against race and sex discrimination are of immense importance in the daily work lives of millions of people. On the other side of the coin, the laws create difficulties for employers who want to avoid hiring workers who they believe cannot do the job (or who want to fire workers who are doing a poor job) when those workers happen to be members of minority groups, women, or other classes protected by the antidiscrimination laws.

Many race or sex discrimination cases raise issues similar to Andrew Beckett's AIDS discrimination case. Was a particular employee not hired (or not promoted or paid too little or discharged) for discriminatory reasons or because of some appropriate, nondiscriminatory reason? Here the fact-finder must decide who is telling the truth and who is lying. As in Beckett's case, the evidence of discrimination is often circumstantial; there are no smoking guns (such as memos or emails about favoring white employees over black employees). Moreover, in many cases, the employer turns out to have mixed motives—both discriminatory and nondiscriminatory reasons motivated the decision. Then the fact-finder must decide whether the decision would have been the same even if the employee were not a member of the protected class.

13.08 Strange doings in *Philadelphia*

The makers of *Philadelphia* dealt with a critical social issue—discrimination against AIDS victims—and did a great service in humanizing and winning public sympa-

thy for AIDS victims as well as other disabled people. However, by attempting to hype its entertainment value, the film goes over the top in its treatment of legal issues and trial procedures.

Evidence is not admissible unless it is "relevant," meaning that it would assist the jury to resolve an issue in the case. As a result, the judge should not have allowed Belinda Conine to ask Beckett to hold up a mirror to his face to see if there were any visible lesions, because the presence of lesions at the time of trial tells us nothing about whether he had lesions when he was fired. Miller's demonstration that Beckett has lesions on his chest now is equally irrelevant since it has nothing to do with whether he had lesions when he was fired. Furthermore, the judge should not have allowed Conine to ask Beckett about visiting the Stallion Cinema or whether he had sex with a stranger there because these questions have nothing to do with the case. For the same reasons, the judge should not have allowed Miller to ask Burton whether the firm had ever discriminated against her. Obviously, Miller's rant about gay stereotypes was completely improper. Lawyers are not permitted to interrupt the trial by making speeches, as Miller does; that is reserved for the closing argument.

Should a film that contains courtroom scenes be criticized because it contains gross inaccuracies about trial practice? Or is this irrelevant, given that the film is a purely commercial product intended to entertain or persuade viewers rather than to educate them about trial practice? Recall the discussion of "reality" in the movies, ¶¶1.06 and 8.07. We think a film should be truthful in the "macro" sense even if it is inaccurate in the "micro" sense, and we think it is important to let students know when a movie is wildly out of sync with the reality of law practice.

13.09 Filmmaking in *Philadelphia*

13.09.1 Framing and Composition

An important scene in the film occurs in a law library with lawyers doing what legal films and television almost never show them doing: hitting the books and reading cases. (Today, however, most of such reading is done on the screen using online databases rather than books.) Very little happens in the conventional sense—just a brief conversation between the two main characters. But the scene marks a major turning point in the film. In an earlier scene, Joe Miller told Andrew Beckett that he did not think Beckett had a case. In the library scene, Beckett shows Miller that he has a case—both factually and legally. The scene lasts nearly six minutes, and it occurs almost exactly 1/4 of the way through the film.

The library scene nicely illustrates how filmmakers use framing and composition to tell a story visually—not just through dialogue and acting. The scene consists of a simple conversation, but it's not filmed like a typical conversation scene. The conventional way of shooting and editing conversations is through a technique called shot/reverse shot (discussed at ¶1.06.3). In the library scene, however, the film does not cut back and forth between over-the-shoulder shots of Miller and Beckett looking at one another. Instead, the camera photographs Beckett and Miller from the side of the table, slowly panning back and forth between them. For instance, when Miller asks Beckett how he can prove that the lawyer who saw Beckett's lesion knew it was from AIDS and that the firm subsequently terminated him on that basis, the camera slowly pans from Miller (even as he is still asking the question) to Beckett. Both men are shown in profile, in closeup. The background is out of focus.

Very likely, the scene was shot with a telephoto lens. A telephoto lens is a long-focus lens that compresses the space between the camera and the subject. As a result, objects at a considerable distance appear closer to the camera than they actually are. Likewise, objects in the foreground and background appear closer together than they really are. Frequently, filmmakers use telephoto lenses to separate the characters from the background. For instance, the background is reduced to an indistinct blur in the shots that pan between Beckett and Miller.

The climax of the library scene occurs when Miller asks Beckett, "So you got a relevant precedent?" In response, Beckett pushes a case towards Miller. As he does so, the camera slowly pans towards Miller, following the book as Beckett pushes it across the table. Once the book reaches Miller, the film cuts to a reaction shot of Miller. A reaction shot of Beckett follows, suggesting that the two have finally connected. The film then cuts to a medium long shot of Miller and Beckett sitting at the table. It's the first shot in which the two men appear together in the frame (aside from a brief shot of Miller's back when he first approaches the table).

The scene ends with an overhead shot of Miller and Beckett sitting at the table, taking turns reading aloud from the case. At first blush, the overhead shot seems an unnecessary flourish. But if you listen closely, you can hear that a slight echo has been added to Miller's voice, giving it more resonance and authority. The overhead shot gives the echo a spatial justification by vastly increasing the space around Miller and Beckett.

13.09.2 Lighting

Lighting in American movies is primarily realistic. Cinematographers strive to give the impression that the lighting in a scene derives from actual lighting sources

within the scene—for instance, sunlight coming through the window, a table or desk lamp, or even a single light bulb hanging from the ceiling. Indeed, even when obviously non-natural lighting is used for dramatic effect—such as to create suspense—cinematographers attempt to provide a realistic justification for the lighting. (For discussion of lighting, see Bordwell & Thompson 2010, 131–38)

Philadelphia contains a scene that departs radically from the convention of realistic lighting. Following the Halloween party, Joe Miller and Andrew Beckett meet to prepare for Beckett's direct examination. The conversation quickly turns to the opera that is playing in the background. As Maria Callas begins to sing "La Mamma Morta," an aria from Umberto Giordano's *Andrea Chénier*, Beckett stands up, turns up the volume on his stereo, and proceeds to "perform" the aria, walking about the room with his IV in tow as he describes the plot, lyrics and music for Miller. A previously brightly lit room suddenly becomes dark, and the room becomes suffused in red light, with some flashes of white light to the create the impression of a raging fire—the fire that consumes Maddelena's childhood home in the aria, but also the emotional fire that rages within Beckett. A fireplace in the background provides a pretense of realism, but only a pretense. It's there throughout the scene and never varies in intensity. Clearly, the lighting in this scene is being used to express in visual terms Beckett's turbulent emotional state, but in contrast to the typical American movie, the filmmakers make no attempt to provide a realistic justification for the sudden changes in lighting. In a more conventional movie, Beckett would have been shown turning down the lights in the room and turning on the fireplace—perhaps right after he was shown turning up the volume on his stereo. That would have provided a more realistic justification for the changes in lighting. Instead, the filmmakers here adopted a flamboyant expressionism that is rare in American movies.

13.09.3 Montage

Philadelphia opens with a montage of the City of Brotherly Love. The montage is accompanied by Bruce Springsteen's soulful "Streets of Philadelphia," a song that was written and performed by Springsteen specifically for the film. The montage consists of a series of shots of ordinary and iconic Philadelphia landmarks and buildings, as well as average, ordinary Philadelphians working, playing, walking, jogging, waving, dancing, standing, and even begging.

The montage lasts approximately two minutes. It is a thematic montage because it is organized around a single theme—the city of Philadelphia, in all of its beauty and ugliness, splendor and squalor. As a result, the sequence of shots is

relatively easy to follow, even though the shots do not have a narrative link and bear little relation to the story that follows.

Although short, the montage is distinctly reminiscent of the city symphony films of the 1920s, which include such acclaimed works as Walter Ruttman's *Berlin: Symphony of a Metropolis* (1927) and Dziga Vertov's *Man with a Movie Camera* (1929). These feature-length silent films were paeans to the modern urban metropolis in which thousands of shots of buildings, machines, and individuals were edited together rhythmically in order to flow with the soundtrack (supplied by a theater organ since the movies were silent) and convey the rhythm of city life. The opening montage of *Philadelphia* is not as rigorous, but it does attempt to capture the tone and pace of the song through the use of drab, washed out colors and tracking shots that match Springsteen's vocals.

13.10 Review questions

1. Should the United States adopt the British system that requires losers to pay the winner's attorneys' fees (¶13.02)?

2. Should there be a constitutional right to an attorney appointed at public expense to represent poor people in civil matters such as evictions, bankruptcy, mortgage foreclosure, family law, or deportation (¶13.02)?

3. Statutes provide that the defendant must pay the plaintiff's legal fees if the plaintiff wins an anti-discrimination suit. If the plaintiff loses, should he or she have to pay the defendant's fees (¶13.02)?

4. Joe Miller reluctantly takes on the case of Andrew Beckett and wins a great victory over Wyant, Wheeler. How does Miller's work for Beckett affect Miller (aside from paying him a fee; ¶¶13.02, 4.07)?

5. Choose an LGBT character in film or television and compare that character to Andrew Beckett.

6. Apply "queer theory" to a film or television show or character. Choose a film or television show that does not deal explicitly with gay issues (see ¶13.03.3).

7. How might *Philadelphia* have been different if Andrew Beckett had been black and Joe Miller had been white (see ¶13.04)?

8. What characteristics does the film *Philadelphia* ascribe to Joe Miller as a lawyer and as a human being? When we first meet him? By the end of the film? Note that Miller's character describes what screenwriters describe as an "arc." This means that his character undergoes a marked personality change as the film goes along.

9. Select an African American character in the movies who is not a lawyer. Does the representation of this character include racial stereotypes?

10. Your sister is a a second-year law student at a top-25 law school located in Chicago. Her grades place her in the top 15% of her class. She is uncertain as to her long-term career plans but is interested in politics. She will graduate with over $100,000 in student loans. She has received two offers for summer employment after she finishes her second year. One offer is for a well-paid summer job in a big Washington, D.C. law firm (such jobs often lead to permanent jobs after graduation). The second is for an unpaid position in a public interest law firm in Chicago that deals with employment and housing discrimination. Please advise her as to which offer she should accept (see ¶13.05).

11. From legally themed films or TV shows you have seen (whether or not in this class), select a lawyer or law firm that personifies the "professional" model. Select another that personifies the "business" model (see ¶13.05.4). Explain.

12. Law firms on television (such as those on *L.A. Law, The Good Wife, Suits,* or *Boston Legal*) seem to be depicted more favorably than law firms in the movies. Do you agree? If so, what's the explanation?

13. As ¶13.08 suggests, the judge in *Philadelphia* allowed a large amount of irrelevant (but entertaining) evidence to be admitted at the trial. Should the film be criticized because it is legally inaccurate, or is this irrelevant given that the purpose of the film is to entertain?

14. Do you regard the representation of Belinda Conine in *Philadelphia* as positive or negative (see ¶10.06)?

15. Discuss the use of editing (see ¶1.06.3) in one scene from *Philadelphia.* Analyze how the filmmaker is using editing to create meaning and emotional impact.

16. Discuss the use of framing and composition in a scene from *Philadelphia* other than the one discussed in ¶13.09.1.

17. In your opinion, why did the filmmakers adopt a "flamboyant expressionism" for the opera scene in *Philadelphia?* How did it serve the narrative and thematic purpose of the scene (see ¶13.09.2)?

18. What is the purpose of the montage scene at the opening of the film (see ¶13.09.3)?

Notes

1. Instructors who wish to concentrate on gender discrimination should consider *North Country* (2005), a well-made movie about sexual harassment of women in a mining company. See Korzec 2007. Another choice is the Australian picture *Brilliant Lies* (1996), which concerns sexual harassment and contains an administrative hearing designed to uncover the truth in a he-said-she-said situation. It is quite explicit in dealing with the harassment. Much less satisfactory is *Disclosure* (1994), which features female-on-male sexual harassment. Instructors who want to focus on sexual orientation discrimination should consider *Wilde* (1997), which is an excellent historical picture about the trial of Oscar Wilde. Instructors who teach this chapter but do not teach Chapter 12 on civil justice may wish to assign the material about the civil justice system in ¶12.01 to be read in connection with this chapter.

2. See Rhode 2004.

3. 43 Penn. Stats. §959(d)(4).

4. See http://www.nalp.org/july2009hoursandprobono

5. http://www.nolo.com/

6. http://www.nalp.org/lgbt_lawyers_dec2011

7. A report of the Los Angeles County Bar Association (1995) was based on a random sample of 1,634 Bar Association members (and 550 attorneys belonging to local gay attorney associations). The survey concluded that at least 6% and perhaps as many as 10% of Los Angeles County lawyers are LGBT, although serious methodological problems arise in trying to estimate this figure. According to the report (which may, of course, be somewhat dated), these attorneys face many barriers and hurdles that their heterosexual peers do not.

8. The need to remain closeted imposes substantial personal costs on LGBT attorneys. As William Rubenstein has noted, a "major component of the suffering that [LGBT] attorneys endure is the emotional anxiety that attends the performance of their sexual orientation. They must constantly scrutinize how much to reveal and how much to conceal of their personal lives in their myriad day-to-day interactions" (Rubenstein 1998, 393–94).

9. See Barrios 2003; Bourne 1996; Dyer & Pidduck 2003; Russo 1987.

10. See Allen 2003, 151–55; Levy 1999, 442–93; Merritt 2000, 337–38, 390–93.

11. See Doty 1993; Butler 1999.

12. http://www.nalp.org/women_minorities_jan2012

13. See Bogle 2001a, 2001b; Cripps 1993; Doherty 1999, 274–93; Fiske 1994; hooks 1996; Lipsitz 1998; Rogin 1998; Snead 1994.

14. For discussion of law firms in the movies and in reality, see Asimow 2001.

15. http://www.law.harvard.edu/programs/plp/pages/statistics.php

16. The 2012 bankruptcy of megafirm Dewey & LeBoeuf was attributable largely to overly rapid expansion and excessive guaranties to new partners. See http://dealbook.nytimes.com/2012/05/28/dewey-leboeuf-files-for-bankruptcy/; http://dealbook.nytimes.com/2012/03/15/lean-times-for-dewey-leboeuf/.

17. http://dealbook.nytimes.com/2011/04/27/big-law-firms-profits-and-revenues-rise-in-american-lawyer-survey/

18. http://www.abajournal.com/legalrebels/article/the_60_hour_lawyer—why_dewey_isnt_abnormal/?utm_source=maestro&utm_medium=email&utm_campaign=weekly_email

19. These figures are derived from various reports written by NALP, the National Association of

Law Placement. For the 2010 figures, see http://www.nalp.org/billable_hours_feb2012.

20. http://www.law.yale.edu/documents/pdf/CDO_Public/cdo-billable_hour.pdf. The Yale study indicated that in order to bill 2,200 hours, including a half-hour commute and three weeks of vacation, an associate must work from 7:30 a.m. to 8:30 p.m. Monday through Friday and from 9:30 a.m. to 5:30 p.m. three Saturdays a month.

21. http://www.harrisinteractive.com/NewsRoom/HarrisPolls/tabid/447/ctl/ReadCustom%20 Default/mid/1508/ArticleId/232/Default.aspx

22. Numerous law firm TV series arrived and swiftly disappeared. They included *Century City, The First Years, The Girls Club,* and *Eli Stone.* Some of these series, like *Century City,* portrayed the firm as a decent place to work.

23. See Player 1999; Rothstein 1999.

Family Law

Assigned Film: *Kramer vs. Kramer* (1979)[1]

14.01 The book and the film

Kramer was based on a low-key but deeply felt novel by Avery Corman published in 1977. The film, written and directed by Robert Benton, won the Academy's Best Picture Award in 1979. Dustin Hoffman and Meryl Streep won Oscars for Best Actor and Best Supporting Actress, and Benton won both Best Direction and Best Adapted Screenplay. There were additional acting nominations for Justin Henry and Jane Alexander. Nestor Almendros (for cinematography) and Gerald B. Greenberg (for editing) were also nominated.

14.02 The cultural context of *Kramer vs. Kramer*

In a year that saw such blockbusters as *Alien* and *Star Trek: The Motion Picture*, *Kramer* was the highest grossing film. It ultimately grossed over $106 million in the United States alone. For a film that had no action or special effects and was not based on a best-selling novel or hit television series, this was an extraordinary showing. Obviously, the film touched a cultural nerve. The question is, which nerve? And why?

Like any film, *Kramer vs. Kramer* was influenced by the cultural climate of its time. That climate was shaped by several important social trends including the rise in the divorce rate, the backlash against feminism, and evolving notions of masculinity.

14.02.1 Divorce

Owing in part to the changes in divorce law and in part to changes in moral and social values brought about by the tumult of the 1960s, the divorce rate exploded in the 1970s. While there were 479,000 divorces in 1965, there were over 1 million in 1975. As a proportion of the population, the divorce rate nearly doubled, going from 2.5 out of 1,000 in 1965 to 4.9 out of 1,000 in 1975. Since then, the rate of divorce has continued to increase (while the rate of marriage has fallen sharply). In 2009, for example, the marriage rate for women was 17.6 per thousand and the divorce rate was 9.7 per thousand. Because there are about twice as many marriages as divorces each year, it is often said that a given marriage has no better than 50% chance of success. However, this 50% probability figure masks large differences. People with college degrees and higher incomes and people who get married later have much lower divorce rates than people with less education and lower income or who get married earlier. There are also large regional differences.[2]

Back in the 1970s, contemporary self-help books portrayed divorce as an opportunity for personal growth and self-discovery. In Gail Sheehy's best-selling *Passages: Predictable Crises of Adult Life* (1978, 208), for instance, divorce is portrayed as a rite of passage, one especially important to women. "Is this ritual necessary," Sheehy asks rhetorically, "before anyone, above all herself, will take a woman's need for expansion seriously?"

In *The Courage to Divorce* (1974, 45), Susan Gettleman and Janet Markowitz claimed that divorce is positive for both spouses: "It has been our experience with patients and friends that both spouses, after an initial period of confusion and depression, almost without exception look and feel better. They act warmer and more related to others emotionally, tap sources of strength they never knew they had, enjoy their careers and their children more, and begin to explore new vocations and hobbies." Similarly, in *Creative Divorce: A New Opportunity for Personal Growth* (1973), Mel Krantzler described the break-up of his marriage as the beginning of an enriching and enlivening voyage of self-discovery. He argued that divorce is a creative act that formed the basis for more satisfying relationships between fathers and children.

Although it initially seems to take a less cheerful view of divorce, *Kramer vs. Kramer* ultimately dramatizes Ted and Joanna Kramer's divorce in terms that are

strikingly similar to these contemporary self-help books. As a result of his separation from Joanna, Ted becomes less career-oriented, develops a closer bond with his son, and becomes a better father and human being. Joanna also seems much happier and more in control of her life than during her marriage.

More recent books about divorce take a decidedly darker tone. Judith Wallerstein and Sandra Blakeslee write:

> In the 1980s, people had the comforting illusion that divorce was a time-limited crisis, that children were resilient, and that within a year or two at most everyone in the family would settle down and life would improve for all.…Adults would be able to undo the mistakes of their youth. Children, in a kind of trickle-down theory of happiness, would be better off because one or both parents would be happier. But that is not what our research revealed. The men, women, and children whom we interviewed were still deeply affected by the divorce ten and fifteen years later. For them, the breakup and its aftermath were life-shaping events. For half of the men and women in our study, after ten years had passed the marriage was history, a dead issue. But for the other half, the lost marriage was still alive with raw feelings and strong longings. These people were angry, bitter, and mired in conflict even fifteen years after the breakup.…My most troubling findings concerned the children. Divorce was an entirely different experience for them. Not one considered it a dead issue. They remembered the day that one parent left home with a vividness that took my breath away.…Unlike the 1970s and early 1980s, today the national mood is decidedly pessimistic.…(Wallerstein & Blakeslee 2004, xii–xiv)

14.02.2 The backlash against feminism

Feminism won a series of victories in the early 1970s, the most dramatic of which was the Supreme Court's decision in *Roe v. Wade* (1973), which established the constitutional right to have an abortion. However, by the late 1970s, feminism was on the defensive. By 1977, 35 of the required 38 states had ratified the Equal Rights Amendment (ERA). Only three more states needed to ratify the ERA to make it the 27th Amendment to the Constitution. Thanks to the grassroots politicking of conservative opponents such as Phyllis Schlafly, however, no other state ratified the amendment, and in 1982 it expired.

Many contemporary film critics saw *Kramer vs. Kramer* as emblematic of the backlash against feminism. Rebecca Bailin called *Kramer vs. Kramer* a "well crafted, beautifully acted backlash movie" (1980, 4–5). Michael Ryan and Douglas Kellner (1988, 159) faulted the film for "saying that a man can both mother and work successfully" while implying that a woman can't do the same. Thomas O'Brien (1981, 91–92) complained that in both *Ordinary People* (1980) and *Kramer vs. Kramer,* "the villain is Mom." He noted that the narrative pattern of both films "involves the rejection or reduction of women's significance, their dismissal as emotionally

superficial." Molly Haskell (1987, 673) lambasted the "open misogyny" of films such as *Ordinary People* and *Kramer vs. Kramer,* characterizing them as "man-child paradises," in which "women are either relegated to the wings or expelled altogether." Eileen Malloy (1981, 5) wrote: "Single mothers should be incensed by the injustice done to the difficulty of their position by the trivial way that Hoffman's single-parents are dealt with." Malloy describes Margaret as a "Benedict Arnold." Papke (1996b, 1204) said, "The gaze at legal process is almost always biased, and viewers are invited to adopt the male perspective."[3]

Do you agree with these criticisms? Are they true of the film's representation of Margaret Phelps? Do they adequately address the film's representation of Ted Kramer? By the end of the film, doesn't Ted have a newfound respect and understanding for the burdens and responsibilities women typically shoulder within the family structure?

14.02.3 The "sensitive male movement"

The 1970s witnessed the emergence of a new vision of masculinity. Partly as a result of feminism, and partly in reaction to the Vietnam War (which many critics believed had been fueled by "macho" ideas of masculinity), the traditional image of masculinity, embodied most famously by John Wayne, came under ferocious attack. Numerous books[4] blamed traditional notions of masculinity for everything from heart disease to the Vietnam War. In its place, they championed what was variously described as the "free male," the "liberated male," and, most commonly, the "sensitive male."

Alan Alda. The person who most personified this new image of sensitive manhood was Alan Alda, star of the hit TV series *M*A*S*H.* In various articles in and interviews with magazines like *Ms.* and *Redbook,* Alda berated traditional notions of masculinity while celebrating traits traditionally associated with women.

Although *Kramer vs. Kramer* portrays Joanna Kramer in unflattering terms, the film initially portrays Ted Kramer negatively as well. He is a career-oriented, self-absorbed father who spends little or no time with his family and stifles Joanna. Nonetheless, Ted is ultimately portrayed more positively than Joanna because he takes on responsibilities and traits that are typically associated with mothers and women. Ted becomes, in other words, the prototypical sensitive male.

As Thomas O'Brien (1981, 91) has written of *Kramer vs. Kramer* and *Ordinary People,* "Central to both films is the way a father evolves from being a mere bread-winner or standard-bearer to becoming a caring, involved friend of his son." Indeed, Ted even joins the "sisterhood" when he befriends Margaret, the woman whose friendship with Joanna he had snidely dismissed as the "sisterhood." Moreover, despite what viewers may at first expect, there are no romantic connotations to Ted's relationship with Margaret—it is a true male-female friendship.

14.03 From the Hays Code to *Kramer vs. Kramer*

14.03.1 Divorce under the Hays Code

Marital trouble and divorce are unpleasant but ever-present realities of modern life. Marital breakdown generally precedes divorce. The parties become increasingly incompatible and unhappy in their lives together. Frequently, there are complex and clandestine love affairs outside of marriage; deception, jealousy, and betrayal; emotional upheaval; disruption of the lives of children; and economic warfare. The routine of everyday life is shattered. Divorce is often followed by physical and emotional isolation for one or both parties, or it may be followed by promiscuity. Forced out of the shelter of the household, some spouses who had worked in the home find satisfying new careers; others find that the world of work holds nothing for them. Often one ex-spouse's standard of living rises while the other's plummets. One partner's true personality blooms when freed from the stifling constraints of marriage; another's joy of life is snuffed out. A high divorce rate insures that there are plenty of complex blended families with multitudes of stepchildren and former spouses.[5]

This is intensely dramatic material. It would seem that marital breakdown and divorce should appear as thematic material in movie narratives almost as often as those reliable standbys of romance, marriage, and childbirth. These days, movies routinely dwell on the emotional and financial prequels and sequels to divorce. However, it was not always like that. Divorce figured prominently in many silent films of the 1920s and in the films of the early 1930s, such as Alfred Hitchcock's *Easy Virtue* (1928) or Robert Leonard's *The Divorcee* (1930). Then, for thirty or forty years, serious treatment of divorce was blotted off the screen.

As discussed in ¶¶2.03, 5.05, and 13.03.2, the PCA administered the movie industry's system of self-censorship from 1934 to 1968. No film could be released without a PCA certificate; the PCA bureaucrats scrutinized every word of every film (as well as song lyrics and costumes). The Hays Code provided that "the sanctity of the institution of marriage and home shall be upheld." The censors interpreted those words to mean that divorce was mostly off limits as thematic material in film.

What little movies were allowed to say about divorce during the censorship era was wildly wrong. When the story line included divorce during the Code era, it was usually in romantic remarriage comedies like *The Philadelphia Story* (1940) or *The Awful Truth* (1937) (Cavell 1981). In these films, a couple gets divorced at the beginning of the film but gets back together in the end. Needless to say, divorced couples in real life seldom remarry. Other couples went to the brink of divorce but came to their senses, as in *Penny Serenade* (1941). In a few films, such as *Dodsworth* (1936), the censors allowed a spouse entrapped in a truly ghastly marriage to get and stay divorced. The other spouse (normally an adulterer) was punished by a life of misery. Annulment or death (whether natural, violent, or self-imposed) were the preferred ways to dispense with inconvenient spouses in the movies made during the PCA era.

Divorce as opposed to crime and sex under the Hays Code. Note that the Hays Code treatment of divorce was quite different from the way it treated subjects like crime and sex. Crime and sex remained permissible thematic elements—how could it be otherwise? The Code required only that sex be handled with extreme discretion. It also required that criminals and those who practiced sex outside of marriage be appropriately punished. In the case of divorce, however, the subject could not be dealt with at all (except within such narrow conventions as comedies about divorce and remarriage). A few other subjects, such as homosexuality, abortion, and miscegenation (that is, interracial sex) were similarly forbidden. The Code was written by a priest and enforced by Catholic laymen like Breen. One of its purposes of movie industry self-censorship was to get the Catholic Church to stop censoring movies (see ¶2.03). Divorce, homosexuality, and abortion are prohibited by Catholic doctrine. Evidently, the censors believed that if these subjects never appeared in the movies, fewer people would get divorced, procure abortions, or be homosexuals.

14.03.2 From the Hays Code to Kramer vs. Kramer

After steadily weakening through the 1950s and 1960s, the Hays Code finally fizzled out in 1968, replaced by the ratings system that remains in effect today. In the late 1960s and 1970s, divorce themes crept back into the movies, but it took ten years before American film treated the subject seriously and in depth.

In the late 1970s and early 1980s, many filmmakers discovered the dramatic potential of divorce stories. In addition to *Kramer vs. Kramer,* a number of other memorable films addressed seriously the whole range of issues posed by marital breakdown and divorce. One of the best remembered is *An Unmarried Woman* (1978). In that film, Erica seems happily married to Martin until he announces his affair. After some false starts, Erica hooks up with Saul, an abstract artist. Their 15-year-old daughter Patti struggles with her relationship to her father and to Saul. Perhaps most startling to viewers accustomed to the mandatory remarriage scenario, Erica refuses to take Martin back when he pleads for forgiveness. Of course, not everything about *An Unmarried Woman* is realistic. Erica remains in her gorgeous New York apartment despite holding a low-paying art gallery job. Martin has plenty of money and uncomplainingly uses it to support his ex-wife and daughter in the style to which they have become accustomed. Generally, these films have little or nothing to say about the legal process of divorce or about the family lawyers who helped pave the way to singlehood.

14.04 Ingredients of a classic divorce movie

A film that wants to take seriously the process of marital disintegration and divorce should, like any other picture, have a strong story and empathetic characters. It should treat both spouses with understanding and insight; neither should be perfect but neither should be a demon. In addition, the film should engage many of the following issues:

- The reasons for the fundamental breakdown of the marital relationship, including treatment of gender issues
- The economic aspects of splitting one household into two
- The effect of the divorce on children
- Single parenthood and noncustodial parenthood
- Social and relationship problems encountered by newly divorced spouses
- Perverse and outdated family law doctrines (see ¶¶14.05 and 14.06)
- The legal process of divorce (see ¶14.07)
- The problems of the lawyer-client relationship in family law (see ¶14.08)

Remarkably, *Kramer* tackles all of these issues (Asimow 2000b, 250–67). The film lit a path for the many films and television shows of the last thirty years that grap-

ple forthrightly with the human drama of divorce as well as with the legal institu-
tions and processes of family law.

14.05 Fault and no-fault divorce

Until the late 1970s, the movies relating to divorce rarely focused on the antiquated
doctrines of family law that divorcing couples used to endure.

14.05.1 Fault divorce

Until the early 1970s, divorce law was heavily oriented towards determining which
of the spouses was at fault. The petitioning spouse had to prove abandonment, adul-
tery, or physical or mental cruelty, depending on the state, in order to be awarded a
divorce. Some states, such as New York, permitted divorce only in cases of adultery.

The law in action, however, was entirely different from the law in the books.
In the vast majority of cases, divorce actions were collusive affairs based on perjured
testimony. These cases were embarrassing to the parties and to the legal system. One
spouse (usually the woman) came to court with perjured evidence (including
rigged photos) about her spouse's supposed adultery; the other spouse defaulted by
not showing up. Judges knew the cases were phony but waved them through.
Affluent spouses who did not want to act out this charade traveled to Nevada (or
some other divorce haven) where one could get divorced without proof of fault after
six weeks of residence—but only if the other spouse consented.

Friedman's (2000) article on fault divorce begins with an account of *Kreyling v.
Kreyling* (New Jersey 1942). Anna wanted children but Daniel did not, so he insisted
on using contraceptives. Anna objected to contraceptives, so the couple had no sex-
ual relations and Anna moved to a separate bedroom. After a year and a half, Anna
sued for divorce. Anna won, on the grounds that Daniel has "deserted" her (a ground
for divorce under New Jersey law). The court remarked that Daniel's conduct was "a
violation of both human and divine law...[his] willful, obstinate, continual
refusal...to have natural, uncontracepted intercourse" constituted desertion as a
matter of law. Ironically, *Kreyling* was actually a progressive decision. If the court had
not found that Daniel's conduct was "desertion," neither party would have been enti-
tled to a divorce, and they would have remained captives of this miserable marriage.

Fault was important for reasons beyond establishing entitlement to divorce.
Fault played an important role in determining the division of marital property and
the award of alimony. If the man was found to be at fault, the woman would get
most of the marital property and might get considerable alimony; if the woman was

at fault, she likely came away with little or nothing. Considerations of fault were often taken into account in child custody determinations as well; parents guilty of adultery were judged unfit custodians.

Very few films zeroed in on fault divorce. In *One More River* (1934), the parties conducted a scorched-earth trial to determine whether the wife had committed adultery (she hadn't but got convicted anyhow). This film, which unfortunately is not yet available on video or DVD, managed to get approved just as the PCA came into existence; its mature treatment of divorce would never have been acceptable later on. It is based on a novel by John Galsworthy.

Generally, however, films about divorce (even those produced before 1934) ignored divorce law entirely. A few films, such as George Cukor's *The Women* (1939), followed divorcing wives to Reno, but they never questioned the absurdity of that practice. *The Forsyte Saga* (1967), a BBC production widely viewed in the United States and also based on a trilogy of books by Galsworthy, lambasted the English fault divorce system of the Victorian era.

14.05.2 No-fault divorce

During the last four decades, an entirely new vision of marriage termination swept away most relics of the older family law doctrine. Today the emphasis is on removing any consideration of fault, mediating instead of litigating, and treating the ownership of marital property as a partnership. California sparked the no-fault revolution with its 1969 statute allowing divorce upon the petition of either spouse on a simple showing of irreconcilable differences[6] and all other states have now followed suit.[7] Fault is no longer considered in determining spousal or child support. The standard for child custody became "the best interests of the child" and the non-custodial parent generally received visitation rights. The determination of child custody was no longer a device to punish the spouse at fault. In addition, joint physical and legal custody of children became the norm in many states (see ¶14.06.2). Courts often award alimony (often called spousal support or maintenance) to the spouse who has need of support after the divorce until the recipient spouse can reenter the labor market.[8]

14.06 The law of child custody

14.06.1 The tender years presumption

In contrast to most earlier films, which ignored the perversities of family law, *Kramer* foregrounds family law doctrine by leveling a withering attack on the "tender

years presumption" (Asimow 2000b, 261–64; Schepard 2003, ch. 2; Abrams 2009, 683–86). A "presumption" as used in the law of evidence establishes a fact (in this case that maternal custody is in the best interest of the child) unless it is rebutted by the other party. In some states, the father could rebut the presumption only by showing the mother was unfit (which often meant at fault); in others, the father could rebut the presumption by showing that paternal custody would better serve the child's developmental needs.

The tender years presumption was universally applied in the United States from the middle of the nineteenth century through the 1960s. (Before then, the child was considered the property of the father, who normally received custody.) By the late 1970s, the presumption was in decline but was still alive in a number of states.[9]

The tender years presumption was and remains the subject of considerable dispute. Feminist theoreticians who pursue the "equal treatment" approach (see ¶6.03.3) tend to oppose the presumption because they believe that the tender years doctrine is based on stereotypes of women as instinctive child-rearers inherently unsuited for worldly pursuits. These writers tend to favor a gender-neutral standard.

However, feminist writers who pursue the "difference" approach (also discussed in ¶6.03.3) tend to favor the presumption or some variation of it. Under the difference approach, laws that recognize actual differences between men and women are appropriate. In the view of a number of writers, mothers have better ability to nurture small children than do fathers. Writers who favor the tender years presumption also believe that the presumption helps to take away a common tactic used by fathers who threaten to contest custody unless mothers decrease their financial demands.

Application of the tender years presumption in *Kramer*. The tender years rule was misapplied in the film. The presumption is completely inapplicable to a *modification* of custody (such as occurred in the film) as opposed to *an initial determination* of custody at the time of divorce. Moreover, Ted clearly rebutted the presumption. The most important point is that Ted, not Joanna, had been Billy's primary caretaker for a year and a half. Ted had formed a close emotional bond with Billy and had been an excellent and caring parent. Changing custody could only be terribly disruptive to Billy. At a minimum, Billy would suffer short-term trauma; he might well suffer long-term damage. The court was impressed with none of this. As the judge saw it, assuming that a mother of a young child is not somehow unfit, she gets custody.

14.06.2 The best interests of the child

Today the tender years presumption has virtually disappeared, usually in favor of a vague "best interests of the child" standard that is followed in virtually all states (see Abrams, 2009, ch. 12). The "best interests of the child" standard gives judges little guidance in how to resolve contested custody cases, and it may permit judges to quietly apply their prejudices and stereotypes. For example, a judge might disapprove of fathers as caretakers of small children and therefore always give custody to the mother under the "best interests" standard. Similarly, the judge might disapprove of cohabitational relationships, same-sex relationships, or atheism and award custody accordingly.

What are the alternatives to the "best interests of the child" standard? One alternative is the "psychological parent" model. That approach awards custody to the parent who has served as the child's primary caretaker prior to separation in order to maximize the benefits of continuity for the child (see Goldstein, Freud, & Solnit, 1979). Another approach suggests, as a starting point, that custody should be divided between the parents according to a percentage that approximates the amount of time that each parent had spent performing caretaking functions prior to the separation. (American Law Institute 2002, §2.08) Another approach might be to take away responsibility for determining child custody disputes from judges and turn it over to social workers or child psychologists working for the state. Would you favor any of these approaches?

In many states, today, the preferred approach is joint physical custody, if one or both parents want it and they can get along reasonably well. In discussing this issue, it is important to distinguish joint legal custody and joint physical custody. Joint *legal* custody means shared responsibility for making decisions about the child such as those relating to medical care or schooling; joint legal custody is consistent with a variety of physical arrangements, including making one parent the custodial parent and giving visitation rights to the other parent. Joint *physical* custody, on the other hand, involves an arrangement for sharing physical custody of the child, such as alternating weeks between the parents' homes or having the child live six months with one parent, then six months with the other. The fathers' rights movement has pushed hard for joint physical custody; women's groups often oppose it. Opinions differ sharply as to whether joint physical custody is good or bad for young children (Abrams 2009, 767–86).

14.06.3 Child custody in the movies

Kramer deserves credit for identifying a dubious family law doctrine, as well as abuse of discretion by the judge, and subjecting both to criticism. In this respect, *Kramer*

blazed a path for future movies in which child custody or adoption disputes illuminated major social or legal issues. These films include *Losing Isaiah* (1995), which involved the question of trans-racial adoption; *I Am Sam* (2002), questioning whether a mentally disabled father can be a fit custodian; *Evelyn* (2002), pitting the Irish Catholic Church against a single father; and *The Good Mother* (1988), in which a mother loses custody of a child because of a trivial indiscretion by her boyfriend.

14.07 The family law process

In order to get divorced in the fault era, and often in the no-fault era as well, a couple had to endure the family law process. While the vast majority of divorce-related disputes are successfully negotiated or mediated (so that the court proceedings are a brief formality), the fact remains that numerous divorce cases are still litigated. When one or both spouses want to fight, the process can be excruciatingly long and costly.

Figure 14.1. *KRAMER VS. KRAMER.* Attorney Howard Duff (John Shaunessy) tries to discredit Joanna Kramer (Meryl Streep) on cross-examination. Columbia Pictures/ Photofest. © Columbia Pictures.

That process often constitutes a grueling ordeal for the human beings enmeshed in it. In the fault era, family law doctrine required the discovery and disclosure of intimate details of the private life of one or both spouses. A judge had to decide who cheated on whom, who was more cruel, who walked out on whom. The trial process became acrimonious, and the testimony often was vicious, intrusive, and humiliating. In the no-fault era, mercifully, such material is not relevant. (Some states still cling to vestiges of the fault system, particular in setting alimony and dividing property.) Even in states that have abolished consideration of fault, it is not unusual to see long, hard-fought trials on property issues, such as valuing the goodwill of a law firm or pension rights, or on child custody issues.

Kramer gets credit for showing what a miserable experience adversarial family law processes can be. The trial itself is marked by vicious mudslinging. Joanna's attorney smears Ted with the playground incident, implying he was a careless father, and mercilessly explores Ted's downward job mobility. Ted's attorney smears Joanna by asking whether she has been a failure at her marriage and at everything she has ever tried. He insists on asking how many lovers she has had and whether she currently has a boyfriend. He uses a patronizing tone and at times yells at her.

In its understandable zeal to show how destructive family court litigation can be, *Kramer* goes over the top. The question about whether Joanna has been a failure at everything she has tried is improper; her lawyer should have objected to this question as argumentative or unduly vague. Whether Joanna has a boyfriend, or the number of her lovers, has nothing to do with the issues at the trial, absent a showing that she is indiscreet. Whether Ted has downward economic mobility counts for little, given that he lost his previous job because he put parenting ahead of job duties. The attorneys cut off witnesses, demanding yes or no answers. This seems unrealistic; in a trial to the judge, a witness should be allowed to give a complete answer to the question.

In the real world, Judge Atkins would never have decided the custody issue cold. He would have considered reports of a social worker on Billy's family situation. He might well have gently interviewed Billy in his chambers, asking him questions about his daily life with his dad. When Ted's lawyer Shaunessy tells Ted that in the event of an appeal he would have to put Billy on the stand, this is nonsense; an appeal is based on the written record, not on new evidence. Even if a new trial were ordered, seven-year-old Billy surely would not be made to take the stand and testify under oath.

The attorneys never discuss mediating the custody dispute rather than duking it out in court. Mediation is a process whereby disputes are resolved through negotiation with the aid of a third-party mediator who facilitates discussion but has no power to impose a settlement. Several studies indicate that a mediated settlement,

as opposed to a litigated decree, has a better chance of keeping both parents involved in the process of raising their children, and it is certainly less expensive than litigation (Schepard 2007; Schulz 2008). The attorneys also fail to consider joint custody solutions or other ways of avoiding zero-sum results. Thus, the actual courtroom battle in *Kramer* was not very realistic, but the film still gets good marks for showing how unpleasant and how costly family law litigation can become.

14.08 Lawyer-client relationships in family law

To get divorced or dispute support, property, or custody, parties who can afford it must hire lawyers. Family lawyers are expensive; they would prefer to limit their practice to clients who can pay high hourly rates. In *Kramer,* the custody fight costs Ted $15,000 (not counting an appeal). In current dollars, the cost would be about three times that amount and probably much more.

Because of the high cost of legal services, a majority of family court litigants today represent themselves in court (self-representation is often referred to as in propria persona or "pro per") because most states provide little or no free legal services for indigent litigants. (See ¶13.02 for discussion of pro pers.) Pro pers often don't have a clue about family law or family court procedures and thus slow down the family court process or make damaging mistakes. If one party has a lawyer and the other does not, a mismatch occurs, and an unjust result (either through negotiation or litigation) becomes likely.

Fanning the flames. Sometimes family lawyers exacerbate the problems, turning a relatively friendly divorce into a take-no-prisoners brawl that can only benefit the lawyers. A prime example of an irresponsible family lawyer is Miles Massey in the Coen brothers' *Intolerable Cruelty* (2003). *The New Yorker* once ran a cartoon with two women having lunch and talking about their divorces. One remarks that her lawyer got the summer house and her husband's lawyer got the Mercedes. Responsible family lawyers, however, do not fan the flames but instead work to cool down their clients and avoid unnecessary litigation.

The trial in *Kramer* reveals how family lawyers often must play harsh, destructive roles in the courtroom (regardless of whether they are nasty people in their private lives). As Ted's lawyer Shaunessy makes clear, Ted's only hope is to destroy Joanna on the stand. Joanna's lawyer played the same game. However, these are good

lawyers; they are doing their job in an ethical, competent, professional way. It is the system for litigating child support disputes that is bad, not the lawyers.

14.09 Cinematic technique in *Kramer vs. Kramer*

Kramer vs. Kramer is a work of striking cinematic simplicity. In contrast to *Anatomy of a Murder* or *12 Angry Men,* there are no elaborate camera movements or complex compositions. Instead, the camera is typically at eye level, there are usually only one or two characters in a shot, and the camera is mainly stationary. In short, *Kramer vs. Kramer* utilizes the simplest of devices to convey the most complex of human emotions.

Consider the two scenes between Ted Kramer and his boss that take place early in the film. The first scene occurs immediately prior to Joanna's leaving. The second occurs the next day. In the first scene, Ted and his boss are in the same frame together for most of the scene. This is called a *two-shot.* Despite the difference in rank, Ted props his legs on his boss's desk, a gesture that suggests they regard one another as equals. In contrast, in the scene following Joanna's departure, Ted and his boss are framed separately. They never share the same frame. Visually, the framing isolates Ted from his boss. The sense of isolation is reinforced by the fact that Ted is sitting on the sofa on the opposite side of the room. Indeed, even when Ted tells his boss "I love you, you bastard," he says it from across the room; he makes no attempt to approach his boss. If their physical proximity in the previous scene suggested chumminess, their physical separation here suggests a new-found emotional distance. In fact, it is not even clear at the beginning of the scene who Ted is talking to. At first, we simply see Ted sitting on a sofa talking to the camera. Because he's sitting on a sofa and seems unable to maintain eye contact with his interlocutor, it appears that Ted is talking to a therapist. We soon learn that he is actually talking to his boss, but the sense of emotional distance and formality that is conveyed by the opening shot lingers throughout the scene.

It is unlikely that many viewers notice the subtle differences between the two scenes when they watch the film. Nevertheless, viewers are certainly aware of Ted's discomfort in the latter scene. Partly this is the result of the dialogue and Hoffman's performance, but it is also the product of the sensitive staging and framing of the two scenes.

14.10 Robert Benton

Benton, the writer and director of *Kramer vs. Kramer,* was born in Waxahachie, Texas. While working as a contributing editor at *Esquire,* he collaborated with David

Newman on the screenplay to *Bonnie and Clyde* (1967), one of the seminal films of the 1960s. Newman and Benton were nominated for an Oscar for their script, a remarkable achievement for first-time screenwriters.

Benton moved into directing in the early 1970s with the realist western *Bad Company* (1972). While *Bad Company* went largely unnoticed, Benton's next directorial effort, *The Late Show* (1977), was widely praised by critics. He received an Oscar nomination for his original screenplay. *Kramer vs. Kramer* was the third film Benton directed. He walked away with Oscars for his direction and his adaptation of Avery Corman's book.

Benton directed eight films after *Kramer vs. Kramer,* including *Places in the Heart* (1984), *Nobody's Fool* (1994), and *The Human Stain* (2003). *Places in the Heart* brought Benton an Oscar for his screenplay and an Oscar nomination for his direction. Benton's screenplay for *Nobody's Fool* earned him an Oscar nomination as well.

Kramer vs. Kramer is typical of Benton's work. In an era dominated by big-budget, special-effects-laden blockbusters, Benton makes intimate character-driven films. Most of his films have been quiet, understated dramas that deal with the prosaic problems faced by ordinary people. Even *Bad Company* (1972), Benton's only Western, depicts the old West in distinctly deglamorized, demythicized terms.

Critics consider Benton as an "actor-centered," rather than an "image-centered" director. The distinction was suggested by Robin Wood (2002) in a famous essay on the films of Alfred Hitchcock. In actor-centered films, the position and movement of the actor within the frame are dictated by the actors' gut instincts as to where they should stand, not by the director's vision of where the actor should be standing in order to create a particularly striking composition. In contrast, practitioners of image-centered cinema tend to use actors to execute a preconceived plan or idea. The actors' every move and position within the frame are carefully plotted out by the director in advance. Otto Preminger, director of *Anatomy of a Murder* (Chapter 2), is generally considered an image-centered director. Still, as the discussion in ¶14.09 of the scenes involving Ted Kramer and his boss suggest, even an actor-centered director like Benton often composes his scenes carefully to produce a particular effect.

14.11 Review questions

1. *Kramer* contained no action sequences or special effects, no violence, no significant sex scenes, and it was not based on a bestseller. However, it grossed over $100 million in the United States alone. What accounts for this success at the box office?

2. Some feminist critics have taken sharp issue with *Kramer* (see ¶14.02.2). Do you agree with their criticisms?

3. Some writers have said that Hollywood made many of its greatest movies (such as *Gone with the Wind, Casablanca, The Big Sleep, Citizen Kane,* or *It's a Wonderful Life*), while the Production Code was in effect (see ¶14.03). They suggest that filmmakers produced better films when they had to work around the Code's restrictions on the depiction of sex, crime, and violence. Do you agree? Some of them would like to re-introduce an updated version of the Code. Do you agree with this proposal?

4. Identify a signifier in *Kramer* (see ¶1.05.2) and provide your interpretation of this signifier.

5. The text states in ¶14.04 that *Kramer* tackles all eight of the relevant issues about the family law process. Select one of these eight issues. What position does the film take on that issue and is the film's treatment fair?

6. Some commentators (particularly pro-family conservatives) believe that we should bring back fault divorce in order to preserve marriages (¶14.05). Do you agree?

7. Today courts make child custody decisions under a vague "best interests of the child" standard (¶14.06.2). Would you favor changes in the way custody decisions are made?

8. Cavell (1981) believes that the final scene of the movie suggests that Ted and Joanna are going to get back together (which would place *Kramer* into Cavell's category of divorce-remarriage pictures). Do you agree with Cavell?

9. The text states that *Kramer* uses the simplest cinematic "devices to convey the most complex of human emotions." Discuss examples in the film (other than those mentioned in ¶14.09) of camera placement or movement designed to convey the characters' emotions.

Notes

1. Instructors who prefer not to teach Kramer might consider *Scenes from a Marriage* (1973), *An Unmarried Woman* (1978), *Manhattan* (1979), *Losing Isaiah* (1995), *War of the Roses* (1989), *I Am Sam* (2001), *Intolerable Cruelty* (2003), *Laws of Attraction* (2004), or *A Separation* (2011). For discussion of family law movies, see Papke, 2012a.

2. For 2009 census data, see http://www.census.gov/prod/2011pubs/acs-13.pdf. For example, in 2009 the divorce rate for women was 7.5 per thousand in the Northeast but 11.1 per thousand in the South.

3. As discussed in ¶1.04.1, pop culture often reflects popular attitudes. Thus *Kramer* can be usefully understood as a reflection of popular attitudes in 1979 about the roles of men and women. Writing about the film *Unforgiven* (1992), Rebecca Johnson stated: "Film is a powerful repository of maps of social life, of common-sense knowledge, and can give us insight into persistent contemporary struggles about the organization of gender in family and social life. With its ability to make its stories and characters hyper-visible, film participates in the process of both constructing and challenging the normal" (Johnson 2005, 187, internal quotation marks deleted).

4. See Farrell 1974; Goldberg 1976; Fasteau 1974; Friedman & Rosenman 1974.

5. For detailed studies of the adults and children involved in divorces, see Wallerstein & Blakeslee, 2004; Hetherington & Kelly 2002.

6. The Coen brothers film, *Intolerable Cruelty* (2003), concerns various family law disputes. The film is set in California in the present, but it inaccurately represents California as a fault jurisdiction. In several of the divorces discussed in the film, the issue is who committed adultery. In fact, such evidence is never permitted in California and divorce is granted on a showing of irreconcilable differences. Nor is fault considered in dividing property or setting support. Had the film been set in New York in 1960, it would have more representative of actual family law.

7. Strangely, British divorce law still turns on fault although it is no longer necessary to prove adultery. About half of all divorces are granted on a showing of "unreasonable behavior." However, what is "unreasonable" covers a lot of ground. One man declared that his wife maliciously and repeatedly served him his least favorite dish, tuna casserole, while a woman complained that her husband made her dress in a Klingon costume and speak to him in Klingon. Many lawyers and judges are urging Britain to adopt a no-fault system, but no change is imminent (Sarah Lyall, "Tuna Again? In Fault-Based Britain, It's a Cause for Divorce." *The New York Times*, p. A1, April 8, 2012.

8. The amount and duration of alimony awards appear to be declining as judges are more likely to expect the dependent spouse to get retrained and go back to work as soon as possible. The large and well-publicized awards often made to celebrity wives do not reflect the reality of alimony awards given to ordinary women (McMullen 2011) .

9. In 1973, the New York Court of Appeals held that the tender years rule illegally discriminated against fathers (*Watts v. Watts*, 1973).

References

Abbott, Walter F. 1999. *A Handbook of Jury Research*. Chicago: American Law Institute.

Abel, Richard L. 1989. *American Lawyers*. Oxford: Oxford University Press.

Abraham, Kenneth S. 1987. Individual Action and Collective Responsibility: The Dilemma of Mass Tort Reform. *Virginia Law Review. 73*: 845.

Abrams, Douglas E., et al. 2009. *Contemporary Family Law*. St. Paul: West.

Abramson, Jeffrey. 1994. *We, the Jury: The Jury System and the Ideal of Democracy*. New York: Basic Books.

_____. 2007. Anger at Angry Jurors. *Chicago-Kent Law Review. 82*: 591.

Adler, Stephen J. 1999. *The Jury*. New York: Times Books.

Alarcon, Arthur L. & Mitchell, Paula M. 2011. *Executing the Will of the Voters? A Roadmap to Mend or End the California Legislature's Multi-Billion-Dollar Death Penalty Debacle*. http://www.death-penaltyinfo.org/california-cost-study-2011

Allen, Michael. 2003. *Contemporary U.S. Cinema*. New York: Longman.

Althouse, Ann. 1999. Reconstructing Atticus Finch: A Response to Professor Lubet. *Michigan Law Review. 97*: 1363.

Amann, Diane Marie. 2005. Abu Ghraib. *University of Pennsylvania Law Review. 153*: 2085.

American Bar Association. 1992. *Legal Education and Professional Development—An Educational Continuum (MacCrate Report)*. Chicago: American Bar Association.

_____. 1999. *Perceptions of the U.S. Justice System*. Chicago: American Bar Association.

_____. 2003. *ABA Model Rules of Professional Responsibility*. http://www.americanbar.org/groups/professional_responsibility/publications/model of_professional_conduct/model_rules_of_pro-fessional_conduct_table_of_contents.html

American Bar Association and Law School Admissions Council. 2012. Official Guide to ABA-Approved Law Schools.

———. 2006. *Charting Our Progress: The Status of Women in the Profession Today.* http://www.americanbar.org/content/dam/aba/migrated/women/ChartingOurProgress.authcheckdam.pdf

American Law Institute. 2002. *Principles of the Law of Family Dissolution: Analysis & Recommendations.* Newark: Bender.

Amsterdam, Anthony G. & Bruner, Jerome. 2000. *Minding the Law.* Cambridge: Harvard University Press.

Anderson, Alison. 1986. Lawyering in the Classroom: An Address to First Year Students. *Nova Law Review. 10*: 271.

Asimow, Michael. 1996. When Lawyers Were Heroes. *University of San Francisco Law Review. 30*: 1131.

———. 1999. In Toxic Tort Litigation, Truth Lies at the Bottom of a Bottomless Pit. *Picturing Justice.* http://usf.usfca.edu/pj//articles/Civil_Action-Asimow.htm

———. 2000a. Bad Lawyers in the Movies. *Nova Law Review. 24*:531.

———.2000b. Divorce in the Movies: From the Hays Code to *Kramer vs. Kramer. Legal Studies Forum. 24*:221.

———. 2001. Embodiment of Evil: Law Firms in the Movies. *UCLA Law Review. 48*: 1339.

———. 2005. Popular Culture and the American Adversarial Ideology. In *Law and Popular Culture.* Michael Freeman, ed. Oxford: Oxford University Press.

———. 2007a. Popular Culture and the Adversary System. *Loyola of Los Angeles Law Review. 40*:653.

———. 2007b. 12 Angry Men: A Revisionist View. *Chicago-Kent Law Review. 82*: 711.

———, ed. 2009. *Lawyers in Your Living Room! Law on Television.* Chicago: American Bar Association.

———. 2012. When Harry Met Perry and Larry: Criminal Defense Lawyers on Television. *Berkeley Journal of Entertainment and Sports Law. 1*: 77. http://scholarship.law.berkeley.edu/bjesl/vol1/iss2/2

———. 2013. Narrative and Narration in Televised Legal Drama: *Ally McBeal* and *Damages.* In *Law & Narrative.* Ana Elena Fierro ed. Mexico City: CIDE.

Asimow, Michael et al. 2005. Perceptions of Lawyers—A Transnational Study of Student Views on the Image of Law and Lawyers. *International Journal of the Legal Profession. 12*: 407.

Asimow, Michael & Weisberg, Richard, 2009. When the Lawyer Knows the Client Is Guilty: Client Confessions in Legal Ethics, Popular Culture, and Literature. *Southern California Interdisciplinary Law Journal. 18*:229.

Atkinson, Rob. 1999. Liberating Lawyers: Divergent Parallels in *Intruder in the Dust* and *To Kill a Mockingbird. Duke Law Journal. 49*:601.

Babcock, Barbara Allen & Sassoubre, Ticien Marie. 2007. Deliberation in *12 Angry Men. Chicago-Kent Law Review. 82*: 633.

Bailin, Rebecca A. Oct. 1980. *Kramer vs. Kramer* vs. Mother-Right. *Jump Cut* 6:4.

Banks, Taunya Lovell. 2006. *To Kill a Mockingbird:* Lawyering in an Unjust Society. In *Screening Justice—the Cinema of Law.* Rennard Strickland et al., eds. Buffalo, NY: William S. Hein & Co.

Banner, Stuart. 2002. *The Death Penalty: An American History.* Cambridge: Harvard University Press.

Barrios, Richard. 2003. *Screened Out: Playing Gay in Hollywood from Edison to Stonewall.* New York: Routledge.

Bashi, Sari & Iskander, Maryana. 2006. Why Legal Education is Failing Women. *Yale Journal on Law & Feminism. 18:* 389.

Baty, S. Paige. 1995. *American Monroe: The Making of a Body Politic.* Berkeley: University of California Press.

Behan, Christopher W. 2003. Don't Tug on Superman's Cape: In Defense of Convening Authority Selection and Appointment of Court-Martial Panel Members. *Military Law Review. 176:* 190.

Bergman, Paul. 2001. The Movie Lawyers' Guide to Redemptive Legal Practice. *UCLA Law Review. 48:* 1393.

Bergman, Paul & Asimow, Michael. 2nd ed. 2006. *Reel Justice: The Courtroom Goes to the Movies.* Kansas City: Andrews & McMeel.

Bergman, Shirley J. The Real Trial. Nov./Dec. 2001. *Michigan History.*

Berman, Paul Schiff. 2001. Approaches to the Cultural Study of Law: Telling a Less Suspicious Story. *Yale Journal of Law & Humanities. 13:* 95.

Bernstein, Richard. 2000, Jan. 18. Playing Fast and Loose with Historical Facts. *The New York Times,* B1.

Binder, Guyora, & Weisberg, Robert. 1997. Cultural Criticism of Law. *Stanford Law Review. 49:* 1149.

Black, David A. 1999. *Law in Film: Resonance and Representation.* Urbana: University of Illinois Press.

Black, Gregory D. 1994. *Hollywood Censored: Morality Codes, Catholics, and Movies.* New York: Cambridge University Press.

_____. 1997. *The Catholic Crusade Against the Movies, 1940–1975.* New York: Cambridge University Press.

Blumenthal, Jeremy A. 1993. A Wipe of the Hands, a Lick of the Lips: The Validity of Demeanor Evidence in Assessing Witness Credibility. *Nebraska Law Review. 72:* 1157.

Bogdanovich, Peter. 1997. *Who the Devil Made It?: Conversations with Legendary Film Directors.* New York: Alfred A. Knopf.

Bogira, Steve. 2005. *Courtroom 302.* New York: Vintage.

Bogle, Donald. 2001a. *Primetime Blues: African Americans on Network Television.* New York: Farrar, Straus & Giroux.

_____. 2001b. *Toms, Coons, Mulattoes, Mammies and Bucks.* 4th ed. New York: Continuum.

Bordwell, David. 1985. *Narration in the Fiction Film.* Madison: University of Wisconsin Press.

Bordwell, David & Thompson, Kristin. 2010. *Film Art: An Introduction.* 9th ed. New York: McGraw-Hill.

Bordwell, David, Staiger, Janet, & Thompson, Kristin. 1985. *The Classical Hollywood Cinema: Film Style and Mode of Production to 1960.* New York: Columbia University Press.

Bounds, J. Dennis. 1996. *Perry Mason.* Westport: Greenwood Press.

Bourne, Stephen. 1996. *Brief Encounters: Lesbians and Gays in British Cinema 1930–1971.* New York: Cassell.

Brabec, Jeffrey & Brabec, Todd. 7th ed. 2011. *Music, Money, and Success.* New York: Schermer Trade Books.

Brinkerhoff, Corinne. 2009. *Reality Bites: Boston Legal's Creative License with the Law. In Lawyers in Your Living Room! Law on Television.* Michael Asimow, ed. Chicago: American Bar Association.

Brooks, Peter. 1976. *The Melodramatic Imagination: Balzac, Henry James, Melodrama, and the Mode of Excess.* New Haven: Yale University Press.

Burke, Alafair S. 2002. Rational Actors, Self-Defense, and Duress: Making Sense, Not Syndromes, Out of the Battered Woman. *North Carolina Law Review. 81*: 211.

Butler, Judith. 1999. *Gender Trouble: Feminism and the Subversion of Identity.* 10th anniv. ed. New York: Routledge.

Butler, Lisa. 1995. The Psychological Impact of Viewing the Film *JFK*: Emotions, Beliefs, and Political Behavior Intentions. *Political Psychology. 16*: 237.

Caplow, Stacy. 1999. Still in the Dark: Disappointing Images of Women Lawyers in the Movies. *Women's Rights Law Reporter. 20*: 55.

Carodine, Montré. 2011. Trust Is Something You've Gotta Earn, and It Takes Time. In *Imagining Legality: Where Law Meets Popular Culture.* Austin Sarat, ed. Tuscaloosa: University of Alabama Press.

Carrington, Paul. 2003. The Civil Jury and American Democracy. *Duke Journal of Comparative and International Law. 13*:79.

Carroll, Jenny E. 2012. The Jury's Second Coming. *Georgetown Law Journal 100*: 657.

Caudill, David S. 2008. Idealized Images of Science in Law: The Expert Witness in Trial Movies. *St. John's Law Review. 82*: 921.

Cavell, Stanley. 1981. *Pursuits of Happiness: The Hollywood Comedy of Remarriage.* Cambridge: Harvard University Press.

Chase, Anthony. 2002. *Movies on Trial.* New York: New Press.

Clark, Gerald J. 1993. The Lawyer as Hero? In *The Lawyer and Popular Culture: Proceedings of a Conference.* ed. David Gunn. Littleton, CO: F. B. Rothman.

Clover, Carol J. 1998. God Bless Juries! In *Refiguring American Film Genres.* ed. Nick Browne. Berkeley: University of California Press.

Cohen, Deborah L. June, 2012. Few Jobs, but a Rack of Suits. *American Bar Association Journal. 98*:18.

Cohen, Jonathan. 2009. Mediated Relationships and Media Effects: Parasocial Interaction and Identification. In *The Sage Handbook of Media Processes and Effects.* Robin L. Nabi & Mary Beth Oliver, eds. Thousand Oaks, CA: Sage.

Cole, Simon A. & Dioso-Villa, Rachel. 2009. Investigating the "*CSI* Effect" Effect: Media and Litigation Crisis in Criminal Law. *Stanford Law Review. 61*: 1335.

Corcos, Christine Alice. 2003. We Don't Want Advantages: The Woman Lawyer Hero and Her Quest for Power in Popular Culture. *Syracuse Law Review. 53*: 1225.

Corman, Avery. 1977. *Kramer vs. Kramer.* New York: Random House.

Covey, Russell D. 2009. Criminal Madness: Cultural Iconography and Insanity. *Stanford Law Review. 61*:1375.

Cripps, Thomas. 1993. *Making Movies Black.* Oxford: Oxford University Press.

Damaska, Mirjan. 1986. *The Faces of Justice and State Authority: A Comparative Approach to the Legal Process.* New Haven: Yale University Press.

Davis, Peggy Cooper, and Steinglass, Elizabeth Ehrenfest. 1997. A Dialogue about Socratic Teaching. *New York University Review of Law and Social Change. 23*: 249.

Death Penalty Information Center. http://www.deathpenaltyinfo.org.

Denvir, John. 1996. *Introduction. Legal Reelism: Movies as Legal Texts.* Urbana: University of Illinois Press.

_____. 2011. *Being Bogart: Professional Identity After Michael Clayton.* http://ssrn.com/abstract=1777210

_____. 2012. Guile Is Good: The Lawyer as Trickster. http://ssrn.com/abstract=2010074

Dezhbakhsh, Hashem, Rubin, Paul H. & Shepherd, Joanna M. 2003. Does Capital Punishment Have a Deterrent Effect? New Evidence from Postmoratorium Panel Data. *American Law & Economics Review.* 5: 344.

Dickens, Charles. 1853/2012. *Bleak House.* New York: Vintage Classics.

Dinovitzer, Ronit, & Garth, Bryant D. 2007. Lawyer Satisfaction in the Process of Structuring Legal Careers. *Law & Society Review.* 41: 1.

Dixon, Thomas. 1905. *The Clansman: A Historical Romance of the Ku Klux Klan.* Lexington: University of Kentucky Press.

Doherty, Thomas. 1999. *Pre-Code Hollywood.* New York: Columbia University Press.

Dolovich, Sharon. 1998. Making Docile Lawyers: An Essay on the Pacification of Law Students. *Harvard Law Review.* 111:2027.

Donohue, John J. & Wolfers, Justin. 2005. Uses and Abuses of Empirical Evidence in the Death Penalty Debate. *Stanford Law Review.* 58: 791.

_____. 2009. Estimating the Impact of the Death Penalty on Murder. *American Law and Economics Review.* 11: 251.

Doty, Alexander. 1993. *Making Things Perfectly Queer: Interpreting Mass Culture.* Minneapolis: University of Minnesota Press.

Dow, David R. 2000. Fictional Documentaries and Truthful Fictions: The Death Penalty in Recent American Film. *Constitutional Commentary.* 17: 511.

Dressler, Joshua. 5th ed. 2010. *Understanding Criminal Procedure.* New Providence, NJ: LexisNexis.

Dworkin, Ronald. 2011. *Justice for Hedgehogs.* Cambridge: Harvard University Press.

Dyer, Richard & Pidduck, Julianne. 2003. *Studies on Lesbian and Gay Film.* New York: Routledge.

Elkins, James R. 2004. Reading/Teaching Lawyer Films. *Vermont Law Review.* 28: 813.

_____. 2007. Popular Culture, Legal Films, and Legal Film Critics. *Loyola of Los Angeles Law Review.* 40: 745.

Engler, Russell. 2001. The MacCrate Report Turns 10: Assessing Its Impact and Identifying Gaps We Should Seek to Narrow. *Clinical Law Review.* 8: 109.

Fair, Bryan K. 1994. Using Parrots to Kill Mockingbirds: Yet Another Racial Prosecution and Wrongful Conviction. *Alabama Law Review.* 45: 403.

Farrell, Warren. 1974. *The Liberated Man.* New York: Random House.

Fasteau, Marc Feigen. 1974. *The Male Machine.* New York: Signet.

Feldman, Sam. 2001. *The Jewish Lawyer in Popular Culture: In Character and Appearance.* Available from asimow@law.ucla.edu.

Findley, Keith A. 2011. Adversarial Inquisitions: Rethinking the Search for Truth. *New York Law School Law Review.* 56: 911.

Fish, Stanley. 1980. *Is There a Text in This Class?* Cambridge: Harvard University Press.

Fisher, Roger & Uri, William. 2nd ed. 1991. *Getting to Yes.* New York: Penguin Books.

Fiske, John. 1987. *Television Culture.* London: Routledge.

_____. 1994. *Media Matters: Everyday Culture and Political Change.* Minneapolis: University of Minnesota Press.

_____. 1996. Admissible Postmodernity: Some Remarks on Rodney King, O. J. Simpson, and Contemporary Culture. *University of San Francisco Law Review.* 30: 917.

Frank, Jerome. 1963. *Courts on Trial.* New York: Atheneum.

Freedman, Monroe H. 1994. Atticus Finch—Right and Wrong. *Alabama Law Review.* 45: 404.

Friedland, Steven. 1996. How We Teach: A Survey of Teaching Techniques in American Law Schools. *Seattle University Law Review.* 20: 1.

Friedman, Lawrence M. 1989. Law, Lawyers & Popular Culture. *Yale Law Journal.* 98: 1579.

———. 2000. A Dead Language: Divorce Law and Practice Before No-Fault. *Virginia Law Review.* 86: 1497.

Friedman, Lester D. 1987. *The Jewish Image in American Film.* Secaucus, NJ: Citadel Press.

Friedman, Meyer, & Rosenman, Ray H. 1974. *Type A Behavior and Your Heart.* Greenwich, CT: Fawcett Publications.

Gabler, Neal. 1989. *An Empire of Their Own: How the Jews Invented Hollywood.* New York: Doubleday.

Galanter, Marc, & Palay, Thomas. 1991. *Tournament of Lawyers: The Transformation of the Big Law Firm.* Chicago: University of Chicago Press.

Garbicz, Adam, & Klinowski, Jacek. 1983. *Cinema, the Magic Vehicle: A Guide to Its Achievement.* Metuchen, NJ: Scarecrow Press.

Gerbner, George. 2002. Growing Up with Television: The Cultivation Perspective. In *Media Effects: Advances in Theory and Research.* 2nd ed. Jennings Bryant & Dolf Zillman eds. Hillsdale, NJ: Erlbaum.

Gershman, Bennett L. 2005. Contaminating the Verdict: The Problem of Juror Misconduct. *South Dakota Law Review.* 50: 322.

Gettleman, Susan, & Markowitz, Janet. 1974. *The Courage to Divorce.* New York: Simon & Schuster.

Gilles, Myriam. 2012. Public-Private Approaches to Mass Tort Victim Compensation: Some Thoughts on the Gulf Coast Claims Facility. *DePaul Law Review.* 61: 419.

Gilligan, Carol. 1993. *In a Different Voice: Psychological Theory and Women's Development.* Cambridge: Harvard University Press.

Ginsburg, David R. 2009. The Defenders: TV Lawyers and Controversy in the New Frontier. In *Lawyers in Your Living Room! Law on Television.* Michael Asimow, ed. Chicago: American Bar Association.

Gitlin, Todd. 2000. *Inside Prime Time.* Berkeley: University of California Press.

———. 2002. *Media Unlimited.* New York: Owl Books.

Gladwell, Malcolm. 2009, Aug. 10. The Courthouse Ring—Atticus Finch and the Limits of Southern Liberalism. *The New Yorker.*

Goldberg, Herb. 1976. *The Hazards of Being Male.* New York: Signet.

Goldstein, Joseph, Freud, Anna & Solnit, Albert J. 1979. *Beyond the Best Interests of the Child.* New York: Free Press.

Goodman, James. 1994. *Stories of Scottsboro.* New York: Vintage Books.

Graham, Louise Everett, & Maschio, Geraldine. 1995–96. A False Public Sentiment: Narrative and Visual Images of Women Lawyers in Films. *Kentucky Law Review.* 84: 1027.

Granfield, Robert. 1992. *Making Elite Lawyers.* New York: Routledge.

Greenfield, Steven. 2001. Hero or Villain? Cinematic Lawyers and the Delivery of Justice. *In Law and Film.* Stefan Machura & Peter Robson, eds. Oxford: Blackwell.

Greenfield, Steven, Osborn, Guy, & Robson, Peter. 2001. *Film and the Law.* London: Cavendish.

———. 2009. Judge John Deed: British TV Lawyers in the 21st Century. In *Lawyers in Your Living Room! Law on Television.* Michael Asimow, ed. Chicago: ABA Press.

Griffin, Leslie C. 2001. The Prudent Prosecutor. *Georgetown Journal of Legal Ethics. 14*: 259.

Grossberg, Lawrence, Wartella, Ellen & Whitney, D. Charles. 2nd ed. 2006. *Media Making: Mass Media in a Popular Culture.* Thousand Oaks, CA: Sage.

Guinier, Lani. 1997. *Becoming Gentlemen: Women, Law School, and Institutional Change.* Boston: Beacon Press.

Haddon, Phoebe A. 1994. Rethinking the Jury. *William & Mary Bill of Rights Journal. 3*: 29.

Haley, Alex. 1976. *Roots.* Doubleday.

Hallam, Julia, & Marshment, Margaret. 2000. *Realism and Popular Cinema.* Manchester: Manchester University Press.

Hans, Valerie P. 2007. Deliberation and Dissent: *12 Angry Men* Versus the Empirical Reality of Jurors. *Chicago-Kent Law Review. 82*: 579.

Harr, Jonathan. 1995. *A Civil Action.* New York: Vintage Books.

Harries, Keith D., & Cheatwood, Derral. 1997. *The Geography of Execution: The Capital Punishment Quagmire in America.* Lanham, MD: Rowman & Littlefield.

Harris, Thomas J. 1987. *Courtroom's Finest Hour in American Cinema.* Metuchen, NJ: Scarecrow Press.

Haskell, Molly. 2nd ed. 1987. *From Reverence to Rape: The Treatment of Women in the Movies.* Chicago: University of Chicago Press.

Heinz, John P., & Laumann, Edward O. 1982. *Chicago Lawyers: The Social Structure of the Bar.* Chicago: Northwestern University Press and American Bar Foundation.

Henderson, William D. & Zahorsky, Rachel M. Jan. 2012. The Law School Bubble: How Long Will It Last if Law Grads Can't Pay Bills? *American Bar Association Journal. 98*.

Herman, Jan. 1995. *A Talent for Trouble: The Life of Hollywood's Most Acclaimed Director, William Wyler.* New York: Putnam.

Hermann, Donald L. J. 2012. Character or Code: What Makes a Good and Ethical Lawyer. *South Carolina Law Review. 63*: 339.

Hess, Gerald F. 2002. Heads and Hearts: The Teaching and Learning Environment in Law School. *Journal of Legal Education. 52*: 75.

Hetherington, E. Mavis & Kelly, John. 2002. *For Better or for Worse: Divorce Reconsidered.* New York: Norton.

Hirsch, Foster. 2007. *Otto Preminger: The Man Who Would Be King.* New York: Alfred A. Knopf.

Hoff, Timothy, ed. 1994. Symposium: To Kill a Mockingbird. *Alabama Law Review. 45*: 389–584.

Holmes, Oliver Wendell. 1881. *The Common Law.* Boston: Little Brown & Co.

Holmquist, Kristin. 2012. Challenging Carnegie. *Journal of Legal Education. 61*: 353.

hooks, bell. 1996. *Reel to Real: Race, Sex, and Class at the Movies.* New York: Routledge.

Hornblass, Jerome. 1993. The Jewish Lawyer. *Cardozo Law Review. 14*: 1639.

Hudson, Matthew. 2007, March 1. Unnatural Selection. *Psychology Today.*

Hyland Jr., William G. 2008. Creative Malpractice: The Cinematic Lawyer. *Texas Review of Entertainment & Sports Law. 9*: 231.

Jarvis, Robert M., & Joseph, Paul R., eds. 1998. *Prime Time Law.* Durham: Carolina Academic Press.

Johnson, Claudia. 1994. Without Tradition and Within Reason: Judge Horton and Atticus Finch. *Alabama Law Review. 45*: 483.

———. 2012. Television, Pleasure and the Empire of Force: Interrogating Law and Affect in *Deadwood.* In *Law and Justice on the Small Screen.* Peter Robson & Jessica Silbey, eds. Oxford: Hart Publishing.

Johnson, Rebecca. 2005. Law and the Leaky Woman: The Saloon, the Liquor License, and Narratives of Containment. *Journal of Media and Cultural Studies.* 19: 181.

Jonakait, Randolph N. 2007. Law in the Plays of Elmer Rice. *Law and Literature. 19*: 401.

Joseph, Paul R. 2003. Saying Goodbye to Ally McBeal. *University of Arkansas at Little Rock Law Review. 25*: 459.

Kagan, Robert A. 2001. *Adversary Legalism: The American Way of Law.* Cambridge: Harvard University Press.

Kahn, Paul. 1999. *The Cultural Study of Law: Reconstructing Legal Scholarship.* Chicago: University of Chicago Press.

Kalven, Harry. 1964. The Dignity of the Civil Jury. *Virginia Law Review. 50*: 1055.

Kalven, Harry, & Zeisel, Hans. 1966. *The American Jury.* Chicago: University of Chicago Press.

Kaufman, Joanne. 2011, Nov. 10. Judges with Temperaments. *The Wall Street Journal,* D4.

Kaye, Judith S. 2007. Why Every Chief Judge Should See *12 Angry Men. Chicago-Kent Law Review. 82*: 627.

Keates, William R. 1997. *Proceed with Caution.* Chicago: Harcourt Brace.

Keetley, Dawn. 1998. *Law & Order.* In *Prime Time Law: Fictional Television as Legal Narrative.* Robert M. Jarvis & Paul R. Joseph, eds. Durham: Carolina Academic Press.

Kellerman, Henry. 2009. *Greedy, Cowardly, and Weak: Hollywood's Jewish Stereotypes.* Fort Lee, NJ: Barricade Books.

Kelley, David E. 2012. Creating Law Franchises on Television. *Berkeley Journal of Entertainment and Sports Law. 1*: 99. http://scholarship.law.berkeley.edu/cgi/viewcontent.cgi?article=1009&context=bjesl

Kellner, Douglas. 1995. *Media Culture.* New York: Routledge.

Kerr, Orin S. 1999. The Decline of the Socratic Method at Harvard. *Nebraska Law Review. 78*: 113.

Kershen, Drew. 1997. *Breaker Morant. Oklahoma City University Law Review. 22*: 107.

Klarman, Michael J. 2009. Scottsboro. *Marquette Law Review. 93*: 379.

Klinger, Barbara. 1994. *Melodrama and Meaning: History, Culture, and the Films of Douglas Sirk.* Bloomington: Indiana University Press.

Korzec, Rebecca. 2007. *North Country*: Sexual Harassment Goes to the Movies. *University of Baltimore Law Review. 36*: 303.

Krantzler, Mel. 1973. *Creative Divorce: A New Opportunity for Personal Growth.* New York: M. Evans.

Kronman, Anthony. 1993. *The Lost Lawyer.* Cambridge: Belknap Press.

Krutch, Joseph Wood. July 1955. The Case for Courtroom Drama. *Theater Arts. 39*: 69.

Kuzina, Matthias. 2005. Military Justice in American Film and Television Drama: Starting Points for Ideological Criticism. In *Law and Popular Culture.* Michael Freeman, ed. Oxford: Oxford University Press.

LaFave, Wayne. 2010. *Criminal Law.* 5th ed. St. Paul: West.

Landsman, Stephan. 1984. *The Adversary System: A Description and Defense.* Washington, DC: American Enterprise Institute for Public Policy Research.

_____. 2007. Mad About *12 Angry Men. Chicago-Kent Law Review. 82*: 749.

Lane, Maureen E. 1999. Twelve Carefully Selected Not So Angry Men: Are Jury Consultants Destroying the American Legal System? *Suffolk Law Review. 32*: 463.

Langbein, John H. 1985. The German Advantage in Civil Procedure. *University of Chicago Law Review. 52*: 823.

Langer, Maximo. 2004. From Legal Transplants to Legal Translations: The Globalization of Plea Bargaining and the Americanization Thesis in Criminal Procedure. *Harvard International Law Journal. 45*: 1.

LeBel, Paul A. 2002. Misdirecting Myths: The Legal and Cultural Significance of Distorted History in Popular Media. *Wake Forest Law Review. 37*: 1035.

Lee, Harper. 1999. *To Kill a Mockingbird.* 40th anniv. ed. New York: HarperCollins.

Leff, Leonard J., & Simmons, Jerold L. 1990. *The Dame in the Kimono: Hollywood, Censorship, and the Production Code Administration from the 1920s to the 1960s.* New York: Anchor Books.

Lenz, Timothy. 2003. *Changing Images of Law in Film and Television Crime Stories.* New York: Peter Lang.

Lesser, Wendy. 1993. *Pictures at an Execution.* Cambridge: Harvard University Press.

Levinson, Sanford. 1993. Identifying the Jewish Lawyer: Reflections on the Construction of Professional Identity. *Cardozo Law Review. 14*: 1577.

Levit, Nancy. 2010. One L Revisited. *University of Missouri Kansas City Law Review. 78*: 1015–126.

Levy, Leonard W. 1999. *Origins of the Bill of Rights.* New Haven: Yale University Press.

Liebman, James S., et al. 2000a. *A Broken System: Error Rates in Capital Cases 1973–1995.* http://www2.law.columbia.edu/instructionalservices/liebman/liebman_final.pdf

_____. 2000b. Capital Attrition: Error Rates in Capital Cases 1973–1995. *Texas Law Review. 78*: 1839.

_____. 2000c. The Overproduction of Death. *Columbia Law Review. 100*: 2030.

Lipsitz, George. 1998. Genre Anxiety and Racial Representation in 1970s Cinema. In *Refiguring American Film Genres.* Nick Browne, ed. Berkeley: University of California Press.

Littleton, Christine A. 1987. Reconstructing Sexual Equality. *California Law Review. 75*: 1279.

LoBrutto, Vincent. 1999. *Principal Photography: Interviews with Feature Film Cinematographers.* Westport: Praeger.

Los Angeles County Bar Association Committee on Sexual Orientation Bias. 1995. Report. *Southern California Review of Law & Women's Studies. 4*: 295.

Lubet, Steven. 1999. Reconstructing Atticus Finch. *Michigan Law Review. 97*: 1339.

Lucia, Cynthia. 2005. *Framing Female Lawyers.* Austin: University of Texas Press.

Lyon, Jason. 2010. Revolution in Progress: Third-Party Funding of American Litigation. *UCLA Law Review. 58*: 571.

Machura Stefan, & Ulbrich, Stefan. 2001. Law in Film: Globalizing the Hollywood Courtroom Drama. In *Law and Film.* Stefan Machura & Peter Robson, eds. Oxford: Blackwell.

Mader, Shannon. 2009. *Law & Order.* In *Lawyers in Your Living Room! Law on Television.* Michael Asimow, ed. Chicago: ABA Publishing.

Malloy, Eileen. 1981, Dec. *Kramer vs. Kramer: A Fraudulent View. Jump Cut. 7*, 5–7.

Manderson, Desmond. 2011. Trust Us Justice: *24*, Popular Culture, and the Law. In *Imagining Legality: Where Law Meets Popular Culture.* Austin Sarat, ed. Tuscaloosa: University of Alabama Press.

Manual for Courts-Martial, United States. 2008.

Marder, Nancy S. 1999. The Myth of the Nullifying Jury. *Northwestern University Law Review. 93*: 877.

_____. 2002. Juries, Justice & Multiculturalism. *Southern California Law Review. 75*: 659.

_____. 2006. Why 12 Angry Men? (1957): The Transformative Power of Jury Deliberations. In *Screening Justice—The Cinema of Law.* Rennard Stricklin et al., eds. Buffalo: Hein.

_____, ed. 2007. Symposium: The 50th Anniversary of *12 Angry Men*. *Chicago-Kent Law Review.* *82*: 551 to 899.

_____. 2009. Judging Judge Judy. In *Lawyers in your Living Room! Law on Television.* In *Lawyers in your Living Room! Law on Television.* Michael Asimow, ed., Chicago: ABA Publications.

_____, ed. 2011. Symposium on Comparative Jury Systems. *Chicago-Kent Law Review.* *86*: 449–853.

_____. 2012. *Batson* Revisited. *Iowa Law Review. 97*: 1585.

Marquart, Jaime, & Byrnes, Robert Ebert. 2001. *Brush with the Law.* Los Angeles: Renaissance Books.

Martyn, Susan R. 1981. Lawyer Competence and Lawyer Discipline: Beyond the Bar? *Georgetown Law Journal. 69*: 705.

McDonough, Molly. Oct. 2006. Rogue Jurors. *American Bar Association Journal. 92*: 39.

McMullen, Judith G. 2011. Alimony: What Social Science and Popular Culture Tell Us About Women, Guilt, and Spousal Support After Divorce. *Duke Journal of Gender Law & Policy. 19*: 41.

Menkel-Meadow, Carrie. 1985. Portia in a Different Voice: Speculations on a Women's Lawyering Process. *Berkeley Women's Law Journal. 1*: 39.

———. 1988. Feminist Legal Theory, Critical Legal Studies, and Legal Education. *Journal of Legal Education. 38*: 61.

Merritt, Greg. 2000. *Celluloid Mavericks: A History of American Independent Film.* New York: Thunder's Mouth Press.

Meyer, Philip N. 2009. Revisiting *L.A. Law.* In *Lawyers in Your Living Room! Law on Television.* Michael Asimow, ed. Chicago: American Bar Association.

Mezey, Naomi & Niles, Mark C. 2005. Screening the Law: Ideology and Law in American Popular Culture. *Columbia Journal of Law & the Arts. 28*: 91.

Milgram, Stanley. 1974. *Obedience to Authority: An Experimental View.* New York: Harper & Row.

Miller, Carolyn Lisa. 1994. What a Waste. Beautiful, Sexy Gal. Hell of a Lawyer: Film and the Female Attorney. *Columbia Journal of Gender & Law. 4*: 203.

Miller, William Ian. 1998. The Shortcomings of Law in Popular Culture. In *Law and the Domains of Culture.* Austin Sarat & Thomas R. Kearns, eds. Ann Arbor: University of Michigan Press.

Minow, Martha. 2007. Living Up to Rules: Holding Soldiers Responsible for Abusive Conduct and the Dilemma of the Superior Orders Defense. *McGill Law Journal. 52*: 1.

Mittell, Jason. 2010. *Television and American Culture.* New York: Oxford University Press.

Mitchell, Margaret. 1936. *Gone with the Wind.* New York: Macmillan.

Mnookin, Jennifer L., & West, Nancy. 2001. Theaters of Proof: Visual Evidence and the Law in *Call Northside 777. Yale Journal of Law & the Humanities. 13*: 329.

Model Penal Code. 1985. Chicago: American Law Institute.

Morgan, Michael. 2009. Cultivation Analysis and Media Effects. In *The Sage Handbook of Media Processes and Effects.* Robin L. Nabi & Mary Beth Oliver, eds. Los Angeles: Sage.

Morley, David. 1992. *Television, Audiences, and Cultural Studies.* London: Routledge.

Moyer, Daniel & Alvarez, Eugene. 2001. *Just The Facts, Ma'am: The Authorized Biography of Jack Webb.* Cabin John, MD: Seven Locks Press.

Mulvey, Laura. 1975. Visual Pleasure and Narrative Cinema. *Screen. 16.3*: 6.

_____. 2005. When Celluloid Lawyers Started to Speak: The First Golden Age of Juriscinema. In *Law and Popular Culture.* Michael Freeman, ed. Oxford: Oxford University Press.

Nevins, Francis M. 2001. Tony Richardson's The Penalty Phase: Judging the Judge. *UCLA Law Review* 48:1557.

———. 2005. When Celluloid Lawyers Started to Speak: The First Golden Age of Juriscinema. In *Law and Popular Culture*. Ed. Michael Freeman. Oxford: Oxford Univ. Press.

———. 2009. Perry Mason. In *Lawyers in Your Living Room! Law on Television*. Michael Asimow, ed. Chicago: American Bar Association.

Nichol, Gene R. 2012. Rankings, Economic Challenge, and the Future of Legal Education. *Journal of Legal Education*. 61: 345.

Nichols, Bill. 1991. *Representing Reality: Issues and Concepts in Documentary*. Bloomington: Indiana University Press.

Nussbaum, Emily. 2012, March 5. Net Gain. *The New Yorker*.

O'Brien, Thomas. 1981. Love and Death in the American Movie. *Journal of Popular Film and Television*. 9: 91.

Oliver, Mary Beth. 2009. Entertainment. In *The Sage Handbook of Media Processes and Effects*. Robin L. Nabi & Mary Beth Oliver, eds. Thousand Oaks, CA: Sage.

Organ, Jerry. 2011. What Do We Know About the Satisfaction/Dissatisfaction of Lawyers? A Meta-Analysis of Research on Lawyer Satisfaction and Well Being. *St. Thomas Law Journal*. 8: 225.

Osborn, John J. 1971. *The Paper Chase*. Boston: Houghton Mifflin.

——— 1996. Atticus Finch—The End of Honor: A Discussion of *To Kill a Mockingbird*. *University of San Francisco Law Review*. 30: 1139.

Owens, John M. 2000. The Clerk, the Thief, His Life as a Baker: Ashton Embry and the Supreme Court Leak Scandal of 1919. *Northwestern University Law Review*. 95: 271.

Papke, David Ray. 1996a. Myth and Meaning. In *Legal Reelism: Movies as Legal Texts*. John Denvir, ed. Urbana: University of Illinois Press.

———. 1996b. Peace Between the Sexes: Law and Gender in *Kramer vs. Kramer*. *University of San Francisco Law Review*. 30: 1199.

———. 1998. The Defenders. In *Prime Time Law*. Robert M. Jarvis & Paul R. Joseph, eds. Durham: Carolina Academic Press.

———. 2001. Law, Cinema, and Ideology: Hollywood Legal Films of the 1950's. *UCLA Law Review*. 48: 1473.

———. 2007a. From Flat to Round: Changing Portrayals of the Judge in Popular Culture. *Journal of the Legal Profession*. 31: 127.

———. 2007b. *12 Angry Men* Is Not an Archetype: Reflections on the Jury in Contemporary Popular Culture. *Chicago-Kent Law Review*. 82: 735.

———. 2012a. Skepticism Bordering on Distrust: Family Law in the Hollywood Cinema. *Family Court Review*. 50: 13.

———. 2012b. Muted Message: Capital Punishment in the Hollywood Cinema. http://ssrn/com/abstract=2179186

Parker, Richard. 2006. The Good Lawyer: The Verdict (1982). In *Screening Justice—The Cinema of Law*. Rennard Stricklin et al., ed. Buffalo: William S. Hein & Co.

Pearce, Russell G. 1993. Jewish Lawyering in a Multicultural Society. *Cardozo Law Review*. 14: 1613.

Perkins, V. F. 1972. *Film as Film: Understanding and Judging Movies*. Baltimore: Penguin.

Pfau, Michael. 1995. Television Viewing and Public Perceptions of Attorneys. *Human Communication Research*. 21: 307.

Phelps, Teresa Godwin. 2002. Atticus, Thomas, and the Meaning of Justice. *Notre Dame Law Review.* 77: 925.

Player, Mack A. 1999. *Federal Law of Employment Discrimination.* St. Paul, MN: West Group.

Podlas, Kimberlianne. 2001. Please Adjust Your Signal: How Television's Syndicated Courtrooms Bias Our Juror Citizenry. *American Business Law Journal.* 39: 1.

_____. 2008. Guilty on All Accounts: *Law & Order*'s Impact on Public Perception of Law and Order. *Seton Hall Journal of Sports and Entertainment Law.* 18: 1.

Prejean, Helen. 1994. *Dead Man Walking.* New York: Vintage Books.

Preminger, Otto. 1977. *Preminger: An Autobiography.* Garden City, NY: Doubleday.

Rabin, Robert L. 1993. Some Thoughts on the Efficacy of a Mass Toxics Administrative Compensation Scheme. *Maryland Law Review.* 52: 951.

Rafter, Nicole. 2001. American Criminal Trial Films: An Overview of Their Development, 1930–2000. In *Law and Film.* Stefan Machura & Peter Robson, eds. Oxford: Blackwell.

Ramachandran, Banu. 1998. Note, Re-Reading Difference: Feminist Critiques of the Law School Classroom and the Problem with Speaking from Experience. *Columbia Law Review.* 98: 1757.

Rapping, Elayne. 2009. The History of Law on Television. In *Lawyers in Your Living Room! Law on Television.* Michael Asimow, ed. Chicago: ABA Publications.

Rawls, John. 1971. *A Theory of Justice.* Cambridge: Harvard University Press.

Rebello, Stephen. 1990. *Alfred Hitchcock and the Making of* Psycho. New York: Dembner Books.

Reed, Barry. 1980. *The Verdict.* New York: Simon & Schuster.

Reichman, Amnon. 2008. The Production of Law (and Cinema): Preliminary Comments on an Emerging Discourse. *Southern California Interdisciplinary Law Journal.* 17: 457.

Resnik, Judith. 1982. Managerial Judges. *Harvard Law Review 96*: 374.

Resnik, Judith & Curtis, Dennis. 1987. Images of Justice. *Yale Law Journal 96*: 1727.

_____. June, 2007. Representing Justice: From Renaissance Iconography to Twenty-First Century Courthouses. *Proceedings of the American Philosophical Society.* 151:139.

Rhode, Deborah L. 2001/2004. *Access to Justice.* New York: Oxford University Press.

Robbennolt, Jennifer K. 2005. Evaluating Juries by Comparison to Judges: A Benchmark for Judging? *Florida State University Law Review.* 32: 469.

Robson, Peter. 2007. Lawyers and the Legal System on TV: The British Experience. *International Journal of Law in Context.* 2: 333.

Robson, Peter & Silbey, Jessica, eds. 2012. *Law and Justice on the Small Screen.* Oxford: Hart Publishing.

Rogin, Michael. 1998. "Democracy and Burnt Cork": The End of Blackface, the Beginning of Civil Rights. In *Refiguring American Film Genres.* Nick Browne, ed. Berkeley: University of California Press.

Rosato, Jennifer. 1997. The Socratic Method and Women Law Students: Humanize, Don't Feminize. *Southern California Review of Law and Women's Studies.* 7: 37.

Rosen, Jeffrey. 1997, Feb. 24 and March 3. One Angry Woman. *The New Yorker.*

Rosenberg, Norman L. 1991. *Young Mr. Lincoln*: The Lawyer as Super-Hero. *Legal Studies Forum.* 15: 215.

_____. 1998. *Perry Mason.* In *Prime Time Law.* Robert M. Jarvis & Paul R. Joseph, eds. Durham: Carolina Academic Press.

_____. 2002. Constitutional History After the Cultural Turn: The Legal-Reelist Texts of Henry

Fonda. In *Constitutionalism and American Culture: Writing the New Constitutional History*. Sandra VanBurkleo, ed. Lawrence: University Press of Kansas.

Rosenstone, Robert A. 1995. *Visions of the Past: The Challenge of Film to Our Idea of History*. Cambridge: Harvard University Press.

Rothstein, Mark A. 1999. *Employment Law*. 2nd ed. St. Paul, MN: West.

Rubenstein, William. 1998. Queer Studies II: Some Reflections on the Study of Sexual Orientation Bias in the Legal Profession. *UCLA Women's Law Journal*. 8: 379.

Rubin, Alan M. 2009. Uses-and-Gratification: An Evolving Perspective of Media Effects. In *The Sage Handbook of Media Processes and Effects*. Robin L. Nabi & Mary Beth Oliver, eds. Thousand Oaks, CA: Sage.

Russo, Vito. 1987. *The Celluloid Closet: Homosexuality in the Movies*. New York: Harper & Row.

Ryan, Michael & Kellner, Douglas. 1988. *Camera Politica: The Politics and Ideology of Contemporary Hollywood*. Bloomington: Indiana University Press.

Salzmann, Victoria. 2011. The Film Law Abiding Citizen: How Popular Culture Is Poisoning People's Perceptions of Pleas. *Southwestern Law Review 41*: 119.

Samberg, Joel. 2000. *Reel Jewish*. Middle Village, NY: Jonathan David.

Sarat, Austin. 1999. The Cultural Life of Capital Punishment: Responsibility and Representation in *Dead Man Walking* and *Last Dance*. *Yale Journal of Law & Humanities. 11*: 153.

Sarat, Austin & Simon, Jonathan. 2001. Beyond Legal Realism? Cultural Analysis, Cultural Studies, and the Situation of Legal Scholarship. *Yale Journal of Law & the Humanities. 13*: 3.

Sarat, Austin, Douglas, Lawrence & Umphrey, Martha Merrill. 2005. *Law on the Screen*. Palo Alto: Stanford University Press.

Sayles, John. 1995. *Past Imperfect: History According to Movies*. Ed. Mark C. Carnes. New York: Henry Holt.

Schepard, Andrew. 2003. *Kids, Courts and Custody: Models for the Twenty-First Century*. Cambridge: Cambridge University Press.

——. 2007. *Kramer vs. Kramer* Revisited: A Comment on the Miller Commission Report and the Obligation of Divorce Lawyers for Parents to Discuss Alternative Dispute Resolution with Their Clients. *Pace Law Review. 27*: 677.

Schiff, Ellen, ed. 1995. *Awake & Sing: 7 Classic Plays from the American Jewish Repertoire*. New York: Mentor Books.

Schiltz, Patrick J. 1999. On Being a Happy, Healthy, and Ethical Member of an Unhappy, Unhealthy, and Unethical Profession. *Vanderbilt Law Review 52*: 871.

Schlichtmann, Jan. 2000. Law and the Environment: Reflections on Woburn. *Seton Hall Legislative Journal. 24*: 268.

Schulz, Jennifer L. 2008. Law & Film: Where Are the Mediators? *University of Toronto Law Journal. 58*: 233.

Shaffer, Thomas L. 1981. The Moral Theology of Atticus Finch. *University of Pittsburgh Law Review. 42*: 181.

Shale, Suzanne. 1996. The Conflicts of Law and the Character of Men: Writing *Reversal of Fortune* and *Judgment at Nuremberg*. *University of San Francisco Law Review. 30*: 991.

Shanahan, James & Morgan, Michael. 1999. *Television and Its Viewers: Cultivation Theory and Research. New York:* Cambridge University Press.

Shapiro, Carole. 1994. Women Lawyers in Celluloid: Why Hollywood Skirts the Truth. *University of Toledo Law Review. 25*: 955.

_____. 1996. Do or Die: Does *Dead Man Walking* Run? *University of San Francisco Law Review.* *30*: 1143.

_____. 1998. Women Lawyers in Celluloid, Rewrapped. *Vermont Law Review.* *23*: 303.

Sharp, Cassandra. 2009. *Ally McBeal*—Life and Love in the Law. In *Lawyers in Your Living Room! Law on Television.* Michael Asimow, ed. Chicago: American Bar Association.

Shaul, Richard D. Nov./Dec. 2001. Backwoods Barrister. *Michigan History,* 85.

Sheehy, Gail. 1978. *Passages: Predictable Crises of Adult Life.* New York: Dutton.

Shelton, Donald E., Kim, Young S. & Barak, Gregg. 2009. Indirect Effects Model of Mediated Adjudication: The CSI Myth, the Tech Effect, and Metropolitan Jurors' Expectations for Scientific Evidence. *Vanderbilt Journal of Entertainment & Sports Law.* *12*: 1.

Sherwin, Richard K. 2000. *When Law Goes Pop.* Chicago: University of Chicago Press.

_____. 2011. Law's Screen Life: Criminal Predators and What to Do About Them. In *Imagining Legality: Where Law Meets Popular Culture.* Austin Sarat, ed. Tuscaloosa: University of Alabama Press.

_____. 2012. Visual Jurisprudence. http://papers.ssrn.com/sol3/papers.cfm?abstract_id=2135801

Shrum, L. J. 1996. Psychological Processes Underlying Cultivation Effects. *Human Communication Research.* *22*: 496.

Silbey, Jessica. 2001. Patterns of Courtroom Justice. *Journal of Law & Society.* *28*: 97.

_____. 2007. Truth Tales and Trial Films. *Loyola of Los Angeles Law Review.* *40*: 551.

Simon, William H. 2000. Moral Pluck: Legal Ethics in Popular Culture. *Columbia Law Review.* *100*: 421.

Singer, Ben. 2001. *Melodrama and Modernity: Early Sensational Cinema and Its Contexts.* New York: Columbia University Press.

Sklansky, David. Alan. 2012. Evidentiary Instructions and the Jury as Other. *Stanford Law Review.* *65.*

Smith, Justin T. 2009. JAG: Maintaining the Front Lines of Justice. *In Lawyers in Your Living Room! Law on Television.* Michael Asimow, ed. Chicago: ABA Publications.

Snead, James A. 1994. *White Screens/Black Images.* New York: Blackwell.

Staiger, Janet. 1992. *Interpreting Films.* Princeton: Princeton University Press.

_____. 2002. *Perverse Spectators.* New York: New York University Press.

Stam, Robert. 2000. *Film Theory: An Introduction.* Oxford: Blackwell.

Stark, Steven D. 1987. Perry Mason Meets Sonny Crockett: The History of Lawyers and the Police as Television Heroes. *University of Miami Law Review.* *42*: 229.

Steiker, Carol A. 2002. Capital Punishment and American Exceptionalism. *Oregon Law Review.* *81*: 97.

Steiner, Ronald L., Bauer, Rebecca & Talwar, Ronit. 2011. The Rise and Fall of the *Miranda* Warning in Popular Culture. *Cleveland State Law Review.* *59*: 219.

Steinitz, Maya. 2012. The Litigation Finance Contract. *William & Mary Law Review.* *54.*

Stowe, Harriet Beecher. 1995. *Uncle Tom's Cabin.* New York: Knopf.

Strier, Franklin. 1996. *Reconstructing Justice: An Agenda for Trial Reform.* Chicago: University of Chicago Press.

Sullivan, William M. et al. 2007. *Educating Lawyers: Preparation for the Practice of Law* (Carnegie Commission Report). San Francisco: Jossey-Bass.

Sundquist, Eric. 1995. Blues for Atticus Finch: Scottsboro, *Brown,* and Harper Lee. In *The South as an American Problem.* Larry Griffin & Don Doyle, eds. Athens: University of Georgia Press.

Tamanaha, Brian Z. 2012. *Failing Law Schools.* Chicago: University of Chicago Press.

Tartakovsky, Joseph. 2012, Feb. 5. Dickens v. Lawyers. *The New York Times,* A-23.

Thomas, Jeffrey. 2009. The Practice: Debunking Television Myths and Stereotypes. In *Lawyers in Your Living Room! Law on Television.* Michael Asimow, ed. Chicago: ABA Publications.

Thompson, Kristin. 1988. *Breaking the Glass Armor: Neoformalist Film Analysis.* Princeton: Princeton University Press.

———. 1999. *Storytelling in the New Hollywood: Understanding Classical Narrative Technique.* Cambridge: Harvard University Press.

Toobin, Jeffrey. May 7, 2007. The CSI Effect. *The New Yorker.*

Traver, Robert [John Voelker]. 1983. *Anatomy of a Murder.* 25th anniv. ed. New York: St. Martin's Press.

Turley, Jonathan. 2002. Tribunals and Tribulations: The Antithetical Elements of Military Governance in a Madisonian Democracy. *George Washington Law Review. 70*: 649.

Turow, Scott. 1988. *One L.* New York: Warner Books.

———. 2003. *Ultimate Punishment.* New York: Farrar, Straus & Giroux.

Tyler, Tom R. 2006. Viewing *CSI* and the Threshold of Guilt: Managing Truth and Justice in Reality and Fiction. *Yale Law Journal. 115*: 1050.

Uniform Code of Military Justice. http://www.military-network.com/main_ucmj/main_ucmj.htm

Vidmar, Neil et al. 1998. The Performance of the American Civil Jury: An Empirical Perspective. *Arizona Law Review. 40*: 849.

———. 2003. The American Civil Jury for Auslander (Foreigners). *Duke Journal of Comparative and International Law. 13*: 95.

Vidmar, Neil, Beale, Sara Sun, Chemerinsky, Erwin & Coleman, James E. 2007. Was He Guilty as Charged? An Alternative Narrative Based on the Circumstantial Evidence from *12 Angry Men. Chicago-Kent Law Review. 82*: 691.

Vieira, Mark A. 1999. *Sin in Soft Focus: Pre-Code Hollywood.* New York: Harry N. Abrams.

Villez, Barbara. 2009. French Television Lawyers in *Avocats et Associes.* In *Lawyers in Your Living Room! Law on Television.* Michael Asimow, ed. . Chicago: ABA Publications.

Vitiello, Michael. 2005. Professor Kingsfield: The Most Misunderstood Character in Literature. *Hofstra Law Review. 33*: 955.

Waldman, Diane. 2005. A Case for Corrective Criticism: *A Civil Action.* In *Law on the Screen,* Austin Sarat et al., eds. Stanford, CA: Stanford University Press.

Wallerstein, Judith S. & Blakeslee, Sandra. 2004. *Second Chances.* Boston: Houghton Mifflin.

Walsh, Frank. 1996. *Sin and Censorship: The Catholic Church and the Motion Picture Industry.* New Haven: Yale University Press.

Weisberg, Richard H. 2000. "The Verdict" Is in: The Civic Implications of Civil Trials. *De Paul Law Review. 50*: 525.

Wellborn, Otis Guy, III. 1991. Demeanor. *Cornell Law Review. 76*: 1075.

Wightman, Linda. 1996. *Women in Legal Education: A Comparison of the Law School Performance and Law School Experiences of Women and Men.* Newtown, PA: Law School Admissions Council.

Wilkins, David & Gulati, Mitu. 1996. Why Are There So Few Black Lawyers in Corporate Law Firms? An Institutional Analysis. *California Law Review. 84*: 496.

Williams, Linda. 1998. Melodrama Revised. In *Refiguring American Film Genres.* Nick Browne, ed. Berkeley: University of California Press.

_____ 2001. *Playing the Race Card: Melodramas of Black and White from Uncle Tom to O. J. Simpson.* Princeton: Princeton University Press.

Wood, Robin. 2002. *Hitchcock's Films Revisited.* New York: Columbia University Press.

Wydick, Richard C. 1995. The Ethics of Witness Coaching. *Cardozo Law Review. 17*: 1.

Yale Law Women. 2012. *Yale Law School Faculty and Students Speak Up About Gender: Ten Years Later.* http://www.law.yale.edu/stuorgs/speakup.htm

Yanovitzsky, Itzhak & Greene, Kathryn. 2009. Quantitative Methods and Causal Inference in Media Effect Research. In *The Sage Handbook of Media Processes and Effects.* Robin L. Nabi & Mary Beth Oliver, eds. Los Angeles: Sage.

Yeazell, Stephen C. 1990. The New Jury and the Ancient Jury Conflict. Univ. of Chicago Legal Forum 1990:87.

_____. 2012. *Civil Procedure.* New York: Aspen.

Yunker, James A. 2001. A New Statistical Analysis of Capital Punishment Incorporating U.S. Postmoratorium Data. *Social Science Quarterly, 82*: 297.

Zacharias, Fred C. 2001. The Professional Discipline of Prosecutors. *North Carolina Law Review, 79*: 721.

Stage plays

Counsellor at Law. 1931. Au. Elmer Rice.

On Trial. 1914. Au. Elmer Rice.

The Scottsboro Boys. 2010. Au. John Kander & Fred Ebb.

Street Scene. 1931. Au. Elmer Rice.

Movies

Absence of Malice. 1981. Dir. Sydney Pollack. Perf. Paul Newman, Sally Field. Columbia Pictures.

Accused, The. 1988. Dir. Jonathan Kaplan. Perf. Kelly McGillis, Jodie Foster. Paramount Pictures.

Adam's Rib. 1949. Dir. George Cukor. Perf. Spencer Tracy, Katharine Hepburn. MGM.

Adventures of Priscilla, Queen of the Desert, The. 1994. Dir. Stephan Elliott. Perf. Guy Pearce, Terence Stamp. Polygram.

Advise and Consent. 1962. Dir. Otto Preminger. Perf. Henry Fonda, Don Murray, Charles Laughton, Walter Pidgeon. Columbia Pictures.

Alien. 1979. Dir. Ridley Scott. Perf. Tom Skerritt, Sigourney Weaver. Twentieth Century-Fox.

American Violet. 2008. Dir. Tim Disney. Perf. Nicole Beharie, Will Patton, Alfre Woodard. Uncommon Productions.

Amistad. 1997. Dir. Steven Spielberg. Perf. Morgan Freeman, Anthony Hopkins, Matthew McConaughey, Djimon Hounsou, Nigel Hawthorne. DreamWorks.

Anatomy of a Murder. 1959. Dir. Otto Preminger. Perf. James Stewart, George C. Scott, Lee Remick, Ben Gazzara. Columbia Pictures.

. . . And Justice for All. 1979. Dir. Norman Jewison. Perf. Al Pacino. Columbia Pictures.

Angels with Dirty Faces. 1938. Dir. Michael Curtiz. Perf. James Cagney, Pat O'Brien. Warner Brothers.

Attorney for the Defense. 1932. Dir. Irving Cummings. Perf. Edmund Lowe, Evelyn Brent. Columbia Pictures.

Avatar. 2009. Dir. James Cameron. Perf. Sam Worthington, Zoe Saldana, Sigourney Weaver. Twentieth Century Fox.

Awful Truth, The. 1937. Dir. Leo McCarey. Perf. Irene Dunn, Cary Grant. Columbia Pictures.

Baby Doll. 1956. Dir. Elia Kazan. Perf. Carroll Baker, Karl Malden, Eli Wallach. Warner Brothers.

Bad Company. 1972. Dir. Robert Benton. Perf. Jeff Bridges, Barry Brown. Paramount Pictures.

Basic Instinct. 1992. Dir. Paul Verhoeven. Perf. Michael Douglas, Sharon Stone. TriStar Pictures.

Battleship Potemkin, The. 1925. Dir. Sergei Eisenstein. Goskino.

A Beautiful Mind. 2001. Dir. Ron Howard. Perf. Russell Crowe, Jennifer Connelly. Universal Pictures.

Ben-Hur. 1959. Dir. William Wyler. Perf. Charlton Heston. MGM.

Berlin: Symphony of a Metropolis. 1927. Dir. Walter Ruttman. Perf. Paul von Hindenberg. Fox.

Best Man, The. 1964. Dir. Franklin Schaffner. Perf. Henry Fonda, Cliff Robertson. United Artists.

Best Years of Our Lives, The. 1946. Dir. William Wyler. Perf. Frederic March, Dana Andews, Harold Russell, Myrna Loy, Teresa Wright, Virginia Mayo. RKO.

Big Easy, The. 1987. Dir. Jim McBride. Perf. Dennis Quaid, Ellen Barkin. Columbia Pictures.

Big Sleep, The. 1946. Dir. Howard Hawks. Perf. Humphrey Bogart, Lauren Bacall. Warner Brothers.

Birdcage, The. 1996. Dir. Mike Nichols. Perf. Robin Williams, Gene Hackman, Nathan Lane. United Artists.

Birth of a Nation. 1915. Dir. D. W. Griffith. Perf. Lillian Gish. Mutual Film Corporation.

Blind Side, The. 2009. Dir. John Lee Hancock. Perf. Sandra Bullock, Quinton Aaron, Tim McGraw. Alcon Entertainment.

Body Heat. 1981. Dir. Lawrence Kasdan. Perf. William Hurt, Kathleen Turner. Warner Brothers.

Boys in the Band, The. 1970. Dir. William Friedkin. Perf. Kenneth Nelson, Peter White, Leonard Frey, Cliff Gorman. National General Pictures.

Breaker Morant. 1980. Dir. Bruce Beresford. Perf. Edward Woodward, Jack Thompson, John Waters. Australian Film Commission.

Brilliant Lies. 1996. Dir. Richard Franklin. Perf. Gia Carideas, Zoe Carides, Anthony LaPaglia. Bayside Pictures.

Brokeback Mountain. 2005. Dir. Ang Lee. Perf. Heath Ledger, Jake Gyllenhaal. Focus Features.

Cabaret. 1972. Dir. Bob Fosse. Perf. Liza Minnelli, Michael York, Joel Grey. Allied Artists.

Cabinet of Dr. Caligari, The. 1920. Dir. Robert Wiene. Per. Werner Krauss, Conrad Veidt. Decla-Bioscop AG.

Caine Mutiny, The. 1954. Dir. Edward Dmytryk. Perf. Humphrey Bogart, Jose Ferrer, Fred MacMurray, Van Johnson. Columbia Pictures.

Carlito's Way. 1993. Dir. Brian De Palma. Perf. Al Pacino, Sean Penn. Universal Pictures.

Casablanca. 1942. Dir. Michael Curtiz. Perf. Humphrey Bogart, Ingrid Bergman, Paul Henreid, Claude Rains. Warner Brothers.

Cat on a Hot Tin Roof. 1958. Dir. Richard Brooks. Perf. Paul Newman, Elizabeth Taylor, Burl Ives. MGM.

Celluloid Closet, The. 1995. Dir. Rob Epstein, Jeffrey Friedman. Sony Pictures Classics.

Chamber, The. 1996. Dir. James Foley. Perf. Chris O'Donnell, Gene Hackman. Universal Pictures.

Changing Lanes. 2002. Dir. Roger Michell. Perf. Ben Affleck, Samuel L. Jackson. Paramount Pictures.

Children's Hour, The. 1961. Dir. William Wyler. Perf. Audrey Hepburn, Shirley MacLaine, James Garner. United Artists.

China Syndrome, The. 1979. Dir. James Bridges. Perf. Jack Lemmon, Jane Fonda. IPC Films.

Citizen Kane. 1941. Dir. Orson Welles. Perf. Orson Welles, Joseph Cotton. RKO.

Civil Action, A. 1998. Dir. Steve Zaillian. Perf. John Travolta, Robert Duvall. Buena Vista Pictures.

Class Action. 1991. Dir. Michael Apted. Perf. Gene Hackman, Mary Elizabeth Mastrantonio. Twentieth Century-Fox.

Client, The. 1994. Dir. Joel Schumacher. Perf. Susan Sarandon, Tommy Lee Jones. Warner Brothers.

Compulsion. 1959. Dir. Richard Fleischer. Perf. Orson Welles, Dean Stockwell, Bradford Dillman. Twentieth Century-Fox.

Constant Gardener, The. 2005. Dir. Fernando Meireilles. Perf. Ralph Fiennes, Rachel Weisz. Focus Features.

Conviction. 2010. Dir. Tony Goldwyn. Perf. Hillary Swank, Sam Rockwell, Melissa Leo. Omega Entertainment.

Cool Hand Luke. 1967. Dir. Stuart Rosenberg. Perf. Paul Newman. Warner Brothers.

Counsellor at Law. 1933. Dir. William Wyler. Perf. John Barrymore. Universal Pictures.

Court Martial of Billy Mitchell, The. 1955. Dir. Otto Preminger. Perf. Gary Cooper. Warner Brothers.

Cradle Will Rock. 1999. Dir. Tim Robbins. Perf. Hank Azaria, Ruben Blades, Joan Cusack, John Cusack, Cary Elwes. Buena Vista Pictures.

Cruising. 1980. Dir. William Friedkin. Perf. Al Pacino. United Artists.

Daisy Kenyon. 1947. Dir. Otto Preminger. Perf. Joan Crawford, Dana Andrews. Twentieth Century-Fox.

Daniel. 1983. Dir. Sidney Lumet. Perf. Timothy Hutton, Mandy Patinkin, Lindsay Crouse, Edward Asner. Paramount Pictures.

Dead End. 1937. Dir. William Wyler. Perf. Sylvia Sidney, Joel McCrea, Humphrey Bogart. United Artists.

Dead Man Walking. 1996. Dir. Tim Robbins. Perf. Susan Sarandon, Sean Penn. Gramercy Pictures.

Defenseless. 1991. Dir. Martin Campbell. Perf. Barbara Hershey, Sam Sheppard. New Line Cinema.

Devil's Advocate. 1997. Dir. Taylor Hackford. Perf. Al Pacino, Keanu Reeves. Warner Brothers.

Dirty Harry. 1971. Dir. Don Siegel. Perf. Clint Eastwood. Warner Brothers.

Disclosure. 1994. Dir. Barry Levinson. Perf. Michael Douglas, Demi Moore. Warner Bros.

Divorcee, The. 1930. Dir. Robert Z. Leonard. Perf. Norma Shearer, Chester Morris. MGM.

Dodsworth. 1936. Dir. William Wyler. Perf. Walter Huston, Ruth Chatterton, Mary Astor. MGM.

Dog Day Afternoon. 1975. Dir. Sidney Lumet. Perf. Al Pacino, John Cazale. Warner Brothers.

Doom Generation, The. 1995. Dir. Gregg Araki. Perf. Rose McGowan, James Duval. Trimark Pictures.

Dracula. 1931. Dir. Tod Browning. Perf. Bela Lugosi. Universal Pictures.

Dragnet. 1987. Dir. Tom Mankiewicz. Perf. Dan Aykroyd, Tom Hanks, Christopher Plummer. Universal.

Easy Virtue. 1928. Dir. Alfred Hitchcock. Perf. Isabel Jens. World Wide Distributors.

Employees' Entrance. 1933. Dir. Roy del Ruth. Perf. Warren William, Loretta Young. Warner Brothers.

Erin Brockovich. 2000. Dir. Steven Soderbergh. Perf. Julia Roberts, Albert Finney. Universal Pictures.

Evelyn. 2002. Dir. Bruce Beresford. Perf. Pierce Brosnan, Sophie Vavasseur. MGM.

Even Cowgirls Get the Blues. 1993. Dir. Gus Van Sant. Perf. Uma Thurman, Lorraine Bracco. Fine Line Features.

Far from Heaven. 2002. Dir. Todd Haynes. Perf. Julianne Moore, Dennis Quaid, Dennis Haysbert. Focus Features.

Fear Strikes Out. 1956. Dir. Robert Mulligan. Perf. Anthony Hopkins, Karl Malden. Paramount Pictures.

Few Good Men, A. 1992. Dir. Rob Reiner. Perf. Tom Cruise, Jack Nicholson, Demi Moore. Columbia Pictures.

Find Me Guilty. 2006. Dir. Sidney Lumet. Perf. Vin Diesel, Ron Silver. Yari Productions.

Firm, The. 1993. Dir. Sydney Pollack. Perf. Tom Cruise, Gene Hackman. Paramount Pictures.

Fox, The. 1968. Dir. Mark Rydell. Perf. Sandy Dennis, Keir Dullea. Claridge Pictures.

Freebie and the Bean. 1974. Dir. Richard Rush. Perf. James Caan, Alan Arkin. Warner Brothers.

From the Hip. 1987. Dir. Bob Clark. Perf. Judd Nelson, Elizabeth Perkins, John Hurt. DeLaurentiis Productions.

Fury. 1937. Dir. Fritz Lang. Perf. Spencer Tracy, Sylvia Sidney. MGM.

Gentleman's Agreement. 1947. Dir. Elia Kazan. Perf. Gregory Peck, Dorothy McGuire, John Garfield, Celeste Holme. Twentieth Century-Fox.

Ghosts of Mississippi. 1996. Dir. Rob Reiner. Perf. Alec Baldwin, Whoopi Goldberg, James Woods. Columbia Pictures.

Gladiator. 2000. Dir. Ridley Scott. Perf. Russell Crowe, Joaquin Phoenix. DreamWorks.

Go Fish. 1994. Dir. Rose Troche. Perf. V. S. Brodie, Guinevere Turner. Samuel Goldwyn Company.

Godfather, The. 1972. Dir. Francis Ford Coppola. Perf. Al Pacino, Marlon Brando, James Caan, Robert Duvall. Paramount Pictures.

Gone with the Wind. 1939. Dir. Victor Fleming. Perf. Clark Gable, Vivien Leigh, Leslie Howard, Olivia de Havilland. MGM.

Good Mother, The. 1988. Dir. Leonard Nimoy. Perf. Diane Keaton, Liam Neeson, Jason Robards. Buena Vista Pictures.

Graduate, The. 1967. Dir. Mike Nichols. Perf. Dustin Hoffman, Anne Bancroft, Katharine Ross. Embassy Pictures Corporation.

Grapes of Wrath, The. 1939. Dir. John Ford. Perf. Henry Fonda. Twentieth Century-Fox.

Green Mile, The. 1999. Dir. Frank Darabont. Perf. Tom Hanks, Michael Clarke Duncan, David Morse, Bonnie Hunt. Warner Brothers.

Guess Who's Coming to Dinner. 1967. Dir. Stanley Kramer. Perf. Spencer Tracy, Katharine Hepburn, Sidney Poitier. Columbia Pictures.

Guilty as Sin. 1993. Dir. Sidney Lumet. Perf. Rebecca De Mornay, Don Johnson. Buena Vista Pictures.

Help, The. 2011. Dir. Tate Taylor. Perf. Emma Stone, Viola Davis, Octavia Spencer. DreamWorks.

High Crimes. 2002. Dir. Carl Franklin. Perf. Jim Caviezel, Ashley Judd, Morgan Freeman. Twentieth Century Fox.

Hitchcock. 2012. Dir. Sacha Gervasi. Perf. Anthony Hopkins, Helen Mirren. Fox Searchlight Pictures.

Hud. 1963. Dir. Martin Ritt. Perf. Paul Newman, Patricia Neal, Melvyn Douglas, Brandon de Wilde. Paramount Pictures.

Human Stain, The. 2003. Dir. Robert Benton. Perf. Anthony Hopkins, Nicole Kidman, Ed Harris, Gary Sinise. Miramax Films.

Hurricane, The. 1999. Dir. Norman Jewison. Perf. Denzel Washington, Vicellous Reon Shannon. Universal Pictures.

I Am Sam. 2001. Dir. Jessie Nelson. Perf. Sean Penn, Michelle Pfeiffer. New Line Cinema.

I Want to Live! 1958. Dir. Robert Wise. Perf. Susan Hayward, Virginia Vincent. United Artists.

Imitation of Life. 1934. Dir. John Stahl. Perf. Claudette Colbert, Warren William, Louise Beavers, Fredi Washington. Universal Pictures.

Imitation of Life. 1959. Dir. Douglas Sirk. Perf. Lana Turner, John Gavin, Sandra Dee, Juanita Moore, Susan Kohner. Universal Pictures.

In the Name of the Father. 1993. Dir. Jim Sheridan. Perf. Daniel Day-Lewis, Pete Postlethwaite. Universal Pictures.

Incredibly True Adventures of Two Girls in Love, The. 1995. Dir. Maria Maggenti. Perf. Laurel Holloman, Nicole Parker. Fine Line Features.

Inherit the Wind. 1960. Dir. Stanley Kramer. Perf. Spencer Tracy, Frederic March, Gene Kelly. United Artists.

Insider, The. 1999. Dir. Michael Mann. Perf. Al Pacino, Russell Crowe, Christopher Plummer. Buena Vista Pictures.

Into the Abyss. 2011. Dir. Werner Herzog. Perf. Werner Herzog, Richard Lopez. IFC Films.

Intolerable Cruelty. 2003. Dir. Joel and Ethan Coen. Perf. George Clooney, Catherine Zeta-Jones, Geoffrey Rush. Universal Pictures.

Intruder in the Dust. 1949. Dir. Clarence Brown. Perf. David Brian, Juano Hernandez. MGM.

It's a Wonderful Life. 1946. Dir. Frank Capra. Perf. James Stewart. Donna Reed, Lionel Barrymore. RKO.

Jagged Edge. 1985. Dir. Richard Marquand. Perf. Jeff Bridges, Glenn Close. Columbia Pictures.

Jaws. 1975. Dir. Steven Spielberg. Perf. Roy Scheider, Richard Dreyfus. Universal.

JFK. 1991. Dir. Oliver Stone. Perf. Kevin Costner, Kevin Bacon, Tommy Lee Jones, Sissy Spacek. Warner Brothers

Judge Priest. 1934. Dir. John Ford. Perf. Will Rogers. Fox Film Corporation.

Judgment at Nuremberg. 1961. Dir. Stanley Kramer. Perf. Spencer Tracy, Burt Lancaster, Richard Widmark, Maximilian Schell, Marlene Dietrich, Judy Garland, Montgomery Clift. United Artists.

Juror, The. 1996. Dir. Brian Gibson. Perf. Demi Moore, Alec Baldwin. Columbia Pictures.

Jury Duty. 1995. Dir. John Fortenberry. Perf. Pauly Shore. TriStar Pictures.

Just Cause. 1995. Dir. Arne Glimcher. Perf. Sean Connery, Laurence Fishburne, Ed Harris. Warner Brothers.

Kids Are All Right, The. 2010. Dir. Lisa Cholodenko. Perf. Annette Bening, Julianne Moore, Mark Ruffalo. Focus Features.

Killing of Sister George, The. 1968. Dir. Robert Aldrich. Perf. Beryl Reid, Susannah York. Cinerama.

Kramer vs. Kramer. 1979. Dir. Robert Benton. Perf. Dustin Hoffman, Meryl Streep. Columbia Pictures.

Last Dance. 1996. Dir. Bruce Beresford. Perf. Sharon Stone, Rob Morrow, Randy Quaid. Buena Vista Pictures.

Laws of Attraction. (2004). Dir. Peter Howitt. Perf. Pierce Brosnan, Julianne Moore. New Line Cinema.

Lawyer Man. 1932. Dir. William Dieterle. Perf. William Powell, Joan Blondell. Warner Brothers.

Legal Eagles. 1986. Dir. Ivan Reitman. Perf. Robert Redford, Debra Winger, Daryl Hannah. Universal Pictures.

Legally Blonde. 2001. Dir. Robert Luketic. Perf. Reese Witherspoon, Luke Wilson. MGM.

Legally Blonde 2: Red, White & Blonde. 2003. Dir. Charles Herman-Wurmfeld. Perf. Reese Witherspoon, Sally Field. MGM.

Let Him Have It. 1991. Dir. Peter Medak. Perf. Tom Courtenay, Christopher Eccleston. First Independent Films.

Letter, The. 1940. Dir. William Wyler. Perf. Bette Davis, Herbert Marshall. Warner Brothers.

Liar Liar. 1997. Dir. Tom Shadyac. Perf. Jim Carrey. Universal Pictures.

Life and Times of Judge Roy Bean, The. 1972. Dir. John Huston. Perf. Paul Newman. National General Pictures.

Life of David Gale, The. 2003. Dir. Alan Parker. Perf. Kevin Spacey, Kate Winslet, Laura Linney. Universal Pictures.

Lilies of the Field. 1963. Dir. Ralph Nelson. Perf. Sidney Poitier, Lilia Skala. United Artists.

Little Foxes, The. 1941. Dir. William Wyler. Perf. Bette Davis, Herbert Marshall, Teresa Wright. RKO.

Lincoln. 2012. Dir. Steven Spielberg. Perf. Daniel Day-Lewis, Sally Field. DreamWorks.

Lincoln Lawyer, The. 2011. Dir. Brad Furman. Perf. Matthew McConaughey, Marisa Tomei, Ryan Phillippe. Lionsgate.

Living End, The. 1992. Dir. Gregg Araki. Perf. Mike Dytri, Craig Gilmore. Strand Releasing. IT.

Longtime Companion. 1990. Dir. Norman Rene. Perf. Stephen Caffrey, Patrick Cassidy, Brian Cousins, Bruce Davison, Campbell Scott. Samuel Goldwyn Company.

Looking for Mr. Goodbar. 1977. Dir. Richard Brooks. Perf. Diane Keaton, Richard Gere. Paramount Pictures.

Losing Isaiah. 1995. Dir. Stephen Gyllenhaal. Perf. Jessica Lange, Halle Berry. Paramount Pictures.

Love and Death on Long Island. 1997. Dir. Richard Kwietniowski. Perf. John Hurt, Jason Priestley. Lions Gate Films.

Making Love. 1982. Dir. Arthur Hiller. Perf. Michael Ontkean, Kate Jackson, Harry Hamlin. Twentieth Century-Fox.

Man for All Seasons, A. 1966. Dir. Fred Zinnemann. Perf. Paul Scofield, Wendy Hiller, Leo McKern, Robert Shaw, Orson Welles. Columbia Pictures.

Man with the Golden Arm, The. 1955. Dir. Otto Preminger. Perf. Frank Sinatra, Eleanor Parker, Kim Novak. United Artists.

Man with a Movie Camera. 1929. Dir. Dziga Vertov. Perf. Mikhail Kaufman. VUFKU.

Manhattan. 1979. Dir. Woody Allen. Perf. Woody Allen, Diane Keaton, Michael Murphy, Mariel Hemingway, Meryl Streep. United Artists.

Marked Woman. 1937. Dir. Lloyd Bacon. Perf. Bette Davis, Humphrey Bogart. Warner Brothers.

Matrix, The. 1999. Dir. Andy Wachowski, Lena Wachowski. Perf. Keanu Reeves, Laurence Fishburne, Carrie-Anne Moss. Warner Brothers.

Maurice. 1987. Dir. James Ivory. Perf. James Wilby, Rupert Graves, Hugh Grant. Merchant Ivory Productions.

Michael Clayton. 2007. Dir. Tony Gilroy. Perf. George Clooney, Tilda Swinton, Tom Wilkinson. Castle Rock.

Milk. 2008. Dir. Gus Van Sant. Perf. Sean Penn, Josh Brolin. Focus Features.

Monster's Ball. 2001. Dir. Marc Forster. Perf. Billy Bob Thornton, Halle Berry, Peter Boyle. Lions Gate Films.

Moon Is Blue, The. 1953. Dir. Otto Preminger. Perf. William Holden, David Niven. United Artists.

Moulin Rouge. 2001. Dir. Baz Luhrman. Perf. Nicole Kidman, Ewan McGregor, John Leguizamo. Twentieth Century-Fox.

Mouthpiece, The. 1932. Dr. Elliott Nugent, James Flood. Perf. Warren William. Warner Brothers.

Music Box. 1989. Dir. Costa Gavras. Perf. Jessica Lange, Armin-Mueller-Stahl, Frederic Forrest. TriStar Pictures.

My Own Private Idaho. 1991. Dir. Gus Van Sant. Perf. River Phoenix, Keanu Reeves. Fine Line Features.

Natural Born Killers. 1994. Dir. Oliver Stone. Perf. Woody Harrelson, Juliette Lewis, Robert Downey, Jr., Tommy Lee Jones. Warner Brothers.

Night Falls on Manhattan. 1997. Dir. Sidney Lumet. Per. Andy Garcia, Richard Dreyfus, Lena Olin, Ian Holm. Paramount Pictures.

Nixon. 1995. Dir. Oliver Stone. Perf. Anthony Hopkins, Joan Allen. Buena Vista Pictures.

Nobody's Fool. 1994. Dir. Robert Benton. Paul Newman, Jessica Tandy, Bruce Willis, Melanie Griffith. Paramount Pictures.

Norma Rae. 1979. Dir. Martin Ritt. Perf. Sally Field, Beau Bridges, Ron Leibman. Twentieth Century Fox.

North Country. 2005. Dir. Niki Caro. Perf. Charlize Theron, Jeremy Renner, Frances McDormand. Warner Brothers.

October. 1928. Dir. Sergei Eisenstein. Sovkino.

Oleanna. 1994. Dir. David Mamet. Perf. William H. Macy, Debra Eisenstadt. Samuel Goldwyn.

On Trial. 1928. Dir. Archie Mayo. Perf. Pauline Frederick, Bert Lytell, Lois Wilson. Warner Brothers.

On Trial. 1939. Dir. Terry Morse. Perf. Margaret Lindsay, John Litel. Warner Brothers.

One More River. 1934. Dir. James Whale. Perf. Diana Wynyard, Colin Clive, Frank Lawton. Universal Pictures.

Ordinary People. 1980. Dir. Robert Redford. Perf. Donald Sutherland, Mary Tyler Moore, Judd Hirsch, Timothy Hutton. Paramount Pictures.

Ox-Bow Incident, The. 1943. Dir. William Wellman. Perf. Henry Fonda, Dana Andrews. Twentieth Century-Fox.

Paper Chase, The. 1973. Dir. James Bridges. Perf. Timothy Bottoms, Lindsay Wagner, John Houseman. Twentieth Century-Fox.

Paths of Glory. 1957. Dir. Stanley Kubrick. Perf. Kirk Douglas, Adolphe Menjou, Ralph Meeker. Bryna Productions.

Pelican Brief, The. 1993. Dir. Alan Pakula. Perf. Julia Roberts, Denzel Washington. Warner Brothers.

Penny Serenade. 1941. Dir. George Stevens. Perf. Irene Dunn, Cary Grant. Columbia Pictures.

People v. Larry Flynt, The. 1996. Milos Forman. Perf. Woody Harrelson, Courtney Love, Edward Norton. Columbia Pictures.

Personal Best. 1982. Dir. Robert Towne. Perf. Mariel Hemingway, Scott Glenn, Patrice Donnelly. Warner Brothers.

Philadelphia. 1993. Dir. Jonathan Demme. Perf. Tom Hanks, Denzel Washington, Jason Robards, Antonio Banderas. TriStar Pictures.

Philadelphia Story, The. 1940. Dir. George Cukor. Perf. Katharine Hepburn, Cary Grant, James Stewart. MGM.

Physical Evidence. 1989. Dir. Michael Crichton. Perf. Burt Reynolds, Theresa Russell. Columbia Pictures.

Pinky. 1949. Dir. Elia Kazan. Perf. Jeanne Craig, Ethel Barrymore, Ethel Waters. Twentieth Century-Fox.

Place in the Sun, A. 1951. Dir. George Stevens. Perf. Montgomery Clift, Elizabeth Taylor, Shelley Winters. Paramount Pictures.

Places in the Heart. 1984. Dir. Robert Benton. Perf. Sally Field, Lindsay Crouse, Ed Harris, John Malkovich, Danny Glover. TriStar Pictures.

Poison. 1991. Dir. Todd Haynes. Perf. Edith Meeks, Larry Maxwell, Chris Singh, Millie White. Zeitgeist Films.

Postman Always Rings Twice, The. 1946. Dir. Tay Garnett. Perf. Lana Turner, John Garfield. MGM.

Presumed Innocent. 1990. Dir. Alan Pakula. Perf. Harrison Ford, Brian Dennehy, Raul Julia, Bonnie Bedelia, Greta Scacchi. Warner Brothers.

Prick Up Your Ears. 1987. Dir. Stephen Frears. Perf. Gary Oldman, Alfred Molina, Vanessa Redgrave. Samuel Goldwyn Company.

Primal Fear. 1996. Dir. Gregory Hoblit. Per. Richard Gere, Laura Linney, Edward Norton. Paramount Pictures.

Prince of the City. 1981. Dir. Sidney Lumet. Perf. Treat Williams, Jerry Orbach, Bob Balaban, James Tolkan. Orion Pictures Corporation.

Psycho. 1960. Dir. Alfred Hitchcock. Perf. Anthony Perkins, Janet Leigh, Vera Miles. Paramount Pictures.

Pulp Fiction. 1994. Dir. Quentin Tarantino. Perf. John Travolta, Samuel L. Jackson, Uma Thurman, Harvey Keitel, Ving Rhames, Tim Roth. Miramax Films.

Q&A. 1990. Dir. Sidney Lumet. Perf. Nick Nolte, Timothy Hutton, Armand Assante. TriStar Pictures.

The Rainmaker. 1997. Dir. Francis Ford Coppola. Perf. Matt Damon, Danny DeVito, Claire Danes, Jon Voight. Paramount Pictures.

Rashomon. 1950. Dir. Akira Kurosawa. Perf. Toshiro Mifune, Machiko Kyo, Masayuki Mori. Daiei Motion Pictures.

Regarding Henry. 1991. Dir. Mike Nichols. Perf. Harrison Ford, Annette Bening. Paramount Pictures.

Rent. 2005. Dir. Chris Columbus. Perf. Taye Diggs, Rosario Dawson, Jesse L. Martin. Sony.

Reversal of Fortune. 1990. Dir. Barbet Schroeder. Perf. Glenn Close, Jeremy Irons, Ron Silver. Warner Brothers.

Rules of Engagement. 2000. Dir. William Friedkin. Perf. Tommy Lee Jones, Samuel L. Jackson, Guy Pearce. Paramount Pictures.

Runaway Jury. 2003. Dir. Gary Fleder. John Cusack, Gene Hackman, Dustin Hoffman. Twentieth Century-Fox.

Saving Private Ryan. 1998. Dir. Steven Spielberg. Perf. Tom Hanks, Edward Burns, Tom Sizemore, Jeremy Davies, Vin Diesel, Adam Goldberg, Barry Pepper, Giovanni Ribisi, Matt Damon. Paramount Pictures.

Scenes from a Marriage. 1973. Dir. Ingmar Bergman. Perf. Liv Ullmann, Erland Josephson, Bibi Andersson. Cinema 5 Distributing.

Schindler's List. 1993. Dir. Steven Spielberg. Perf. Liam Neeson, Ben Kingsley, Ralph Fiennes. Universal Pictures.

Separation, A. 2011. Dir. Asghar Farhadi. Perf. Payman Maadi, Leila Hatami, Sareh Bayat. Sony Pictures Classics.

Serpico. 1973. Dir. Sidney Lumet. Perf. Al Pacino, John Randolph. Artists Entertainment Complex.

Silkwood. 1983. Dir. Mike Nichols. Perf. Meryl Streep, Cher, Kurt Russell. ABC Entertainment.

Single Man, A. 2009. Dir. Tom Ford. Perf. Colin Firth, Julianne Moore. Weinstein Co.

Socratic Method, The. 2001. Dir. George Hunlock. Perf. David Ries, John Renfree. Pothole Productions.

Soldier's Story, A. 1984. Dir. Norman Jewison. Perf. Howard E. Rollins, Jr., Adolph Caesar, Dennis Lipscomb, Art Evans, Denzel Washington, Robert Townsend, Larry Riley. Columbia Pictures.

Soul Man. 1986. Dir. Steve Miner. Perf. C. Thomas Howell, Arye Gross, Rae Dawn Cong, James Earl Jones. New World Pictures.

Staircase. 1969. Dir. Stanley Donen. Perf. Richard Burton, Rex Harrison. Twentieth Century-Fox.

Star Chamber, The. 1983. Dir. Peter Hyams. Perf. Michael Douglas, Hal Holbrook, Yaphet Kotto. Twentieth Century-Fox.

Star Trek: The Motion Picture. 1979. Dir. Robert Wise. Perf. William Shatner, Leonard Nimoy. Paramount Pictures.

State's Attorney. 1932. Dir. George Archainbaud. Perf. John Barrymore, Helen Twelvetrees. RKO.

Sting, The. 1973. Dir. George Roy Hill. Perf. Robert Redford, Paul Newman. Universal.

Stoning of Soraya M, The 2008. Dir. Cyrus Nowrasteh. Perf. Shohreh Aghdashloo, Jim Caviezel, Mozhan Marno. Roadside Attractions.

Street Scene. 1931. Dir. King Vidor. Perf. Sylvia Sidney. United Artists.

Streetcar Named Desire, A. 1951. Dir. Elia Kazan. Perf. Vivien Leigh, Marlon Brando, Kim Hunter, Karl Malden. Warner Brothers.

Strike. 1925. Dir. Sergei Eisenstein. Goskino.

Suddenly, Last Summer. 1959. Dir. Joseph Mankiewicz. Perf. Elizabeth Taylor, Katharine Hepburn, Montgomery Clift. Columbia Pictures.

Sunday, Bloody Sunday. 1971. Dir. John Schlesinger. Perf. Glenda Jackson, Peter Finch, Murray Head. United Artists.

Suspect. 1987. Dir. Peter Yates. Perf. Cher, Dennis Quaid, Liam Neeson. TriStar Pictures.

Sweet Hereafter, The. 1997. Dir. Atom Egoyan. Perf. Ian Holm, Sarah Polley. Fine Line Features.

Swoon. 1992. Dir. Tom Kalin. Perf. Daniel Schlachet, Craig Chester. Fine Line Features.

Tea and Sympathy. 1956. Dir. Vincente Minnelli. Perf. Deborah Kerr, John Kerr, Leif Erickson. MGM.

10 Rillington Place. 1971. Dir. Richard Fleischer. Perf. Richard Attenborough, Judy Geeson. Columbia Pictures.

These Three. 1936. Dir. William Wyler. Perf. Miriam Hopkins, Merle Oberon, Joel McCrea. United Artists.

They Won't Forget. 1937. Dir. Mervyn LeRoy. Perf. Claude Rains. Warner Brothers.

Thin Blue Line, The. 1988. Dir. Errol Morris. Perf. Randall Adams, David Harris. Miramax.

Thin Man, The. 1934. Dir. W. S. Van Dyke. Per. William Powell, Myrna Loy. MGM.

Time to Kill, A. 1996. Dir. Joel Schumacher. Perf. Sandra Bullock, Samuel L. Jackson, Matthew McConaughey, Kevin Spacey. Warner Brothers.

Titanic. 1997. Dir. James Cameron. Perf. Leonardo DiCaprio, Kate Winslet, Billy Zane. Paramount Pictures.

To Kill a Mockingbird. 1962. Dir. Robert Mulligan. Per. Gregory Peck, Mary Badham, Philip Alford, Brock Peters. Universal Pictures.

Torch Song Trilogy. 1988. Dir. Paul Bogart. Perf. Anne Bancroft, Matthew Broderick, Harvey Fierstein. New Line Cinema.

Traffic. 2000. Dir. Steven Soderbergh. Perf. Michael Douglas, Benicio Del Toro, Catherine Zeta-Jones. NBC Universal.

Trial by Jury. 1994. Dir. Heywood Gould. Perf. Joanne Whalley-Kilmer, Armand Assante, Gabriel Byrne. Warner Brothers.

12. 2007. Dir. Nikita Mikhalkov. Perf. Sergey Makovetskiy, Sergey Garmash. Federal Agency for Culture & Cinematography.

12 Angry Men. 1957. Dir. Sidney Lumet. Perf. Henry Fonda, Lee J. Cobb, Ed Begley, E. G. Marshall. United Artists.

Uncle Tom's Cabin. 1903. Dir. Edwin S. Porter. Edison Manufacturing Company.

Unforgiven. 1992. Dir. Clint Eastwood. Perf. Clint Eastwood, Morgan Freeman, Gene Hackman, Richard Harris. Warner Brothers.

Unmarried Woman, An. 1978. Dir. Paul Mazursky. Perf. Jill Clayburgh, Alan Bates. Twentieth Century-Fox.

Verdict, The. 1982. Dir. Sidney Lumet. Perf. Paul Newman, Charlotte Rampling, James Mason. Twentieth Century-Fox.

Victim. 1961. Dir. Basil Dearden. Perf. Dirk Bogarde, Sylvia Sims, Dennis Price. Pathe-American Distributing Company.

Victor Victoria. 1982. Dir. Blake Edwards. Perf. Julie Andrews, Robert Preston, James Garner. MGM.

Waiting to Exhale. 1995. Dir. Forest Whitaker. Perf. Whitney Houston, Angela Bassett, Loretta Devine, Lela Rochon. Twentieth Century-Fox.

Wall Street. 1987. Dir. Oliver Stone. Perf. Michael Douglas, Charlie Sheen. Twentieth Century Fox.

War of the Roses. 1989. Dir. Danny DeVito. Perf. Michael Douglas, Kathleen Turner, Danny DeVito. Twentieth Century-Fox.

Widow of St. Pierre, The. 2000. Dir. Patrice Leconte. Perf. Juliette Binoche, Daniel Auteuil, Emir Kusturica. Lions Gate Films.

Wild Boys of the Road. 1933. Dir. William Wellman. Perf. Frankie Darro, Edwin Phillips, Rochelle Hudson. Warner Brothers.

Wilde. (1997). Dir. Brian Gilbert. Perf. Stephen Fry, Jude Law. BBC.

Windows. 1980. Dir. Gordon Willis. Perf. Elizabeth Ashley, Talia Shire. United Artists.

Winslow Boy, The. 1999. Dir. David Mamet. Perf. Nigel Hawthorne, Rebecca Pidgeon, Jeremy Northam, Matthew Pidgeon, Gemma Jones. Sony Pictures Classics.

Witness for the Prosecution. 1957. Dir. Billy Wilder. Perf. Charles Laughton, Marlene Dietrich, Tyrone Power. United Artists.

Women, The. 1939. Dir. George Cukor. Perf. Joan Crawford, Norma Shearer, Rosalind Russell. MGM.

Wrong Man, The. 1956. Dir. Alfred Hitchcock. Perf. Henry Fonda, Vera Miles. Warner Brothers.

Wuthering Heights. 1939. Dir. William Wyler. Perf. Merle Oberon, Laurence Olivier. United Artists.

Young Mr. Lincoln. 1939. Dir. John Ford. Per. Henry Fonda. Twentieth Century-Fox.

Young Philadelphians, The. 1959. Dir. Vincent Sherman. Perf. Paul Newman, Barbara Rush. Warner Brothers.

Zero Dark Thirty. 2012. Dir. Kathryn Bigelow. Perf. Jessica Chastain, Joel Edgerton, Chris Pratt. Universal.

Television Shows and Series

All in the Family. 1971–79. CBS.

Ally McBeal. 1997–2002. Fox.

Amos 'n' Andy. 1951–53. CBS.

Arrest & Trial. 1963–64. ABC.

Boston Legal. 2004–08. ABC.

Boston Public. 2000–04. Fox.

Century City. 2004. NBC.

Chicago Hope. 1994–2000. CBS.

Close to Home. 2005–07. CBS.

Cosby Show, The. 1982–92. NBC.

Court, The. 2002. ABC.

Damages. 2007–. FX.

Deadwood. 2004–06. HBO.

Defenders, The. 1961–65. CBS.

Defenders, The: Choice of Evils. 1998. Showtime.

Defenders, The: Payback. 1997. Showtime.

Doogie Howser, M.D. 1989–93. ABC.

Dragnet. 1951–59. NBC.

Dragnet. 2003–04. ABC.

Early Frost, An. 1985. NBC.

Eli Stone. 2008–09. ABC.

Ellen. 1994–98. ABC.

Family Law. 1999–2002. CBS.

First Years, The. 2001. NBC.

Forsyte Saga, The. 1967. BBC.

Friday Night Lights. 2006–11. NBC.

Gideon's Trumpet. 1980. CBS.

Girls Club, The. 2002. Fox.

Glee. 2009–. Fox.

Good Wife, The. 2009–. CBS.

Guardian, The. 2001–. CBS.

Gunsmoke. 1955–75. CBS.

Happy Endings. 2011–. ABC.

Harry's Law. 2011–12. NBC.

Hill Street Blues. 1981–87. NBC.

Homeland. 2011–. Showtime.

I Love Lucy. 1951–57. CBS.

Indictment. 1995. HBO.

JAG. 1995–2005. NBC.

Judge Horton and the Scottsboro Boys. 1976. NBC.

Judge John Deed. 2001–. BBC.

Judge Judy. 1996–. Paramount.

Judging Amy. 1999–. CBS.

Jury, The. 2002. Granada.

L.A. Law. 1986–94. NBC.

Law & Order. 1990–. NBC.

Law & Order: Criminal Intent. 2001–11. NBC.

Law & Order: Special Victims Unit. 1999–. NBC.

Law & Order: Trial by Jury. 2005–06. NBC.

Lesson Before Dying, A. 1999. HBO.
Lost. 2004–10. ABC.
Mary Tyler Moore Show. 1970–77. CBS.
*M*A*S*H.* 1972–83. CBS.
Matlock. 1986–95. NBC.
Modern Family. 2009–. ABC.
Murder One. 1995–97. ABC.
N.Y.P.D. Blue. 1993–. ABC.
100 Centre St. 2001. A&E.
Paper Chase, The. CBS (1978–79), Showtime (1983–86).
Perry Mason. 1957–66. CBS.
Picket Fences. 1992–96. CBS
Practice, The. 1997–. ABC.
Roots. 1977. ABC.
Scottsboro: An American Tragedy. 2000. Social Media Productions.
Sex and the City. 1998–2004. HBO.
Shark. 2006–08. CBS.
Simpsons, The. 1989–. Fox.
South Park. 1997–. Comedy Central
Sopranos, The. 1999–2007. HBO.
Star Trek: The Original Series. 1966–69. NBC.
Studio One. 1948–58. CBS
Suits. 2011–. USA.
To Tell the Truth. 1956–68. CBS.
12 Angry Men. 1997. Showtime.
24. 2001–10. Fox.
West Wing, The. 1999–. NBC.
Will & Grace. 1998–2006. NBC.
Wire, The. 2002–08. HBO.

Court Cases

Alyeska Pipeline Service Co. v. Wilderness Society, 421 U.S. 240 (1975)
Anderson v. Cryovac, Inc., 862 F.2d 910 (1st Cir. 1988)
Atkins v. Virginia, 536 U.S. 304 (2002)
Bates v. State Bar of Arizona, 433 U.S. 350 (1977)
Batson v. Kentucky, 476 U.S. 79 (1986)
Bradwell v. Illinois, 83 U.S. 130 (1872)
Brown v. Board of Education, 347 U.S. 483 (1954)
Burdine v. Johnson, 262 F.3d 336 (5th Cir. 2001)
Bush v. Gore, 531 U.S. 98 (2000)
Cain v. Hyatt, 734 F. Supp. 671 (E.D. Pa. 1990)
Caperton v. A. T. Massey Coal Co., 556 U.S. 868 (2009)

Daubert v. Merrell Dow Pharmaceuticals, 501 U.S. 579 (1993)

Dickerson v. United States, 530 U.S. 428 (2000)

Furman v. Georgia, 408 U.S. 238 (1972)

Gideon v. Wainwright, 372 U.S. 335 (1963)

Gregg v. Georgia, 428 U.S. 153 (1976)

Grimshaw v. Ford Motor Co., 119 Cal. App. 3d 757, 174 Cal. Rptr. 348 (1981)

Hawkins v. McGee, 146 Atl. 641 (New Hampshire, 1929)

Joseph Burstyn, Inc. v. Wilson, 343 U.S. 495 (1952)

Kreyling v. Kreyling, 23 Atl. 2d 800 (N.J. Chancery Ct. 1942)

Mapp v. Ohio, 367 U.S. 643 (1961)

McClesky v. Kemp, 481 U.S. 279 (1987)

M'Naghtens Case, 8 Eng. Rep. 718 (1843)

Meritor Savings Bank v. Vinson, 477 U.S. 57 (1986)

Miranda v. Arizona, 384 U.S. 436 (1966)

Missouri v. Frye, 132 Sup. Ct. 1399 (2012)

Mutual Film Corp. v. Ohio Industrial Commission, 236 U.S. 230 (1915)

Nix v. Whiteside, 475 U.S. 157 (1986)

Norris v. Alabama, 294 U.S. 587 (1935)

Ohralik v. State Bar of Ohio, 436 U.S. 447 (1978)

Payne v. Tennessee, 501 U.S. 808 (1991)

Powell v. Alabama, 287 U.S. 45 (1932)

Reid v. Covert, 354 U.S. 1 (1957)

Ring v. Arizona, 536 U.S. 584 (2002)

Roe v. Wade, 410 U.S. 113 (1973)

Roper v. Simmons, 543 U.S. 551 (2005)

Schechter Poultry Co. v. United States, 295 U.S. 495 (1935)

State Farm Mutual Insurance Co. v. Campbell, 538 U.S. 408 (2003)

Taylor v. Louisiana, 419 U.S. 522 (1975)

Terry v. Ohio, 392 U.S. 1 (1968)

United States v. Douglas, 68 M.J. 349 (CAAF 2010)

United States v. Thomas, 22 M.J. 388 (CAAF 1986)

United States v. Thomas, 116 F.3d 606 (2d Cir. 1997)

Watts v. Watts, 350 N.Y.S.2d 285 (N.Y. Court of Appeals 1973)

Index